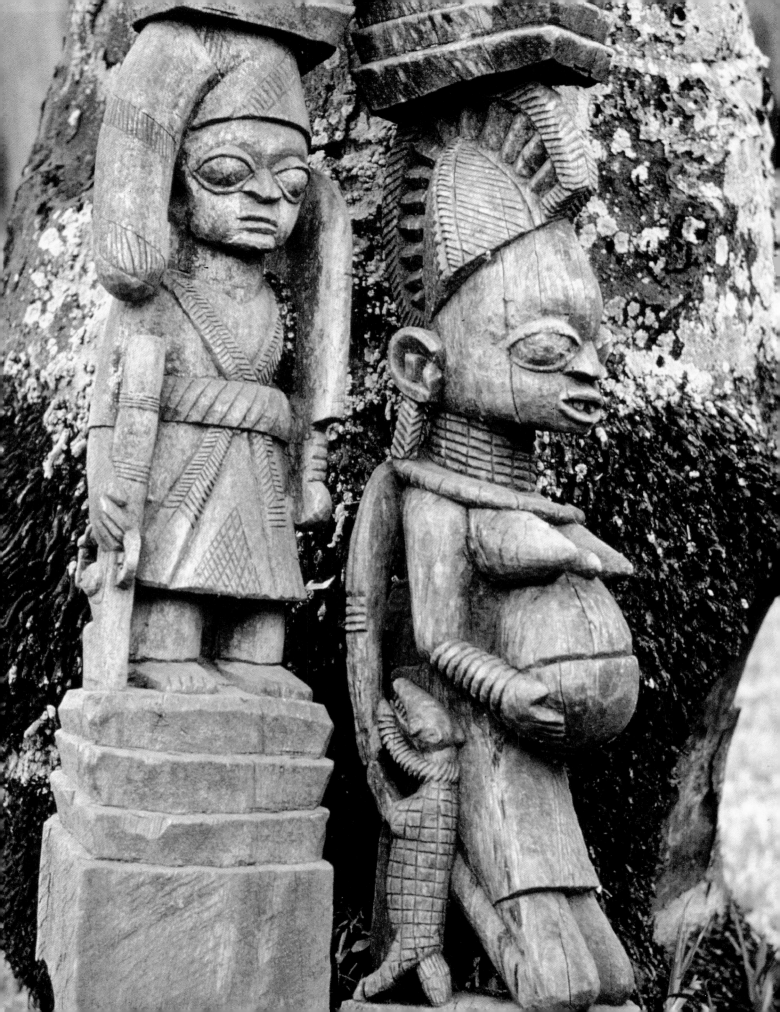

THE YORUBA ARTIST

NEW THEORETICAL PERSPECTIVES ON AFRICAN ARTS

EDITED BY
ROWLAND ABIỌDUN,
HENRY J. DREWAL,
AND
JOHN PEMBERTON III

SMITHSONIAN INSTITUTION PRESS · Washington and London

This publication was made possible by generous contributions from the Swiss Academy of Human and Social Sciences, the Swiss Society for African Studies, and Dr. Charlotte von Graffenried, Berne, Switzerland

Copy Editor: Frances Kianka
Production Editor: Duke Johns
Designer: Janice Wheeler

Library of Congress Cataloging-in-Publication Data
The Yoruba artist : new theoretical perspectives on African Arts / edited by Rowland Abiodun, Henry J. Drewal, John Pemberton III.
p. cm.
Based on a 1992 symposium held at the Museum Rietberg Zürich. Includes bibliographical references.
ISBN 1-56098-339-6 (cloth). — ISBN 1-56098-340-X (paper)
1. Arts, Yoruba—Congresses. 2. Arts, Black—Nigeria—Congresses. 3. Arts, Black—Benin—Congresses.
I. Abiodun, Rowland. II. Drewal, Henry John. III. Pemberton, John, 1928– . IV. Museum Rietberg.
NX589.6.N5Y67 1994
700'.89'96333—dc20 93-20763

British Library Cataloguing-in-Publication Data is available

Manufactured in China
01 00 99 98 97 96 95 94 5 4 3 2 1

Cover/dust jacket: Detail of Ikere palace door, ca. 1925, carved by Olowe of Ise. Irwin Green Collection. Photo courtesy of Pace Gallery, New York. Back cover: Sango Ponle, a devotee of òrìṣà Sango, with an *arugbá Sàngó* carved by Fakeye in Ila-Orangun, 1977. Photo by John Pemberton III.

Frontispiece: Veranda posts, said to be the work of Rotimi Baba Oloja. National Museum, Lagos. Photo by John Picton, 1964.

Contents

Preface

In January 1992 a symposium on "The Yoruba Artist" was held at the Museum Rietberg Zürich in conjunction with the exhibition *Yoruba: Nine Centuries of African Art and Thought*. The essays in this volume, with the exception of two, are based on the papers presented at the Rietberg. The symposium was jointly sponsored by the Museum Rietberg Zürich and the Swiss Society for African Studies. Scholars from Nigeria, Europe, Great Britain, and the United States participated. At the conclusion of the symposium Dr. Claude Savary, president of the Swiss Society for African Studies, announced that the Society would seek funds to support a publication of the proceedings. We are grateful to Dr. Savary and Dr. Charlotte von Graffenried, the Society's treasurer, for their support of the symposium. The publication of this volume was made possible by generous contributions from the Swiss Academy of Human and Social Sciences, the Swiss Society for African Studies, and Dr. Charlotte von Graffenried.

The symposium was organized by Lorenz Homberger, curator of African Art at the Museum Rietberg Zürich, who had also arranged the European venue of *Yoruba* and whose installation received applause from European scholars, collectors, and the general public. Dr. Eberhard Fischer, director of the museum, gave his strong support and good counsel to the preparation of a new exhibition catalogue, *Yoruba Art and Aesthetics*, which the Rietberg Museum published in English and German editions. In many respects this catalogue, in addition to the exhibition, provided the basis and context for the further explorations in Yoruba art historical studies pursued by the contributors to the symposium on "The Yoruba Artist."

The name of William Fagg was often mentioned in papers and during the discussions, as well as at social occasions of a type that Bill would have enjoyed. William Fagg's name is virtually synonymous with Yoruba art historical studies. He established standards of research and writing that few will achieve. He was generous with his extensive knowledge and never failed to ask interesting questions, suggesting new lines of inquiry. He encouraged persons new to Yoruba studies, valuing their enthusiasm, patient with their naiveté. He was gracious in his criticism of those in whose work he found some small or even egregious error but silently dismissive of those whose comments he found unworthy of the subject he so valued. William Fagg was unable to attend the symposium due to illness. He died on 10 July 1992. In gratitude we dedicate this volume

to his memory and request that the royalties be given to the William B. Fagg Memorial Fund of the British Museum.

We wish to acknowledge our gratitude to the staff at SKILLS in Amherst, Massachusetts, for their assistance in the preparation of this manuscript for publication. Their editorial expertise and enormous patience made possible the completion of this project on schedule. Special words of praise are due Susan B. Winslow, who responded with grace and insight to the awesome task of editing the diversity of styles, formats, and languages in which the eighteen authors submitted their manuscripts, and to Frances Kianka, whose careful copy editing and thoughtful comments in the final stages of manuscript preparation were invaluable. We also wish to thank Duke Johns, Cheryl Anderson, and Amy Pastan of the Smithsonian Institution Press for their wise counsel and gracious support as this volume proceeded to publication.

We are grateful to the staff of many museums, libraries, archives, and publishing houses for their generous assistance with our research and to private collectors of African art and devotees of the òrìṣà who permitted us to enter their homes and shrines to see and photograph objects of value and veneration. Above all, we wish to express our indebtedness to all those throughout Yorubaland (in West Africa and the diaspora) who shared with us their knowledge about individual artists in order that we might better understand the Yoruba artist.

Rowland Abiọdun
Henry John Drewal
John Pemberton III

A Note on Orthography

Yoruba is a tonal language, with three underlying pitch levels for vowels and syllabic nasals: low tone (indicated with a grave accent: kò, ǹ), mid tone (not marked: le, n), and high tone (indicated with an acute accent: wí, ́n). We have used tone accents and subscript marks (as in ẹ, ọ, ṣ) throughout the text. Where subscript marks are required, the ẹ is roughly equivalent in English to "yet," the ọ sound to "ought," and ṣ has the sound of "sh." However, we have not used the tone accents on the names of persons, places, or similar references in the English-language texts, although they do appear in the quotations from *oríkì* (praise poetry) and where the use of a Yoruba term is essential. The Yoruba orthography used generally follows that of Abraham (1958), which is based on the Ọyọ dialect. Texts collected in other areas have been presented in their original dialect form.

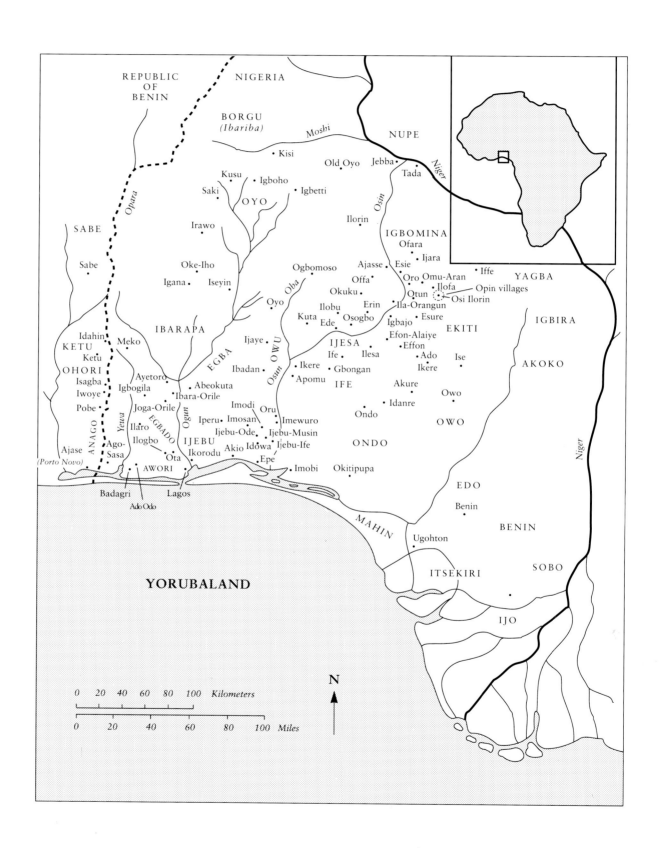

REPUBLIC
OF
BENIN

NIGERIA

BORGU
(Ibariba)

Moshi

NUPE

Kisi

Old Oyo

Jebba

Tada

Niger

Kusu

Igboho

Igbetti

Saki

OYO

Ilorin

Osin

IGBOMINA

Ofara

Irawo

Ajasse

Esie

Ijara

Iffe

YAGBA

Oke-Iho

Ogbomoso

Oro Omu-Aran

Ilofa

Opin villages

SABE

Offa

Qtun

Osi Ilorin

Igana

Iseyin

Oba

Okuku

Ila-Orangun

IGBIRA

Sabe

Oyo

Ilobu

Erin

Esure

Kuta

Ede

Osogbo

Igbajo

EKITI

Efon-Alaiye

Ijaye

OWU

IJESA

Effon

Ise

AKOKO

IBARAPA

Ife

Ilesa

Ado

EGBA

Osun

Ikere

Gbongan

Ikere

Meko

Ibadan

Apomu

IFE

Akure

Owo

Idahin

Ayetoro

Abeokuta

Idanre

KETU

Igbogila

Ibara-Orile

Imodi

Oru

Ondo

OWO

Ketu

OHORI

Isagba

Joga-Orile

Iperu

Imosan

Imewuro

Iwoye

Ilaro

Ijebu-Ode

Ijebu-Musin

Pobe

Ilogbo

Akio Idowa

Ijebu-Ife

ONDO

Ajase

Ago-
Sasa

Ota

Ikorodu

Epe

(Porto Novo)

ANAGO

Yewa

EGBADO

Ogun

IJEBU

Imobi

Okitipupa

AWORI

Badagri

Lagos

EDO

Ado Odo

Benin

MAHIN

BENIN

Ugohton

YORUBALAND

ITSEKIRI

SOBO

Niger

IJO

0 20 40 60 80 100 *Kilometers*

0 20 40 60 80 100 *Miles*

N

1. Art, Identity, and Identification: A Commentary on Yoruba Art Historical Studies

John Picton

There really is no such thing as Art. There are only artists. (E. H. GOMBRICH, *THE STORY OF ART*, 1963:5)

These are the opening sentences of a book that for almost thirty years has provided a text basic to the training of many British historians of art. In preparing a paper for publication that originated as the opening address at a conference dedicated to the artist, they might seem to have a certain relevance. Gombrich continues by reminding us that "such a word [i.e., art] may mean very different things in different times and places. . . . Art with a capital A has no existence . . . [and] . . . has come to be something of a bogey and a fetish." We can be sure that, year after year, students have been wondering what on earth he might mean: after all, we are so used to seeing "Art with a capital A" on the timetable; and at the opening of a conference on The Artist, no matter that the artist is Yoruba, we might wonder too. Is it likely that Gombrich intends to direct our attention toward the individual artist, or art worker, at the expense of his/her works? Whatever else we might think, *The Story of Art* will not permit that oversimplification. So, is he, like George Kubler (1962:1) in another opening sentence, suggesting that "the idea of art can be expanded to embrace the whole range of manmade things"? Or is he telling us to concentrate on the processes (technical, social, perceptual, aesthetic, and so on) of an art? These questions might seem like an insistence on the need to contextualize; except that this would be just another oversimplicity, unless we ask another question: which context? For the artifact itself (the work of art, the working of an art: the ambiguity is inevitable) is a context, a "weaving together." We must reckon with a derivation from the Latin verb *texere*, to weave, from which we also derive "textile" and "text" (Picton 1990b:50); and just as the artifact is a context, so too it is a participation in, a presupposition of, an enactment, a representation, a re-presentation of other contexts, severally, and succeeding one another through time and space.

There is, of course, a certain irony in the recognition that, whatever else one might argue about, the art work is given the capacity to survive. Whether as material fact or as that memory of forms (material or ephemeral) that enables their reinvention, art works are possessed of the uncomfortable habit of surviving beyond, and without necessary reference to, the lifetimes of artists and patrons. Indeed, artists and patrons survive only in virtue of the artifacts for which they claim a

responsibility. Yet neither artistry nor patronage provides for context as fixed properties of art works; and, as I have written elsewhere, "we should not be surprised at any of this, for art has always been a process of reification, a making of things with an independent and 'worldly existence' (Read, 1959:280). This is, of course, not to be taken as if artifacts are somehow animate. Their 'independence' is a function of our necessity for art" (Picton 1990b:63). This might seem as if I have turned Gombrich upside down, and subverted the intention of the conference and its publication, but for the fact that the artist is likewise a function of that same necessity (even if "Art with a capital A has no existence").

In any case, no matter how we may contextualize art in regard to social and historical circumstances, the practice of an art also possesses an autonomy. Karin Barber raised these kinds of questions as she began her presentation at the Zurich conference: "objects are never just objects" (as an example of this she talked about the quality of the greeting needed to initiate the performance of an *egúngún* masquerader). Whatever is true in this statement is true of all material artifacts. A Yoruba identity can be recognized of certain things by reason of material form, if only because we know enough to presume an origin of certain shapes in certain parts of the world. At the same time, we recognize that this kind of identification gives no indication of the place of objects, no indication of the particular realization of these forms, within the traditions of Yoruba practice.

Nevertheless, mere objects seemingly as objects have their life histories, individually and within particular sequences of objects. This is not somehow intended to suggest that art works really are animate after all. These life histories are because of what we do with things; and, of course, they can no longer be just about the original conditions of existence of particular art works, but must take in the livelihood of dealers, the bank balances of connoisseurs, the cases of museums, and the pages of books. Likewise, artists, patrons, and so on have life histories, and those histories participate in sequences of artists, patrons, etc. Likewise, that which makes an object "never just" an object has a history (several histories, indeed); and we might include the memory of objects of the past, and the memory of great artists even when we can no longer identify their works. Professor Wande Abimbọla's reference to the *oríkì* that tells us about famous sculptors, made in discussion of this paper and elaborated later in his own presentation, is a case in point (see also J. R. O. Ojo n.d.). This brings us to another paradox of art: that each kind of history is functionally related to each other kind, a relationship that is easily capable of documentation; and yet each history is at the same time independent of each other, for we can never reduce one to another, nor the whole to any one of its parts. In other words, objects certainly exist as objects, this fact serving to enable their appropriation and reinvention within one context after another. Yet, at the same time, they are just as certainly "never just objects"; and any account of that "never just" must inevitably have reference to the artist and to the remembrance of artists, whether this is in some sense institutionalized, as in Yoruba *oríkì,* or within the memories of people in the communities within which an artist lived and worked.

Although the paper that follows is little more than a series of comments as if scribbled in the margins of one's personal library, at its core there is an account of the problems of investigating that local memory to which I have just referred. The intention is to discuss some of the characteristic features of the history of Yoruba (art historical) studies, with suggestions of areas for development. If the discussion is selective—neither exhaustive nor comprehensive—this is an inevitable consequence of the volume and substance of the published literature.

The single most important fact about Yoruba studies is that it is a field of research and publication initiated by Yoruba people. It is an area of intellectual discourse about Africa in which the African "voice" has been present from the beginning—and not merely present but the very agent of its inception. The first publication concerning the Yoruba language was the *Yoruba Primer* by Samuel Ajayi Crowther, 1849, "his own book written wholly in Yoruba" (Awoniyi 1978:40). Ajayi Crowther was consecrated a bishop of the Anglican Church in 1864. Then there was *The History of the Yorubas from the Earliest Times to the Beginning of the British Protectorate*, written by another Anglican minister, the Reverend Samuel Johnson, completed in 1897 but not published until 1921 due to the loss of the original manuscript by an English publisher. In his preface, Johnson notes: "Educated natives of Yoruba are well acquainted with the history of England and with that of Rome and Greece, but of the history of their own country they know nothing whatever!" (1921:vii).[1]

Following Crowther and Johnson, so many other Yoruba scholars have provided their own contributions to the growth of Yoruba studies, particularly in the fields of language, literature, history, religion, music, and the performing arts, that it is impossible even to contemplate the writing of a survey, at least not in the context of this brief essay. For the mid-1970s the collection of essays edited by Abimbọla, *Yoruba Oral Tradition* (1975b), provides a ready-made account of part of this field. We also remember, of course, that Wọle Ṣoyinka was the first writer of sub-Saharan Africa to be awarded the Nobel Prize for literature. In the documentation, including the history, of the visual arts, however, Yoruba scholarship has, curiously, been relatively late in appearance, and the writers relatively few in number. The pioneers are J. R. O. Ojo (1973, 1975, 1978), Babatunde Lawal (1974, 1977), and Rowland Abiọdun (1975a, 1975b, 1976), although they were preceded by the geographer, G. J. A. Ojo (1966a and b). They have, of course, each continued writing, and their work has inspired others, leading to the enlargement of Yoruba scholarship; see, for example, the papers in *Kurio Africana* (Okediji 1989) and also the excellent bibliographies in Fagg and Pemberton (1982) prepared by C. Owerka, and in Drewal, Pemberton, and Abiọdun (1989). The late entry into art historical[2] studies on the part of Yoruba scholars demands explanation. The extraordinary richness of the poetic and literary traditions is well known and extensively celebrated in the published literature, and the *àṣe* attributed to words is equally well known. Is it the case, then, that the European interest in the visual arts is simply misplaced? Yoruba sculpture is, after all, more-or-less immediately available to appreciation, whereas the poetic traditions are essentially inaccessible to anyone without facility in the Yoruba language, other than in translation. A basis for European misrepresentation would seem imme-

diately obvious; and yet recognition of the sheer diversity of the traditions of visual practice, past and present, gives no encouragement to so simple an explanation. There is, however, an alternative, which, in a sense, follows from the Reverend Johnson's comments about the content of a Eurocentric education: it might be (among other things?) a function of the particular logocentric bias of Western education and intellectual activity, given the extraordinary fascination with ancient Greece and the influence of Greek philosophical writings.[3] I leave it to others, better qualified than I, to comment on Yoruba attitudes in this regard, particularly in view of the *àṣẹ* of words.[4]

We must also remark upon the fact that the very beginnings of opposition to British colonial rule, an opposition that is earlier than the formation of the present state of Nigeria, were initiated by Yoruba people. The principal agents in the emerging nationalism were the descendants of freed slaves of Yoruba origin repatriated from Sierra Leone. Herbert Macauley was a case in point; but many rejected the English names, and dress, with which they had returned to Lagos and consciously asserted a Yoruba identity, taking Yoruba names and taking up Yoruba dress forms. The place of dress in early nationalism is surely part of the background to understanding the continuing relevance and flourishing of certain Yoruba handwoven textiles (see Picton 1992a).

The basis for an Africanist art history has been established by William Fagg, and we all stand in his debt for establishing our fields of study. In particular, he, more than any other single person, defined the place of Yoruba within African art studies.[5] Bill himself attributed his expertise to his access to public and private collections (including those of Charles Ratton and Josef Mueller, as well as, of course, the material in the British Museum, of which he was the Keeper) put together largely prior to the widespread manufacture of fakes intended to deceive the unwary, and to his friendship with the sculptor Leon Underwood. With his younger brother, Bernard, in Nigeria it was perhaps inevitable that Bill should develop a particular interest in that country; and there he had the particular benefit of the securely documented collection made for the Lagos Museum by Kenneth Murray.[6] After his return to London in 1959 from a six-month research program on behalf of the Yoruba Historical Research Scheme (see Postscript 1), Bill had begun putting together photographs for a book to be called *Seven Yoruba Masters*. The book remains unwritten, and Bill is no longer with us; but I do not doubt that among his papers the cardboard box containing those photographs still exists. The sculptors to be included will have little surprise for those familiar with the published literature:

> Adigbologe of Abẹokuta
> Ọlọgan of Ọwọ
> Ọlọwẹ of Isẹ-Ekiti
> Areogun (or Arowogun) of Osi-Ilọrin
> Bamgboye of Odo-Ọwa

Agbọnbiofẹ of Ẹfọn-Alaye
Agunna of Ikọle-Ekiti (or Oke Igbira, Odo Igbira, Oke Ayedun)
Ologunde also of Ẹfọn-Alaye
Bamgboṣe also of Osi-Ilọrin
Ajigunna of Ilọfa
Akiode also of Abẹokuta
the Master of Isare
etc. . . . Seven? It is a convenient number.[7]

Since then we have discovered that some of these names, for example, Akiode, are the names of lineages or households; that Ologunde is a chiefly title; that through the work of Tim Chappel, Bob Thompson, Henry Drewal, John Pemberton, and myself, all following in Fagg's footsteps, we now know of many more; that the Master of Isare is actually two distinct sculptors; and that, as William Rea (personal comm.) has found recently, Agunna is more than one person. Nevertheless, these names continue to dominate the literature; and very often the first published identifications of individual sculptural hands were made by Bill Fagg. The fact that, Abẹokuta and Ọwọ apart, all are Ekiti or Ọpin masters might, of course, be construed, in part, as a consequence of Bill Fagg's friendship with Father Kevin Carroll, whose employment of Yoruba artists to service the liturgical needs of the Catholic Church was, and continues to be, innovative (and certainly not restricted to the so-called "traditional"). On the other hand, in their ability to handle form on a larger scale than is characteristic of western or central Yoruba, those sculptors were the inheritors of a tradition that would be bound to dominate any attempt at comparative study and, indeed, any collection of Yoruba sculpture. Of course, other judgments are possible, and I have already noted Professor Abimbọla's account of some of the great sculptors of the Ọyọ empire commemorated in *oríkì*. The problem here, of course, is that the memory of artistry is preserved but with no means of relating that memory to material artifacts; but it is a problem that will need to be addressed.[8]

One takes it for granted, now, that Yoruba sculptors of the premodern tradition can be identified by name. From a standpoint within a Yoruba community this must always have been obvious; but when William Fagg first entered African art studies, from a standpoint located in the collections of Europe and America, this fact was very far from obvious. Not least among the attractions of Yoruba sculpture to many scholars was precisely that, Bill having identified the possibilities, one might approach it art historically in the manner of the great flourishings of European art. On the other hand, the fact that we have established an identification of certain sculptures with the names of certain sculptors in itself could be said to prove nothing in particular, beyond the fact that exact replication is a particularly complex achievement. These identifications might serve only to enable dealers and collectors to place a higher financial value on their possessions, in seeming to establish a likeness with the more familiar artifacts that are the currency

operating within the present framework of an art world dominated by Europe and European-America: not merely "a" Yoruba (after all, whoever heard of "a" Spanish), but "a" Dada Areogun (as, for example, "a" Pablo Picasso). This is, of course, a matter of documentary interest in regard to the market in "Art with a capital A," and its appropriation of Africa; and this is a legitimate Africanist concern. On the other hand, it might be little more than pseudo-scholarly conceit as far as the people for whom these things were made are concerned. Rather, what do these identifications amount to in regard to the life of a community and its arts? In order to answer that question we must also consider the status of the information available to us and the ideological place of the artist in discourse about art; and the transformations in art and art worlds in Africa consequent upon and subsequent to colonial domination. Perhaps, in reality, the *oríkì* tell us more about the esteem of artists and the reception of their works within the premodern tradition than the works themselves of, for example, the *Seven Yoruba Masters*.

The fact that we have established an identification of certain sculptures with the names of certain sculptors has generated an expectation that we can name the hand responsible for each and every work. However, Chappel's paper on Abẹokuta sculptors (1972) provided a necessary corrective to such an assumption: in that case the attribution of a sculpted door to the founder of one or other of the carving houses in that city was so bound up with the validation of a political status that certain identification proved both contentious and impossible. Nevertheless, the expectation has, in its turn, led to a pressure to name the hand even when the evidence (whether of our eyes or from field documentation) is less than clear, when silent discretion would be the better part of art historical valor, at least until we were more certain of the nature of the information at our disposal. All too often, field investigation reveals seemingly endless names of sculptors, as well as the visual evidence for the existence of a multitude of hands at work; and yet we lack the key by means of which we can join the one list with the other.[9]

My own research on the sculptors of Ọpin is a case in point.[10] The sculpture of Areogun of Osi-Ilọrin has long been well established as providing a distinct aesthetic identity, recognized in and around his home community, as testified by the quantity and distribution of his work; and recognized in the literature as a result of the work of Fr. Carroll (1961, 1967). Other scholars have also published the work of Areogun, but all identifications derive, directly or indirectly, from Carroll's friendship with the great master himself, whom he had met as a consequence of his work with Areogun's son, George Bandele. Indeed, father and son were estranged at that time, and Carroll effected their reconciliation. Moreover, it was through this friendship that the securely documented works of Areogun were identified for and collected by Kenneth Murray for the Lagos Museum.

Osi-Ilọrin is a village so designated because of its incorporation within the Ilọrin Emirate in the mid-nineteenth century, and in order to distinguish it from Osi-Ekiti. In 1964–65, when I carried

out the research summarized here, Osi-Ilọrin was the administrative center of the Osi District of Ilọrin Province (now Kwara State), which comprised a group of villages known collectively as Ọpin, together with two Ekiti communities, Ẹtan and Obo Ayegunlẹ. The inhabitants of Ọpin regarded themselves as not Ekiti, however, while recognizing political and cultural affinities with Ekiti. Originally there were twelve Ọpin villages, but with the conquest of the area for the Ilọrin Emirate the original pattern had been disturbed. Ikẹrin, for example, as its name suggests, was originally four villages. In other cases, subsequent growth had led to the division of villages that were once one.

The corpus of works, and photographs, established in the collections and archives in Lagos, together with Carroll's notes of conversations with George Bandele (see Postscript 2) and their discussion of sculptural technique, provided an invaluable research tool with which to consider and evaluate questions of individual hand.[11] I had access to this material upon my arrival at the Lagos Museum in 1961, and visited Ọpin briefly, with Kevin Carroll, in 1963. Then, in the course of thirteen months, from January 1964 to January 1965, I engaged in ethnographical survey work in the Yoruba-speaking region, extending the photographic archives in Lagos and collecting works that had fallen into disuse for the national collection, following up the work of Kenneth Murray and Philip Allison. Toward the end of this period I spent more and more time in Ọpin, where I photographed anything that was shown to me and talked to anyone who would talk to me. I began to understand something of the political, social, and ritual traditions of Ọpin as a basis for more exhaustive inquiries about the history of sculpture. I interviewed every living sculptor, whether still working or not, and descendants of the great masters of the past with the exception of Bamgboṣe, to whom Areogun had been apprenticed: his house and people seemed to have disappeared from the face of the earth.

George Bandele, Areogun's son, was the only sculptor in anything like full-time employment, and that was provided by Fr. Carroll. Another sculptor at Osi, Roti, had long since given up carving, having taken the chiefly title of Agbanna. On the other hand, two titled village heads reckoned to continue to do some carving now and again: Faṣiku, the Alaaye of Ikẹrin, and Ogungbemi, the Asọlọ of Isọlọ.[12]

Indeed, Faṣiku, with the encouragement of the traders from Ibadan, began carving quite substantial pieces which could be passed off as "antiquities" to those unfamiliar with the local situation. At Isare, Dada Owolabi Ọdẹ, a grandson of the great Rotimi Baba Ọlọja, produced work in a schematic and somewhat (in my view) inept style, mostly smaller objects such as decorative bowls, mirror frames, and combs, though I did see a door panel he had made.[13] Yusuf Amuda of Ikẹrin, though once a sculptor of some expertise, had given up for lack of work and applied himself to his farm. The only sculptures he completed during my time in the area were for me, though under the stimulus of my interest he started work on a door panel for no other apparent reason than to test and renew his remaining skill. Yusuf was a grandson of Rotimi Alaari,

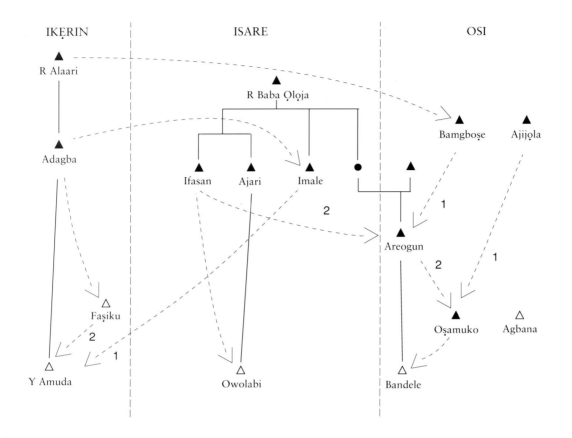

**Fig. 1.1.
Sculptors of Ọpin showing who was the father of whom, and who was said to have taught whom. For Areogun, Ọṣamuko, and Y. Amuda, the number 1 indicates the direction of apprenticeship and 2 of a later assistantship.**

the great nineteenth-century Ọpin artist, who proved to be the earliest identifiable Ọpin hand. At any rate, I was able to establish relative chronologies for the nineteenth and twentieth centuries in regard to who was the father of whom, and who taught whom[14] (see fig. 1.1). Nevertheless, one of the most tantalizing aspects of research in Ọpin was the apparent impossibility of identifying the variety of individual hands with all the names of sculptors of the previous hundred or so years, except in a very few cases. To what could one attribute this apparent loss of memory? The sculptural tradition represented by these men seemed in decline, although the reasons for this were certainly not straightforward,[15] and there was hope of regeneration made possible through the patronage of Kevin Carroll[16] and the developments that followed from that. There might be other reasons, of course, for a lack of memory. For one thing, people do differ in regard to what they choose to remember; and for another, even if they do remember, why should they be obliged to tell me; in any case, it was always possible that one was asking questions beyond the limits of social relevance as locally perceived. There was also the tendency to attribute objects to the best known of local sculptors.

Then there was the matter of relating these genealogies to some kind of absolute dating; and I found that two kinds of time frame, among others used by Ọpin people, were of particular value.

One was provided by the wars of the present and past century, and the other by the age-grade system.

There were three wars in the nineteenth century which seemed to provide reference points within memory of past events as inherited from the previous century: first, *ogun Àlí*, that period in the 1850s when Ọpin was brought under the control of Ilọrin by Ali Balogun Gambari; second, *ogun Kíríjì*, the period of the Ekiti Parapọ, 1879–1886, in which, incorporation within the Ilọrin Emirate notwithstanding, an Ọpin contingent participated; third, *ogun Ẹrinmope*,[17] the final attempt on the part of Ilọrin in 1896 to extend its control as far south as Ọtun: the Ilọrin army was halted by Hausa soldiers who met them in battle at Ẹrinmope south of Ilọfa (not to be confused with another Ẹrinmope south of Omu-Aran). Thus, for example, Yusuf Amuda recalled having been told that Rotimi Alaari had been part of the Ọpin contingent in the Ekiti Parapọ at Kiriji, but was dead by the time of the Ẹrinmope war. That gives us a date of around 1890 for the death of Rotimi Alaari. I had no way of cross-checking this, but Yusuf Amuda did not seem inclined to make up stories just to keep me happy.[18] The two world wars of the present century provided further reference points.

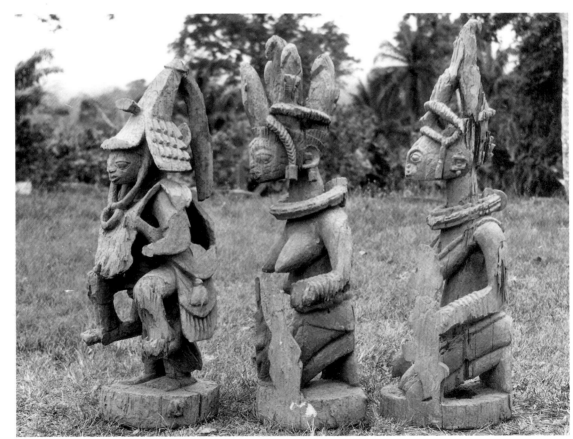

Fig. I.2.
The oldest extant sculptures of Ọpin, perhaps early nineteenth century and long since replaced, from the temple of Onifọn, Isare; now in the National Museum, Lagos. Left to right: Balogun (a warrior on the shoulders of a priest), height, 86.4 cm, and Arundegbe, height, 86.4 cm, are by the same hand; Eliye, height, 96.5 cm, is by another. Wood with traces of red ochre. Photo: John Picton, 1964.

The age-grade system comprised six grades with a festival, called *ikon*, held throughout Ọpin every seventh year. At the time of my research, the last time had been in 1962 and the next was scheduled for 1968. A new set of elders, *àgbà ìlú*, would be discharged from the *egbé ikon* grade, people within the system would move up to the next grade, and a new set of boys would enter the first grade. People dying before graduation as *àgbà ìlú* did not merit full burial rites; and I found that when people said of someone, as in the case of Oṣamuko of Osi Ilọrin (see below), that he died before he was old, *àgbà*, the point was that that person had not in fact graduated from the age-grade system. Thus, on the assumption that the festival had in fact taken place at absolutely regular intervals, it gave some possibility of guessing someone's approximate age in absolute, in contrast to social, terms.

The oldest extant sculptures of Ọpin are three antique figure sculptures (fig. 1.2) first seen by William Fagg and Kevin Carroll in 1958–59 at Isare. In February 1964 I was able to purchase them for the Lagos Museum after public negotiation with the Alara, the village head. (I was lucky, for I noticed some of the Ibadan traders hanging around in the village. Had I not purchased them for the national museum, they would have been stolen and decontextualized.) They had not been used for as long as anyone could remember, having been replaced before the beginning of the present century. People were emphatic that they were not the work even of Rotimi Baba Ọlọja, the founder of the present dynasty of carvers in Isare, who died probably no later than 1900, that is, after the *ogun Ẹrinmope*. This all suggests a date before the wars of the 1850s, which effectively destroyed all prior memory (other than legends of mythical heroes). They had been lying, covered in termite casts, in a corner of the house at the entrance to *ilé imọnlè*, the sacred enclosure dedicated to Onifọn, or Ọbanifọn, the principal deity of Isare. Two quite distinct hands were involved: the figure of a kneeling woman with a single-pointed hairstyle is the work of the more schematic hand; while the other two—a kneeling woman with a five-pointed hairstyle and a warrior riding on the shoulders of a priest—are the work of the more naturalistic hand. The replacement figures remained in active use but were kept in a house in the village. I was not given the opportunity to establish the identity of the sculptor(s) of these images either.

The name Rotimi Baba Ọlọja was widely remembered throughout Ọpin, but like the sculptors of Ọyọ Ile (see Wande Abimbọla, this volume; J. R. O. Ojo n.d.), he too is an example of the memory of a sculptor surviving without reference to specific works. Three of his sons were also sculptors, Ifasan and Ajari, full brothers, and Imale; and (one of) his daughter(s) was Areogun's mother. Ajari was the father of the present-day carver in Isare, Dada Owolabi Ọde, to whom I have already referred. I was shown many sculptures in Isare, exhibiting between them a variety of hands; but such was the inconsistency of attribution that, with the exception of Dada Owolabi, names could not be put to hands with any certainty, and any attempt to establish a distinctive corpus of works is not merely tentative but hazardous. I collected two veranda posts (figs. 1.3, 1.4) for the Lagos Museum at Isare, both from the same vendor and both said to be the work of Baba

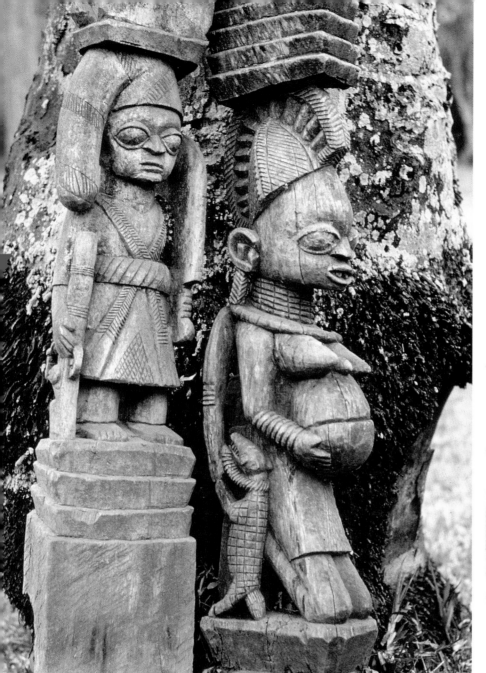

Fig. 1.3.
Veranda posts said
to have been the
work of Rotimi
Baba Ọloja, from
Isare; now in the
National Museum,
Lagos. Height of
figures only, left:
42.5 cm; right: 59.1
cm. Wood. Photo:
John Picton, 1964.

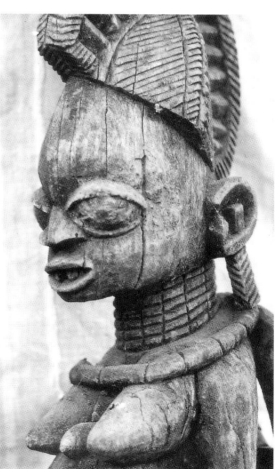

Fig. 1.4.
Detail of post at
right in figure 1.3.
Photo: John Picton,
1964.

Ọlọja. In certain respects, however, they differ from each other such that, without further clearly identified examples of his works, it is impossible to determine whether or not they fall within the range of work from his hands. The absence of a corpus of works renders the identification problematic. I also collected two *àgúrù* helmet masks, again for the Lagos Museum. Both were evidently, in my view on the basis of shared conventions in the making of the human figure, by the same hand (fig. 1.5). Yet one, with the superstructure in the shape of a local priest beating together a pair of buffalo horns, was said to be the work of Rotimi Baba Ọlọja; while the other, surmounted by a warrior, was said to have been carved by Ifasan, his son. Once again, we lack a clearly defined corpus with which to check these identifications; but we know enough about the character of Yoruba sculpture to be sure that both *àgúrù* were by the same person, and that, whoever he was, he was not responsible for the two posts.

There were other kinds of questions concerning the status of Ọṣamuko of Osi-Ilọrin. Bandele insisted that Ọṣamuko had been Areogun's apprentice; and one might think that Bandele, as an apprentice of Ọṣamuko, was in a position to know. However, on the basis of other information it seemed more likely that he had worked with Areogun as his assistant. He may well have been only one grade below Areogun in the age system, not the kind of difference one might expect between master and apprentice. In any case, according to members of Ọṣamuko's own household, he had been apprenticed to another sculptor altogether, Ajijọla, also of Osi. When Carroll discussed this information with Bandele, the latter's comment was: "someone has been telling *òpẹ léngẹ́* (slender-person; literally, slender palm tree) lies." My concern, however, was not only to unravel the relationship between the two sculptors but also to define their difference of hand.

This discussion ought, therefore, to lead beyond questions of relative status to another important matter, obvious enough in art historical studies beyond Africa, namely, the development of personal style. As Bandele once said to Carroll, "each man's work is different"; but at what stage do these differences appear? Carroll has noted development in the later maturity of Areogun's work, but what about his early work? And what about the range of variation at one given time? As I have already said, the problem of establishing a corpus is hazardous, even for someone whose work is as well known as Areogun. Moreover, the problems of "authorship" are magnified when we know that several people might well be involved in a given work.

Ọṣamuko's work is clearly similar in style to that of Areogun and might seem easily confused with it. However, there was no doubt in the minds of the owners of his work at Ọtun-Ekiti and at Iporọ: at Ọtun, a door (purchased for the Lagos Museum) and a post in the royal palace—and the Ọọrẹ of Ọtun was in no doubt that Ọṣamuko was the sculptor, not Areogun, whose works he also possessed; and at Iporọ: two posts (now in the Barbier-Mueller Collection, Geneva). This is a small body of work, but I regard it as unequivocally identified as one could hope for, bearing in mind the consistent presence in them of certain distinctive sculptural features. These include, first,

Fig. 1.5. Two àgúrù masks. Left: height, 124.5 cm, Aworoke, a priest; right: height, 116.2 cm, Ologun, a warrior. From Isare and now in the National Museum, Lagos; Aworoke said to be the work of Baba Ọlọja, and Ologun the work of Ifasan his son. Photo: John Picton, 1964.

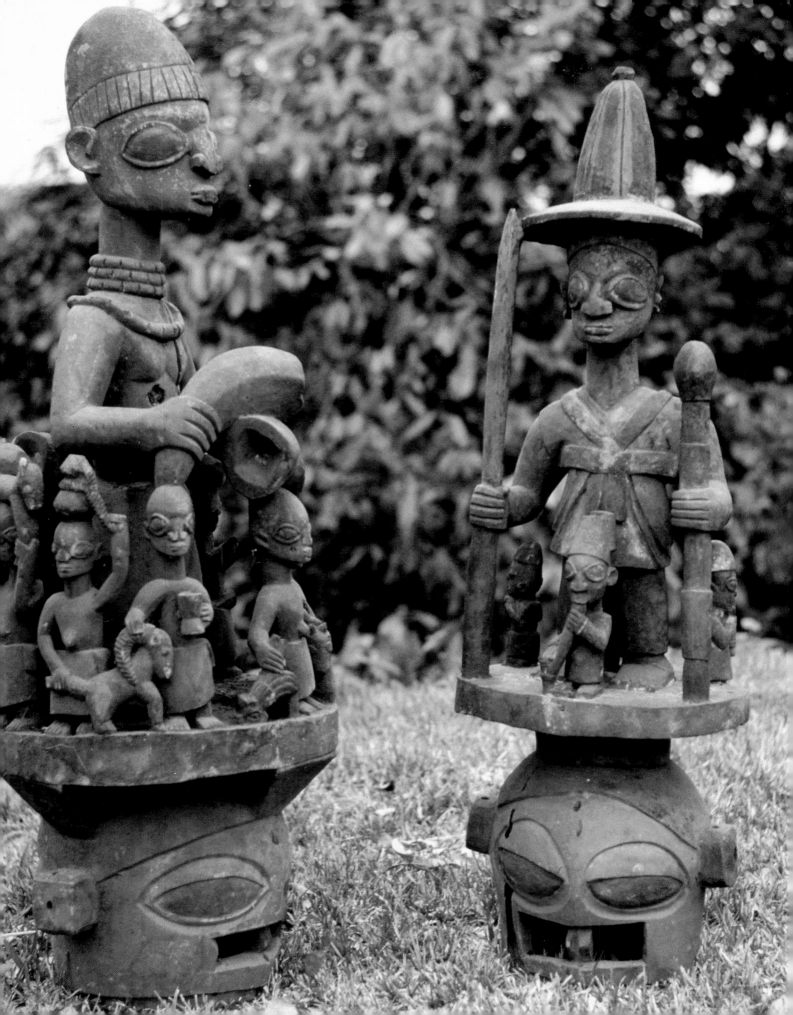

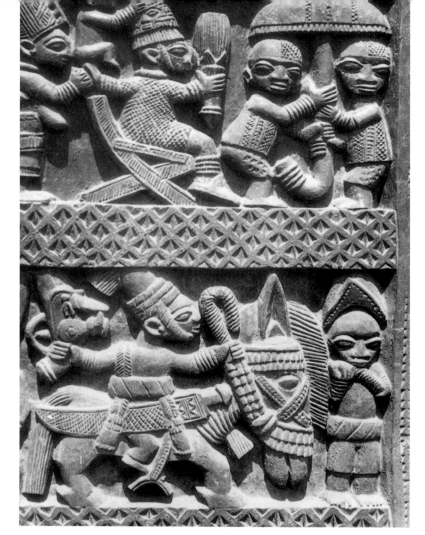

Fig. 1.6.
Detail of door by
Areogun. Compare
scale and layout
with figure 1.7.
Photo: John Picton,
1964.

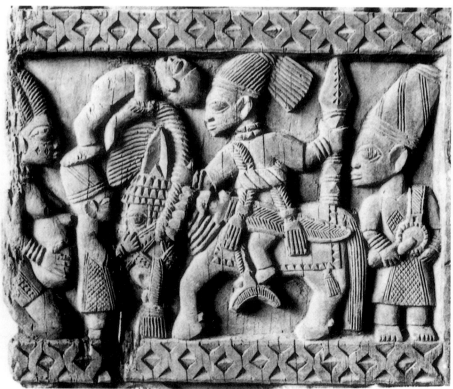

Fig. 1.7.
Detail of door by
Oṣamuko. Photo:
John Picton, 1964.

an overall difference of scale: Oṣamuko's figures are leaner and more elongated than Areogun's. This is obvious in the layout of door panels (figs. 1.6, 1.7), but is also evident in freestanding figure sculpture. Second, in his veranda posts of the mother giving a drink of water to her child, Oṣamuko places the child across its mother's lap with its head lower than its buttocks (figs. 1.8, 1.9). Third, in the image on the door panels Carroll identifies as the Nupe slave raider, Oṣamuko

Fig. 1.8.
Veranda post by
Areogun at Obo
Aiyegunle. Wood.
Compare position
of baby with figure
1.9. Photo: John
Picton, 1964.

Fig. 1.9.
Veranda post in
the palace of the
Ọore of Ọtun,
carved by Oṣa-
muko. Wood
painted with red
ochre, chalk, and

washing-blue.
Photo: John Picton,
1964.

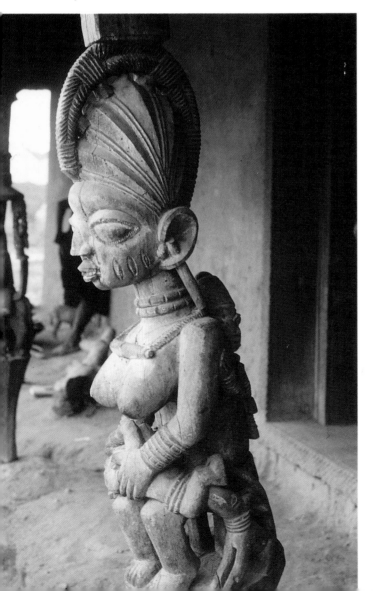

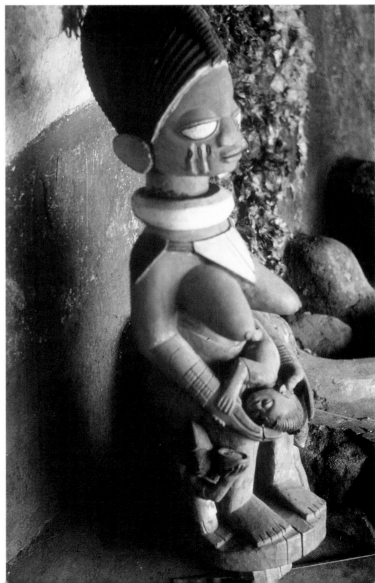

invariably has a captive tied to the horse and positioned horizontally above the horse's head, a feature only possible because of that overall elongation of scale. Fourth, in the image of the diviner holding his wrought iron staff, the tangs of the clappers of individual bells are always realistically shown hooked through the bells themselves. Yet we know nothing of his pupils, other than George Bandele, or of any personal development in style. On the other hand, we know that Oṣamuko was originally apprenticed to Ajijọla-ogun, whose work was represented by a door (fig. 1.10) said to have been carved for his half brother when the latter was Olosi around the turn of the century. (If this were so, it would make it the oldest sculpture in Osi.) Comparison of this door with the work of Oṣamuko is instructive, given that Ajijọla's forms are even more elongated than those of his pupil; but I am not at all sure that the comparison has any more than anecdotal value, without a great many more such comparisons. We return to the problem of the lack of a secure corpus: Ajijọla, if he is known sculpturally at all, is known only by this one door.

Whether or not we can identify the individual hand responsible for a work of art, we must also recognize that our facility in identification of individual hands tells us nothing of itself about the social placing of artists; and I have already suggested that we still know all too little about this. The documentation of *oríkì* might be one obvious way forward, but there is another problem of more general relevance. Although, for Yoruba as for Africa, we must take account of the individual hand, and of the locally realized placing of an artist, we must at the same time beware of reinventing the artist as presiding genius of art ("Art with a capital A"?). The arguments are well enough known (see Woolff 1981): that art is a form of work and not a species of privileged perception, and that we must write into the account all those other people responsible, in addition to the artist, for the making of any work of art. In suggesting this, the intention is not to diminish the artist. For there is always a subtle balance between individual agency and given structure, the former enabled by (while yet recreating) the latter, and no one is a mere automaton acting only according to the program of a ready-made environment, but as language enables any given speech act, so particular historical and social circumstances enable the practice of an art (and, one may as well add, tradition enables creativity). Rather than dethroning the artist, we must enthrone all those participating in the practice of an art: the artist, of course; and his teachers, pupils, patrons, and critics; and all those others that make possible the time for him to practice an art. Moreover, not just "his," for within the Yoruba tradition, as throughout Africa as much as in Europe, there are women artists: the potters, painters, plaiters, single-heddle weavers, indigo dyers . . . and their teachers, patrons, critics, pupils, and so on.

To this end, we must also address that force of habit, wherein we write/talk about this extraordinary diversity as if it could somehow be reduced to a definite article ("The Yoruba do this/say that/believe the other thing," etc.). One obvious way of subverting that style of writing, of course, is to publish much more detailed information about real people. How do they place themselves in

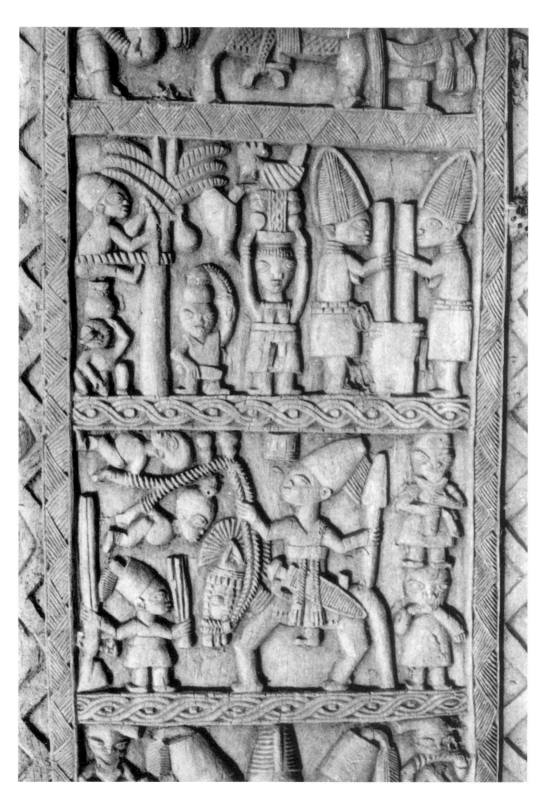

Fig. 1.10.
Detail of door at
Osi-Ilọrin said to
have been carved
circa 1900 by Aji-
jọla, the master of
Oṣamuko. Wood.
Photo: John Picton,
1964.

relationship to the work and the practice of an art, how do they place themselves in relation to one another through and in terms of the practice of art; and what do they have to say about it all? (We need, too, to be more open about our field methods and about the manner in which we arrive at our conclusions.) Then with sufficient data at our disposal, we might begin to understand the succession of works, temporal and spatial, such that we can write a history of art.[19] One advantage we have is that as we begin to provide that systematic account, that writing about real people, we can enjoy the benefits of an intellectual hindsight, allowing our writing to be informed by the advances and developments in critical theory. That way we might begin to find that an Africanist history of art could decenter the Eurocentric "mainstream."[20]

If the idea of the artist is problematic, so too is the word *yorùbá,* as many Yoruba scholars themselves point out (e.g., Awoniyi 1978:17–21). It is, indeed, well known that the word probably originates as a Hausa name for the Ọyọ kingdom. In the region south and west of the middle and lower Niger, from the fifteenth century onward, the dominant political centers were Ọyọ and Ẹdo (i.e., Benin), each ruled by a dynasty claiming descent from the same mythical hero, Ọranyan/ Ọranmiyan. At Ọyọ, Ọranyan descends from heaven to create the world (Morton-Williams 1964). At Ẹdo, that is, Benin City, Ọranyan comes from Ile-Ifẹ (where Oduduwa descended from heaven to create the world; Bradbury 1967). Ẹdo, however, though enjoying imperial authority over substantial parts, southern and eastern, of what we now identify as the Yoruba-speaking region, is not Yoruba-speaking by any definition of that term. Within and between the hegemonies of Ọyọ and Ẹdo were a multitude of kingdoms. Some of these, especially the kingdoms of Ekiti, shared a sense of cultural identity; but there was no overall common name, and no certain evidence of the kind of common identity now so obvious. Even as late as the 1920s, in district officers' reports dealing with the kingdoms of Ekiti, when the term "Yoruba" is used, it does not refer to the area that is the subject of the report but to the Ọyọ kingdom. In the emergence of that contemporary sense of Yoruba identity that is so important a part of the history of Nigeria, there is a whole series of events between and beyond the translation of the Bible and the formation of the Action Group, including the first movement for independence from the English empire.

The emergence of Standard Yoruba as a medium of primary education was a powerful element in this process. Even beyond the borders of the Yoruba-speaking region this had its effect, for example, in the Akoko region of what is now Ondo State and in the adjacent Akoko-Ẹdo region, in which the languages are related to Ẹdo (see Picton 1991). A comparison of maps in Forde (1951) and Eades (1980) shows this very clearly. Each has a map marking the cultural groupings within the Yoruba-speaking region; but in the former not only is the Akoko area shown as thoroughly Yoruba-speaking, but there is a gap in the boundaries as drawn on the map with a kind of unbounded spillage eastward taking in Akoko-Ẹdo; whereas in the latter, the spillage is now thoroughly bounded as part of the Yoruba-speaking region. The use of Standard Yoruba as the

medium of education was indeed beginning to create an identity with the emerging sense of Yoruba ethnicity, and there was a short-lived phase in which there was a debate within Akoko-Ẹdo as to the direction of their loyalties and the benefit of a "greater Yoruba" ethnic alignment. Ironically, the formation of the Mid-West Region, later Bendel State, put an end to all this, given the greater possibilities for a northern Ẹdo elite in Benin City, a regional capital closer at hand than Ibadan, the capital of the old Western Region. (For more accurate maps of this area, see Picton 1991; Ọbayẹmi 1976; Hansford et al. 1976.)

However, to suggest that in the past there was a complete absence of common identity, in contrast to the present, would be an obvious and crass oversimplification. The modern emergence of a Yoruba identity must have some basis in premodern and precolonial tradition. The fact that most contemporary "ethnic" identities in Nigeria can be documented as emerging in response to, and as a function of, empire does not imply that that is all there is to it. In the Yoruba case, an obvious element in the premodern tradition is the mythology of kingship, the fact that all Yoruba kings claim descent from Oduduwa (even the king of Ọyọ, at one remove), a claim that is still brought into play in the gradual yet seemingly never-ending proliferation of kingly titles. Another part of this might be the traditions of cult affiliation, each cult encouraging a sense of identity with some particular place identified in rite and myth as its central focus; but rarely the same place, suggesting less overt and multiple senses of identity. Obvious cases in point might be Ifa and Ile-Ifẹ, Sango and Ọyọ, Ogun and Irẹ-Ekiti, Oko and Irawo, Ọsun and Oṣogbo (and it will be noted that such places as Irẹ and Irawo have little significance in Yoruba history other than as cult centers).

Once again this all exemplifies that principle that, rather than assuming the long-term temporal status of "tribal" or "ethnic" identities, taking them, indeed, for granted, we must understand and identify the circumstances under which it becomes necessary to identify an identity (Mack 1982; Picton 1991). In Nigeria, these circumstances included, and were dominated by, the imposition of colonial rule followed by the emergence of an independent nation state; and in both cases, new political realities determined the emergence of novel identities. The novelty might, of course, consist of bringing out or rather reworking something already implicit; but we cannot rule out the possibilities for creating identities that have little or no precolonial justification. Indeed, John Peel has recently suggested (1989) that twentieth-century Yoruba identity is indeed largely the invention of a Christian and Muslim intelligentsia.

That we can identify certain objects as Yoruba may be an unwitting participation in that political history. The cataloguing as "Yoruba" of the three Isare sculptures in the records of the Lagos Museum (or of the Ikẹrẹ-Ekiti door in the records of the British Museum)[21] is to give them a label at variance with their conditions of origin. On the other hand, an identity as Yoruba was chosen by many of those pioneers in the building of a modern Nigeria, of whom I have already written above. If, then, we raise the question of how many of the works classified as Yoruba in any

museum, exhibition, or publication would have been considered within that category by their makers and users, we must also recognize that the complexity of giving an answer is dependent not only on the emergence of the contemporary sense of identity as Yoruba but also on the degree of local perception of that identity. Clearly this has proceeded at different rates within different parts of the Yoruba-speaking area. This is a topic for which I suspect the research is still needed, if indeed it can still be done. Some might consider it no longer relevant, of course; but the relatively shallow temporal status of an overt identity now taken for granted raises another question, for consideration of the dating of a labeling device, whatever its inherent sociological interest, also has relevance for the contextual placing of the objects themselves.

If, for example, we take the objects illustrated in the catalogue of the exhibition at the Museum Rietberg Zürich, *Yoruba Art and Aesthetics* (1991),[22] as representative a selection as one might wish to find (and leaving to one side the field photographs of objects in current use), we find the following distribution:

Ifẹ:	8
century	
pre-18th:	13
18th:	6
18th–19th:	4
19th:	20
19th–20th:	17
20th:	33

It will be seen that the total number of pieces undoubtedly within the era of colonial exploitation comes to fifty. Then there are the twenty works presumed to be of the nineteenth century, and a total of thirty-one undoubtedly prior to the colonial era. In other words, about one-half to two-thirds of the objects in the exhibition are identified as works of the very period in which the modern sense of Yoruba identity is forged, a period in which, of course, all manner of social, political, and material changes are taking place. The sculptors of Ọpin do, of course, represent the glories of a tradition of presumed antiquity; but they are only part of the story. For neither their works nor the objects in this exhibition represent the total range of visual practice within what was coming to be known as the Yoruba-speaking region of an emergent Nigeria.

It was, perhaps, inevitable that in the development of Africanist art historical research, in circumstances of rapid change resulting from and following the period of colonial rule,[23] the interest of European and European-American scholars should have been directed predominantly toward those traditions with their origins in the precolonial period. And rightly so, for it would be immeasurably to everyone's loss if they were to disappear without documentation and their works

either destroyed or appropriated as exotic found objects in an alien art world. On the other hand, the works themselves, whatever we may presuppose of the antiquity of the traditions they represent, are works of a period in which colonial authority is imposed and, at the same time, contested; and all too often we remain at a loss as to what to make of this. Indeed, the inclination is to leave it out of the account; yet in so doing we invent an authenticity, a traditionality that has only a very partial resemblance to the visual culture people inhabit.[24]

In any case, the circumstances of the inception of new forms and new traditions are worth knowing; and we can look to whether or not the artists working within long-established traditions represented and perhaps contested colonial authority. A brief discussion of forms with their origins within the past hundred and fifty years will suggest ways in which we might place works such as those on exhibition in Zurich within a wider visual environment, and then I shall return to Ọpin sculpture.

Together with the first scholarly writing in Yoruba studies, and the beginning of the movement toward independence from the English, the first artist to open the way to a modern Nigerian painting was also Yoruba: Chief (as he eventually became) Aina Ọnabolu (1882–1963), born not many months after Picasso (b. 25 October 1881). It will be recalled, of course, that Jacob Epstein was born in 1880, and that Carroll estimated Areogun to have been born the same year. Of Picasso and Epstein there is little more to be said in the context of this essay, except that it is virtually impossible for us, certainly in Europe and America, to avoid seeing African art in some sense with the eyes of those great artists; one suspects that if Epstein or Picasso had seen Ọnabolu's work they would have laughed at it as naive, inept, amateur. We, however, must be more careful.

Ọnabolu was essentially self-taught by copying magazine illustrations, which he had started to do as early as 1894, and by 1900 he had resolved upon a career as artist and art educator (Oloidi 1989). This was at a time when received opinion among the kind of person to be found in colonial authority was that "The West African Negro has . . . never sculpted a statue, painted a picture, produced a piece of literature." This was written by Sir Hugh Clifford in 1918, when Areogun was at the peak of his early maturity. We must take note of the reverence that Nigerian artists and art historians give to Ọnabolu, and realize, as Olu Oguibe pointed out to me (personal comm., 1992), that in siting his visual practice within the more conservative tradition of figurative representation, and achieving expertise therein, Ọnabolu was making his own protest at colonial domination. Moreover, as his son records, Ọnabolu was a fighter "against the body of opinion and art propaganda which talked of African art in a purely retrospective sense" (see Ọnabolu 1963 for illustrations of his work).

Aina Ọnabolu stands at the head of a complex series of developments, some of which (e.g., popular sign painting, or the paintings and prints of the Oṣogbo group; see H. U. Beier 1960b, 1991) are better known than others. On my last visit to Nigeria in April/May 1990 I found myself

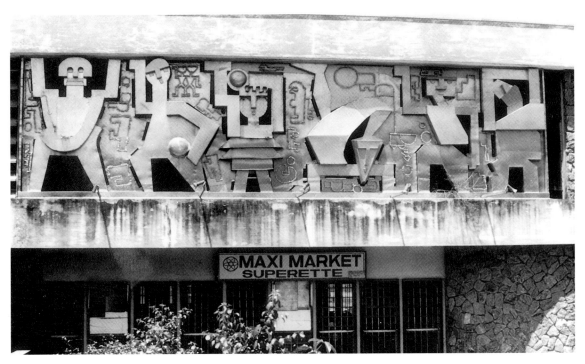

Fig. 1.11.
Aluminum frieze
by Agboọla Fọlarin
(1972–73) showing
various athletic
activities, left to
right: student pro-
test, football, net-
ball, physical
exercise, weight-
lifting, and more
physical exercise.
University of Ifẹ.
Photo: John Picton,
1990.

astonished at how art-minded the Yoruba-speaking region seemed to be, with paintings and statuary everywhere. Moreover, increasing demands for art from public and private patrons, art galleries, and art brokers are now almost commonplace urban phenomena. Older forms have been revived, often under the rubric of "Neo-traditional," while other artists rework older forms in new ways or work old themes with new forms and materials: Nikẹ Ọlaniyi, for example, and her reworking of *àdìrẹ* resist-dyeing; or Agboọla Fọlarin, university professor, sculptor, painter, textile designer, mosaicist (e.g., Ikẹja International Airport), printmaker, architect. His riveted aluminum constructivist work at a former sports center at Ọbafẹmi Awolọwọ University, Ile-Ifẹ, is a case in point (fig. 1.11). This is a large-scale work showing a sequence of figures engaging in, from left to right, student protest, football, netball, physical exercise, weightlifting, and more physical exercise. Is this so very different in principle from the sequences of kings, priests, supplicant women, fornicators, slave dealers, and district officers parading across the doors carved by Areogun?

As in any succession of works through time and space, there are thematic and formal continuities and disjunctions; and these most certainly serve to destroy the commonplace attempt to encapsulate these developments within a simplistic traditional/contemporary paradigm. One simply cannot write an art history in those terms, and in attempting to do so one would also in effect arrive at the absurd situation in which one was denying Yoruba identity to some very obviously

Yoruba people. Indeed, one might go a little further and propose that if the contemporary sense of Yoruba identity is a development of the past 150 years, then the art works that must be considered to represent and signify that identity most clearly and thoroughly are precisely those new forms and practices developing within that same period. Of course, these works bear traces of the past; and yet, as I have already suggested, artists such as the Masters of Isare might well not have considered themselves as Yoruba at all.

In the end, of course, it is not for me to determine what is authentically Yoruba about any of this, for Yoruba art is the art Yoruba people do; and the definition of these terms is not within my competence. From one point of view, to concentrate on the self-taught sign painter, or other works of the *Seven Yoruba Masters,* is a matter of choice, and we all remain free to like as we choose. The making of a scholarly assessment, however, is another matter, and concentration on one part, as if that were the authentic whole, and at the expense of so much else that is happening, is evidently problematic. Rather, we must recognize that there are all kinds of artists, patrons, and critics. Not least among the criticisms of a traditional/contemporary paradigm, in which one side represents stasis and the other change, is the fact that Yoruba art has always been contemporary; and if no one carves like Areogun today, neither does anyone cast like the unknown master-founders of Ife.

Another prior, and equally important, development of the period within which many of the works on display were made, that is, the period of increasing colonial domination, is the Yoruba-Brazilian architectural tradition of the late nineteenth century. This is the style of building introduced to West Africa by Yoruba people repatriated from Brazil. The buildings of Francisco Nobre, for example, were to be found from Lagos to Elmina in what is now Ghana, and his younger compatriot, Joao Baptist Da Costa, was responsible for the strikingly beautiful Martins Street Mosque in Lagos (Laotan 1960). It is often forgotten that the returning Yoruba people from Brazil and from Sierra Leone, in the nineteenth century, included Muslims as well as Christians. In 1891 Muhammad Shitta Bey, merchant, philanthropist, and son of a Sierra Leone repatriate, commissioned the building of the Martins Street Mosque.

While it was still under construction, its fame had spread all over the Yorubaland, and across the seas to Sierra Leone, England and Turkey . . . its formal opening on 4 July 1894 was a grand occasion. . . . The Governor, Sir G. T. Carter, was present, and so was a representative of the Sultan of Turkey in the person of 'Abdallah Quillam, the President of the Liverpool Muslim Association. The mosque was formally opened by the Turkish representative. (Gbadamosi 1978:66)

What was wanted was something in the latest style that was yet unique, and this was provided by Yoruba-Brazilian Catholic artists.[25] Da Costa later laid the foundations of the Central Mosque on Nnamde Azikiwe Street (now tragically demolished), which was completed by his trainee, Sanusi Aka, circa 1900 (Laotan 1960) (fig. 1.12).

**Fig. 1.12.
The Lagos Central
Mosque on
Nnamde Azikiwe
Street. Photo: John
Picton, 1981.**

The fame of the Martins Street Mosque "had spread all over Yorubaland." The period leading up to its construction, during which this architecture became established in West Africa—the last thirty years of the nineteenth century—was also the period within which many of the works in the Zurich exhibition were being made, and often close at hand (as in the carving centers of Ọtta and Abẹokuta). This same period is also the time of the final years of the great archetypal masters of Ọpin—Rotimi Alaari of Ikẹrin, Rotimi Baba Ọlọja of Isare, and Ajijọla of Osi—artists whose life histories have their origins in that now mythical past prior to the establishing of the Ilọrin Emirate. This same period saw the birth of Areogun and Ọnabolu and also their respective entries into the practice of art.

Just as the late nineteenth century cannot, then, be written off as a time in which the death knell of the great traditions of the past is sounded, but rather should be seen as a time of renewal and development, so too it must be recognized that twentieth-century African art is not about plastic

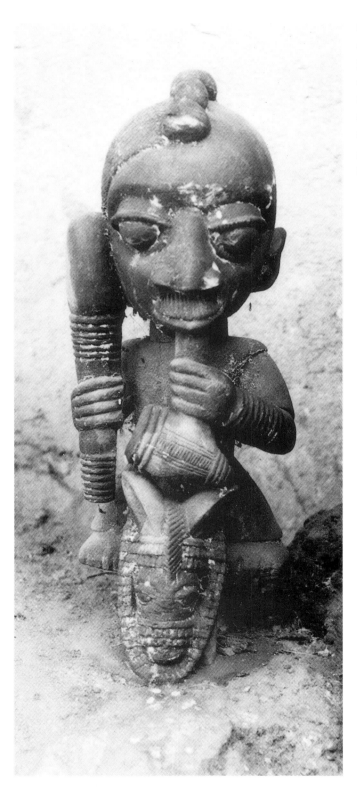

Fig. 1.13.
A shrine to Ẹṣu, a
piece of laterite,
on the front ve-
randa of a house
at Osi-Ilọrin with a
sculpture by Areo-
gun. Photo: Kevin
Carroll.

kettles, lamps made of treacle tins, or the banjo with the sardine-tin sound box. These are of this century, of course, and they impress us with an originality and ingenuity in the recycling of European rubbish that we, in Europe, lack. Twentieth-century African art is about architecture, and sculpture, and painting, and textiles, and masquerade; and about the continuing relevance and viability of particular traditions, together with the emergence of novel practices.[26] Moreover, it is only in studying the visual arts of the here and now, by keeping the company of the artists of the time in which we live, that we can begin to construct our models for writing about the past.

There is, however, one last question: just how do we see the works from the era of colonial rule? Do we see in them only the eventual obsolescence of a tradition in the face of development and modernization? Or do we recognize them as the works of a period in which a modern sense of Yoruba identity is shaped into the form in which we know it today, an identity formed, in part at least, in opposition to and a protest against (if only we can read the signs) colonial rule? Aina Ọnabolu provides one kind of answer; but some of the great Ekiti and Ọpin masters seem to provide others. The doors for Ikẹrẹ carved by Ọlọwẹ of Isẹ-Ekiti show a rather worn-out district officer on tour in his hammock; but is this only a record of an event? Then what do we make of the pipe-smoking figure Areogun often places on the front mudguard of the district officer's bicycle?

Joan Wescott (1962) identified the pipe-smoking figure as, in some sense, emblematic of Eṣu. The mediating role of Eṣu is, of course, well known: the association of Eṣu with the entrance to a house, with a marketplace and the crossroads, with the procedures for divination and sacrifice, with the messengers in the king's palace, with Idowu (the Eṣu that follows twins), and so forth. There was (and perhaps still is) a house in Osi-Ilọrin with a shrine to Eṣu, a piece of laterite, on the front veranda; and beside the laterite a sculpture by Areogun of a figure on horseback, with a crest formed of medicine calabashes and smoking a pipe (see Carroll 1967, pl. 32) (fig. 1.13). Wescott's account evidently applies in Ọpin also.

Wescott also suggests that, juxtaposed with images of authority, the pipe-smoking figure may possess an ambivalence of another kind, an insolent gesture in the presence of a superior, a subversion of his authority. One may ask, of course, whether the image of a man smoking a tobacco pipe is possessed of only this one range of connotations, or is it one among several available interpretations? Are we entitled to see the pipe smoker on the district officer's mudguard, whether smoking his pipe or offering it to the European (fig. 1.14), as an intentionally subversive ridiculing of those agents of a novel but alien authority, a questioning of a questionable legitimacy? We know that we can never be satisfied with a view of art that makes it a merely passive affirmation of things, a recording of events to no other purpose; and we recognize that art can sometimes be most effective as protest when it seems most innocent. Guy Brett (1991) has written about Latin American paintings of angels in similar fashion, and elsewhere I have suggested an

Fig. 1.14. Eṣu offering his pipe to the District Officer, at right lowest register, carved by Areogun of Osi-Ilorin. Painted wood. Photo: John Picton, 1964, at Ola via Omu Aran.

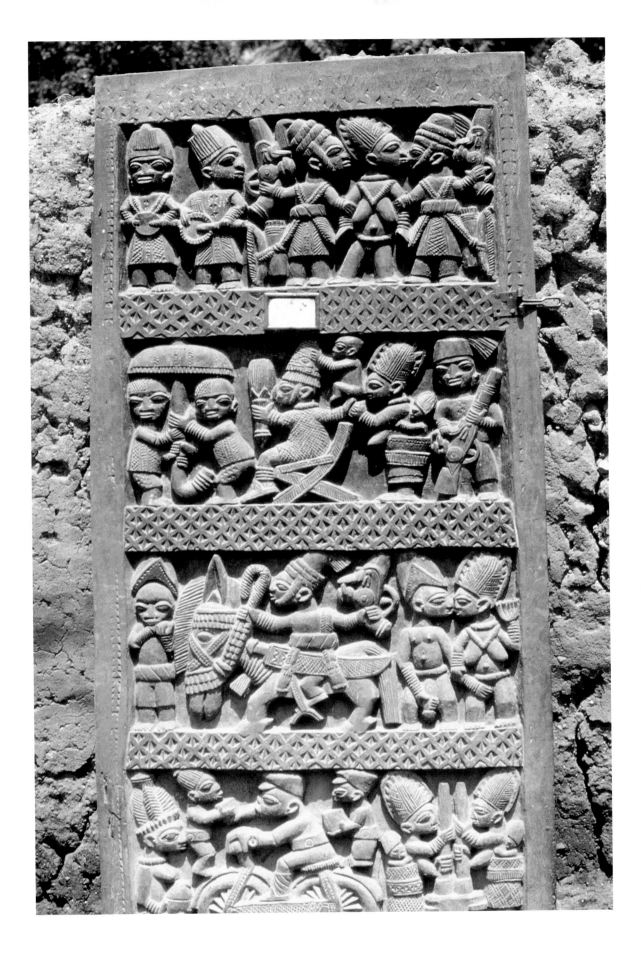

interpretation of another Ọpin sculpture as a subversive commentary on the authority of the Ilọrin Emirate (Picton 1992b). Indeed, the figure on horseback with captives is also sometimes embellished with a pipe smoker. If, then, Areogun, Ọṣamuko, and the others were continuing a tradition in sculptural form as providing for political commentary, the contesting of alien authority, and subversive ridicule, it suggests that the sculptors of Ọpin must be placed alongside other, better-known figures of Yoruba intellectual and political history.

Summary and Conclusion

This paper began with some comments on the problems of understanding and, therefore, of writing art history, and I suggested that what was to follow was something like a series of jottings in the margins. They have not been entirely at random, however.

First: William Fagg has established, in the literature, that it was possible not just to identify the different hands at work in African art, but that one was able to name the artist. The importance of this has, however, created an expectation that cannot always be fulfilled. The possibilities and limitations of my work with Ọpin sculptors (about which there is still more to be written) was a case in point. There was the particular difficulty of establishing a defined corpus of works. In any case, the status of sculptural individuality remained unclear; but this is an area in which the *oríkì* might prove of greater value than the sculptures themselves.

Second: we have to take account of the fact that the present-day sense of Yoruba identity emerged in the contesting of colonial authority in the period since 1850. The sculptors of Ọpin identified here were, of course, working during this time. Yet one can ask whether their work is part of this story, in contrast to the developments in art of the same period, for example, modern painting and Brazilian architecture: which of these arts most clearly represents and embodies that emerging identity? Nevertheless, although the sculptors of Ọpin might not have thought of themselves as Yoruba, their work indicates a response to colonial rule that is more than a mere record of events.

Postscript I

The report that follows remains, as an *aide mémoire,* as relevant today as it was more than thirty years ago when it was first issued. Although in some of these areas progress has been made, and in others we might now redefine the problem, in many we have yet hardly begun. On page 3 of the minutes of the third meeting of the advisory board of the Yoruba Historical Research Scheme on 29 March 1959, chaired by Dr. Biobaku, we read:

Invited by the Chairman to address the Board on his work in Nigeria Mr. W. B. Fagg said that the work which he had been asked to do for the Scheme was in some sense of a pioneering character, since he

could not recall any other instance in which an ethnologist had undertaken to collect a large body of data on the art of a major African tribe, [of course one recoils from the terminology, but even after Independence, the request that one identified one's "tribe" remained on Nigerian government application forms], primarily on a diachronic basis, that is, in an attempt to import a time dimension into the study of African art. . . . [C]onsultation of his notes showed the following to be the principal subjects under which his material could be organized:

i. Intensive study (in collaboration with Mr. Frank Willett) of ancient Ife ethnography from archaeological evidence, and evaluation of relevant traditional evidence where available.

ii. A study of the prehistoric terra cotta sculpture of Nok as a possible indigenous artistic substratum on which the presumably immigrant naturalistic art of Ife may have been grafted.

iii. A study of early Yoruba stone sculpture.

iv. A study of early Yoruba influence on the art and history of the Bini and other Edo-speaking peoples (in collaboration with the Benin Historical Research Scheme).

v. The history and geographical distribution of brass-casting industries (Ife, Owo, Obo, Ijebu, Benin, etc.), and of their associations with other industries to the east and north.

vi. The history of woodcarving, etc, in the last 100–150 years, with implications for earlier periods from which wood sculpture did not survive.

vii. Study of methods of determining the age of woodcarvings in the light of external evidence.

viii. Analytical study of local styles in Yoruba art, with special reference to ibeji figures.

ix. Aesthetic study of the works of Yoruba master sculptors.

x. Study of the interrelations between "inland" or "nuclear" Yoruba art and culture on the one hand and "coastal" art on the other; the latter seemed to be suitably subsumed under the title of "the Deltaic water-spirit complex", and this complex seemed to have played an important part in the development of Yoruba religion and art.

xi. Study of the degeneration (not used in a pejorative sense) of the classical Yoruba cults and cult objects in areas distant from the respective cult centres.

Postscript 2

Another document in my possession, worth publishing as a rich source of documentation in regard to discourse about art, is an account of conversations between Father Kevin Carroll and George Bandele, son of Areogun of Osi-Ilorin and pupil of Osamuko. At this time Carroll and Bandele were living and working at Ijebu-Igbo. Note: tone accents are not given in this transcription.

a. Who said his work is like a box? Here is a summary of my conversation on this point with Bandele last week (February 1964):

CARROLL: Do you remember one day in Iloro you and Lamidi were looking at a post by Ayantola and you made a remark and laughed. Can you remember now what you said?

BANDELE: I said his work was like *otita*?

CARROLL: But you said then 'It is like *apoti*'.

BANDELE: A ha! In Ekiti we call *otita* also *apoti*. (*otita* is a small stool carved out of a log of wood and keeping its cylindrical shape.)

CARROLL: Do you remember in Ọyẹ you and Lamidi used to stand back from your work to look at it from a distance? Why was that?

BANDELE: *gigun isẹ l'a nwo*—we were looking at the straightness of the work; *ki o ma wo*—so it would not be crooked.

CARROLL: But you told me once you wanted to see whether it shone—*dan.*

BANDELE: No, I did not look at the *didan* but the *gigun*. If you remember I was not as good then as I am now. Then I did not know *ọna bibu* as I do now (*ọna bibu* = *ọna lile*).

b. Here are some points from tape-recorded conversation with Bandele. We were discussing photographs of carvings. Remember the four divisions of the work which Bandele insists are common to all carvers everywhere.

ọna lile, which I interpreted as the first blocking out; the verb *le*, or *bu*, the noun *ọna* (which is used for pattern, in a slightly different sense though related); therefore, *le ọna, ọna lile, ọna bibu, bu ọna, ọna lile ti wọn le, lena, buna*, are all phrases from these verbs and nouns, their use depending on grammatical structure.

a le tunle, repeating the *isẹ lile*—breaking up the masses into smaller forms and masses: this is my interpretation, the new element being *tun*.

didan: dan means smooth, polish, shine (verbs). Technically *isẹ didan* means smoothing the forms with knife and chisel (the old tool in Ekiti was *unkan*—the handle and cutting edge formed from one iron bar). But as the phrase used later suggests, *dan* does not refer to the mere physical smoothness—I extended it to the meaning "shine", which, however, I cannot define exactly. *igi didan, dan igi*, depending on grammatical construction.

fifin: this covers various types of knife work; *fifin* is *isẹ abẹ fin* (whereas *didan* is *abẹ* and *unkan/siseli*); *isẹ fifin, ọna fifin*. Much of the work under *fifin* (*ara isẹ fifin*) cannot be used with the verb *fin*; eg.—*wọn la oju* (*oju lila*), *ẹnu, ika ọwọ, ika ẹsẹ, eti*

la, usually to "split", here to cut narrow, sharp lines [i.e., to divide eyes from eyelids, mouth and lips, fingers, toes, ears]
wọn lo ike ọwọ—they groove the *ike* (brass bracelets) on the wrists.
wọn ge ibebe—they cut the waist beads, and other beads.
wọn fin irun, ọja ọna—they incise hair, fringe of scarf, patterns.

Various comments of Bandele's using the above terms:

BANDELE: we know a carver's work is good if he has blocked it out well, *ti o ba ti bu ona, ti o ba ti lena ibi ọna lile dara;* and by the smoothing-shining, *nipa igi didan*. This one was not well blocked out, *wọn lena re ko dara, o le ọna lile ko dara*. They have not smoothed it well, *wọn o dan dara, ko dan dara.*

Discussing the *ọpọn ogun* made by his father (now in his house and in which his tools are still kept) and which his father did not finish (deliberately):

BANDELE: the mouth remains [i.e., to be done], they have not lined, *la*, it; they have not lined, *la*, the fingers; they have not incised the *ọja wọn o fin ọja;* they have grooved it, *lilo ni wọn lo;* smoothing, he has smoothed it well, *didan o dan dara.*

[A note of explanation is required here. The òpón Ògún referred to is a figure of a kneeling woman with a bowl carried on her head, sometimes also known as *arugbá*, she who carries the calabash of sacred emblems. In this particular case, it was made by Areogun as a receptacle for worn carving tools, and as his personal shrine to Ogun at which he would offer sacrifice. I did not see the òpón in Areogun's house, however, as Bandele had sold it to traders from Ibadan. Fortunately, and quite by chance, it was purchased for the Lagos Museum by Tim Chappel, who by then was its curator. I recognized it from Carroll's account and photographs. The òpón also once contained a brass pectoral mask that had been given by Rotimi Baba Ọlọja of Isare to his daughter at the time of her marriage. These were, of course, Areogun's parents. The mask, and the tools also once kept in it, were not present at the time of its sale to the Lagos Museum and are now missing. There is no known photograph of this mask either.—J. Picton]

c. Other revealing comments:

BANDELE: I cannot say which work is better, that of Bamgboye or that of my father. Both are good. You know each man's work is different. The *ipoju* of one man's work is different from that of another, *ipoju lagbaja yato fun eyiti alagbabja; ipoju* = style, manner, *pipa oju.*

Regarding *epa* masks; [and Carroll noted that] the whole mask can be called *igi*, stick, or *epa*, but if we wish to distinguish the top [i.e., superstructure] from the mask proper, we can call the top *igi*, or *epa*, and the bottom *ikoko*, pot:

BANDELE: The *ipoju* of the face of the stick is different from the *ipoju* of the pot, *ipoju oju igi yato fun ipoju ikoko.*

[It should be noted that in the Ọpin area the generic term for masks with a figurative superstructure carved upon a helmet mask is *àgúrù*. The term *epa* is known as the generic term used of this form elsewhere, but in Ọpin is usually restricted to the name of a particular cult of these masks.—J. Picton]

Regarding *ọrun ọwọ*, the neck of the hand, ie. wrist, and *ọrun ori*, the neck of the head, ie. neck:

BANDELE: if the hand of the stick [i.e., sculpture] is good, and the neck of the stick upwards, his work will appear, *yọ, han,* good. Don't we look at the face of the stick, *oju igi*, first, and then the hand, *ọwọ.* Those two places we first take notice of. The body is not so difficult.

Notes

1. This quotation, if he knew of it, would provide grist to Martin Bernal's mill: see Bernal 1987. On the other hand, one wonders what Bernal would think of the Venerable Archdeacon J. Olumide Lucas: "The number of Yoruba ideas and practices which are identical with or similar to those of Ancient Egypt is so large that it affords a clear evidence of the close connection that once existed" (Lucas 1948:23; but see also R. W. Wescott n.d.).

2. I use "art history" in an all-embracing disciplinary sense. I realize that may trouble some people, but in a sense I am only following Evans-Pritchard (1962) in this regard. In any case, it would now be fashionable to argue that the difference between historical, philosophical, anthropological, and fictional literature lies essentially in the rhetorical figures employed (see, for example, Norris and Benjamin 1988).

3. In particular, in Plato's *Republic* (and see Bertrand Russell [1946:14], for a brief account of its pervasive influences), Book 10, part 1, we read that "the artist knows little or nothing about the subjects he represents and that his art is something that has no serious value" (Plato 1955:379). This has been argued as derivative of a "logocentric metaphysics" (Derrida 1976:43), although Plato did not much like poetry either: "It has a terrible power to corrupt" (1955:383). Nevertheless, a logocentric intellectual tradition, together with the fact that in talking/writing about visual art we are using a medium of explanation that is at complete variance with the subject matter of the discourse (for the very simple reason that visual art achieves whatever it does achieve precisely and essentially in the absence of words), would seem to encourage a disregarding of visual art as a matter of serious concern (see also Picton 1990b:62).

4. Does Yoruba tradition itself betray a logocentric bias, also susceptible to deconstruction?

5. This was written prior to Bill's death, which I understand to have been at 2 A.M., 10 July 1992. Obituary notices appeared in the British press the following week: *The Times,* by John Picton; *The Independent,* by Frank Willett; *The Daily Telegraph,* by Jonathan Benthall, director of the Royal Anthropological Institute; and *The Guardian,* by Hermione Waterfield. John Mack is writing an appreciation for *Anthropology Today;* and, of course, there was the *Quaderni Poro* issue dedicated to Bill, edited by Ezio Bassani with a biographical essay by Frank Willett.

6. I first met Bill in 1961, when I worked with him at the British Museum for five months in the hope of securing an appointment in his brother's department in Nigeria. Among other things, I had to accession, in the great registers of the museum, the collection Bill had made in the course of his research program on behalf of the Yoruba Historical Research Scheme (this was the second-best collection: the finest objects had been collected for the Lagos Museum). In those days, accessioning meant drawing; and nothing can be guaranteed to fix a succession of forms in one's mind so much as drawing a large number of *ère ibéjì*. Bill also gave me unlimited access to his field notebooks. When, in June of that year, I arrived to take up an appointment as curator of the Lagos Museum, I had been introduced to the major forms of Yoruba sculpture, to the work of the carving houses of many Yoruba towns and regions, such as Abẹokuta and Ekiti, and to the research and writing of William Bascom, Ulli Beier, Kevin Carroll, Pierre Verger, Frank Willett, and Peter Morton-Williams, among others; and it was about this time that Robert Farris Thompson was to begin his research. In Lagos I soon ran into Michael Crowder, Philip Allison, Justus Akeredolu, Kenneth Murray, Archdeacon Lucas, Aina Ọnabolu, the two *gelede* associations, Egungun, Brazilian architecture . . . In due course, Ulli Beier introduced me to Suzanne Wenger and Georgina Beier; and Kevin Carroll introduced me to Yusuf Amuda, Lamidi Fakẹyẹ, George Bandele, field research, and so forth; and about this time Denis Williams arrived in Nigeria. *Et in arcadia ego,* as I have noted elsewhere.

7. For example: "Ogun is seven men," one of the best-known *oríkì* of the god of iron. Other convenient Yoruba "round" numbers are, of course, 4, 16, and 200.

8. My own work in Ọpin was likewise dependent upon Kevin Carroll introducing me to the area, and George Bandele and Yusuf Amuda (grandson of the great Rotimi Alaari of Ikẹrin). More recently, Roslyn Walker has, with exemplary patience, been compiling the definitive archive of the works of Ọlọwẹ of Isẹ. There is much to do in regard to those other masters; and perhaps one day some of us will yet realize Fagg's project.

9. This assumes, of course, that we know enough about a given tradition to be able to decide whether the differences one can see indicate individual hands rather than the same hand adept within a variety of styles: this latter option certainly characterizes some precolonial sculptural traditions. For Yoruba sculpture,

however, we can be fairly certain that this is not the case, that differences of style can be attributed to hand and to region.

10. The discussion presented here is essentially the preface to a paper dealing more specifically with Opin sculptors, and at greater length, in preparation for *African Arts.*

11. Willett and Picton 1967 was intended as an object lesson in the uses to which Carroll's account of these conversations might be put. Bill Fagg, however, disagreed with our conclusions, though not with the principles of the methodology.

12. If one sculptor gave up his art upon taking a title and Areogun remained untitled at the time of his death, while there are two sculptors who continue to practice their art, titles notwithstanding, what are we to make of the esteem and standing of sculptors in this area?

13. From Dada Owolabi I learned that it was normal practice in this area for a sculptor to paint a door panel with pig's blood before delivery to his patron; and from Yusuf that mask sculptures were painted with red ochre and varnished with cactus latex likewise.

14. Recent consultation of Gabriel Bandele's master's thesis (Bandele 1979), made available by courtesy of Fr. Kevin Carroll, has confirmed, but not amplified, the data available to me.

15. For example, the major festivals of Osi-Ilorin could not be celebrated as long as the village was split between rival heads. Olosi Ezekiel, a supporter of the Action Group, had been ousted by the provincial government in Ilorin and replaced by Olosi Daniel, a supporter of the Northern Peoples Congress. To the north of the main road people supported Ezekiel, and, to the south, Daniel. The unity of the village was necessary for the performance of festivals as the Olosi had essential ritual duties; but which Olosi!

16. Indeed, it has given rise to a particular contemporary school of artists, the Neo-Traditionalists.

17. As far as possible, I have checked tone marks against either R. C. Abraham's *Dictionary* (1958) or some other authoritative source. Where it seems appropriate to treat a Yoruba word as a proper noun in English I have not indicated tones in any case.

18. It is in the handing on of practices and expectations that particular traditions have their existence and determine the possibilities for creativity in the arts. A particular expertise in the making of well-known forms may characterize the work of an artist and provide the basis for the esteem in which he or she is held. This would seem to be the case with Areogun of Osi-Ilorin, for example. The expectations within other traditions may, in contrast, direct the artist toward the exploration of a greater range of options, thus providing the context within which innovation can occur insofar as artists and patrons perceive those options as including elements that are somehow novel; and this would seem to characterize Yoruba textile manufacture. Tradition and creativity are not opposed categories, therefore, for the former makes possible the particular character of the latter. Moreover, creativity does not inevitably imply innovation. A number of writers (e.g., Cole 1982: chap. 5; Giddens 1979) have drawn a useful contrast between innovative and incremental change, the latter being the kind of thing that happens coincidentally in the process of replication. Also of particular relevance here is Irele 1982:95, 117, discussed in Picton 1990b:49–53).

19. "his'tory . . . history, information . . . a narrative of events, a tale, story . . . a systematic account of events"; see *Webster's Collegiate Dictionary* 1932.

20. We might also begin to escape the abstractions of a misunderstood functionalist anthropology. This is not a critique of anthropology, which, after all, has moved rather a long way since then: see H. J. Drewal 1990; and Picton 1990b, 1992b. There is, of course, a series of ironies here. For while it might be said that this whole discussion indicated more than anything else how far behind "mainstream" art history

African art studies still remain, there is the fact that what one is writing about in this way is the history of art in Europe, as if this were the dominant center of things. The fact that one can write in so Eurocentric a manner, ignoring the far greater realities of Africa and Asia, is partly a function of disciplinary history and partly a function of empire: many would argue, of course, that these are really about the same thing, and that is the rise of industrial capitalism. The disciplines of the history of art need Africa and Asia, to put Europe in its very small place; but this will only happen when the writing of an Africanist art history catches up, in terms of intellectual substance and sheer mass of knowledge about Africa. I realize, of course, that there are those who would argue that the history of art is so Eurocentric a thing that it cannot be of use to the rest of the world. That seems to me a defeatist attitude.

21. The proposition is somewhat rhetorical, as the Lagos Museum accessions register does not bother with ethnic labels, relying instead on the precise details of collection. This was a habit insisted upon by Kenneth Murray; the exhibition case labels, likewise, gave the place of origin but not the "tribe." On the other hand, the archive of field photographs did include ethnic labels, and the British Museum registers certainly do.

22. Abiọdun, H. J. Drewal, and Pemberton, the authors of the catalogue, must be congratulated. It is a masterpiece of succinct writing, and, in particular, I commend the account of the conceptual order presupposed in Yoruba sculpture.

23. Most of the developments in education, health care, religion, and government, for example, would have happened in any case; but the context and its consequences would have been very different.

24. And, supposing our invention to be "traditional," we unwittingly place ourselves on the same side as those agents of colonialist and neo-colonialist appropriation that wish always to preserve Africa in the past and always at a distance from the contemporary world. I am not suggesting, however, that every colonial officer was somehow malign. On the contrary, many served their new-found countries with selfless devotion and worked for their independence.

25. The Martins Street mosque was distinguished, among other things, for its exterior decoration with glazed ceramic tiles. This is a well-known feature of Portuguese architecture, also to be found elsewhere in Lagos, Nigeria (as well as Lagos, Portugal), for example, as part of the decoration of Lion House, another of the key monuments of the Brazilian-Yoruba architectural tradition. In Portugal the use of this kind of tile work is regarded as of Moorish-African origin.

26. The premier scholar of the antiquity of Yoruba culture was also the first to include contemporary art within a general account of African art: I refer, of course, to Frank Willett and the last chapter of his *African Art* (1971).

PART ONE

YORUBA
ARTISTIC TRADITION
AND
CREATIVITY

Fig. 2.1.
William B. Fagg
photographing a
pendant mask at
the palace of the
Olowo, Owo, Ni-
geria, 1958. Photo:
Frank Willett.

2. Introduction: An African(?) Art History: Promising Theoretical Approaches in Yoruba Art Studies

Rowland Abiọdun

Very few scholars have equaled the intellectual contribution of William Fagg to Yoruba art studies. His meticulously researched publications, his eye for detailed analysis of style, and his appreciation of Yoruba art are precious gifts to African art scholarship. Fagg's extensive writings demonstrate that he was not only knowledgeable in African art but familiar with the classical traditions of Western art. Whenever appropriate, he used this expertise in Western art history to maximum benefit in his analysis and study of African art. The result of his pioneering work was, among other significant contributions, to enhance the status of African art in the international art scene. Through his efforts it became easier for scholars outside Africa to understand a nonwestern and unfamiliar artistic idiom.

We must not overlook, however, a very important part of the legacy that Fagg (fig. 2.1) left us, which is revealed in his observation that: "The study of meaning in African art is at a rudimentary, not to say primitive, stage . . . It is a pity that full and detailed accounts of the philosophies of tribes are *almost universally absent* from the many excellent anthropological monographs which have appeared in English since the war" (1973:161; italics mine).

We have in this volume a partial execution of that agenda by scholars of Yoruba art and culture. Their contributions, coming from several disciplinary backgrounds, and exhibiting a fairly wide range of research interests, but still focusing on the Yoruba, provide a unique opportunity to reflect upon the study of Yoruba art from different perspectives. No one traditional discipline can adequately supply all the answers to the many unresolved questions in Yoruba art history.

Because of the aesthetic, cultural, historical, and, not infrequently, political preferences already built into the conception and development of Western art history, the discipline of art history as defined and practiced in the West has continued to resist nonwestern approaches to art. Thus it is still largely true, as Joan Vastokas has commented, that:

Artistic developments beyond the pale of Western Europe—even those with extended written histories such as India and China—hold little interest for them [i.e., Western art historians], except in instances of obvious outside influence upon the West at various periods from the Orient, South Seas or Africa. As well, the aesthetic values of Western art historians are shaped by European philosophical aesthetics and uniquely Western visual preferences for monumental works in preferably representational styles, strong colors and tactile presence (1987:8).

With this kind of low esteem for, and the marginalization of, African art within the broader field of art history,[1] Africanist art historians must now begin not only to reexamine their Western-derived methodologies but also to search for theoretical alternatives, lest they lose the "African" in "African art." Father Kevin Carroll, who lived and worked among the Yoruba and studied Yoruba art for several decades, came close to saying this much when he wrote that "African carvings have frequently been interpreted in abstract terms without any attempt to discover the people's own interpretation" (1973:168). It is hard not to reflect on these comments as we introduce and appreciate the essays presented in Part One. All the contributors have raised a number of important theoretical and methodological issues and addressed them from several perspectives.

Frank Willett's essay, "Stylistic Analysis and the Identification of Artists' Workshops in Ancient Ifẹ," has as its goal the adoption of a more or less "objective" approach in the analysis of style and the identification of individual artists' hands, thus moving somewhat beyond "a largely subjective" and "perhaps mystical . . . process" of form which used to be the case decades ago. The lessons from his study of the Ọsanmasinmi heads in Ọwọ, especially their style attribution through relatively objective criteria, are a valuable contribution to the methodology of Yoruba art scholarship. Willett has since extended the base of his research methodology to include quantitative and empirical analyses of form and technique which he now uses on the famous "bronzes" and terracottas of Ifẹ.

Both Ezio Bassani and Hans Witte are interested in the iconography of the *ọpọ́n Ifá* (the tray used in Ifa divination). Bassani pursues the discussion of style in his essay, "The Ulm *Ọpọ́n Ifá* (ca. 1650): A Model for Later Iconography." In a detailed morphological examination and stylistic analysis of the oldest surviving wood carving from sub-Saharan Africa in a European collection, Bassani attempts to reconstruct its place and status art historically within the West African stylistic complex. He draws attention to the high probability of an early presence of figurative sculpture among the Yoruba, thus implicitly criticizing some Africanist art historical writings about the absence of naturalism in African work until the Europeans introduced certain conventions of realism. He opines that it is "reasonable to say that early figurative models were spread over a vast region of West Africa and, in some cases, were handed down in almost the same form until the end of the nineteenth century, which might explain the peculiar archaic look of the more recent figures."

If, as it now appears, the Yoruba had more or less perfected their naturalistic style(s) as evidenced in the figurative terracotta works from Ile-Ifẹ, dating back to the tenth to twelfth centuries A.D., it is indeed plausible that from there various forms of naturalism spread and influenced artists in neighboring communities with whom Ile-Ifẹ must have had religious, political, and/or economic connections. This hypothesis, supported by historical studies on Yoruba interaction with other peoples in West Africa and probably beyond, "even when their rulers were at war" (as Ọlabiyi Yai rightly points out in his essay), makes it sufficiently compelling to adopt an

African-centered approach to the analysis of style in a work such as the Ulm *opón Ifá*.

To address properly the issue of naturalism in African sculpture, it is important to note that naturalism has many possible modes of expression not exclusive to Western cultures, and it would be overly simplistic to claim that naturalism was absent in African art before the advent of Europeans. Furthermore, "artistic naturalism is not merely a matter of form but of content and implies a naturalistic philosophy" (Abiodun 1974:138).

In his essay, "Ifa Trays from the Oṣogbo and Ijẹbu Regions," Hans Witte sets out to discover the logical basis for the representation and composition of images, their interaction with each other and within the *opón* as one integral sculptural whole. Roslyn Adele Walker's paper, "Anonymous Has a Name: Ọlọwẹ of Isẹ," challenges the erroneous belief that traditional African artists were ever anonymous. She discusses the carving style of Ọlọwẹ, who has been acknowledged by many a scholar as probably the most innovative traditional Yoruba sculptor of this century. From available written sources, photographic records, and *oríkì* (praise poetry), she establishes the basis for a study of Ọlọwẹ's artistry.

Finally, Ọlabiyi Babalọla Yai's essay, "In Praise of Metonymy: The Concepts of 'Tradition' and 'Creativity' in the Transmission of Yoruba Artistry over Time and Space," demonstrates the need to "reexamine, question, even abandon certain attitudes, assumptions, and concepts of our various disciplines, however foundational they may seem, and consequently take seriously indigenous discourses on art and art history." He redefines the concept of influence, its usage and meaning in the context of Yoruba art and history.

Drawing extensively on a linguistic and cultural knowledge of Yoruba, Yai argues convincingly for the consideration of Yoruba art work as *oríkì* (praise poetry), making it "a tutelary goddess of Yoruba art history." This makes good sense to students of Yoruba studies, since *oríkì* not only defines but conveys the dynamic and historical nature of a person or thing, and, as a concept, *oríkì* is inseparable from *ìtàn*, generally translated as "history." A more accurate and relevant meaning of *ìtàn*, according to Yai, derives from the verb *tàn:* "to illuminate, enlighten, discern, disentangle."

Yai's essay argues strongly for the indispensable role of Yoruba language and thought in our understanding and practice of Yoruba art history. He considers the Ulm *opón Ifá* an important "text" when viewed as part of the intellectual climate prevalent in the West African region in precolonial times. Yai's reading of this *opón* not only complements Bassani's study but opens new areas of inquiry and possible cooperation for scholars of Yoruba art history and Yoruba language and literature. His observation that the language and metalanguage of the Yoruba verbal and visual arts overlap is an important one. He affirms, for instance, that to *kì* (perform *oríkì* verbally), *gbẹ́,* or *ya* (both meaning to carve) "is to provoke and be provoked." In essence, Yai's approach represents the kind of serious, concerted scholarship needed in Yoruba art studies, which could facilitate a "reconsideration of many (supposedly) closed issues, theoretical frameworks and artistic concepts" (Abiodun 1990:64).

In our effort to construct a new and perhaps more contextually relevant methodology for

studying Yoruba art, we will now turn to selected philosophical concepts in Yoruba culture, granting them "equal and reciprocal elucidatory value as theoretical alternatives"[2] to traditional Western art historical paradigms. This should not pose any special problem, since many scholars who have studied or encountered Yoruba culture acknowledge that it has produced "richness of thought, action and objects in *all* its artistic spheres" (Ottenberg 1990:131). Fortunately, the Yoruba are one of the most studied groups in Africa. Few African ethnic groups have as many indigenous scholars studying their own culture as the Yoruba. Thus it makes the Yoruba a particularly good candidate for the kind of exercise that I propose.

Àṣà: Style and Tradition in Yoruba Art and Thought

The word *àṣà* in Yoruba can mean either "style" or "tradition." *Àṣà* is broadly conceived as any set of ways, approaches, or practices that characterize a person's behavior or mode of work of a group of people or a period. The noun *àṣà* is formed by adding the prefix *à* to the verb *ṣà* (to pick or select many or several things from a collection or an available range of options), a normal nominalization process in the Yoruba language. Because tradition emerges from the kinds of choices persons make with respect to social, political, religious, and artistic modes of expression, it makes sense to hypothesize that *àṣà* (tradition) derives from *àṣà* (style). Moreover, the uses of the term *àṣà* as "tradition" and "style" are related in meaning and not necessarily opposed to each other in Yoruba art and thought. When used in the context of Yoruba artistic discourse, *àṣà* refers to a style or the result of a creative and intelligent combination of styles from a wide range of available options within the culture. This is the reason that *àṣà*, whether as "style" or "tradition," is never static and cannot be, since the concept of *àṣà* already embodies the need for change, initiative, and creativity.

Given the nature of *àṣà*, it is to be expected that art historians will continue to encounter a wider and wider range of new styles, forms, and motifs as well as old ones that have been freshly treated and presented. The Yoruba have terms such as *àṣà-àtijọ́* (old or ancient tradition or style), *àṣà-tuntun* (a new tradition or style), and *àṣà-àtowọ́dọ́wọ́* (a tradition or style passed on from one generation to the next) to convey notions of tradition, change, and continuity in Yoruba art and thought. Gene Blocker reaches a similar conclusion in his article, "The Role of Creativity in Traditional African Art," where he argues that: "Artistic traditions are not opposed to but necessary for artistic creativity . . . [and] that in the absence of a tradition, innovation could not exist at all. Something can be innovative only against a backdrop of tradition" (1982:8).

Hence we see that not only do the Yoruba possess an appreciable awareness of the existence of personal and community styles that accommodate change and innovation, but they also have a sense of history built into the concept and meaning of *àṣà*. In the light of this and similarly strong arguments by Picton (1992b) and advanced by Ọlabiyi Yai in his essay in this volume, we have to

be more critical in our field studies and listen more attentively to the interpretation of such intellectually astute persons as diviners and elders,[3] who are knowledgeable about and sensitive to issues of style among the Yoruba.

To date, art historians have tended to privilege their Western-derived methodologies, much to the detriment of culturally based sources that consist mainly of oral traditions. However, this situation is changing gradually as more scholars see the need to allow the culture to speak for itself. In Walker's essay on Ọlọwẹ of Isẹ, we can see how even a limited but effective use of the information derived from Ọlọwẹ's *oríkì* (praise poetry) produce important data such as the places where his carvings could be found. Accounts of this nature are crucial to a thorough stylistic analysis of Ọlọwẹ's work.

Equally helpful in attempting to know the various influences on an artist, and particularly on his style, is the personal or biographical data that enable the scholar to place his work in the appropriate context. These include data on the artist's family background, life-style, and clients, how much traveling he did, and the regard for him and his work by those in and outside his community. Some of these are retrievable through *oríkì*. In Wande Abimbọla's essay in Part Two, "Lagbayi: The Itinerant Wood Carver of Ojọwọn," it is suggested that famous Yoruba carvers did much traveling, which is how Lagbayi earned the cognomen Are. They were continually exposed to the work of greater and lesser artists, and were therefore influenced by styles beyond their immediate environment. This would be totally consistent with the Yoruba tradition of *àṣà* which enables the artist to innovate through adaptation of styles while still respecting and preserving time-honored visions whose vocabulary of representation has been found supportive of the treasured values of society. Bassani illustrates this point well in his discussion of the *àbíkú* statues from Athieme and Tokpli and related images on the Ulm *opọ́n Ifá*, suggesting an "exchange of iconographic and stylistic models between Yoruba and Aja."

"Anonymity" in Yoruba Art

In order to tackle the problem of anonymity in Yoruba art, it might be useful to ask a few general questions. What, for example, is the status of anonymity in Yoruba culture? How are naming and the tradition of personal identification regarded in the society? What forms do they take, if they exist? Finally, how and where do artists fit into these practices and traditions? It is difficult to find a place for anonymity in a culture such as the Yoruba where "it is absolutely imperative for individuals to acknowledge each other's identity and presence from moment to moment, [and where] there is a special greeting for every occasion and each time of the day" (Abiọdun 1990:85). The problem of identifying individual artists among the Yoruba is still very much with us. This problem is exacerbated by the fact that many Yoruba artists do not sign their works in the way artists in other societies have.

There is no doubt that establishing the authorship of a work of art, or associating specific forms with names, is important for the Yoruba. But this is usually done very discreetly, as in discussions of Yoruba art criticism and aesthetics which scholars once thought never took place (Abiọdun 1990). The myth of anonymity was constructed and reinforced by early researchers who probably believed that the artifacts and the supporting traditional thought systems belong to the Africans but that the interpretation and theorization of African art must always be theirs (that is, the early researchers'). Scholars today, however, are more cautious not to repeat the same old error: to believe that if artistic procedures in other cultures do not take the form with which we are familiar in the West, they must be absent.

One reason that the Yoruba may not publicly or openly associate specific art forms with the names of their authors is perhaps because names given at birth are closely linked to and identified with the essence of one's personality and destiny (called *orí-inú,* inner spiritual head), which in Yoruba religious belief determines a person's success or failure in this world and directs his/her actions (Abiọdun 1987). Though the act of calling out a person's given names generally functions to differentiate individuals, in the Yoruba religious thought system it is also believed to have the ability to arouse or summon to the surface a person's spiritual essence and cause him/her to act according to the meaning of those given names or in some other way desired by the caller. This is the basis of the Yoruba saying, *Orúkọ a máa ro'ni*: "One's name controls one's actions."

It does not take long for anyone who has lived among the Yoruba to discover that their naming ceremonies and practices are among the most elaborate and sophisticated known anywhere. According to Niyi Akinnasọ, "Besides its more obvious function which is the differentiation of individuals, personal naming in Yoruba is another way of talking about what one experiences, values, thinks and knows in the real world" (1983:139).

Chief J. A. Ayọrinde elaborates further on the naming practice: "No child is given a name without also being given an *oríkì,* which is an important adjunct to any name. . . . All chiefs and prominent personalities have *oríkì* describing their character and achievements, which serve, as it were, as their "signature tunes" to announce their approach or presence" (Ayọrinde 1973:63). It is clear that not only do the Yoruba possess and practice a most effective system of naming everyone in their society, but they go even further to identify them more fully through their *oríkì.* This is the reason we must agree with Gene Blocker who points out that "anonymity has more to do with a tradition of individuality than with the 'fact of individuality' " (Blocker 1982:12).

It is worth noting that while in the Euro-American tradition, a child may call his parents by their first names, it would be unthinkable for a Yoruba child, even after attaining adulthood, to do the same even with all the influence of Western education and culture on the Yoruba society today. Yoruba children know their parents' given names, but it is considered disrespectful to address them casually or unceremoniously. This is apart from the fear that unscrupulous people or one's

enemies who hear and know the name could use it to harm the bearers. There are, of course, appropriate traditional contexts and occasions during which one's full given names may be heard, but then adequate countermeasures are taken in advance to foil any machinations of evildoers. These instances include child-naming, installation, and burial ceremonies, blessing and healing rituals, and important family gatherings.

By reason of their profession and position in the traditional community, artists were especially vulnerable and became easy targets for unknown malevolent forces, for which reasons artists rarely revealed their full given names to strangers until relatively recent times. It is, therefore, not surprising that many great Yoruba artists whose works have been collected and studied by researchers have been identified in scholarly literature only by nicknames or bynames, as, for example, Olọwẹ Ise (meaning Olọwẹ from the town of Isẹ), Ologan Uṣelu (Ologan from Uṣelu quarters, in Owọ), and Baba Roti (father of Rotimi).

Early researchers were clearly ill-equipped in their training to grapple with the problems of naming traditions outside their own. This initial lack of understanding could have led them to assume that the authorship of art work was unimportant among the Yoruba. Moreover, the biases of these early researchers must have prevented them from carrying out any diligent probing of artists' full given names. It is ironic that such information was, however, highly valued in Western art history.

We will surely need to collaborate with colleagues in African languages and literatures and modify our research techniques to make room for the valuable data that *oríkì* can provide in our efforts to discover artists' identities among the Yoruba. Indeed, any serious attempt to do art history in a nonliterate society like the Yoruba can no longer ignore the place of their rich oral traditions.

Several of the essays in this volume show that scholars are already doing much to correct that situation. The works of John Picton, Frank Willett, and Roslyn Walker, among others, are most encouraging and demonstrate, to borrow the title of Roslyn Walker's paper, that "Anonymous Has a Name." The field owes William Fagg a debt of gratitude for his pioneering work in this regard. He was one of the first researchers to seek out conscientiously and interview the so-called "anonymous" artists among the Yoruba. His documentation of the lives and works of well-known Yoruba artists is a rich legacy which the present generation of Yoruba art scholars highly value.

Yoruba Iconography: *Oríkì* Made Visible

Both Hans Witte and Ezio Bassani deal with issues of iconography in their papers. Coincidentally, they also focus on ọpọ́n Ifá, carved, flat, wooden trays used for divination by *babaláwo* (Ifa priests). What role can familiarity with Yoruba orature play in this exercise? As I will attempt to

show, Yoruba orature consists mainly of Ifa divination verses, chants, incantations, and songs. Examining these in their ritual contexts can reveal forgotten meanings that would be hard or even impossible to obtain from archival sources and the most cooperative informants.

An Ifa divination verse, for instance, provides us with some insight into the possible origin(s) of the ọpọ́n Ifá. It states in part:

Ile ni mo tètètè	It was on the ground that
Ki ´n tó t'ọpọ́n (Abimbọla 1968:43).	I first printed divination marks
	Before the tray was designed.

All the Ifa priests whom I interviewed on the interpretation of this verse agree that there is nothing unusual about divining on the ground where the ọpọ́n Ifá is not readily available and that this is usually the case when Ifa priests travel long distances away from home or when their services are required in extraordinary circumstances, such as war. It is also not uncommon to find diviner apprentices today practicing divination marks on the ground before they graduate and can afford to commission an ọpọ́n Ifá for a professional career.

The invention of the ọpọ́n Ifá would appear to be linked to the elevated social, political, and economic status that Ifa priests enjoyed in the distant past and which they still aspire to in Yorubaland today. Another Ifa divination verse cited by Ọlabiyi Yai in this volume lends support to this hypothesis.

> Ifa divination is performed for Orunmila,
> Who initiated his three disciples.
> Ifa initiated ọpọ́n [the tray]
> Ọpọ́n traveled to Ido Awuse to seek knowledge
> He became a king there . . .

Faṣiku, the Alaaye (king) of Ikẹrin and an accomplished carver who claims he has carved over two hundred ọpọ́n Ifá, explains the meaning of ọpọ́n as "ohun tí a fi pọ́n Ifá lé" (that which is designed to flatter and honor Ifa).[4]

If, as we know, oríkì (praise poetry) functions more or less in this manner as well, we may consider the ọpọ́n as "a visual salute" to Ifa—in other words as oríkì "made visible," to borrow Sarah Brett-Smith's phrase.[5] As in oríkì,[6] its verbal counterpart, ọpọ́n Ifá may carry "condensed, elaborated, highly charged" visual "salutes" (see Karin Barber's paper) to all the important characters in the Ifa divination process. These visual "salutes" summon them to action; they energize and prepare them for action. Almost literally, Ifa is charged or "loaded" (kì) as when a gun is loaded (kì ibọn), and the priest can expect a powerful response from Ifa.

This is one way of looking at the *opón Ifá* from Ulm (ca. 1650) discussed by Bassani, as well as those from the Oṣogbo and Ijẹbu regions examined by Witte. Like most *opón*, these vary in richness of design and iconographic details dictated by factors such as the skill and creativity of the artist, as well as by the fee that the Ifa priests paid for them.

Since the *opón Ifá* is a ritual object to honor, praise, and flatter Ifa, it is to be expected that its basic forms—the square, rectangle, circle—would reflect visually the most basic and important attributes in the *oríki* of Ọrunmila (the deity of Ifa divination). Thus we may rightly assume that the preeminence of the basic geometric forms of *opón Ifá* allude to Ifa as *ògégé-a-gbáyé-gún*, that is, "perfection, primeval order, the regulative principle of the universe" (Abiọdun 1975a:424). An important word here is *gun*, an adjective meaning "straight, settled, resolved," all of which underscore Ifa's role in healing and normalizing abnormal situations. It is also because of this re-creative function of Ifa that any suggestions of malformation and crookedness are eliminated from the basic shape of the *opón Ifá*, and the central open space on the tray, called *itá òrún* (the spiritual realm), is kept free of any designs and shadows cast by a highly embossed border. Only camwood dust (*iyèròsùn*) may cover the surface of the *opón*, for it is in the dust that the marks made by the Ifa priest during divination sessions appear, revealing the *Odù Ifá*.

Also praised and honored by his representation on the *opón Ifá* is Eṣu, often described as the "Trickster divinity," but who is actually "a neutral force in the conflict between the good supernatural powers and the evil ones" (Abimbọla 1976:152). A symbolic face of Eṣu carved in relief, metaphorically separating the physical world (*ilé-ayé*) from the spiritual realm (*ita-ọrún*), must appear on the border of an *opón*. This arrangement calls attention to Eṣu's influence in the two worlds and his crucial role as the "impartial police officer" (Abimbọla 1976:186). Eṣu is strategically placed where he must be constantly placated through regular sacrifices. An invisible diameter is created on the *opón* when the Ifa priest sits directly opposite the symbolic face of Eṣu during divination. The pivotal position of Eṣu as a powerful *òrìṣà* who assists in maintaining the precarious balance between the malevolent and benevolent forces of the universe is thus reinforced. This representation reflects the way he is characterized in the following condensed and powerful *oríki*: *A ṣ'òtún ṣ'òsì lá ì ni'tìjú* (One who belongs to the right and left sides of an issue without exhibiting any sense of shame) (Abiọdun 1975a:437).

Acknowledging the presence of Eṣu and seeking his cooperation guarantees trouble-free divination sessions. More important, however, Ifa can be assured to have Eṣu's *àṣẹ* (vital force and sanction), so necessary in making all of Ifa's utterances and predictions come to pass. This explains why the symbolic face(s) of Eṣu has become the only permanent motif on the border of an *opón Ifá*, and no other figurative or decorative motif enjoys such status.

Like the *oríki*, most carved border decorations on the *opón Ifá* are more or less "praise images" for they praise (*pón*) Ifa, his priests, clients, and not infrequently artists who execute the carving. The themes are numerous and tend to vary considerably in subject and style of presentation. They

portray the practical effects of successful divination on clients and on the physical world. Hans Witte's study of the images and their compositional structure has drawn our attention to the important findings of Henry John Drewal and Margaret Thompson Drewal on "seriate composition" among the Yoruba. It is, they observe, "a discontinuous aggregate in which the units of the whole are discrete and share equal value with other units. These units often have no prescribed order and are interchangeable" (1987:233). It is interesting that Karin Barber has also identified similar structural features in her study of *oríkì* in Okuku. In her essay in this volume she observes:

Fragmentation is not to be seen as the accidental or regrettable byproduct of the mode of oral composition and transmission. In the view of practitioners and listeners, a certain degree of fluidity and fragmentation is positively desirable. Skilled performers demonstrate the mastery of the genre by exploiting the possibilities of disjunction and polyvocality given to them in the corpus of material they have learned.

The observations by the Drewals and Barber are not unrelated to the Yoruba concept of *ìwà* (character, essential nature, or existence) whereby an artist seeks to realize completely the identity and character of his subject. "*Ìwà* deals with the full recognition and proper appreciation of the thing in itself, the unique qualities of a specific object as totally distinct from the generalized kind of which it is a part" (Abiọdun 1990:70). This accomplished, an artist has fulfilled the most important prerequisite for beauty (*ewà*) in his work.[7]

In this introduction I have examined the important interdependence of the verbal and visual arts in Yoruba culture. Indeed, the basic functions and structures of these verbal and visual art forms are similar, even though their modes and manifestations may be different. It is also incontrovertible that familiarity with Yoruba oral traditions will enhance our present understanding of Yoruba art immensely, as well as the visual arts informing our perceptions of oral traditions. With the progress made so far in Yoruba studies, and the thought-provoking research going on today, the time has now come to start asking questions about the nature and concept of art in Yoruba culture. Such questions are as important as those relating to art history, style, and iconography which have been addressed in this section.

Whichever method we might adopt in answering these questions, the theoretical contributions of Yoruba culture itself can no longer be underestimated; it must play a very important role. The least we can do is to abide by the universally respected legal principle of *audi alteram partem* (hear the other side).

Notes

1. For a cogent analysis and critique of the "marginalization" of African art history, see Blier 1990:91–107.

2. See Hallen 1975:259–72.

3. Suzanne P. Blier makes a similar remark: "by far the most important group of cultural spokespersons who influence the shaping and the explication of art are geomancers . . . Geomancers accordingly are often actively involved in the process of art creation. Frequently, it is they who indicate when a work should be commissioned, what formal qualities it should have" (1988:80). See also Hallen 1975:262.

4. Faṣiku, the Alaaye of Ikerin, personal communication, 3 April 1974.

5. Cf. the title of her article, "Speech Made Visible: The Irregular as a System of Meaning," Brett-Smith 1984:127–47.

6. Chief J. A. Ayọrinde explains that "the word *oríkì* is derived from *orí* (head or origin) and *kì* (to cite), and so means to cite one's origin"; in Biobaku 1973:63. Reciting a person's *oríkì* has the effect of arousing one to action and performing much beyond expectation.

7. See Abiọdun, Drewal, and Pemberton 1991:20–28.

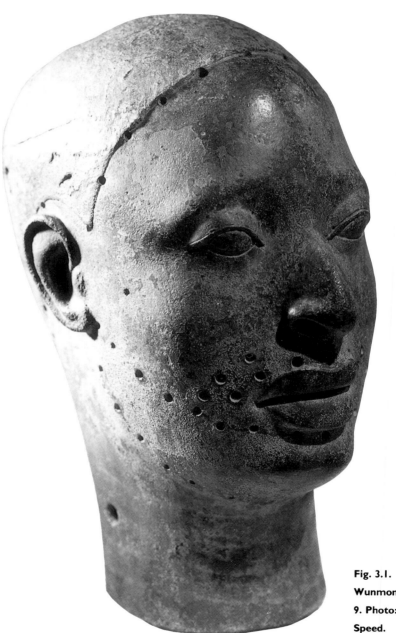

**Fig. 3.1.
Wunmonije head
9. Photo: Francis
Speed.**

3. Stylistic Analysis and the Identification of Artists' Workshops in Ancient Ifẹ

Frank Willett

My topic falls into two parts, one on stylistic analysis in general and the other, quite specific, on the individual styles identified in ancient Ifẹ. I propose to deal with the first one in a rather autobiographical way. Archaeologists and ethnographers have always been interested in style, but the training I received, now more than four decades ago, did not occupy itself formally with questions of style in the way that art history did. In any case, in the art history lectures I attended, the identification of the hands of individual artists was not discussed. Identification appeared to depend on connoisseurship, a largely subjective and perhaps even mystical process.

In the field of African art, it was initially in conversation with William Fagg that I first came close to connoisseurship at work. Clearly he had a very fine eye, even an instinct, for the identification of the individual artist. Yet, on occasion even Homer can nod. For example, in the Christie's sale catalogue of 23 June 1986, no. 83, Fagg wrote of a female figure holding a bowl that it "is unmistakably by the hand of Arowogun Bunna [or Arẹogun] of Osi-Ilọrin," but he subsequently agreed with John Picton, who, relying on Fagg's own field data, showed that it was the work of Bamgboṣe of Osi, the master of Arowogun. Despite the success of my own first attempt to identify the work of individual hands in the workshop of Lamidi Fakẹyẹ (Willett 1971:235–36), it seems to me that there ought to be some way in which we lesser mortals might be able to approach these questions in a less subjective, perhaps even an objective, way. I attempted to make a small contribution toward this in my book, *African Art: An Introduction*, by describing the individual characteristics of a group of carvers working in the style of Osi Ilọrin (1971:228–31). During my time in Ifẹ as Government Archaeologist (1958–63) I had begun to take note of the varying features of the life-size metal heads from Ifẹ with a view eventually to analyzing them to see whether it would be possible to identify the hands of individual artists.

In writing a paper about the possible use of these heads, I referred to the work of a number of recent sculptors who had worked in Ọwọ (Willett 1966). When it was published, John Picton wrote offering to show me his series of photographs of other works attributed to the same artists. As I studied them, it struck me that the *òsánmásìnmì* heads provided a body of material that lent itself to analysis by relatively objective criteria. Using Kevin Carroll's description of modern workshop practice among traditional carvers in Ekiti (1967:94–97), north of Ọwọ, it was possible to distin-

guish the features of the sculpture that would have been established by the master carver and to give priority to these in our classification, as opposed to the work that would be left to an apprentice. The nineteen carvings were attributed in the field to three named carvers or were unattributed. We were able to distinguish five hands, three of which were attributed to one artist, Olujarẹ. We considered that one of these attributions was firsthand information, whereas the others were secondary. We saw no reason to doubt the identification of the other two named groups, so we ended up with three named and two unnamed styles (Willett and Picton 1967:62–70).

This work with John Picton was conducted during my Research Fellowship at Nuffield College Oxford, a postgraduate college devoted to the social sciences. There most of my colleagues were using quantitative methods of analysis, sometimes even attempting to quantify data that was in large degree qualitative. I thought I might try to do the same. I began by listing all those characteristics that each Ifẹ metal head had that were not shared by all of the others. One byproduct of this was the recognition that the holes round the top of the head followed the outlines of two forms of crown and that the raising or recessing of the area thus outlined was not a stylistic feature at all but a practical necessity in adjusting the form of the top of the head to fit the preexisting crown. Now it is possible that the shape of the crown varied with time so this feature can still be retained, since one might expect changes of style and of fashion to go hand in hand. Similarly, it was clear that there were three eye forms and several ear forms. In the same way that a physical anthropologist would, I computed indices for ears and eyes and plotted them against each other on graph paper. Head 9 stood out (fig. 3.1), but the rest seemed to be a continuum.

Looking at ears led me to demonstrate that the ears of Benin "bronzes" do not follow a unilinear progression from "naturalistic" to stylized, which is a cautionary fact since all the attempts to bring order into this large corpus of material have done so on the assumption of a unilinear evolution. The Benin corpus indeed provides a number of salutary warnings that it may be misleading to rely on form alone. Dark's Type I heads (Dark 1975:25–103, esp. 38–39) were not all produced at one time, as Kenneth Murray's artist's eye detected (Dark 1975:39), and this was subsequently confirmed by analysis of the metals used (Willett 1973:17). Paula Ben-Amos' subsequent suggestion that the heads are trophy heads, and thus stand apart from the series of royal ancestor memorial heads, affords a likely explanation (1980:18, caption to pl. 16).

In 1966 I began to teach African art at Northwestern University, and from time to time in my graduate seminar I attempted to encourage my students to experiment with more-or-less quantified methods. Jeff Donaldson, one of my first graduate students there, undertook a study of my photographs of Nok heads. We used only complete heads and sometimes had to guess how to identify the attributes from the photographs. It was especially hard to identify the form of the head, if one had only a single view. Nevertheless it was possible to group the heads into substyles and to show that these corresponded to place of finding. Subsequently thermoluminescence dating showed that one group, from Ankiring,[1] was later than the rest.

A similar attribute analysis ought to work with the Ifẹ material, but none of my students was

willing to attempt it, perhaps because they perceived such a naturalistic style as being too intractable. It is, of course, important to recognize that no art form is strictly naturalistic—only nature is actually naturalistic. Whatever the artist's style, he is using conventions that he will either have learned from his master or else have developed for himself,[2] so the task should not be as difficult as it might at first appear. In 1978 International College, Los Angeles gave an award to Barbara Blackmun to come to Glasgow to study with me during the summer vacation. She was keen to devote herself to this problem and returned the following summer at her own expense to continue the project.

The available data comprised my very full photographic documentation—at least six views of every metal head and many more of most of them—and my detailed notes made from the originals, a much better data base than was available for the Nok study. Dr. Blackmun chose to use as complete a range of data as possible. This gave her eighty-seven criteria in sixteen groups. The first four criteria relate to the presence or absence of facial striations and their completeness; the next five to the handling of the creases on the neck; the next three to the shape of the opening in the

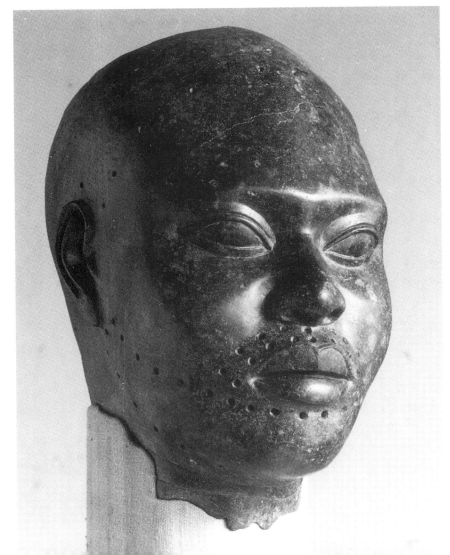

Fig. 3.2.
Wunmonije head
14. Photo: Frank
Willett.

head; then five features of the scalp area; seven criteria relating to the size and spacing of the small holes on most of the faces; six relating to the holes around the "hairline"; three to the shape of the nostrils; thirteen relating to features of the lips; ten to features of the ear; three relating to the piercing through the head of holes in the ears, nostrils, and mouth; eight to features of the eyes; and three to length of the neck. The remaining criteria refer to purely technical aspects: metal composition in two categories; thickness of the metal in four categories; eight criteria relating to the smith's technique in casting; and, finally, height, weight, and scale of representation.

Leon Underwood had identified four basic types among the Ifẹ "bronze" heads that he thought might indicate "different workmanship and period" (Underwood 1949:27). He called them Olokun, Moorish, Ọbalufọn-Egyptian, and Negro. Around 1960 his son John, a cinematographer employed at the time by the Nigerian Government Information Service, was sent to Ifẹ to film the heads. As he arranged them, he pointed out to me that they could well represent groups of brothers. There are nowadays four ruling houses in Ifẹ, all descended from one Ọọni. This raises the problem in a naturalistic art style of distinguishing the features which are characteristic of the artist's style, his schemata as E. Gombrich calls them (1960:passim), from the features portrayed by his subject. For Dr. Blackmun's analysis it was decided to omit overall similarities of facial appearance and to concentrate on the details mentioned above. After studying the metal heads she went on to examine a number of the terracotta heads, using, of course, fewer criteria, since many of the features of the metal heads do not occur in the terracottas.

This is not the place to give details of her analysis which will be published fairly soon in my catalogue raisonné, *The Art of Ifẹ in Metal*. Her conclusions, however, may be summarized in this way. Head 14[3] (fig. 3.2) is quite distinct from all the others, but it shares some features in common with the Seated Figure of Tada[4] and the fragment of a head from Ado Ekiti,[5] as well as with the five terracotta heads from my excavations at Ita Yemọọ (fig. 3.3).[6]

A second style group consists of heads 8[7] (fig. 3.4) and 1,[8] the metal figure of an Ọọni from Ita Yemọọ (fig. 3.5)[9] (three castings that William Fagg had attributed to "The Master of the Acquiline Profiles"[10]) and an unpublished terracotta face fragment from Oliver Myers' excavation at Igbo Ọbameri.

Some features of head 1 are shared with the third group which consists of heads 2[11] (fig. 3.6), 4,[12] 5,[13] 10,[14] and 20.[15] No terracotta heads have so far been assigned definitively to this grouping.

The fourth group is subdivided. The first subdivision comprises heads 3[16] (fig. 3.7), 6,[17] 16[18] (the so-called "Olokun" Head), 18[19] (in the British Museum), and 19[20] (the crowned head formerly owned by William Bascom). The second subdivision comprises heads 7,[21] 11,[22] 15,[23] and 17[24] (the Ọbalufọn mask, fig. 3.8). The comparable terracotta heads do not divide up so clearly, and indeed most (the so-called Lajuwa head,[25] the Guennol Collection face,[26] and the Iwinrin Grove heads 21,[27] 25,[28] 28,[29] and 39) show a combination of features of both subgroups, while the "Mia" head found by Frobenius,[30] Iwinrin Grove heads 22[31] and 24, and the broken metal figure known as Lafogido[32] also show features of the third group.

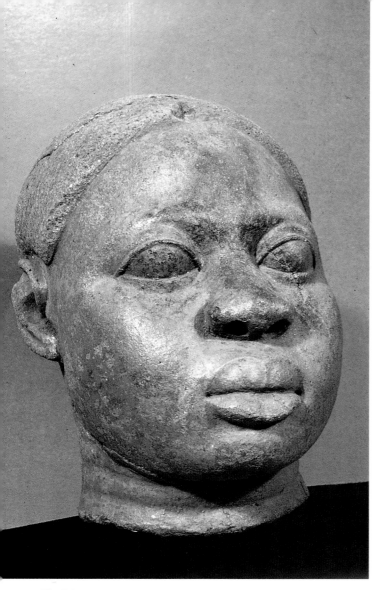

**Fig. 3.3.
Terracotta head
IY30/3. Photo:
Frank Willett.**

**Fig. 3.4.
Wunmonije head
8. Photo: Francis
Speed.**

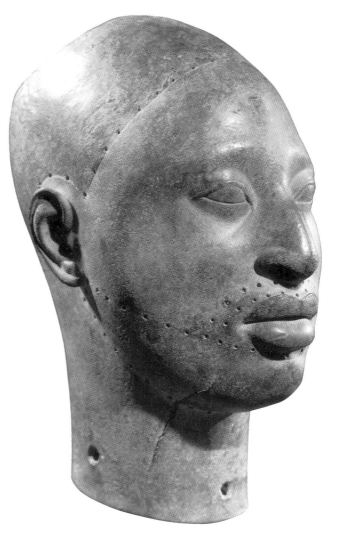

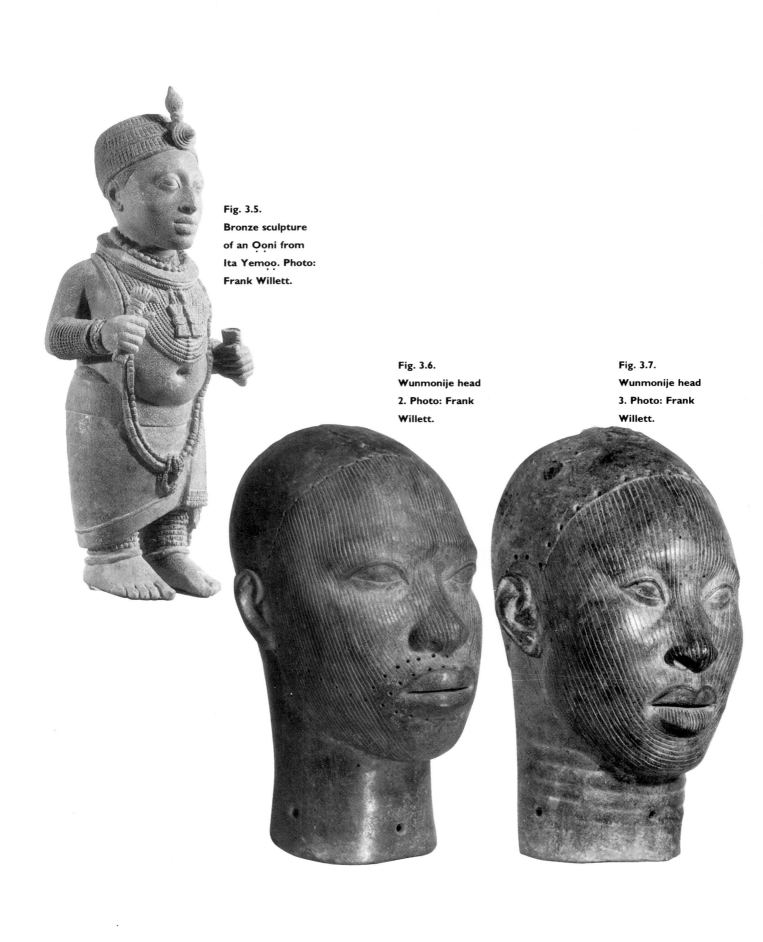

Fig. 3.5.
Bronze sculpture
of an Ọoni from
Ita Yemọo. Photo:
Frank Willett.

Fig. 3.6.
Wunmonije head
2. Photo: Frank
Willett.

Fig. 3.7.
Wunmonije head
3. Photo: Frank
Willett.

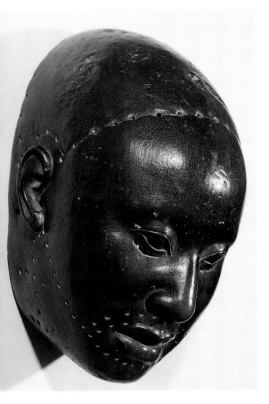

Fig. 3.8.
Head 17, the so-
called "Ọbalufọn"
mask. Photo:
Frank Willett.

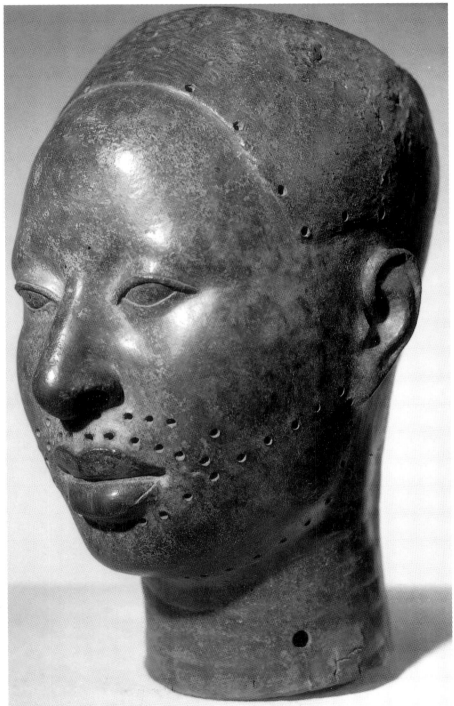

Fig. 3.9.
Wunmonije head
12. Photo: Francis
Speed.

A fifth group consists of heads 9 (fig. 3.1) and 12 (fig. 3.9) with no corresponding terracotta.

The fifteen terracotta heads here tentatively matched to the groupings of the metal heads were identified after a careful examination of sixty examples. There is a much greater variety of styles in the terracotta sculptures. It is surely no longer possible to argue, as Kenneth Murray used sometimes to do (though with how much conviction I am not certain[33]), that all sculptures from Ife could possibly be the work of a single artist, however talented and productive he might have been.

This paper has argued for the adoption of more-or-less objective criteria in the analysis of style. This does not, however, eliminate completely the use of one's judgment. Not all the criteria are sharply distinguished from each other, and, having established the five groupings described, one still has to interpret their meaning. Is each grouping the work of an individual artist or that of a single workshop? Where we get similar features in two groups, does this indicate the work of an apprentice in one workshop who later set up on his own? The great value of the approach is, I think, that it allows one's reasoning and one's criteria to be seen and assessed by others. Moreover, while it may confirm one's initial judgments (for example, the uniqueness among the life-size metal heads of no. 14), it also may cause one to rethink one's initial assessment. For example, Ita Yemoo head 3 (fig. 3.3) has always seemed to me to be unlike any other, in part because of its overall plumpness, but chiefly because the eye is conceived as a sphere within the socket, whereas most of the other terracotta heads tend rather to draw the eye on the surface. The analysis shows that it has a great deal in common not only with the other heads from the site but also with head 14 and with the seated figure of Tada. One conclusion, however, is of particular interest. The terracotta sculptures from Ita Yemoo appear to be all from one artist or workshop, and so do those from the Iwinrin Grove. This suggests that the sculptures were all commissioned from the same artist or workshop and that they may all have been commissioned at one time, that is, that these shrines may have been fully furnished from the beginning.

Notes

1. Illustrated in Bernard Fagg 1977:pl. 71; Willett 1986:pl. 4.

2. This has been discussed most helpfully by Ernst Gombrich 1960.

3. See Underwood 1949:pls. 10 and 11. Note that Underwood gives the catalogue numbers of these heads, though he refers to them as excavation numbers. I believe that they were assigned by the British Museum Research Laboratory when they were sent there for conservation.

4. Ibid.:pl. 21; Werner and Willett 1975:141–56, pl. 8; Eyo 1977:164–65; Eyo and Willett 1980:20 and 146, no. 92.

5. Werner and Willett 1975:pl. 1.

6. Four have been illustrated in Willett 1959:135–37, pls. VIIIb, IXa–b, Xa. See also Willett 1967:pls. VII, VIII, IX; Eyo 1977:57, 61; Eyo and Willett 1980:103, no. 50.

7. Underwood 1949:pl. 7.

8. Underwood 1949:pl. 12.

9. Willett 1967:pl. 6; Eyo and Willett 1980:96 and 97, no. 44.

10. See W. Fagg 1969:47 where he includes a head (no. 9) which does not appear to belong in this group according to Blackmun's analysis.

11. Underwood 1949:pl. 15.

12. Ibid.:pl. 17; Eyo 1977:69.

13. Underwood 1949:pl. 18b; Eyo 1977:78.

14. Underwood 1949:pl. 18a.

15. Eyo 1977:80.

16. Underwood 1949:pl. 13; Eyo 1977:70.

17. Underwood 1949:pl. 14; Willett 1967:pl. 1; Eyo 1977:79.

18. The so-called "Olokun" head, found by Frobenius but known only from the modern copy in the Ife Museum. Illustrated in *African Arts* 9(3):9, fig. 2; Eyo 1977:84.

19. Eyo 1977:80.

20. Ibid.:74; Eyo and Willett 1980:94, no. 42.

21. Underwood 1949:pl. 8; Eyo 1977:77.

22. Underwood 1949:pl. 4; Eyo 1977:76; Eyo and Willett 1980:91, no. 39.

23. Underwood 1949:pl. 9.

24. Ibid.:pl. 6; Willett 1967:pl. 1; Eyo 1977:73; Eyo and Willett 1980:93, no. 41.

25. Eyo 1977:53; Eyo and Willett 1980:102, no. 49.

26. Eyo 1977:48, left. See the exhibition catalogue, *The Guennol Collection*, New York: Metropolitan Museum of Art, 1982, vol. II:17.

27. Eyo 1977:68. Note that the detailed caption on p. 232 is wrong in describing it as a "random find."

28. Willett 1967:pl. 25.

29. Ibid.:pl. 28.

30. Ibid.:pl. 30.

31. Eyo and Willett 1980:100, no. 47; Eyo 1977:51.

32. Willett 1967:pl. 7; Eyo 1977:75; Eyo and Willett 1980:98, no. 45.

33. I think it may have been simply to force me to examine my evidence more closely. Note, however, his comment: "it might be argued that only one artist, working perhaps for only a couple of years, made the majority of the heads!" in *Odu—A Journal of Yoruba and Edo Studies* 9, September 1963:44.

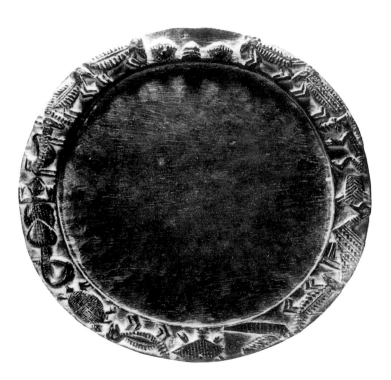

Fig. 4.2.
Grassi Collection,
Museum für
Völkerkunde,
Leipzig, inv. no.
22606. 27 cm. Col-
lected by Frobe-
nius about 1911.
Photo: Ingrid
Hänse.

Fig. 4.1.
Ex-Collection Lut-
tik. 40 cm. On the
right, Ẹṣu-like ani-
mal with frontal-
face human head.
The provenance
from the Oṣogbo
region was con-
firmed by William
Fagg (personal
comm., March

1984). For a simi-
lar tray see H. J.
Drewal 1980:pl. 36.

4. Ifa Trays from the Oṣogbo and Ijẹbu Regions

Hans Witte

Yoruba Ifa oracle trays, *ọpọ́n Ifá*, as in doors, drums, and wooden boxes associated with the cult of Ifa divination, display a combination of representations in a single object which may teach us about the way these images interact, corroborate, or define one another, or, when taken together, form a sculptural unit. Is a symmetrical organization, for instance, significant? We have to ask first if such questions do not already reflect a Renaissance conception of iconography, one in which representations have a symbolic meaning and perhaps convey a message.

At first glance the decoration of the border of Ifa trays forms a well-organized whole that looks like a linear hieroglyphic message. Its beginning seems always clearly marked by what is supposed to be the head of Eṣu sculpted on the section of the border positioned opposite the diviner in divination rites. Its articulation is in most cases further marked by other heads of Eṣu or by separation bars. Sometimes we see a strict parallel between the left and right sides of the relief, and—more intriguing—a quarter of the decoration may be mirrored by the quarter on the opposite diagonal, suggesting also a parallel between the remaining two quarters.

I want to emphasize, as a preliminary remark, that these considerations are of no avail as a general guideline to the interpretation of Ifa tray decoration. The organization of the decoration cannot be compared to the semantic structure of a sentence which subordinates the meaning of its parts to the meaning of the whole. I would underline what Henry and Margaret Drewal say in several publications about "serial" or "seriate" composition: "Seriate composition is defined . . . as a discontinuous aggregate in which the units of the whole are discrete and share equal value with the other units. These units often have no prescribed order and are interchangeable" (H. J. Drewal 1987:143). Again they write: "Emphasis is placed upon the units of the whole rather than upon a progressive development in which each part develops out of an immediately preceding part. Although the units occur in the same context, they otherwise have no relationship, but they may have a common external referent" (Drewal and Drewal 1987:233). Discussing the low relief images on the border of divination trays, the same authors link the seriate composition to the Yoruba world view, specifying that "no narrative links these diverse depictions, rather they convey the myriad autonomous forces operating in the Yoruba cosmos and those affecting the diviner and his clients. Aside from the reference to the divine mediator Eṣu in one or more frontal faces or in

figures in profile, other portions of the carved border may refer to leadership, various occupations, sacrificial offerings, themes of fecundity, and so forth" (1987:246–47).

The fact that every single representation in an Ifa tray carving constitutes an independent entity—a fact often emphasized by vertical separation bars between the images—enables us to understand the variety of iconographic motifs and the general organization of the whole. The concept of seriate composition, however, while emphasizing the freedom of the sculptor, does not suggest chaotic arbitrariness or an iconographical muddle. Ifa tray decoration shows in most cases, as we shall see, a well-defined formal organization and a submission to local tradition with its limited repertoire and a predilection for certain motifs.

According to Henry Drewal (1987:148–49; also Drewal, Pemberton, and Abiodun 1989:23), the formal organization of the Ifa tray into nine sections—eight sections on the border and a center section—refers among Ijẹbu Ifa priests to the "legendary diviners and their exploits." The most important section, the one opposite the diviner, in Ijẹbu is called *ojú opọ́n* (the face of the tray). In the vast majority of cases it shows the head of Eṣu. The section nearest to the diviner and opposite the "face of the tray" is called the "foot of the tray" (*esè opọ́n*). Halfway up the right-hand side is *Ọnà Ọganran* (the Straight Path), and opposite on the left-hand side is *Ọnà Munu* (the Direct Path). Between these sections are four others, starting from the upper right to the lower left. An indication of these eight separate sections on the border can very often be recognized on trays from all parts of Yorubaland, but in my first example of a regional style this arrangement is largely absent.

In recent years our understanding of Yoruba art has made considerable progress by the identification of regional carving styles and their distinctive iconography. Three examples are taken from the Oṣogbo area and one from the Ijẹbu region in southern Yorubaland.

The Procession of Animals

The first example (fig. 4.1) shows very clearly why I call this type of tray from the Oṣogbo region the "procession of animals." Two lines of animals start from the position nearest to the diviner and direct themselves toward the head of Eṣu, clockwise on the left and counterclockwise on the right. There is only one depiction of Eṣu. The remainder of the border is not demarcated by vertical separation bars. These characteristics are found in most trays from this area, including those collected by Frobenius before 1912 (fig. 4.2). Sometimes all the animals march counterclockwise, or they are depicted without a clear system of orientation.

The provenance from the Oṣogbo region is confirmed by William Fagg (see Witte 1984:53, pl. 28), Henry Drewal (1980:38, pl. 36), John Pemberton (in Fagg and Pemberton 1982:172, pl. 60,2), and Witte (1984:pls. 25–27). Henry Drewal remarks that "the texturing of animal torsos with short hatch marks and cross-hatching is similar to the surface treatment in other pieces from

Fig. 4.3 (left).
Private collection.
25.5 × 23 cm. In
the upper half,
right and left, a
mudfish, a bird,
and a scorpion; on
the lower right, a
dog with bell tied
to its neck; left, a
full figure of Eṣu.
Hole for orienta-
tion in the border
at the foot of the
tray.

Fig. 4.4 (right).
Collection of the
National Carillon
Museum, Asten.
37 × 35.2 cm.
Three other trays
from the same
hand are in the
ex-Collection Lut-
tik.

the Oshogbo area" (1980:36, pl. 38). As an example, Drewal refers to an old tray in the Berlin Museum that was collected by Frobenius (fig. 4.13). He also could have used as evidence the old doors and wooden boxes from Ẹrin and Ilobu (see H. U. Beier 1957:pls. 4, 23, 24; H. J. Drewal 1980:25, pl. 6; Witte 1984:pls. 53, 54).

Robert Farris Thompson (1971:passim) was the first, I think, to use the "Oshogbo-Ilobu-Erin" classification for the different styles and sculptural traditions in and around Oṣogbo. We are, of course, well informed about the traditional sculpture in Ilobu by that marvelous classic Ulli Beier wrote in 1957, *The Story of Sacred Wood Carvings from One Small Yoruba Town*, a book that at the time was used by everyone, judging by the fact that in 1964 William Fagg referred to it as "a thief's handbook"! Beier illustrates the presence in Ilobu of sculpture from Ẹrin, notably the famous works of Maku, who died about 1915, and his descendants. It seems superfluous and rather pedantic to distinguish between the sculptural styles and traditions in villages and towns so close to each other, unless, of course, one can specify a particular workshop, as that of Maku and his sons Toibo and Ige.

A characteristic feature of the trays with a procession of animals (figs. 4.1–4.4) is the distinctive rendering of Eṣu's face. The outline or form of the head is not indicated at all, and the face is reduced to eyes, nose, and mouth. The nose is short and forms one sculptural unit with the lips. This unit is placed on one horizontal line with large eyes, the lids indicated by vertical hatch marks. There is no indication of eyebrows. The Ifa tray illustrated in fig. 4.4 is one of several *opón* that appear to be carved by the same hand. This is the only example, however, where the snail is depicted with horns and the "hairline" on Eṣu's head is rendered in a distinctive fashion. The plug

in the lower lip of the Ẹṣu face and the depiction of the head of a snake behind the back of the bird are typical of this carver's style.

The convention of rendering the countenance of Ẹṣu in this way is not limited, however, to trays with a procession of animals. The same face is also seen on trays where the rest of the decoration has an abstract form. Other trays in this Oṣogbo tradition have three or four faces of Ẹṣu. The abstract designs on the other positions of the border somehow clearly mark the remaining sections that are invoked by the Ijẹbu diviner at the beginning of a consultation.

Trays decorated with a procession of animals form one of the rare groups of Ifa trays with a continuous pattern giving no or very slight indication of partitioned areas apart from the face of Ẹṣu. Often the section opposite Ẹṣu is only indicated by a change in the orientation of the animals. However, we do find many examples of mixed types and gradual transitions to other conventions.

The uninterrupted line of ten to nineteen animals gives a highly decorative and playful adornment. Neither the individual animals nor the group, or groups as a whole, should be burdened with profound symbolic meanings. Nevertheless, some of the animals merit our attention. Sometimes one of them has human, Ẹṣu-like, features, such as the quadruped in the upper right half of our first example, which turns its human face with "pigtail" to the spectator (fig. 4.1). More often we find a full Ẹṣu figure that can be recognized by its long plaited hair, such traditional attributes as pipe or flute, or by the fact that it sucks its thumb (figs. 4.3, 4.4; see also Fagg and Pemberton 1982:pl. 60b). Often such Ẹṣu figures are neither fully human nor completely animal (see Witte 1984:pl. 26).

The animal most often depicted is a snail with its shell, which seems to be a hallmark of trays from the Oṣogbo region (figs. 4.1, 4.2, 4.4) (see H. J. Drewal 1980:pl. 36; Fagg and Pemberton 1982:pl. 60b; Witte 1984:pl. 27). I do not recall any link between the snail and Ifa oracle. The snail is, of course, the sacrificial animal for Ọbatala and for òrìṣà funfun (deities of whiteness) in general, and, perhaps, as with the other animals depicted, it is nothing more than a reference to sacrifice.

After the snail, the animals depicted most frequently in the procession are the stylized mudfish and the snake. Their presence is, of course, not surprising, because both animals belong to the standard repertoire of trays from every region of Yorubaland. I have indicated elsewhere (Witte 1984:26) that the frequent presence of the mudfish and the snake in the decoration of Ifa trays is to be explained by the fact that both are at home in water and on the earth. Their ability to pass from one element to the other makes them, like Ẹṣu, the perfect image of a messenger, one who crosses boundaries.

In the case of Ifa trays from the Oṣogbo area, we might query whether the image of the mudfish contains a reference to Erinlẹ whose cult has a principal shrine in Ilobu. Erinlẹ is sometimes symbolized by a mudfish or a mudfish-legged figure but, curiously enough, only in the context of the cult of Ṣango (see Witte 1987, 1991). The mudfish and the mudfish-legged figures, however, are ambiguous symbols which on palace doors and in the Ogboni cult refer to royal ancestors. In

the Ṣango cult they refer to Erinlẹ and in the Ifa cult to messengers such as Eṣu and, perhaps, to diviners. There seems to me no special reason to distinguish between the meaning of the mudfish on trays from the Oṣogbo area and those on trays from other regions. I did not find in the decoration of these trays other iconographical traces of local cults, such as those associated with Erinlẹ in Ilobu or Oṣun in Oṣogbo.

Finally, I would like to discuss an animal that also attracted the attention of Henry Drewal (1980:pl. 36), an animal with a long tail that passes over its back and head or between its legs and then over its head. This curious creature is frequently seen on trays from the Oṣogbo area (fig. 4.2) (see Fagg and Pemberton 1982:pl. 60b; Witte 1984:pl. 27; also on trays with otherwise quite different subject matter: see Krieger 1965–69, 2:pl. 143). I think my interpretation of the animal as a pangolin or scaly anteater is justified. What could lead us astray, perhaps, is the fact that it seems to pass its tail between its legs. But I would suggest that this was done in order to identify the animal clearly as a quadruped. When the pangolin feels in danger it wraps its tail around its body to provide itself with an additional layer of protective scales, thereby making it impervious

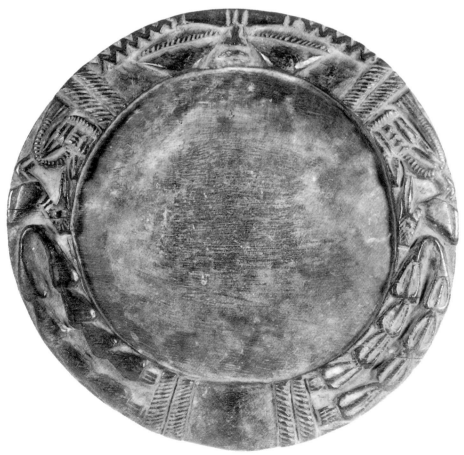

Fig. 4.5. Private collection. 33 × 32 cm. A tray by the same hand, with mudfish-legged figures instead of the birds, is in the Museum of Mankind, London. Cf. H. J. Drewal 1980:pl. 35, who mentions a tray by the same hand in the Field Museum of Chicago.

to an attack. In all representations on the trays the scales of the animal are somehow indicated. William Bascom (1969:39) writes that "the pangolin has a certain link with the Ifá oracle because its scales are sometimes used as markers for the ọ̀pẹ̀lẹ̀ (divination chain)," and Drewal (1980:pl. 34) adds that "the pattern of these scales is sometimes represented in the decoration of Ifa trays" (see Witte 1984:pls. 25, 33). Thompson reports that "the pangolin is used in the making of powerful native medicines and is considered a delicacy to eat" (in Pelrine 1988:72), and Awolalu notes that "the animal is used for sacrifices, especially for Orisha Oko who loves pangolin" (1979:39, 164). The association of the anteater with the Ifa oracle is further strengthened by the observation of Drewal and Drewal (1983:66) that the iron staff of diviners refers to the pangolin in that the power of the substances buried at the base or tail of the staff is likened to the strength and the defensive power of the anteater.

Heads of Eṣu with Elongated Eyebrows

The procession of animals forms an iconographic convention that seems typical for a certain type of Ifa tray from the Oṣogbo region. The differences in carving style and decorative organization, however, indicate that these trays do not come from a single workshop. This seems to be the case with another series of trays from Oṣogbo that is characterized in the section opposite the diviner by the enormous eyes of Eṣu with hatched lines for the upper eyelids, surmounted by what seem to be eyebrows delineated by an undulating line (figs. 4.5–4.8). Two of these trays, now in the

Fig. 4.6 (left). Ex-Collection Luttik. 36 cm. Pub.: Witte 1984:pl. 23.

Fig. 4.7 (right). Grassi Collection, Museum für Völkerkunde, Leipzig, inv. no. 22600. 27 cm. Collected by Frobenius about 1911. Photo: Ingrid Hänse.

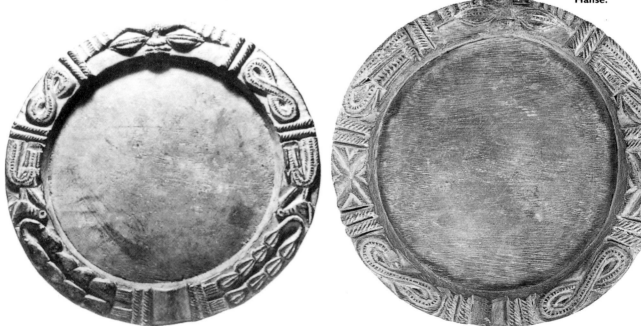

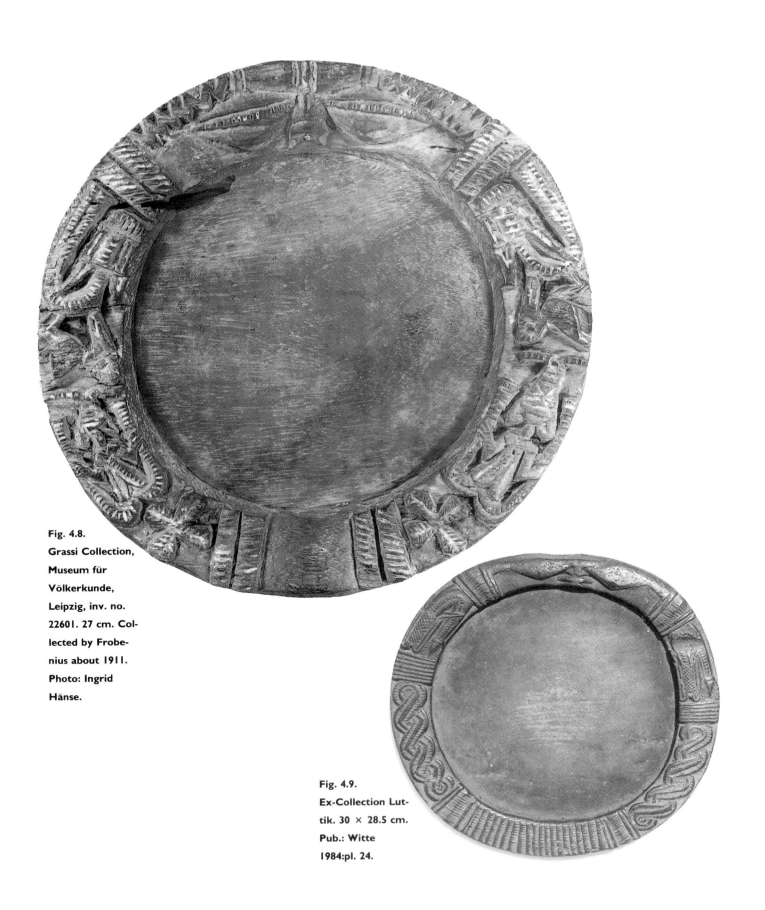

Fig. 4.8.
Grassi Collection,
Museum für
Völkerkunde,
Leipzig, inv. no.
22601. 27 cm. Col-
lected by Frobe-
nius about 1911.
Photo: Ingrid
Hänse.

Fig. 4.9.
Ex-Collection Lut-
tik. 30 × 28.5 cm.
Pub.: Witte
1984:pl. 24.

Grassi Museum in Leipzig, were collected around 1911 by Frobenius (figs. 4.7, 4.8). Henry Drewal reproduced another (1980:pl. 35), mentioning "a tray from the same hand" in the Field Museum in Chicago collected in 1966 in Ibadan. I have published two other examples (1982:pl. 15 and 1984:pl. 23), and another is in the collection of the Museum of Mankind in London.

The "trays with the elongated eyebrows" share additional distinctive characteristics, otherwise we could not postulate their origin from a common workshop. The decoration on the left and right sides is highly symmetrical, and the face of Ẹṣu and its opposing section are demarcated by identical separation bars. There is only one head of Ẹṣu, and on the opposite side there is a smooth empty space (figs. 4.5–4.8). The motifs are restricted to mudfishes and sometimes a mudfish-legged figure, ibọ́ (interwoven pattern), òpèlè chains, birds, and snakes.

There is a closely related series of trays (figs. 4.9–4.12) with heads of Ẹṣu that often have no eyebrows. In these trays the position opposite the head of Ẹṣu is not an empty space, but rather a motif constructed of a large number of hatch marks that served in the preceding series as separation bars between the motifs. The rest of the subject matter is limited to mudfishes, ibọ́ patterns, and sometimes a mudfish-legged figure. In the vast majority of cases, the mudfishes flank the head of Ẹṣu. They are represented in a U-form with the quadrangular head beside the tail, and their bodies are covered with a texture of hatching. The carving style and choice of motifs are similar to that of the series with elongated eyebrows.

Two examples of the second series from Ẹrin-Ilobu-Oṣogbo (fig. 4.10) were published by Thompson (1971:ch. 5, pls. 13, 14). Thompson reports that Pierre Verger collected one "in a somewhat similar style" at Oṣogbo (Nigerian Museum, Lagos, 59.15.13) and in the same year another at Ẹrin (Nigerian Museum, Lagos, 59.33.38). Wande Abimbọla (1976:pl. 4) published an essay on a tray in the same iconographic tradition but in a different style of carving. The preponderance of mudfish symbolism in both series might be taken as an indication that the workshop trays could be located in the town of Ilobu where the worship of Erinlẹ is traditionally important. I have not discovered other specific traces of Erinlẹ cult symbolism on the trays, and mudfish symbols seem to refer to Erinlẹ only in the context of the cult of his friend Ṣango. For these reasons, I think that the mudfish symbols on these trays do not permit us to locate the workshop in Ilobu. As in the depiction of snakes and crocodiles, I believe that they refer to amphibious characteristics of creatures who are at home in diverse environments, who cross boundaries, and who, by analogy, are instrumental in the communication between òrìṣà, spirits, and humankind. This communication is the very object of the Ifa oracle, and Ẹṣu is, of course, the messenger par excellence.

After the mudfish, the second most frequent motif on these trays is the ibọ́ or interlaced pattern, which in the first series is represented in the most simple form of a figure eight. As in the body of the mudfishes, it is always embellished with hatching. Thompson (1971:ch. 5/4, 9/1), Ulli Beier (1982:28), and others have argued convincingly that the ibọ́ pattern refers to royal embroidery

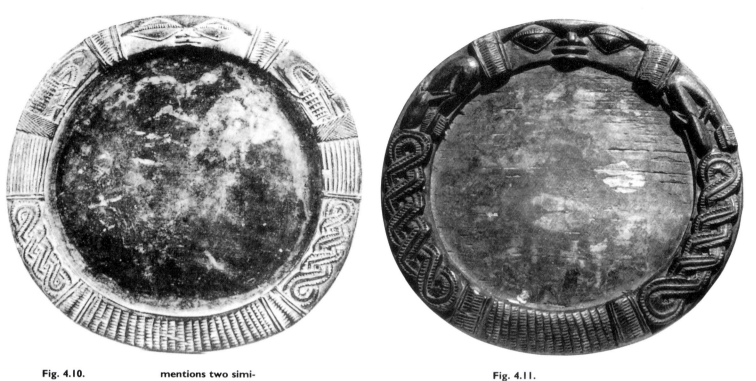

Fig. 4.10.
Collection of the
Fowler Museum of
Cultural History,
University of Cali-
fornia, Los Ange-
les, inv. no. X70-
659. 30.6 cm. Pub.:
Thompson 1971:ch.
5, pl. 13; cf. also pl.
14. Thompson

mentions two simi-
lar trays in the Na-
tional Museum,
Lagos, collected by
Pierre Verger in
1959.

Fig. 4.11.
Ex-Collection Lut-
tik. 35 cm.

Fig. 4.12.
Private collection.
37 cm.

and thus has become the emblem of aristocracy and kingship. This would reinforce the reference to Erinlẹ, "the King in the Waters." However, the interlacing pattern is also one of the most frequently used motifs in the decoration of Ifa trays, and its combination with the mudfish is seen on trays from nearly every province of Yorubaland.

Among the remaining motifs, the ọ̀pẹ̀lẹ̀ chains, which are depicted in the èjìogbè and the ọ̀yèkú configurations (figs. 4.5, 4.6), and the four cowries laid out in the form of a cross (fig. 4.8) relate to divining procedures. Snakes are another example of messengers. And birds, usually depicted as pecking a mudfish, may refer to the witches.

Eṣu's Face with Arched Eyebrows

The next examples are closely related to the preceding group by the form of the head of Eṣu with very large eyes, small nose, and lips forming a single unit and, in this case, a large arched line that suggests eyebrows (figs. 4.13, 4.14). Trays with these characteristics are produced, however, in different styles of carving, and the evidence that permits us to locate them all in the Oṣogbo area is less firmly established.

The first example (fig. 4.13) is a rather famous tray in the Berlin Museum für Völkerkunde that Frobenius collected about 1911 (see Frobenius 1912:251, pl. 5; Krieger 1965–69, 2:pl. 148). Henry Drewal, in a somewhat oblique reference, seems to attribute it to the Oṣogbo region, because of "the texturing with hatch marks and cross-hatching" (H. J. Drewal 1980:pl. 36). The way in which the head of Eṣu is sculpted with the enormous eyes and the marking of the upper eyelid is similar to the heads of Eṣu with the elongated eyebrows on the preceding trays from Oṣogbo. The subject matter of this tray with interlacing patterns, mudfishes, and birds is also in line with other Oṣogbo trays, with the exception of the seventeenth palm nut in a ring of cowries that is depicted in the four corners. These cowries are called ajé Ifá (money of Ifa), and Bascom reports that ìyẹ̀ròsùn (divining powder) is sprinkled on the seventeenth palm nut called in Ifẹ olóri ikin (chief of palm nuts) or òdùṣó (watch nut) because "nobody may see its naked head" (1969:28). In its sculpted form the seventeenth palm nut is equipped with a human face. The quadrangular shape of the tray reminds us of those from more western regions of Yorubaland.

The Oṣogbo features displayed on this tray (enormous eyes, ribbed textures, motifs) are repeated in simple form in three examples from the Grassi Museum in Leipzig that were also collected by Frobenius. The motifs, in fact, are reduced to four cowries in the form of a cross or to interlacing patterns.

Finally, we should examine a few very special cases of "elongated eyebrows." In some magnificent trays the arched eyebrows, descending to the lower side of the enormous eyes, are sculpted in high relief. In fact, in one case the "eyebrows" are equipped with small eyes and thus represent snakes or eel-like mudfishes (Witte 1984:pl. 31). These trays have a symmetrical structure in the

Fig. 4.13.
Collection of the
Museum für
Völkerkunde, Ber-
lin, inv. no. IIIC
27134. 40.5 × 29
cm. Collected by
Frobenius about
1911. Pub.: Frobe-
nius 1912:251–55;
Krieger 1965–69,
2:pl. 148.

Fig. 4.14.
Collection of
Steven van de
Raadt and Kathy
van der Pas. 44 ×
31 cm. The mud-
fish, bird, and sev-
enteenth palm nut
in a ring of cowries
can also be seen in
figure 4.13.

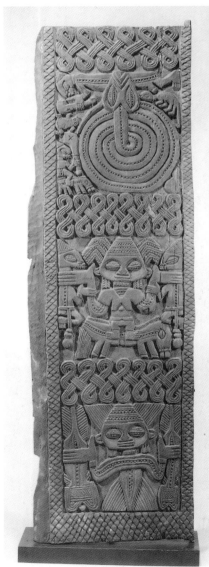

Fig. 4.15.
Door, Ijẹbu. Nine-
teenth or twenti-
eth century. Wood;
height, 151.8 cm.
New Orleans Mu-
seum of Art; pur-
chased: Robert P.
Gordy Fund.

Fig. 4.16.
Door, Ijẹbu. Nine-
teenth or twenti-
eth century. Wood;
height, 130 cm.
Staatliche Museum
für Völkerkunde,
Munich. Photo: S.
Autrum-Mulzer.

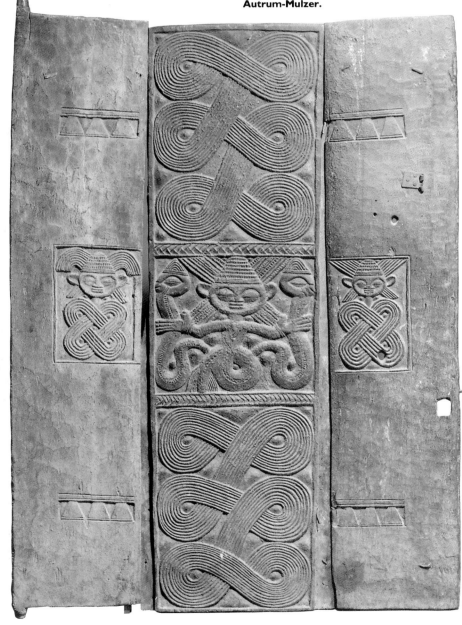

upper part which is much less pronounced in the lower half. The motifs are large and boldly sculpted with many details.

On our last Oṣogbo tray (fig. 4.14) we have what seem to be frogs on either side of Eṣu's head. As the snakes on the same tray, they refer to Eṣu's role as a messenger in Ifa divination. The two snakes have different heads, perhaps to indicate different species. Or does this only serve to show the imagination of the sculptor? In the rest of the decoration we see a figure of Eṣu with a walking stick and a bag under his left shoulder. Three other motifs are rendered in a remarkably similar way on the Frobenius tray in Berlin (fig. 4.13): the seventeenth palm nut with a human face in a ring of cowries, a skewered mudfish in that typical "bow and arrow figuration," and a bird.

Ifa Trays from Ijẹbu

There seems to be only a limited number of Ifa trays from Ijẹbu. Or perhaps our insight is distorted by the fact that only a few brilliantly carved examples are recognized as Ijẹbu? The trays used in Ijẹbu-Ode that were photographed by John Pemberton (Drewal, Pemberton, and Abiọdun 1989:pl. 12; Abiọdun, Drewal, and Pemberton 1991:pls. 13, 23) seem sculpted, as far as can be

Fig. 4.17. Arnett Collection, Atlanta. 38 cm. Pub.: H. J. Drewal 1980:pl. 39. Cf. Drewal, Pemberton, and Abiọdun 1989:pl. 13, where three frontal figures with assistants on the left and right sides of the tray are replaced by intertwined mudfishes.

The M-shape on the face of the tray is repeated in the heads of the mudfishes between the four main motifs.

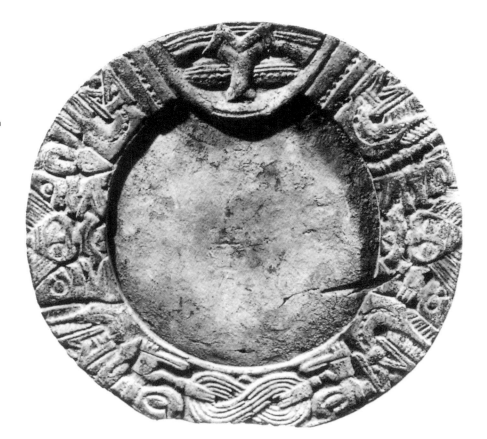

seen, in a style that is different from the one we associate with Ijẹbu. The Ijẹbu trays of which I speak have a broad border. The "face of the tray" protrudes into the central section. The head of Eṣu often has an M-shape on the forehead or wavy lines protruding from it. The decoration is particularly dense and attests to a sense of *horror vacui*. And mudfish and snake imagery is predominant (figs. 4.17–4.20).

I wish to make the point that the iconography in this style of tray combines the symbolism of messengers and aristocracy. The notion of messenger is represented in the symbol of mudfishes and mudfish-legged figures in different forms. The aspect of aristocracy is symbolized by the *ibọ* interlacing pattern and, perhaps, by the hierarchical image of a frontal face figure supported by two "attendants" in profile.

In our first example (fig. 4.17), the decoration seems, at first sight, a chaotic tangle of images. Nevertheless, it has a very clear structure made up of four closely linked motifs. First, we have what is usually called the head of Eṣu with a curious M-shape on its forehead (figs. 4.17, 4.18). At the foot of the tray, we see the motif of two attendants holding an interlacing pattern, while at both ends of the horizontal axis they seem to support a frontal figure whose special status is indicated by two bundles of rays emanating from its head. The remaining space between these four motifs is filled with four mudfish and, on the left side, by two snakes.

If we look for a first clue to the meaning of the M-shape on the face of the tray, we may notice that the same M-shape makes up the head of the mudfishes. In other trays from Ijẹbu, which are carved in a somewhat different iconographic tradition, we see that the head of Eṣu on the face of the tray has developed into a full mudfish-legged figure (fig. 4.20; see also Witte 1982:pl.16).

Let us now turn our attention to the tripartite figuration. Its central motif, an interlacing pattern or a frontal faced human figure with a kneeling figure on each side, reminds us of the motifs with three figures clearly depicted on Ijẹbu drums and doors (see Drewal, Pemberton, and Abiọdun 1989:pls. 124, 125; Abiọdun, Drewal, and Pemberton 1991:pls. 71, 72) (fig. 4.16). The two figures in profile support the central figure, even if the former sometimes seem to float in the air and be diminished, if not suffocated, by the central figure holding them by the throat (Drewal, Pemberton, and Abiọdun 1989:pl. 125). In the more explicit renderings on doors and drums, a reference to Eṣu is suggested by the medicine gourds attached to the hair of the supporting figures or attendants, as seen on the Zurich drum (Abiọdun, Drewal, and Pemberton 1991:pl. 58; Kecskesi 1989:pl. 19) and the door in Berg en Dal (Drewal, Pemberton, and Abiọdun 1989:pl. 124; also in Dobbelmann 1976:pl. 156; Witte 1982:pl. 6; Kecskesi 1989:pl. 2). In other instances, the calabash is attached to their belts, as on a door in the New Orleans Museum of Art (fig. 4.15; cf. Drewal, Pemberton, and Abiọdun 1989:pl. 125).

Maria Kecskesi (1989:241–42) refers to the same Oṣugbo drums and suggests that the attendants should be interpreted as *edán Ògbóni*, sculpted brass spikes linked by a chain which are ritual artifacts for the Ogboni or Oṣugbo society of elders. On some of these drums we do indeed

Fig. 4.18.
Pub.: Frobenius
1912:ch. 14, pl. II.
60 cm. The size
given by Frobenius
seems doubtful. A
smaller tray with
nearly identical
figuration, but per-
haps from a differ-
ent hand, is in the
Staatliche Museum
für Völkerkunde,
Munich (pub.: Kecs-
kesi 1989:fig. 4).

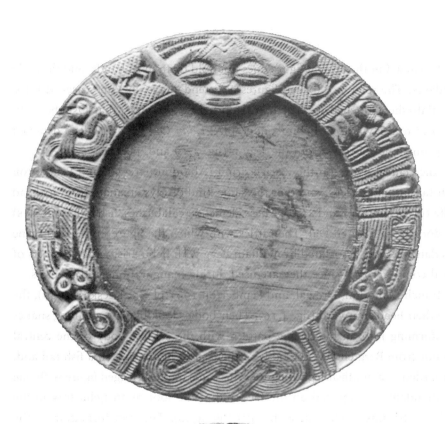

Fig. 4.19.
Private collection.
42 cm. Photo: M.
Coppens. Pub.:
Dobbelmann
1976:pl. 158; Witte
1982:pl. 14. Every
motif on this tray,
apart from the
bird with worm on
the lower right,
can be seen in
figure 4.18.

see a number of *edán* depicted, but the central figure does not hold them in its hands, and the *edán* do not figure as attendants. The reference to Eṣu figures as attendants is, in some cases at least, made explicit by the calabashes attached to their hair. I do agree, of course, that Oṣugbo symbolism is intimately linked to the whole of Ijẹbu iconography. *Edán Ògbóni* are indeed depicted as an identifiable image on some Ifa trays from the region (fig. 4.19 and, perhaps, 4.18).

We also notice that the central figure on the Zurich drum (Abiọdun, Drewal, and Pemberton 1991:pl. 71) has a fish tail instead of legs, and that the same kind of rays emanate from its head that we saw on some Ifa trays (figs. 4.17 and 4.20). These elements (calabashes, fish tails, and rays) are seen again on the door from Berg en Dal. The rattles with which the figure in the Òrò scene in the lower register is dancing were associated by William Fagg with Ijẹbu aristocracy ("chiefs of royal lineage," personal comm., 1975) since they are used during inaugurations and funerals.

On the door from Munich (Abiọdun, Drewal, and Pemberton 1991:pl. 59; Kecskesi 1989), the supporting figures turn their heads outward (fig. 4.16). Their bodies look like intertwining snakes in the process of transforming into an interlacing pattern with the eel-like body of the central figure. Similar to the door from Berg en Dal, the body of the central figure ends in a fish tail and, therefore, should be regarded as a mudfish-legged figure. This same mudfish-legged figure with one fish tail, but without attendants, is depicted on the face and at the foot of an Ijẹbu tray in the Musée National des Arts Africains et Océaniens in Paris (fig. 4.20). The transformation of the body into an interlacing pattern is completed on the side panels of the door, but now the two "attendants" have disappeared. Exactly the same figure with interlaced body, but with attendants above and below, can be seen on the left side of the tray in Paris.

We can take the analysis one step further and observe that we have the same motif of interlacing pattern between two attendants, but without a human head, that we see in figure 4.17 and on the Ijẹbu tray in Drewal, Pemberton, and Abiọdun (1989:pl. 13). The rays emanating from the head of the figures with interlaced bodies indicate that we are dealing with superhuman beings, while the bodies refer to aristocracy. This leads to the suggestion that the different configurations depicted between the attendants in profile, ranging from the interlacing patterns to the frontal human figures, symbolize the aristocratic ancestors, that is, the divine ancestors of the king and the royal founders of the community (Thompson 1969:131, n. 21; Witte 1982:159). At the same time, the mudfish symbolism in the central panel of the door in Munich refers to creatures that are at home both in water and on the earth, and therefore are able to pass between the two elements. In this capacity, they can act as messengers. It is also important to note that this ability is also an aspect of kingship. In *Yoruba Art and Aesthetics,* Abiọdun, Drewal, and Pemberton make the following comment on the relationship between mudfish symbolism and kingship in an Ọwọ context: "kings are marginal beings in whose sacred persons are combined the powers of men and gods. They thus become mediators between the realms of the human and the divine" (1991:pl. 92).

Fig. 4.20.
Collection of the
Musée des Arts
Africains et Océ-
aniens, Paris. 38
cm. Photo: Ré-
union des Musées
Nationaux. Pub.:
Kecskesi 1989:
fig. 5.

We have some very interesting variants of the tripartite theme on the New Orleans door (Drewal, Pemberton, and Abiọdun 1989:pl. 125). In the central panel a superhuman rider on horseback is supported by two messengers with calabashes attached to their belts. In the lower register a mudfish-legged figure holds two mudfishes upside down. Note in passing the M-shape of the head of the mudfishes, which is an Ijẹbu convention. In the figure with the mudfishes we are still dealing with three separate beings. There is, however, only a small step from this figure to the classic Ijẹbu figure with mudfish legs. I shall only mention two examples. On a wooden box in the Afrika Museum of Berg en Dal (Dobbelmann 1976:pl. 157; Kecskesi 1989:pl. 21), the "legs" of the figure do not end in fish tails but in the heads of mudfishes (with M-shapes). (For further evidence that we are dealing with heads see Witte 1982:pls. 2, 3.)

The drum in the Völkerkundemuseum of the University of Zurich seems to sum up my argument by offering four different versions of the same symbol. At the front, we see a forward facing figure with fish tail holding two attendants (see Abiọdun, Drewal, and Pemberton 1991:pl. 71). On the back there is a figure holding two mudfishes. On the sides we see, on the right, a figure with a single fish tail and two mudfish arms, while on the left there is a figure with two fishtail legs.

In view of this evidence, I suggest that in the Ijẹbu context the mudfish-legged figure is a tripartite figuration and is closely related to the iconographic themes of either an interlacing pattern with supporting figures or a frontal face figure with attendants. All of these themes refer to a combination of messengers and aristocracy.

On the Ifa trays we note that this symbolism is repeated in a different key. The human figure between the two attendants is replaced by an interlacing pattern. The mudfish-legged figure acquires human legs, but snakes are no longer part of this three-person motif. They now serve to fill the empty spaces between the motifs. Thus we find mudfishes intertwining instead of snakes (see Drewal, Pemberton, and Abiọdun 1989:pl. 13). What we usually refer to as the head of Eṣu on the "face of the tray" acquires traces of mudfish symbolism through the M-shape on the forehead (figs. 4.17, 4.18). On trays carved in another Ijẹbu style, it develops into a complete mudfish-legged figure (fig. 4.20).

In the case of all of the Ijẹbu Ifa trays, the role of Eṣu seems to diminish slightly from that of messenger. The reason seems to be that in this context the notion of messenger is combined with that of kingship and aristocracy, which somehow does not suit Eṣu. Unlike Oduduwa and Ṣango, Eṣu never founded a human community and a royal lineage. On the other hand, the reference to ancient diviners, who in Ijẹbu are invoked at the beginning of every divining session and who are represented by the eight sections of the border of the tray (Drewal, Pemberton, and Abiọdun 1989:23–24), seems to come to the fore. Perhaps the aristocratic interlacing patterns refer to these diviners. After all, important diviners with their beaded caps, beaded flywhisks, walking sticks, and pouches (Fagg in Fagg and Pemberton 1980:160) enjoy royal prerogatives and can be assim-

ilated to aristocracy. Rowland Abiọdun (1975a:454–57) calls attention to the high socioeconomic status of diviners and the royal status of Ọrunmila himself and some of his sons. On the other hand, these legendary diviners can also be seen as messengers who bring ancient wisdom and insight into the actual situation that is analyzed on the Ifa trays.

Nevertheless, the image of Eṣu never seems to disappear completely from the decoration of the *opọ́n Ifá*, not only because it is difficult to give the human head on "the face of the tray" a completely different meaning, but also because the Eṣu character of the supporting figures in profile seen on doors and drums never vanishes completely from our memory. After all, Ọrunmila the diviner is supported by Eṣu the king of messengers.

Fig. 5.1.
Ọpọ́n Ifá, Yoruba
or Aja, Alada. Sev-
enteenth century.
Wood; 55.5 × 34.7
cm. Weickmann
Collection, Ulmer

Museum, Ulm.
Photo: Helga
Schmidt-Glassner,
Stuttgart.

5. The Ulm *Ọpọ́n Ifá* (ca. 1650): A Model for Later Iconography

Ezio Bassani

For many years I have studied the ancient artifacts of Black Africa which were in European collections dating from the sixteenth to the eighteenth century. The results of my research are reasonably encouraging and, in my opinion, very worthwhile. The number of items discovered exceeded my expectations at the start of this project and also exceeded what previous scholarly works had led me to expect (Bassani and McLeod 1985). Answers to certain problems are beginning to be resolved, while new questions pose themselves. As a result of extensive studies of ancient artifacts, one sees glimpses of unexpected findings—not only problems in aesthetics, which are of great importance to me, but also questions of historical and ethnographical significance.

In the past, the need to provide a historical background for studies in African art was neglected. The standard rules of research, which would be taken for granted in studies of Western art, were never applied to the works of African artists, because the assumption made was that "primitive" societies had no art history or, at least, did not have a historical past comparable to that of the Western world. Recent research, however, has disclosed that we are able, in some cases, to establish connections between different cultures by comparing the morphological and stylistic similarities of recently discovered works with those works for which we have determined a place and date of collection or arrival in Europe.

A second type of research that is important and useful, and as critical as the historical, is the study of the work of individual artists or, at least, of specific workshops. I firmly believe that in Africa, as in all parts of the world, art is an individual creation that embodies the artist's concept of the world as well as his relationship with the cultural and formal values of his society.

From these points of view, I shall examine a wooden divination tray (*ọpọ́n Ifá*) that has been in Europe since the middle of the seventeenth century (fig. 5.1) and a group of statues collected in the early twentieth century in the Republic of Benin (formerly Dahomey) and Togo.

The *ọpọ́n Ifá* belonged to the famous collection assembled in Ulm by the wealthy German merchant Christoph Weickmann about the middle of the seventeenth century. In keeping with the tradition of the period, this collection consisted of *naturalia, artificialia,* and *mirabilia.* In the year 1659 a catalogue was published. Its long title, *Exoticophylacium Weicckmannianum oder Verzeichnis Unterschiedlicher Thier/Vogel/Fisch/ Meergewachs/Ertz- und Bergarten/Edlen und an-*

*deren Stein/auslandischen Holz und Fruchten/fremden und seltsamen Kleidern und Gewohr, Cu-
riousen Sachen/Malereyen/Muscheln un. Schneckenwerck/Heydnischen und anderen Mutzen . . .*,
lists the different categories of artifacts in the collection. Some of the references are to African
objects.

In addition to the Ifa divination tray, there are two Yoruba ivory bracelets, two embroidered
gowns, a woven bag from West Africa, five Bini-Portuguese ivory spoons, a bag of plaited raffia
(possibly from Benin), a group of spears from Gabon, a large raffia cloth, a flask made from a
gourd covered with plaited osiers and a basket with lid from the Kongo, and a bow, spears, and
a sword with its sheath from the Akan. What remains of the collection is now on exhibit in the
Ulmer Museum.

The African artifacts were bought by Weickmann through agents of merchants in Augsburg who
were his colleagues and who were in close contact with merchant houses of the Atlantic coast. It
was quite common for sons of Augsburg patricians, having completed their apprenticeship, to
work abroad and make business trips on behalf of merchant houses located in coastal towns of
Germany and Holland. One of these Augsburg travelers, Johann Abraham Haintzel, who died in
1662, worked for the Swedish and for the Danish African Companies, and brought back artifacts,
such as the Akan sword, for the Weickmann Collection (*Exoticophylacium*, 55; Andree 1914).

The Ifa divination tray is the oldest wooden carving from sub-Saharan Africa proven to have
belonged to a European collection and to have survived until now. Other African wood carvings
in Europe at the end of the fifteenth and sixteenth centuries have either been destroyed or dis-
persed, such as the "wooden figures like idols" bought by Charles the Bold in 1470 and for which
Professor Duverger found the receipt in the Royal Archives in Brussels.[1] The Ulm *ọpọ́n Ifá*,
therefore, is an important item for the study of African art history, and for this reason has often
been discussed and illustrated. Jan Vansina considered it an emblematic example of African art
because of the important art historical questions it raised (1984:3).

The Ulm *ọpọ́n Ifá* is rectangular and measures 55.5 × 34.7 cm. It is highly probable, if not
absolutely certain, that it is the same item described in *Exoticophylacium* (p. 52) as "an offering
board carved in relief with rare and loathsome devilish images, which the king of Ardra, who is
a vassal of the great king of Benin, together with the most important officers and men of the region,
uses to employ in fetish rituals or in sacrifices to their gods. This offering board was given to, and
used by, the reigning king of Ardra himself."[2] It is reasonable to attribute the negative judgment
("loathsome and devilish images") to the author of the catalogue rather than to Weickmann
himself. In the catalogue, Ardra is mentioned also as the place of origin of the ivory bracelets and
the gowns in the Weickmann Collection of the Ulmer Museum.

In the seventeenth century, the kingdom of Ardra, known today as Allada, was the most
important Aja state after the decline of the original Aja kingdom of Tado on the Mono River in
Togo. It controlled the ports of Offra and Jakin on the Gulf of Guinea which were important for

slave trade. Allada was not subject to the king of Benin (as stated in the German catalogue), but was under the hegemony of the vast Yoruba empire of Ọyọ (Law 1977:150–53). It is worth adding that in the seventeenth century the Dutch had close commercial relations with the kingdom of Allada, as we can deduce from Olfert Dapper's report (Dapper 1989 [1686]:303–5). If we remember the relationship between Christoph Weickmann and the Dutch firms, noted earlier, the provenance of the tray from Ardra given in *Exoticophylacium* seems acceptable.

The reference in the seventeenth-century catalogue regarding the use of the tray is incomplete. It is clear from our present knowledge that it is a ritual artifact for the oracle of Ifa used in divination. A sacrifice was certainly made at the beginning of the ceremony, and drops of blood of the sacrificial victim (fowl, duck, or goat) were sprinkled on the sacred instruments. Bernard Maupoil (1943:195, n. 3) mentions a tray "especially meant for offerings of blood."

The ethnic origin of the carving is not easy to establish, even though most scholars who have discussed it have been inclined to accept a Yoruba origin (Willett 1971:81–84; Sieber and Walker 1987:no. 30). Recently Drewal, Pemberton, and Abiọdun wrote that "its style and elements of iconography suggest it was probably carved by an Aja or Fon artist who was familiar with Yoruba sacred art" (1989:235, n. 1).

The Ulm *ọpọ́n* is a carving of great formal refinement, the work of an artist of unique ability who depicted a complex universe of men, women, animals, cowrie shells, leaves, and items of human manufacture. At the top of the *ọpọ́n* the head of Eṣu-Ẹlẹgba, the divine mediator, presides

Fig. 5.2.
Detail of Ulm
ọpọ́n Ifá.

over the formal, geometric composition which frames the elaborate surface ornamentation (fig. 5.2). It is undoubtedly true that the manifold meanings embodied in the images are not evident to those lacking personal knowledge of the divination rituals. Hence the help of the Yoruba specialist is indispensable. Without such knowledge our understanding would remain incomplete. Nevertheless, even the foreigner may recognize the rhythmical complexity and the sense of measure and order of the work resulting from the conscious choices of the sculptor.

In his analysis of the Ulm *ọpọ́n Ifá,* Henry Drewal remarked that images of "things present in the world crowd the space and express a wide variety of themes, [including] leadership, warfare, survival, fertility, [and] protection. No narrative unifies these diverse depictions; rather they convey the autonomous forces operating in the Yoruba cosmos that affect the concern of the diviner and his client" (1987:147). He termed this segmented composition *serial* or *seriate* and defined it "as a discontinuous aggregate in which the units of the whole are discrete, and share equal value with the other units" (1987:143). The carver of the tray, however, conceived a unified structure that organizes the whole surface of his work in a lively as well as rigorous composition, in which expressive density and geometrical clarity are admirably blended, thus not conveying chaos but a cosmos.[3]

The images, carved in low relief in a simple and straightforward visual language, are concentrated in a band that runs along the sides of the rectangle and in a circular pattern defined by two circumferences with their center at the intersection of the diagonals of the rectangle, one touching the inner side of the band and the other the outer side. The composition of intersecting geometrical patterns is quite unusual and, to my knowledge, has been identified only in this particular work. *Ọpọ́n Ifá* are usually square, rectangular, or circular, and the motifs are always carved in a relatively broad border around the sides of the tray.[4] It would appear that the sculptor of this tray wished to concentrate in one artifact the characteristics of the two contrasting models.

My knowledge of this subject does not allow me to establish whether the artist adopted this solution for functional reasons in order to create three hollow spaces between the carved borders in relief or for an aesthetic purpose. The absence of similar artifacts makes further discussion of this problem difficult. Considering space and balance as expressive values that go beyond the mere functionality of this tray, the highly controlled and symmetrical arrangement, which makes the smooth areas shine like mirrors, reveals the hand of an artist concerned with defining space and imparting a subtle balance to his work.

The carved areas flow from the circular bands to the rectilinear ones and vice versa, creating a coherent and effective visual universe. Six human figures and two large quadrupeds fill longitudinally the rectangular spaces. Small animals, possibly frogs and toads, in dorsal view, and groups of tools and weapons placed in the corners provide smooth transitions when the sequence of images changes direction. The circular bands are crowded with a small woman, birds, snakes, and quadrupeds, as well as three divination tappers (*ìróké Ifá*) that are larger than the other items, perhaps to underline their importance in the ritual. The carver gave the privilege of a frontal view

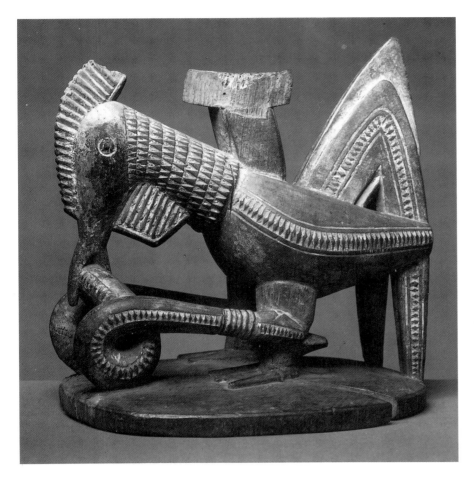

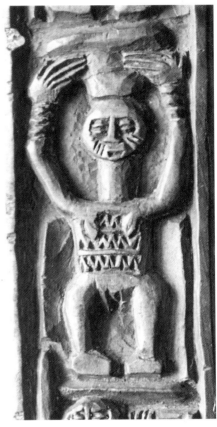

Fig. 5.3.
Agere Ifá, Yoruba, Nigeria. Nineteenth century? Wood; height, 17 cm. Museum für Völkerkunde, Berlin.

Fig. 5.4.
Detail of Ulm *ọpọ́n Ifá.*

to the rather stiff human figures who call attention to themselves by their discrete gestures. This position lends a sense of monumentality even to these small figures and also allows the carver to emphasize their sexual identity and body scarification. The dorsal and lateral views are used to depict the animals. The lateral view, in particular, is most suitable for rendering a specific subject in its entirety, since it enables the artist to develop surface detail more fully.

In the overall composition of the *ọpọ́n* the artist juxtaposes the solemn isolation of the human figures to the lively and swarming groups of animals. The two worlds, however, are related by a design that appears throughout: the recurrent use of a zigzag pattern that creates the effect of scarification on the human figures and a patterning of fur and feathers on the quadrupeds and birds, and is also a decorative motif on many of the artifacts. No doubt the artist had an "eye for design," or "design consciousness" (*ojú-ọnà*), which Abiọdun, Drewal, and Pemberton have identified as one of the important concepts in Yoruba aesthetics (1991:20–21).

Let us now examine the carved images and identify possible sculptural parallels. The first point of interest is the motifs featured on the circular bands of the tray, which, I believe, have their

morphological and iconographic counterpart in ancient Yoruba works of art. The way in which birds are represented on the Ulm opọn is the same rendering seen on an ivory bracelet in the Museum für Völkerkunde in Berlin that belonged to the Friedlander Collection and was bought by the museum in 1831 (inv. no. IIIC 4882).

The bird pecking at a snake is a recurrent motif in Yoruba art; it is also carved, for example, on an ivory trumpet in the Museum Rietberg Zürich (inv. no. RAF 622) and on an ivory armlet illustrated in a Christie's auction catalogue (25 June 1984, lot no. 94). The musical instrument and the armlet may date from the seventeenth or eighteenth century. The same motif is often found on the base of Ifa divination bowls (agere Ifá), as, for example, in the fragment of an agere Ifá collected by Frobenius in 1912 (Museum für Völkerkunde, Berlin, inv. no. IIIC 27087) (fig. 5.3).

An antelope eating a leaf, which is featured at the center of the group of animals on the Ulm opọn, also appears on Bini-Portuguese spoons dating from the sixteenth century attributed to Owọ carvers, as, for example, on one of the spoons in the Weickmann Collection in Ulm (see Abiọdun, Drewal, and Pemberton 1991:no. 64). The same subject is also carved on several ivory bowls with lids dating from the seventeenth or eighteenth century (Musée des Beaux Arts, Lille, illustrated in Bassani and Fagg 1988:fig. 264; Christie's auction, 14 July 1976, lot 52).

Human beings are the main subjects carved on the borders of the Ulm opọn. A male figure, perhaps depicting a chief, smokes a long pipe similar to an image found on a tray in the collection of Veena and Peter Schnell in Zurich (Abiọdun, Drewal, and Pemberton 1991:no. 92). Another man carries on his shoulder what seems to be a gun, and a third male figure is distinguished by a braided hairstyle often associated with hunters.

Of the four female figures, three do not have identifiable characteristics, but the fourth carries on her head what appears to be a large, round bowl (fig. 5.4). The image suggests an arugbá Ṣàngó, a ritual artifact usually depicting a kneeling female figure carrying a bowl on her head and found on Yoruba Ṣango shrines (Abiọdun, Drewal, and Pemberton 1991:no. 34).

It is noteworthy that Yoruba sculpted figures rarely depict body decoration, whereas the chests of the men and women carved on the Ulm opọn are decorated with an abundance of scarification marks. Moreover, the way in which the eyes are depicted in the shape of coffee beans occurs in the traditional art of the Fon in the Republic of Benin (Kerchache 1986:249, 253, 261, 272).

Artifacts and inanimate objects fill the space in the outer band: gourds (three of them crown the head of Eṣu-Ẹlẹgba), a knife with its sheath (perhaps an emblem of Ogun), a quiver with arrows, an axe, a broom and what appear to be three pots (a possible reference to the "preferred wife" of the diviner charged with the upkeep of the Fa-ox [Maupoil 1943:167]), forked sticks, and other items that I am unable to identify.

Nevertheless, the most frequently seen subjects are cowrie shells or leaves, both important elements in Ifa divination ceremonies. Sixteen shells or leaves are arranged in groups of four in the lower register of the band opposite the head of Eṣu; another sixteen, in groups of diminishing

quantities (6, 4, 3, 2, 1), are interspersed among the human and animal figures. Maupoil wrote that sixteen leaves were introduced as a sacrifice into the *Duwo*, "an essential item for divination in the ancient Slave Coast," and he noted that "sixteen is the number of Fá" (1943:169). It is interesting to remember that leaves of the sacred *akòko* tree were also featured in Ọwọ terracottas dating from the sixteenth century (Eyo and Willett 1980:pls. 70, 71).

This tentative and brief examination of the composition and surface ornamentation of the Ulm *ọpọ́n* indicates why we must speak of it as a work of art. The *ọpọ́n*, however, also provides visual evidence of a possible cross-cultural exchange that may have occurred between Yoruba and other peoples living on the northern border of the Yoruba provinces in the seventeenth century. The geometrical austerity that characterizes the imaging of male and female carved on the *ọpọ́n* seems to me difficult to reconcile with the "humanism" of much Yoruba wood sculpture. I shall elaborate further on this point and devote particular attention to the image of the woman carrying a pot on her head, for it reminds me of some statues collected in recent times which are not of Yoruba origin.

The French scholar Christian Merlo, colonial administrator of Dahomey from 1927 to 1937, published an article in *African Arts* entitled "Statuettes of the Abiku Cult" (1975). There he examined in detail a series of similar wood sculptures depicting male and female figures which are in the Musée de l'Homme in Paris, the Museum für Völkerkunde in Berlin, and the Linden Museum in Stuttgart. The author, in agreement with the well-known Yoruba scholar Pierre Verger, believes that these sculptures are related to the *àbíkú* cult and were used in annual ceremonies. Merlo also states that the statues could represent the divinities who preside over the male and female sections of the heavenly society of the *àbíkú*.

For the purpose of our inquiry, the most interesting items are the sculpture of a female figure in the museum in Paris,[5] which was collected before 1931 in the Athieme region (previously Dahomey) and which is listed in the catalogue as Kota-Fon; a female figure in the museum in Stuttgart (inv. no. 57071); and a pair of figures in Berlin (inv. nos. IIIC 20833 and IIIC 20834) (fig. 5.5). All were collected before 1906 or 1908 in the Tokpli region of Togo and have been attributed to Ewe carvers. I found a fourth female figure in the Museum für Völkerkunde in Vienna, which was collected before 1906 also in the Tokpli region. It is listed as an Ewe work.[6]

The Athieme and Tokpli regions are situated on opposite shores of the Mono River. The figures are called *àbíkú* in the Athieme region, whereas in the Tokpli region they are called *venavi*.[7] *Àbíkú* are thought to be children born-to-die. The statues are characterized by an "archaic or archaistic style," which, according to Merlo, "is unlike the eastern Fon and Yoruba-Nago styles, and reflects the so-called Ashanti styles. It may be designated as Adja in a broad stylistic sense of the term" (1975:35).

The figures are of considerable size, when compared with most African sculptures, averaging 80 cm. in height. The torsos are compact and slightly cone-shaped, and, in the case of the female

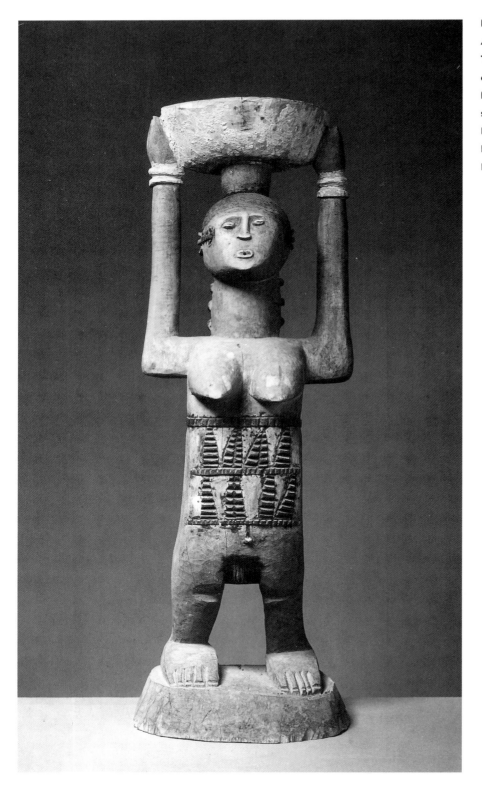

Fig. 5.5.
Àbíkú statue, Ewe?
Togo. Nineteenth
century? Wood;
height, 85 cm. Mu-
seum für Völker-
kunde, Berlin.
Photo: Ruth
Hietzge-Salisch.

figures, are covered with scarification marks consisting of triangular patterns. The arms and legs of the figures are short and stiff. The large hands and feet are carved schematically. The backs are flat, and the protruding buttocks balance the volume of the conical breasts. The neck supports an egg-shaped, forward-jutting head. The facial features are carefully carved. The female figures have their arms raised over their heads and are holding round pots, perhaps containers for offerings.

Viewed frontally, especially the figures from the Tokpli region, the vertical elements (legs, torsos, necks, heads, and uplifted arms) and the rigid horizontal partitions (e.g., the lines of the feet, the treatment of the knees, the pubic region, the scarification marks, the breasts, the arms that bend at right angles, the squared shoulders, and the horizontal lines of the pots) form a clearly defined geometric framework of perfect symmetry. From this severe stylization the sculptures derive an architectural austerity that divests them of any naturalistic character. As I noted, these stylistic elements are especially evident in the statues collected in the Tokpli region. It may be reasonable, therefore, to attribute this group of statues to an individual carver working there at the end of the nineteenth century, possibly using an ancient model as his guide, a master who was deeply concerned with the monumental quality of his carvings.

We may now return to the Ulm *ọpọ́n Ifá* and look once more at the image of the woman carrying a bowl carved on the Ulm *ọpọ́n*. The depiction of this essentially two-dimensional figure is almost identical to the sculptures in the round from the Athieme and Tokpli regions. The similarities are striking when we examine the details, specifically the hollowed face, the treatment of the eyebrows, the eyes shaped like coffee beans, the protruding mouth, and the depiction of the genital area. The torso bears the same triangular scarification pattern arranged in horizontal bands. The arms are decorated with the same kind of bracelets. The posture of the figures in the round and those in low relief is identical. They all carry on their heads bowls with a large base which, according to Merlo, is a symbol of wealth and power. What possible relationship can there be between the female image appearing on the seventeenth-century Ulm *ọpọ́n* and the more recent figure sculptures that bear such a close resemblance to it? What tentative conclusion can we reach from this brief comparison?

Pierre Verger, quoted by Merlo, noted that "the Akan, Ibo, Hausa, Fanti and Mossi share a similar belief [regarding the *àbíkú* cult]. It is, therefore, impossible to determine whether the Togolese and Dahomeans got their *àbíkú* belief . . . [from] the Yoruba in the East or from the Akan and Fanti in the West" (Verger 1968, quoted in Merlo 1975:31). Merlo, however, observes: "The word *àbíkú*, the cult, and the names of the presiding deities are all Yoruba, as in the ceremonial of *Fa*, to which the *àbíkú* cult refers; and so might be the statuary. . . . The Yoruba contribution may be explained by the migration of the Adja from Ifẹ, who founded Tado, and by the migration of the Nago Egba from Ọyọ, who established a new dynasty in Dahomey in the twelfth century" (Merlo 1975:35).

Although the derivation of the Tado dynasty from Ile-Ifẹ is questionable, and the domination

over the non-Yoruba people to the west by the Ọyọ empire is complicated by Ọyọ propaganda (see Law 1977), the analogies between the images carved on the seventeenth-century Ifa tray and the *àbíkú* statues suggest an exchange of iconographic and stylistic models between Yoruba and Aja as a result of political contact and consequent transmission of cultural elements. Indeed, the models might have traveled even farther west than Togo, as the geometric stylization of an imposing work of art collected at the beginning of our century in the Fanti region in Ghana seems to suggest (fig. 5.6).

The large sculpture, now in the Naprastek Museum in Prague (inv. no. 23524), depicts a female figure holding on her head an Akan type stool. Notwithstanding the iconographic difference that the figure holds a stool rather than a bowl, it has in common with the *àbíkú* figures a distribution of the volumes in accordance with a similarly strict orthogonal structure. The inclusion of a

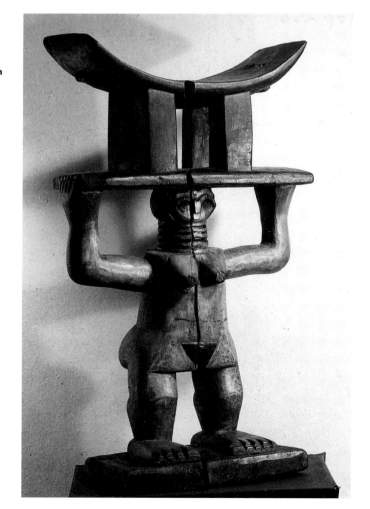

Fig. 5.6.
Figure holding a
stool, Fanti,
Ghana. Nineteenth
or twentieth cen-
tury. Wood;
height, 86 cm. Na-
prastek Museum,
Prague.

significant number of open spaces is even more prominent than in the *àbíkú* statues. It gives to the Fanti sculpture a powerful presence enhanced by its exceptional size.

In conclusion, I would like to add that the problems raised by the analogies I have emphasized in this paper are open to further discussion, and their solutions require more interdisciplinary research both in the field and in museums. However, given the extent of our knowledge today, it is reasonable to say that early figurative models were spread over a vast region of West Africa and, in some cases, were handed down in almost the same form until the end of the nineteenth century, which might explain the peculiar archaic look of the more recent figures.

Notes

1. "A Alvare de Verre, serviteur de Messire Jehan d'Aulvekerque, chevalier portugalois . . . 21 livres . . . quant nagaires il luy a presente une espee et aucuns personnages de bois comme ydoilles," Algemeen Rijksarchief of Brussels, Rekenkamer, no. 1925, fol. 348, quoted in Olbrechts 1941:8.

2. "Ein Opferbrett/ von erhabenen wunderseltzamen/ und abschewlichen Teufelsbildern geschnitten/ welches der Konig zu Haarder, so dess Grossen Konigs Bennin Vassal ist/ sampt dessen grosten Officieren und Naturalen derselbigen Provinz, bey ihrer Gotter Opffer/ oder Fetissie, zu gebrauchen/ und ihnen darauf zu opfern pflegen und ist dises Opfer-Brett von dem ietz Regierenden Konig zu Haarder selbsten infestirt, und von ihme gebraucht worden."

3. W. Fagg and M. Plass (1964:112, 114) illustrated the Ulm tray as an "example of baroque-like decoration" (together with the two Yoruba bracelets from the Weickmann collection). However, they recognized that "though the design of individual elements is fairly free, the composition as a whole shows marked unity and coherence."

4. E. Merwart, quoted by Maupoil (1943:184, n. 4), mentioned oval trays.

5. Other statues, resembling less our model, are illustrated in Merlo 1975.

6. Inv. no. 75.379, height 81 cm. A statue similar in style, but smaller and without the bowl, is kept in the Naprastek Museum in Prague where it was listed as an Ewe work for the *venavi* cult: inv. no. A 3636, height 55.5 cm; see Herold 1989, no. 112. It was acquired by the museum in 1943. No information is given about the year or the place of collection. Formerly it belonged to Joe Hloucha and was exhibited in Prague in 1929–30 (personal comm., Dr. Eric Herold).

7. According to Merlo 1975, the same word *venavi* is employed for the statuettes used to represent a deceased twin.

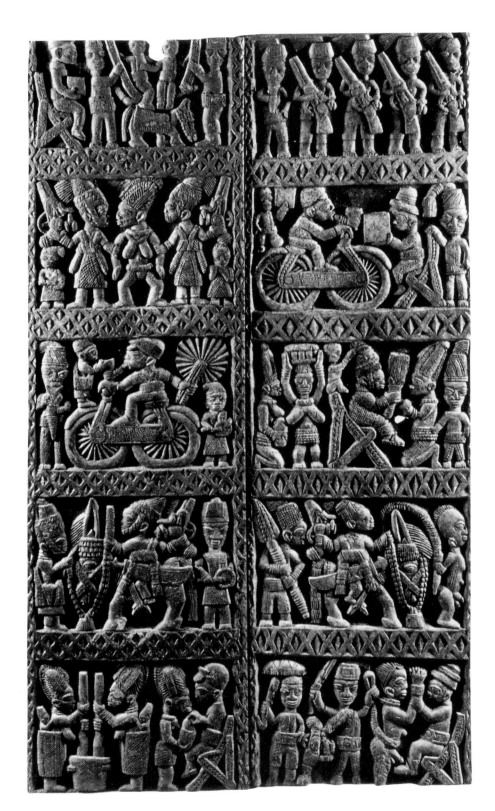

Fig. 6.1.
Pair of doors,
twentieth century.
Attributed to
Areogun of Osi-
Ilorin (d. 1954).
Wood; height, 182
cm. University of
California, Los An-
geles, Fowler Mu-
seum of Cultural
History, X69-66,
X69-67. Photo:
Richard Todd.

6. Anonymous Has a Name: Ọlọwẹ of Isẹ

Roslyn Adele Walker

Traditional African artists were never anonymous. Their names were known to the patrons who commissioned works of art and probably to the people who saw them. The artists' names are unknown to us for several reasons, the most fundamental being that, because of racial and cultural biases, early ethnographers did not ask "*Who* made this?" The subject of this paper is a Yoruba sculptor whose fame in Nigeria extended well beyond the town in which he lived. His name is Ọlọwẹ of Isẹ-Ekiti, and he died in 1938. He was a court artist in the employ of the Arinjale (king) of Isẹ, but he carved for several other Yoruba rulers and wealthy families in northeastern Yorubaland. Ọlọwẹ was a highly esteemed artist in his own time, and today many art historians and art collectors in Africa, America, and Europe consider him to be the most important Yoruba artist of the twentieth century. This essay discusses Ọlọwẹ's unique style of carving, the sculptures he created for his royal patrons, and the sources that may be used to reconstruct the artist's biography. It also addresses other Nigerian visual traditions that may have influenced Ọlọwẹ's oeuvre.

The difference between Ọlọwẹ's style of carving and that of other Yoruba artists is immediately apparent. For example, let us compare Ọlọwẹ's doors and those of another Yoruba master. Typically, Yoruba doors are divided into panels or registers on which images are carved in low and even relief. The images are raised only a few centimeters from the background and are contained within the thickness of the wood. This approach to relief carving is exemplified by a door made by Areogun of Osi-Ilọrin (ca. 1880–1956) or his atelier for a site in Ekiti (fig. 6.1).

Ọlọwẹ's approach to relief carving contrasts sharply with that of the aforementioned sculptures. A door from the Arinjale's palace at Isẹ makes this point (fig. 6.2). As the profile of the door shows, the figures are carved in such high relief they project several centimeters from the background, casting shadows (fig. 6.3). While other Yoruba sculptors typically created frontal, static figures, Ọlọwẹ created dynamic forms. He turned the heads of some of the elongated figures to face the viewer, while posing their bodies in profile, with one leg crossing the other. All of the figures are active. Thus Ọlọwẹ creates the illusion of movement. In addition, the textured backgrounds, herringbone-patterned frames, and bold color—originally red, white, and blue—contribute to this energetic composition.

The posts Ọlọwẹ carved to support the roofs of the verandas surrounding palace courtyards are

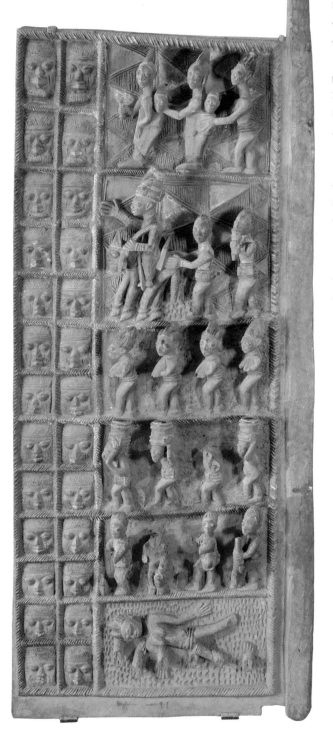

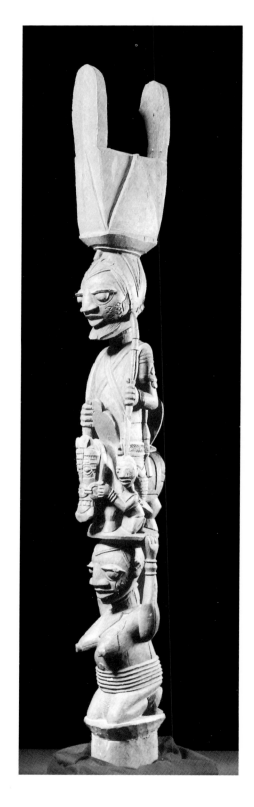

Fig. 6.2.
Palace door, Ise,
twentieth century.
Oloẉe of Ise (ca.
1875–1938). Wood,
pigments; height,
221 cm. National
Museum of African
Art, Smithsonian
Institution. Gift of
Dr. and Mrs. Rob-
ert Kuhn, NMAfA
88-13-1. Photo: Jef-
frey Ploskonka.

Fig. 6.3 (below).
Palace door, pro-
file detail of figure
6.2. Photo: Jeffrey
Ploskonka.

also distinctive. The prevailing type of veranda post seems to have been two or more tiers with figures. For example, a veranda post carved by Obembe, Chief Ologunde of Ẹfọn-Alaye (d. 1939), depicts a kneeling female figure supporting a mounted warrior (fig. 6.4). Ọlọwẹ also depicted these subjects in a tiered arrangement on a veranda post for the Ogoga (king) of Ikẹrẹ (fig. 6.5). As on the palace door, Ọlọwẹ has carved elongated figures with richly textured and polychromed surfaces. However, in contrast to Obembe, Ọlọwẹ downsizes the capital to accentuate the horseman and kneeling female. Whereas Obembe's figures seem to be contained within the dimensions of the capital, Ọlọwẹ's figures project beyond the width and depth of the capital.

In summary, in comparison with other Yoruba carvers, Ọlọwẹ was an innovator. He honored the Yoruba canon of style but expressed his own unique vision. His carving style is characterized by large-scale, elongated, often angular forms, illusion of movement, exceedingly high relief, polychromy, and richly textured surfaces.

Ọlọwẹ of Isẹ: A Carver for Kings

Ọlọwẹ of Isẹ was a court artist whose architectural sculptures embellished several Yoruba palaces within a radius of forty to sixty miles. Ọlọwẹ's first patron, the Arinjale of Isẹ, commissioned him to carve veranda posts and doors for his palace (figs. 6.2, 6.6). Other kings also availed themselves of Ọlọwẹ's skill and talent. Thus he carved veranda posts and doors for the Ọwa of Ijẹsa (fig. 6.7), the Ọjọmu of Ọbaji in Akoko (figs. 6.8, 6.9), and the Ogoga of Ikẹrẹ (figs. 6.10, 6.11), among others.

The pair of doors Ọlọwẹ carved for the Ogoga of Ikẹrẹ was the first of Ọlọwẹ's sculptures to be exhibited outside Nigeria.[1] The ensemble, which includes a carved lintel, was selected for the 1924 British Empire Exhibition at Wembley, London, where it was installed at the entrance to the timber exhibit in the Nigerian Pavilion.[2] The doors may have been particularly attractive to the European selection committee because two Englishmen are depicted on the right-hand door. One Englishman sits in a hammock carried by two African porters. The other Englishman rides a horse. The men are thought to be Captain Ambrose and Major Reeve-Tucker, each of whom served as travelling commissioner for the Ondo Province around the turn of the century. Directly opposite on the left-hand door, the Ogoga of Ikẹrẹ is shown seated on a European-style chair ready to receive the visitors. The door is thought to commemorate an actual event: the historic first meeting of the Ogoga of Ikẹrẹ and the British representative of the Crown, Captain Ambrose, in 1901.[3]

While they were on display at the exhibition, the Ikẹrẹ palace doors attracted the attention of the British Museum authorities. According to a report by Major C. T. Lawrence, exhibition commissioner for Nigeria, the authorities considered this door to be "the finest piece of West African carving that has ever reached England."[4] In fact, they admired the doors so much they attempted to buy the ensemble for the museum. The Ogoga refused to sell them. However, he did

Fig. 6.4 (opposite right). Veranda post, Efọn-Alaye, early twentieth century. Obembe, Chief Ologunde of Efọn-Alaye (d. 1939). Wood; height, 144 cm. Staatliche Museen Preußischer Kulturbesitz, Museum für Völkerkunde, Berlin. Abt. Afrika III c 27410.

Fig. 6.5.
Veranda post, Iṣẹ,
twentieth century.
Palace of the
Ogoga of Ikere.
Olowẹ of Iṣẹ.
Wood, pigment;
height, 223 cm.
Pitt Rivers Mu-
seum, Oxford Uni-
versity. Gift of
B. J. A. Matthews,
1969.25.1.

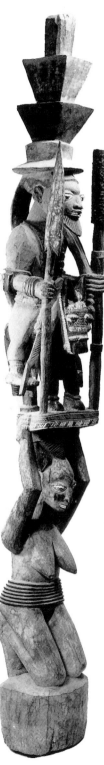

Fig. 6.6.
Veranda post, Iṣẹ,
twentieth century.
Installed at the
palace of the Arin-
jale of Iṣẹ. Olowẹ
of Iṣẹ. Photo:
William Fagg,
1958. The William
B. Fagg Archives,
Royal Anthropo-
logical Institute of
Great Britain and
Ireland. Gift of
Paul and Ruth
Tishman.

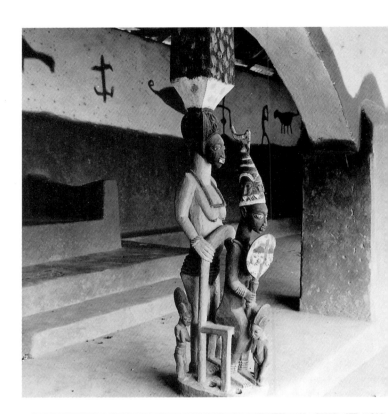

Fig. 6.7.
Palace door, Ileṣa,
twentieth century.
Installed at the
palace of the Owa
of Ijeṣa. Photo:
William B. Fagg,
1959. The William
B. Fagg Archives,
Royal Anthropo-
logical Institute of
Great Britain and
Ireland. Gift of
Paul and Ruth
Tishman.

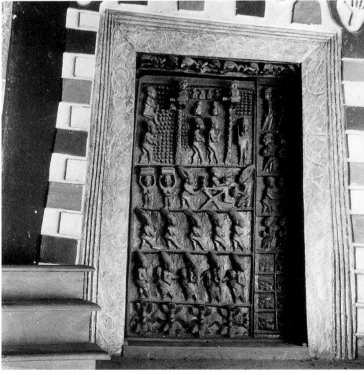

Fig. 6.8.
Veranda post representing a herbalist priest, twentieth century. Formerly in the residence of the Ọjọmu of Ọbaji in Akoko. Olọwẹ of Ise. Wood; height, 210 cm. Collection of Gerd Stoll, Berchtesgaden, Germany. Photo: Ingeborg Limmer.

Fig. 6.9.
Veranda post representing a mounted hunter, twentieth century. Formerly in the residence of the Ọjọmu of Ọbaji in Akoko. Olọwẹ of Ise. Wood; height, 212 cm. Collection of Gerd Stoll, Berchtesgaden, Germany. Photo: Ingeborg Limmer.

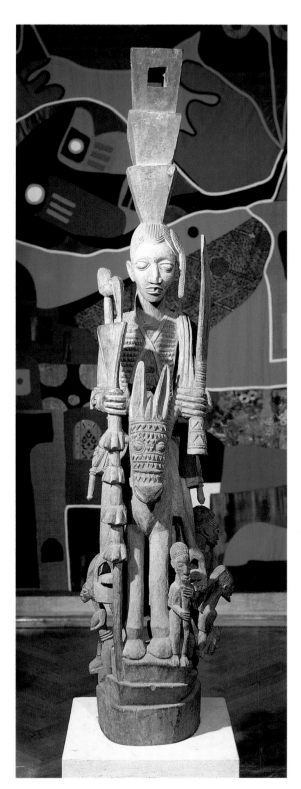

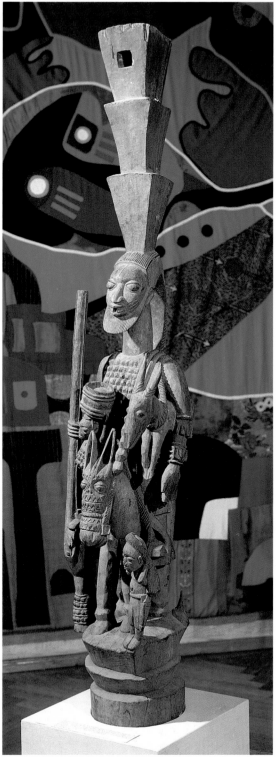

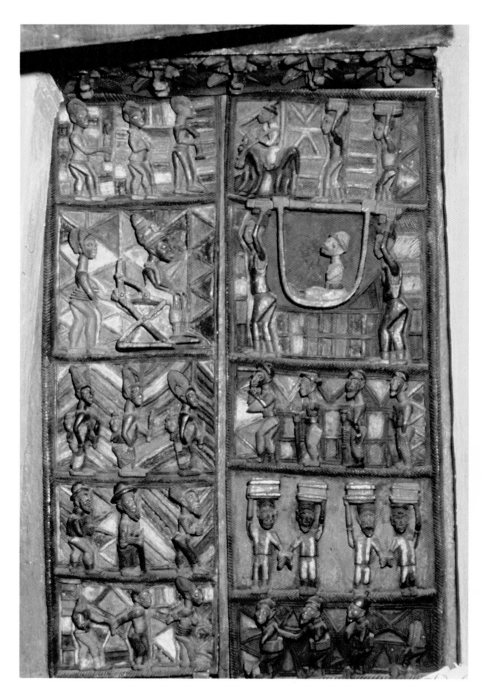

Fig. 6.10. Palace door, Ikẹrẹ, twentieth century. British Museum. Olọwẹ of Isẹ. Wood, pigment; height, 209 cm. The Trustees of the British Museum, 1924.135 a & b.

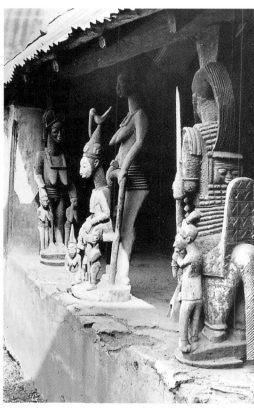

Fig. 6.11. Veranda posts, Ikẹrẹ, twentieth century. Installed at Ikẹrẹ palace. Olọwẹ of Isẹ. Wood. Photo: John Picton, 1964.

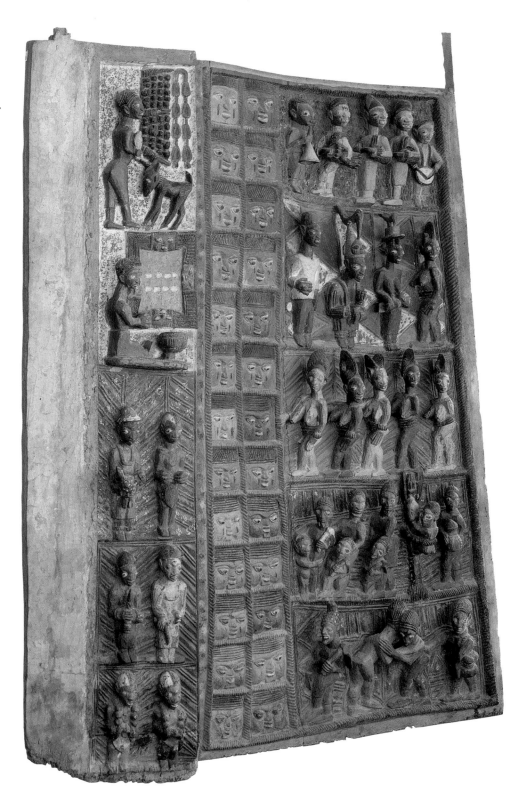

Fig. 6.12.
Palace door. For-
merly installed at
Ikẹrẹ palace, ca.
1925. Olọwẹ of Isẹ.
Wood; height,
190.5 cm. Irwin
Green Collection.
Photo: courtesy of
Pace Primitive.

agree to exchange the palace doors for a British-made throne (W. B. Fagg 1969:55). Thus the doors became the property of the British Museum. Ọlọwẹ was still alive and subsequently carved new doors for the Ogoga (fig. 6.12).

Ọlọwẹ's commissions included bowls and boxes for various purposes. His containers are also clearly products of an innovative and highly skilled sculptor. For example, the Figure with Bowl (fig. 6.13) is an unusually complex and dynamic example of this genre. Four female figures are depicted on the separately carved lid. They hold each other by the shoulder; their elaborately coifed heads are slightly tilted, and their knees are flexed as if dancing. The kneeling female figure holding the bowl is an elongated form. The back of her swan-like neck and broad shoulders are carved with intricate designs. She carries an infant adorned with triangular pendants on her back in a baby tie. The male and female figures supporting the bowl stand or kneel and project at an angle from the base, like the figures on the palace doors. Almost every centimeter of the surfaces of the bowl and base are carved with varied geometric designs: zigzags on the vertical and horizontal planes, opposing diagonal lines, opposing inward curving lines. Originally the sculpture was painted; now only traces of white and red pigments remain. The artist's virtuosity and skill are further demonstrated in the carved bearded head on the base. Because the head can be moved within the "cage" formed by the figures but not removed from it, the head was carved from within the cage.

While this brief survey does not exhaust Ọlọwẹ's oeuvre, it demonstrates that Ọlọwẹ was an exceptionally skillful and creative sculptor.

Sources for the Artist's Biography

Ọlọwẹ of Isẹ's life and art may be reconstructed from two main sources: written accounts and photographs by Philip Allison and William Fagg, and the artist's *oríkì* (praise song).

Philip A. Allison, who died in 1990, worked for the British colonial Forestry Department in Nigeria from 1931 until his retirement in 1959, the year before Nigeria gained independence. Allison stayed on and worked for the National Museum as an ethnographer. In this capacity he collected a few of Ọlọwẹ's architectural sculptures for the National Museum at Lagos and photographed others *in situ* for the archives. Allison met Ọlọwẹ in Isẹ in 1937 on a visit to his friend the Arinjale of Isẹ.[5] In 1944 Allison published the first article dedicated to the artist in *Nigeria Magazine* (1944:49–50). In this article, Allison introduces Ọlọwẹ and indicates the locations of his sculptures in Great Britain and Nigeria. The article is illustrated with details of a door from the Isẹ palace and another that was then preserved at the Akoko Jubilee School in Ikarẹ.

Shortly after World War II, Allison visited the British Museum, where he met William B. Fagg, then an ethnologist on the staff (W. B. Fagg 1968:vii). It was at this time that Allison identified the sculptor of the Ikẹrẹ palace doors that had been on display at the Wembley exhibition and

Fig. 6.13. Figure with Bowl, twentieth century. Ọlọwẹ of Isẹ. Wood, pigment; height, 63.5 cm. National Museum of African Art, Smithsonian Institution. Bequest of William A. McCarty-Cooper.

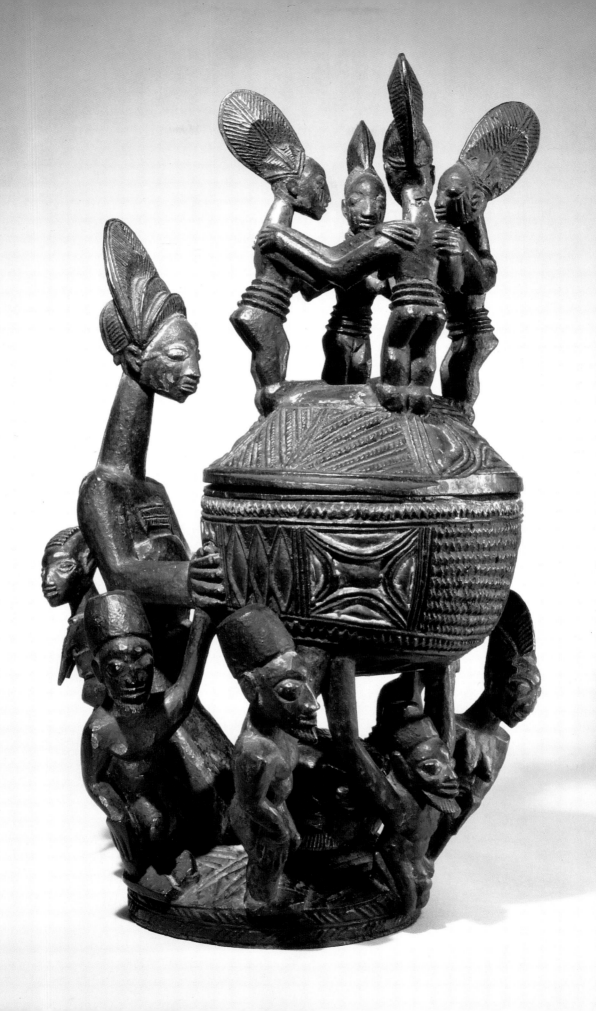

explained the historical meeting depicted on them. In 1958 Fagg went to Nigeria, visiting some of the towns where Olọwẹ had worked and photographing the architectural sculptures and other objects *in situ* at Ikẹrẹ, Ilẹsa, Isẹ, and New Idanre.[6] He subsequently wrote extensively about Olọwẹ, whose talent he obviously admired, first in scholarly publications and, after his retirement from the British Museum, in auction catalogues.[7]

In addition to Allison's personal knowledge of Olọwẹ of Isẹ and Fagg's field photographs, there is the equally important oral record. In Yoruba culture, *oríkì*—poetry or praise songs—preserve an individual's lineage, personal history, and the achievements that distinguish him or her within the society (see Awe 1974:331–49). In 1988 John Pemberton III recorded Olọwẹ's *oríkì* as recited by the artist's fourth wife, Oloju-ifun Olọwẹ.

Emi . . . , Oloju-ifun Olọwẹ	I am . . . Oloju-ifun Olọwẹ
Olọ́wẹ̀, okọ̀ mi kare o	Olọwẹ, my excellent husband
Àṣèri Àgbàlíjù	Outstanding leader in war.
Elémòṣó	Elemoṣo. [Emissary of the king.]
5 Ajuru Agada	One with a mighty sword.
Ó sun òn tẹgbétẹgbé	Handsome among his friends.
Elégbé bí ọni ṣà	Outstanding among his peers.
Ó p'ùrókò bí oní p'ugbá	One who carves the hard wood of the *irókò* tree as though it were as soft as a calabash.
Ó m'éó rókò dáun ṣe	One who achieves fame with the proceeds of his carving.
10 Àgèrè Èṣù í kón mọ́ jó'un	The frightening Eṣu forbids his being burnt.
Àgèrè Èṣù í kón mọ́ lù ún	The frightening Eṣu forbids his being hurt.
Oní bá tí jo, jó'ran	Whoever burns him [Olọwẹ] invites trouble.
Oní lù, Èṣù ló lù	Whoever hurts him [Olọwẹ] incurs the wrath of Eṣu.
Í kọn ọ́n mọ́ lù ún là'de	[Eṣu] forbids that [Olọwẹ] be publicly disgraced.
15 Wọ ka re o	Olọwẹ, you are great!
Mọ lórò kọ ṣàn yẹrejẹrẹ	You walk majestically
Mọ lórò kọ ṣàn káká rọrọ	And with grace.
Orò kọ́ ṣàn rábé ọta	A great man, who, like a mighty river, flows beneath rocks,
Loya sègbìgbò agbóyùn	Forming tributaries,
20 Òun ló sá jíere Kéléméja rèrò ki mọopa	Killing the fish as it flows.
Omi ĩléru,	A river has no slaves.
Omi àbá rẹ í ilérú	His father had slaves.
Òkú èsìkàn leé ṣeru omi àbá rè léyìn orò	The unworthy dead are his father's slaves.
Lémìsí rẹ	But Olọwẹ is honorable.
25 Ọmọ abeégún jẹ	The son of one who dines with masquerades.

	Ọmọ a pa torò gbònìfòn	The son of the great elephant killer in the forest.
	Wọ p'ajá s'úlé	Even though he slaughters a dog at home
	Wo p'oluọ̀ séyìnde	And a slave behind the house
	Ajá nùkàn ní mọ bá in jẹ	He is only interested in joining them in consuming the dog.
30	Mé jẹ oluọ̀ Ẹlékòlé	He does not join them to eat Elekole's slave.
	Elékòlé nùkàn ló jérúkọ ko mèkikì m̀bájẹ́	Although Elekole has a good name, his oríkì spoils it.
	Ọmọ Ẹlékòlé òbalaya asọ	The son of Elekole, who has an overabundance of clothes
	Ìkòlé iun má sọ tàlà b'ọsẹ	And uses them to wrap the Ose tree.
	Asọ yéye si kàn mibọbọ rókòkó	His cloth is so plentiful that there is enough to throw away.
35	Ọmọ lúlé fun kọ́n ọń jò jò jò d'ọnò̀	The one whose house is painted white [with lime chalk] right up to the gate.
	Í kó dà kúlé ẹbọ mó sunò̀n, Í efun á reni reni	Rather than being ugly, the lime chalk makes it attractive.
	Ote mu ru awusi	It is against Ọlọwẹ's custom,
	Òun lé j'ọn modi ÈÈ.kòlé ko nu l'úlé rè	And so we do not use ego to drink water in his house.
	Mo morí balè 'lúà mi	My lord, I bow down to you.
40	Olórí olúsọnà	Leader [senior head] of all carvers.
	Omọ̀ jíjó yíye	He is a great dancer
	O mège dídá bèrè ẹ rè	Whose dancing entertains.
	Mà a sìn o	I adore you!
	Wo ku'sẹ o	You have done well.
45	Omo olíyà ò gbèrè mowù	You have brethren who are not unitiated.
	Ogbère ka wu ya in e de ya rin ola	The ignorant person who does not know his mother today will never know her.
	Omo oliya Ejìge para ebo	You, the brethren of Ejige, where rituals are performed.
	Mà a sin o'luà mi	I shall always adore you, my lord.
	Ó m'éó 'rókò dá un sẹ	He [Ọlọwẹ] spends irókò money to achieve great things,
50	Ó p'urókò b'oni pugba	Who carves the irókò tree with the ease of carving a calabash.
	Oni kà a riọ lóriri	Whoever meets you unawares risks
	Tí doniyan à bọ	Becoming a sacrificial victim.
	Oni kà a ri o lóriri	Whoever meets you unawares
	Òràn ló ò	Sees trouble.

55	Mà a sìn Olówè	I shall always adore you, Olowe.
	Olówè kè e p'uroko	Olowe, who carves *irókò* wood.
	Olówè kè e sonà	The master carver.
	O lo ulé Ògògà	He went to the palace of Ogoga
	Odún mérin ló se líbè	And spent four years there.
60	O sonò un	He was carving there.
	Kú o bá tí d'élé Ògògà	If you visit the Ogoga's palace
	Kú o bá tí d'Owo	And the one at Owo,
	Use okò me e élíbè	The work of my husband is there.
	Ku'o bá tí de'kàrè	If you go to Ikare,
65	Use okò mi í líbè	The work of my husband is there.
	Kuo bá tí d'Ígèdè	Pay a visit to Igede,
	Use okò mi é e líbè	You will find my husband's work there.
	Kuo ba ti de Ukiti	The same thing at Ukiti.
	Use okò mi í líbè	His work is there.
70	Ku o li Olówè l'Ogbagi	Mention Olowe's name at Ogbagi,
	L'use	In Use too,
	Use okò mi í líbè	My husband's work can be found.
	Ulé Déjì	In Deji's palace,
	Okò mi suse líbè l'Ákuré	My husband worked at Akure.
75	Olówè suse l'Ogòtun	Olowe also worked at Ogotun.
	I kiniún	There was a carved lion
	Kon gbélo sílú oyibo	That was taken to England.
	Owó e ló mú sé	With his hands he made it.[8]

According to the aforementioned sources, Olowe was born in Efon-Alaye but spent most of his life in Ise, where he was initially engaged as a court messenger in the Arinjale's court. It was here that he began his career as a sculptor. According to Emi-ola Adeyeye, a daughter of the Arinjale who commissioned many of Olowe's carvings, Olowe had as many as fifteen apprentices helping with large commissions, which included carving furniture and household objects, musical instruments, toys and game boards, ritual paraphernalia, and masquerade headdresses, in addition to the architectural sculptures. As a child, she remembered taking Olowe his food and watching him working alone in a room reserved for him in the palace.[9] And, according to Oloju-ifun Olowe, Olowe preferred to work in private and undisturbed. Olowe seems not to have left any students to carry on his work after he died (Allison 1944:50). However, the artist and his achievements have been locally celebrated since his death. For example, in 1946 Yoruba rulers attending a conference at Ikere honored the artist's memory by sending a wreath to his grave (W. B. Fagg 1968:vii). Currently, Olowe's family continues to celebrate annually the festival for Ogun in the artist's honor (Pemberton in Drewal, Pemberton, and Abiodun 1989:211). Ogun is the god of iron and a "patron saint" of Yoruba carvers and blacksmiths.

There are, in addition to the aforementioned sources, European collections containing relevant official reports, diaries, memorabilia, and photographs dating from the turn of the century to the 1960s. These help researchers identify and locate Olowe's sculptures in time and space. For example, Major C. T. Lawrence's scrapbook and other memorabilia from the 1924 and 1925 British Empire Exhibition at Wembley are preserved at the Foreign and Commonwealth Library in London. This writer found among Lawrence's photographs one showing the Ikere palace door installed in the exhibition and another of the throne that the British Museum exchanged for it. Among photographs by E. Harland Duckworth housed at the Rhodes House Library at Oxford University, England, are some photographs he made in 1933 of several veranda posts in Idanre. These posts were still standing on the abandoned residence when a photograph of them was published in a 1955 issue of *Nigeria Magazine*.[10] Another research treasure is an *in situ* photograph made by Eva Meyerowitz in 1937 at the Ogoga's palace in Ikere. It shows the three famous single-tiered veranda posts of the Queen with her Twins, the Enthroned King, and the Equestrian installed with two other posts in a different setting than when Fagg and Picton photographed them in 1959 and 1964, respectively.[11] Among Charles Partridge's pictures preserved at the British Museum's Museum of Mankind is a 1909 photograph of Olowe's chief patron, the Ogoga of Ikere, with his son. Perhaps somewhere there is a photograph of the artist.[12]

Many questions about Olowe's life and art remain unanswered. For example, how old was Olowe when he moved from the art-rich town of Efon-Alaye to Ise? Who was Olowe's artistic mentor? To whom was he apprenticed? Traditionally, Yoruba carvers learn their craft in an apprenticeship system. Did Olowe come from a carving family? Among some Yoruba groups, if the father is a sculptor he apprentices his son to another master. How old was Olowe when he established his own atelier? How well acquainted was Olowe with other sculptors of his time? Did he know, for example, Obembe of Efon-Alaye (d. 1939), Areogun of Osi-Ilorin (d. 1954), and their work? Indeed, did Olowe have knowledge of other visual traditions beyond Ekiti?

The last question arises from analyzing two features of Olowe's carving. One is his unique style of carving figures in very high relief. The second is a design that Fagg asserts is the artist's signature. Fagg describes the latter as a "saltire within a rectangle" (W. B. Fagg 1981:106). It appears on the previously cited Figure with Bowl (fig. 6.13) and on two other containers,[13] but not on every sculpture he carved. In this writer's opinion, the design is in reality an Ekiti-style Ifa divination board with inward curving sides. Olowe carved such a divination board on the doors for the Ikere palace that replaced the pair sent to the British Museum at the time of the British Empire Exhibition of 1925. The containers on which this design appears are thought to have been used in Ifa divining rituals, which would explain the motif.

Yet perhaps there is another source of inspiration for the design Olowe carved on the containers. A mark that is similar in form is associated with the kingdom of Benin,[14] located southeast of Ekitiland. Elephant tusks belonged to the Oba (ruler) of Benin by divine right. Whenever an

Fig. 6.14.
Tusk with Ọba's
mark, eighteenth
century, detail.
Kingdom of Benin,
Nigeria. Ivory;
height, 40 cm.
Courtesy of Field
Museum of Natu-
ral History, Chi-
cago, neg. no.
A99447; cat. nos.
89718, 89727.

elephant was killed, one of the tusks was presented to the king and was marked with an inward curving form to signify his ownership (Roth 1968:96) (fig. 6.14). Can Ọlọwẹ have seen such a tusk in his youth before the British captured Benin in 1897? For that matter, had he ever seen cast copper alloy plaques from Benin? Considering how wooden figures carved in such high relief are so vulnerable to breakage and how metal is more appropriate for this style of sculpture, one can ask whether or not Ọlọwẹ ever saw or heard about high-relief metal castings. The cast copper alloy plaques that decorated the Ọba's palace come to mind (fig. 6.15). Can Ọlọwẹ have seen such castings? Considering that there are ancient historical links between the Ekiti and Benin kingdoms, carved tusks and other symbols of Benin authority and prestige may have been available for Ọlọwẹ to see as a court messenger and court sculptor.

Whatever the inspiration for his style, Ọlọwẹ of Isẹ was unique among African artists. As a master of composition and design (ojú-ọnà), a talented, highly skilled, and innovative artist, Ọlọwẹ remains without peer.

This essay has sought to demonstrate two points. First, traditional African artists are not anonymous. They were well known within and, sometimes, beyond the towns in which they worked. Second, it is possible to identify an individual artist's style within the "ethnic" or "regional" style of a cultural group. It is possible to prove these points when there are complementary oral and written records about the artist, especially when they are supplemented by *in situ* photography. In addition, and most important, there must exist a corpus of art work by the artist and from the group with which he/she worked, not only those associated with the artist as apprentices or assistants, but also by his peers in neighboring workshops. In Ọlọwẹ's case, his artistic brilliance was distinctive, his style readily identifiable, and, happily for the researcher, the other essential information about him was retrievable.

Fig. 6.15.
Plaque with multiple figures, mid-sixteenth–seventeenth century. Kingdom of Benin, Nigeria. Cast copper alloy; height, 45.7 cm. National Museum of African Art, Smithsonian Institution. Purchased with funds provided by the Smithsonian Collections Acquisition Program, 1982, NMAfA 82-5-3. Photo: Jeffrey Ploskonka.

Notes

1. These palace doors were not the first of Ọlọwẹ's sculptures to reach Europe. As noted in a Christie's (London) auction entry in *Antiquities and Primitive Art,* Wednesday, 11 December 1974, Harry Hinchliffe brought a similar and earlier Figure with Bowl by the artist from Nigeria in ca. 1900. Research to date does not indicate that Hinchliffe ever exhibited the sculpture publicly. In an interview with Ọlọwẹ's junior wife, Oloju-ifun Ọlọwẹ, on 12 June 1988, John Pemberton was told that Ọlọwẹ had once been invited to visit Great Britain by a European researcher, but he refused to go. "He consented, however, to his work being taken overseas and exhibited. Ọlọwẹ explained that he was a family man with many wives and children and did not wish to leave his home" (J. Pemberton, personal comm., February 1993).

2. A photograph of the installation is contained in Major C. T. Lawrence's box for 1925 housed at the Foreign and Commonwealth Office Library, London.

3. For a discussion of the British travelling commissioners in Ondo Province (comprising Ilẹsa and Ekiti), see Allison 1952:100–115. In this article, Allison reports the first travelling commissioner was Major Reeve-Tucker who arrived at Ilẹsa in November 1899. Captain Ambrose, who had previously toured Ekiti in 1898 in another administrative capacity, was travelling commissioner in 1901, 1903, and 1904. According to Allison, Ambrose, who had been given a Yoruba nickname, was still remembered in Ekiti. He is depicted on various palace doors wearing "a cricketing cap and an enormous pair of drooping moustaches." Because he is carried in the hammock, and posed directly opposite the Ogoga of Ikẹrẹ, it is safe to assume that the meeting between Ambrose and the Ogoga is commemorated on the Ikẹrẹ palace doors.

4. C. T. Lawrence 1924:12–14.

5. Philip A. Allison, personal communication, July 1989.

6. The original negatives are housed in the Royal Anthropological Institute, London. Complete sets of copy prints are available at the Eliot Elisofon Archives, National Museum of African Art, Smithsonian Institution, Washington, D.C. and the Metropolitan Museum of Art (Gift of Paul and Ruth Tishman: compiled by William B. Fagg, C.M.G., Deborah Stokes Hammer, and Jeffrey S. Hammer, M.D., 1985).

7. See Fagg 1969:54–57 and "A Superb Yoruba Wood Bowl and Cover," *Important Tribal Art,* auction catalogue, day of sale Monday, 24 June 1985 (London: Christie's), pp. 61–62, Lot 110.

8. Recorded by John Pemberton III, 12 June 1988, at Ọlọwẹ's house in Isẹ Ekiti. Sanmi Adu-Fatoba transcribed the *oríkì* and J. F. Ade Ajayi and Rowland Abiọdun assisted in the translation.

9. John Pemberton III interview with Emi-ola Adeyẹye in Isẹ Ekiti, 9 June 1988.

10. Anonymous 1955:165.

11. Eva Meyerowitz's photograph was originally published in Meyerowitz 1943:66–70. For a discussion of the installations in the earlier and later photographs, see Walker 1991:77–78.

12. John Pemberton III was told by Chief S. I. Akindahunse, a grandson of Ọlọwẹ, that a photograph, taken by a European, had hung in the reception·room in Ọlọwẹ's house for a number of years. It had been damaged and lost several years ago. Neither he nor other family members with whom Pemberton talked on 12 June 1988 could remember when or by whom the photograph was taken. Personal communication, February 1993.

13. These are illustrated in Vogel 1981:103 and 105.

14. For a discussion of the relationship between the Ekiti and Benin kingdoms, see Smith 1988:45–48.

7. In Praise of Metonymy: The Concepts of "Tradition" and "Creativity" in the Transmission of Yoruba Artistry over Time and Space

Olabiyi Babalola Yai

As students of Yoruba art history from citadels of Western production of knowledge about others, we cannot hope to do justice to Yoruba art and art history unless we are prepared to reexamine, question, even abandon certain attitudes, assumptions, and concepts of our various disciplines, however foundational they may seem, and consequently take seriously indigenous discourses on art and art history.

One concept that needs to be questioned is objectivity, for the African art historian's claim to scientific objectivity results in portraying art as emanating from self-contained cultures within identifiable frontiers. It is doubtful, however, if such portrayals reflect the experience and intellectual stance of Yoruba artists and of those we would call "traditional art historians" in today's parlance. Admittedly our analyses invariably accommodate divers influences on specific artistic traditions (e.g., Benin influence on Owo art, Portuguese influence on Benin, etc.). But how relevant is this very concept of influence, in its current usage, when examined in the context of the world views and intellectual traditions of African cultures? What is its epistemological or heuristic status or value? Is it indigenous to Western cultures, conceivable on their terms, or is it alien to and alienating of Africa's cultures?

When approaching Yoruba art, an intellectual orientation that would be more consonant with Yoruba traditions of scholarship would be to consider each individual Yoruba art work and the entire corpus[1] as *oríkì*. One advantage of such an attitude is that it allows the researcher to answer the series of questions pertinently raised by Jan Vansina in the introduction to his *Art History in Africa* (Vansina 1984:3) and to raise new issues and inquiries, for by its nature an *oríkì* is an unfinished and generative art enterprise, as emphatically stated in the following *meta-oríkì*, that is, an *oríkì* that is a discourse on *oríkì*: *àkììkìtán* (the one whose praises are endless).[2]

Making *oríkì* a tutelary goddess of Yoruba art history studies enjoins us to pay more attention to the history dimension of the discipline's title. This in turn entails that we familiarize ourselves with Yoruba concepts of history and be conversant with the language and metalanguage of Yoruba art history.[3]

For a Yoruba intellectual, *oríkì* as a concept and a discursive practice is inseparable from the concept and discursive practice of *ìtàn*. Indeed it can be argued that both are members of a constellation of basic Yoruba concepts without the elucidation of which it is almost impossible to

understand any aspect of Yoruba culture. An exploration of the concept based on its linguistic analysis is therefore in order. This is no idle exercise, for the Yoruba word *itàn* is invariably translated as "history," a word and concept with so vast a meaning as to deserve the appellation of "continent histoire" (continent history) in contemporary European discourse. Now the *itàn* = history equivalence involves both reduction and translation, and perhaps more the former than the latter. More important, this equivalence blocks our understanding of the Yoruba concept of and attitudes toward history.

Etymologically *itàn* is a noun derived from the verb *tàn*. *Tàn* means to spread, reach, open up, illuminate, shine.[4] The verb *tàn* and the derivative noun *itàn* are polysemic and integrate at least three fundamental dimensions. First, there is the chronological dimension through which human generations and their beings, deeds, and values are related. Second, there is the territorial or geographical dimension through which history is viewed as expansion (not necessarily with the imperial connotation that has become the stigma of that concept in the English language) of individuals, lineages, and races beyond their original cradle. In that sense it is important to observe that the Yoruba have always conceived of their history as diaspora. The concept and reality of diaspora, viewed and perceived in certain cultures (Greek, Jewish) as either necessity or lamented accident, are rationalized in Yorubaland as the normal or natural order of things historical.

In the intellectual traditions of the Yoruba, as elaborated by and handed down to us by the *babaláwo* in Ifa texts, the geographical dimension of *itàn* revolves around five cardinal axes. Wande Abimbọla accurately circumscribes this element of the definition of *itàn* in the following terms:

Ifa has long ago divided the globe into five regions, namely:
 a. *Ìkọ Awúsí* (the Americas)
 b. *Ìdòròmù Àwúsè* (Africa)
 c. *Meréetélú* (Europe and Asia)
 d. *Mẹsìn Àkáárúbà* (Arabia, the land of the worship of Kaaba)
 e. *Ìwónran níbi ojúmó tí í móọ wá* (which refers to Australasia)
As far as the Yoruba are concerned, all the above mentioned parts of the world are all lands of Ifa. Thus, when an Ifa priest wakes up in the morning, he will salute Ifa in all these five divisions of the earth (Abimbọla 1983:80).

The third dimension of *itàn* has paradoxically and tragically been neglected by most Yoruba historians. This is the discursive and reflexive dimension of the concept. *Tàn* means to illuminate, enlighten, discern, disentangle. *Tàn* is therefore to discourse profoundly on the two dimensions earlier mentioned. The noun *itàn* for this dimension always requires the active verb *pa*.

Pa itàn (*pìtàn* in contracted form) is often trivially and somewhat inadequately translated as "to tell a story." *Pa* is also used for such nouns as *èkùró* (kernel) *obì* (kola nut) = to separate the two lobes of the kola nut; *ẹyin, ọmọ* (egg, to hatch); *òwe* (proverb); *àló* (riddle, parable).[5] *Pìtàn*

therefore means to produce such a discourse that could constitute the Ariadne's thread of the human historical labyrinth, history being equated with a maze or a riddle. *Pa ìtàn* is to "de-riddle" history, to shed light on human existence through time and space. No wonder Ọrunmila, the Yoruba deity of wisdom, knowledge, and divination, is called *Òpìtàn ilẹ Ifẹ̀* (He who de-riddles *ìtàn*, i.e., unravels history throughout Ifẹ territory).

We cannot hope to understand fully the art history of Yorubaland and neighboring cultures unless and until we become conversant with the intellectual climate prevalent in the region in precolonial times. Historians' histories of the area unduly inflate politics by emphasizing the hegemonic behavior of certain kings and dynasties and the unquestionably divisive factor of the slave trade, to the detriment of a strong unifying undercurrent observable among the peoples and the intellectuals of the various ethnic groups at all times, even when their rulers were at war. In this respect A. Akinjogbin's "*ẹbí* social theory" remains unsurpassed as the most reliable and convincing historical paradigm for its sensitivity to Yoruba values and its explanatory power, while his critics' argumentation lacks cultural relevance. The intellectual climate of the region was and still is largely characterized by a dialogic ethos, a constant pursuit to exchange ideas, experience, and material culture. Each city was a locus of intellectual interaction between intellectuals (*babaláwo*, herbalists, poets, artists, et al.), and Ile-Ifẹ was regarded as a sanctuary and the university par excellence in the etymological sense of this word.

Polyglottism was a common feature among intellectuals, and the Yoruba language in its Ifẹ and Ọyọ varieties was the preferred language of intellectual discourse of the entire region, particularly among diviners. The degree to which polyglottism and multiculturalism was highly valued, and indeed required of intellectuals, is expressed in the well-known *oríkì* of Ọrunmila, the god of divination. He is known as *Afèdèfẹyọ̀*, that is, "He who speaks all languages and Yoruba." Polyglottism and multiculturalism feature prominently in the divination "corpus" of the Ewe, Gun, Fon, and Aja where "lines" and sometimes entire verses of other languages of the region are found in the Yoruba Ifa "corpus" (see Maupoil 1936; Abimbọla 1968).

The leading role of the Yoruba language is also documented in the accounts of early travelers, although little attention has hitherto been paid to this important aspect of the intellectual history of the area. For example, Alonso de Sandoval referred to the Ọyọ Yoruba, then known as Lucumi, as peoples whose culture was prestigious among the Bini, Arda, Mina, and Popo (Sandoval 1956:16–17).[6] In 1640 a Jesuit missionary, Frei Colombina de Nantes, likened the status of the Yoruba language in West Africa to that of Latin in Europe: "lingua eorum est facilis, vocatur lingua Licomin et est universalis in jstis partibus sicut latinum in partibus Europa" ("their language is easy to learn, it is called the lucumi language and is universal in this area as Latin is in Europe") (Brasio 1956–68:465, my translation). Art objects should ideally be appraised with this broad context in mind.

Viewed from this perspective, the Ulm divination tray (*opọ́n Ifá*) takes on a pivotal significance

for the art history of the region and the mode and mood of interaction between West African cultures. For want of a better term, the Ulm divination tray is an important "text." It must be kept in mind that a divination tray is not just an art object or ritual paraphernalia. For a Yoruba intellectual, an *opọ́n Ifá* is itself a *babaláwo*. An Ifa verse from the Eji Ogbe "chapter" (*odù*) describes the *opọ́n Ifá* as one of the three main *ọmọ awo* (disciples) of Ọrunmila sent to foreign lands to seek wisdom and knowledge.

	Oore ìí gbé	Generosity is never wasted.
	Oore ìí nù	Generosity is never lost.
	E ẹ rọra gìidò	Exercise great caution
	Kóore ó má baà ṣe gbé	That generosity may not be wasted.
5	A dífá fún Ọrunmila	Ifa divination is performed to Ọrunmila,
	Ifá ó tẹ ọmọ awo mẹ́ta re nífá	Who initiated his three disciples.
	Ifá lo topọ́n nífá	Ifa initiated *opọ́n* [the tray].
	Opọ́n ṣawo lọ síkọ Àwúsí	*Opọ́n* traveled to Iko Awusi to seek knowledge.
	ọba ló je	He became a king there.
	Ifá ló tẹ ajere nífá	Ifa initiated *ajere*.
	Ajeré ṣawo lọ sÓdòròmù Àwúsè	*Ajere* traveled to Idoromu Awuṣe.
10	Oba ló je níbè	There he became a king.
	Ifá ló tẹbò nífá	Ifa initiated *ibọ́*.
	Ìbọ́ ṣawo lọ síwọnrán ibi ojúmọ́ọre	*Ìbọ́* traveled to Iworn in the Orient to seek
	é ti í mó	knowledge.
	Níbè ni o gbé di ọba	There he became a king.
	Kí í màá gbé adésè	Generosity is rewarded.
15	Kì i gbe, adésè	Generosity is never wasted.
	Orire	Generosity.

What this Ifa verse tells us is that *opọ́n Ifá*, the divination tray, is an agent in the Yoruba mode of relating to other cultures.

That an *opọ́n Ifá* from Alada is among the oldest "art works" in a European museum is no accident for Alada is often mentioned in Ifa divination literature. The name of Alada or Arada is emblematic of wealth and evoked and invoked in Ifa recitations to signify abundance of riches resulting from compliance with Ifa's suggestions, recommendations, or prescriptions. This is ritually evoked in the following context.

Otítí baba ajé	Otiti, epitome of wealth
Ọlógìnìngíní aṣọ Àràdà	Ọlọginingini cloth originated from Alada
Àkóòkótán ohun ọrọ nÍfè	Inexhaustible riches from Ife

The Ulm *opọ́n Ifá* is also symbolic of the will of the West African elite to engage European cultures in a dialogue on an equal footing. The tray belonged to King Tezifon of Alada and was described

in the *Exoticophylacium* (p. 52) as "an offering board carved in relief with rare and loathsome devilish images, which the king of Ardra, who is a vassal of the great king of Benin, together with the most important officers and men of the region, uses to employ in fetish rituals or in sacrifices to their gods. This offering board was given to, and used by, the reigning king of Ardra himself" (see Ezio Bassani, this volume).

We know that about the time this was written (1659) King Tezifon of Alada had been sending emissaries to European powers. King Felipe IV of Spain responded by sending to Alada a delegation of twelve Capuchins who in 1658 brought to the kingdom a translation (into the Alada language) of Christian doctrine (Labouret and Rivet 1929; Yai 1992). We must resist the secular temptation of interpreting the decision of King Tezifon in sending his divination tray to Europe as a mere gesture of kindness from an African to a European prince. It would be equally senseless to hypothesize that the king was trying to convert his European counterparts to his religion, since proselytizing was not a feature of his religion. If, as was stressed by contemporaries, the Ulm tray belonged to the king himself, he could not possibly have sent a divination tray overseas gratuitously, given what an *ọpọ́n Ifá* represented to him.

I surmise that Tezifon's gesture was one of diplomatic and cultural reciprocation. As European kings sent to West Africa missionaries who were perceived as the most representative wise men and intellectuals of their respective nations, the king of Alada, in an attempt to establish an equal cultural and political exchange, must have thought of sending to European kings a divination tray that he perceived as the perfect equivalent of the text European missionaries carried with them along the West African coast. We must not forget that most missionaries were accountable to their kings. A divination tray is always the result of the collaboration between two creative individuals, a diviner and an artist. It was a carved text par excellence. Tezifon, therefore, was engaging the contemporary European elite in a cultural dialogue, an exchange of texts or discourses. Because King Tezifon knew some Portuguese,[7] it is possible, and indeed likely, that he might have explained the meaning of the tray to those who carried it to Europe. The iconography of the tray lends some credence to this hypothesis. The tray is an "*ọlọ́gìnìngínì*" on wood. The word *ọlọ́gìnìngínì*, which designates a luxury textile of which Alada specialized in producing, is an ideophone. The nature and combination of the consonants and vowels, as well as the tonal pattern of this word, together suggest to the ears of a cultured Yoruba the impression of a textile that is very rich in motifs and colors, an epitome of the baroque.

In the same way, the Ulm tray is a supremely loaded text (Bassani, this volume; H. J. Drewal 1983). It abounds in symbols of political and spiritual power and authority. The variety of the motifs represented (human beings of both sexes and various ages, animals of various order, plants, Eṣu's head with magic gourds, a divination chain, etc.) and their syntax seem to suggest that the artist and his patron deliberately sought to portray the Alada polity as one, diverse, and wealthy.

Who was the artist? Was he a Yoruba? Can the Alada-Ulm tray still be considered as a Yoruba

art work? Are these questions meaningful in the context of the area in the seventeenth century? Ezio Bassani has convincingly demonstrated that the Alada-Ulm tray shows some morphological and stylistic similarities with a group of statues collected in the Benin Republic and Togo. The same morphological and stylistic features can be identified, I may add, in modern appliqué textiles in Alada and Abomey, which seem to suggest that there exists some permanence of style in the region. But the Alada-Ulm tray is unique in one important respect: it creolized the cardinal types of Yoruba and Fon divination trays. While divination trays can be either circular or quadrangular in Yorubaland, the preferred shape in Fon-speaking areas is the quadrangle (Maupoil 1936). The Alada-Ulm tray inscribes, so to speak, a circle within a quadrangle. The artist, if a native of Alada, was conversant with Yoruba religious and artistic traditions. There is good reason to believe that his style, far from being an aberration, was paradigmatic of artistic and intellectual traditions in the Alada kingdom, for Olfert Dapper in his *Description de l'Afrique,* originally published in Dutch in 1686, said concerning Alada: "C'est une chose fort singulière que ces Nègres méprisent leur langue maternelle et ne la parlent presque point, pour en apprendre une autre qu'ils ont toujours à la bouche, nommée Ulcumy." (It is quite remarkable that these Negroes disdain their mother tongue and hardly speak it, in order to learn another language that they always speak called Ulcumy [i.e., Yoruba]) (Dapper 1989:225, my translation).

If the Yoruba language was spoken by the Alada people without it being imposed,[8] to the point that Dapper was shocked by what must have appeared to him as alienation, we can infer that other aspects of Yoruba culture, artistic traditions included, were also well known and practiced in the kingdom of Alada. Dapper's unjustifiably neglected observation raises fundamental issues concerning the modes of relating Yoruba artistic traditions in time and space. How could the Alada peoples and their elite have accepted that which in many, perhaps most, historical circumstances would have necessitated some measure of imperialism? How does one account for this paradox of *deliberate alienation?* I would like to offer, not a definitive answer to the enigma, but a few hypothetical suggestions. It is hoped that they will provoke contributions from as many angles as possible, for it is only through a diverse and collective approach that Yoruba culture, a perfect Harlequin robe, is best apprehended.

Since the paradox, far from being accidental, appears to be characteristic of Yoruba cultures whenever they are in permanent contact with other cultures, an examination of some tenets of Yoruba philosophy could perhaps prove useful. We must keep in mind that the ideal artist in the Yoruba tradition is an *àrè* (itinerant). Lagbayi, the legendary Yoruba sculptor, lived as an *àrè*. An *àrè* is an itinerant, a permanent stranger, precisely because he or she can be permanent nowhere. Being an *àrè* is therefore being an individual exponent of *ìtàn* as defined in the first part of this essay.[9]

In a culture where *orí,* the principle of individuality, is perceived as a deity that informs and

shapes the world view and behavior of persons, it is simply "natural" that the privileged idiom of artistic expression, indeed, the mode of existence of art, should be through *constant departure*. The English word "representation," with its assumption of and intrinsic bias toward similarity, cannot do justice to Yoruba traditions of aesthetics and modes of relating to otherness.[10]

Even deconstruction theory and idiom, often praised as the most advanced mode of criticism, lacks the vocabulary needed to account for Yoruba attitudes toward "representation," since its "decentering" concept presupposes a center. In the Yoruba world view the best way to recognize reality and artistically relate to it is to depart from it. An entity or reality worth respecting is that from which we depart or differ. Thus the essence of art is universal bifurcation. Yoruba verbal art, *oríkì*, abundantly displays this bifurcation ethos as do the visual arts, which, as we now know, are modalities of *oríkì*.

The language and metalanguage of the Yoruba verbal and visual arts predictably overlap, and perhaps critics should be more sensitive to them. The key concept in this domain is *yà*, as in the expression *yà ère* (to carve), *yà àwòrán* (to design, paint). Similarly, in the verbal arts, in *ijálá* for example, the following metalinguistic and critical verses punctuate any performance:

Orí kan nù un nì	Here is one orí,
Ìyàtò kan nu un ni	Here is one departure/difference.

These two emphatic metalingual and critical "lines" are used to signal the "fluidity, boundarilessness and centrelessness" of the constituent parts of an *oríkì* performance (Barber 1991:249).

It is no accident that the key Yoruba concepts of *orí* (individuality) and *ìyàtò* (difference, originality) are prominent in these lines. This is because oral and visual *oríkì* are essentially vocative discourse in which dialogue is an essential ingredient. But *oríkì* is also evocative and provocative.

I would like to suggest that the Yoruba mode of artistically engaging reality and their way of relating to one another, to the *òrìsà*, and other cultures is more metonymic than metaphoric. To "*kì*" (perform *oríkì* verbally) and to "*gbé*" or "*yà*" (carve) is to provoke and be provoked.[11] Art is an invitation to infinite metonymic difference and departure, and not a summation for sameness and imitation.

In such a culture, the perennial question in art history regarding the relation between tradition and creativity is less tragically posed, solved, and lived, for to a large extent the tradition/creativity binary opposition is neutralized. "Tradition" in Yoruba is *àsà*. Innovation is implied in the Yoruba idea of tradition. The verb *sà*, from which the noun *àsà* is derived, means to select, choose, discriminate, or discern. *Sà* and *tàn* are semantically cognate. Hence *àsà* and *ìtàn* are inextricably related. Something cannot qualify as *àsà* which has not been the result of deliberate choice (*sà*) based on discernment and awareness of historical practices and processes (*ìtàn*) by individual or

collective *orí*. And since choice presides over the birth of an *àṣà* (tradition), the latter is permanently liable to metamorphosis.

One can therefore easily understand Muraina Oyelami, a prominent Oṣogbo artist, when he affirms that he loses a piece of himself with every painting. Similarly one has no difficulty understanding the irritation and anger of another member of the same school, Rufus Ogundele, when called "the Picasso of Nigeria." His insistence that "Rufus is Rufus" is Yoruba and traditional (H. U. Beier 1992:15, 48). The perception of tradition as iteration of individual and collective *orí*'s, acts based on choice in an infinite figure of contiguity, is also perceptible in the often heard and seemingly paradoxical statement by Yoruba artists: "Our tradition is very modern." A paradox in the English language, this statement squarely resists translation into Yoruba, for *àṣà* is both the "traditional" and the "modern." It is one of those pronouncements that is not admissible in the Yoruba language and can only be rendered at the risk of being tautological. Indeed, it is a pronouncement invariably meant for and directed to non-Yoruba people.

This ability to reconcile opacity and difference and openness in an unending movement of metonymic engagements might explain the success and popularity of Yoruba culture in the New World where it has greatly contributed to cement and creolize African and non-African cultures, despite a social climate of intolerance and invitation to mimetism. As the Yoruba themselves believe and say emphatically: "Orúkọ tó wu ni làá jé lẹ́hìn odi" (Outside the walls of your birthplace, you have a right to choose the name that is attractive to you).

Notes

1. Expressions such as "Ifa literary corpus" and "*oríkì* corpus" are nonsensical from the point of view of Yoruba culture because of their assumption of closure.

2. In this regard, the title of Karin Barber's book, *I Could Speak until Tomorrow*, could not have been more appropriate.

3. We are all victims of the imperialism of writing, with its pejorative attitude toward oral cultures. As a consequence, most Africans conduct their research with an implicit assumption of a discursive and meta-linguistic *tabula rasa* in the cultures being studied. The epistemological poverty of this attitude need not be elaborated. Fortunately, Yoruba art scholars are increasingly going against this grain, resulting in more perceptive analyses.

4. As it sometimes happens in the Yoruba language, the verb *tàn* has a mid-tone pseudo homophone, *tan*. They belong to the same semantic range. *Tan* means to relate, to belong to the same family.

5. For a systematic exploration of the concept encapsulated in the verb *pa* and its relation to other concepts used in Yoruba metalanguage and literary/artistic discourse, see Adeeko 1991.

6. "Los lucumies, gente no menos en numero que en consideración" are Sandoval's words.

7. He was sent to São Tomé in his younger years because his father wanted him to master the secrets of the European's might. But the Europeans wanted to convert him to Christianity, which he resisted (Labouret and Rivet 1929; Lombard 1967:48).

8. It is only in 1698 that Ọyọ made military incursions in Alada, according to Dalzel (see Lombard 1967:49).

9. *Àrè* used to be quintessentially laudatory in meaning to the point that it sounds like a "chieftaincy title," for example, Are Lagbayi. Sadly enough, with colonization and the erosion of Yoruba values, *àrè* nowadays in certain quarters has acquired a pejorative connotation. An *àrè* nowadays is more of a vagabond than an itinerant poet or artist.

10. Margaret Thompson Drewal points to the difficulties encountered in this domain by Western scholarship on representation and new ways of coming to terms with conventional views of repetition by advocating a "repetition with critical difference" (M. T. Drewal 1992:3).

11. For a brilliant discussion of this approach to art and creativity, as equally brilliantly represented in Yoruba modern letters by Wọle Ṣoyinka, see Fioupou (1991:491–518).

PART TWO

THE INTERPLAY
OF THE ARTS
IN
YORUBA CULTURE

8. Introduction: In Praise of Artistry

John Pemberton III

John Pemberton III

**Fig. 8.1.
Areogun with
carvings made in
1952. Osi-Ilorin.
Photo: Kevin
Carroll.**

The following group of essays may, at first glance, appear to the reader a rather odd grouping of topics without linkage of theme or argument. Indeed, this is in part true. There is, however, a purpose in their juxtaposition. As diverse as they are in topic, they invite the reader to explore two issues: (1) the relevance of the verbal arts, particularly a chant form known as *oríkì* (praise poetry), for historical inquiry in the visual arts and (2) the nature of Yoruba aesthetic discourse with reference to diverse modes of artistic expression.

Wande Abimbola's essay, "Lagbayi: The Itinerant Wood Carver of Ojowon," focuses on a verbal art form known as *oríkì* which, in this instance, celebrates the memory and lineage of an eighteenth-century carver from the area of Old Oyo. So great were Lagbayi's powers as a carver that at his approach the mighty *irókò* trees trembled and "collided with the palm trees in great fear." Karin Barber continues the discussion of *oríkì* as an art form with an analysis of the contrasting types of *oríkì* chanting and the distinctive styles of three singers from the town of Okuku. His Highness, Oba Solomon O. Babayemi, the Olufi of Gbongan, continues the discussion of *oríkì*, employing it as a source, along with oral histories (*itàn*), for understanding the architectural history of the palaces in the town of Gbongan. (Karin Barber's conversations with His Highness, which have been placed in the endnotes, are of considerable importance when reading this essay.) Akin Euba's essay analyzes the role of drumming as a verbal as well as rhythmic agent, and the task of the lead drummer in shaping the choreography of lineage masquerades (Egungun) in festivals for the ancestors in Ede. Finally, Margaret Drewal provides a detailed analysis of the place of metaphor in Ifa divination poetry (*ese Ifá*). She is especially interested in the intellectual playfulness of mind in an Ifa priest's interpretation of *ese Ifá* in the context of rituals designed to discern one's personal destiny or inner head (*orí-inú*), insofar as its possibilities and limitations may be known for making choices in and for one's life. Again, these essays, along with others in this volume, provide a context for exploring questions of the type noted above concerning the nature of the interplay and significance of the relationship among the verbal, visual, and performing arts, including ritual, in Yoruba art historical studies.

The Role of *Oríkì* in Yoruba Art Historical Studies

In every Yoruba household there is a male elder, often the *baálẹ*, who can recite the oral history (*ìtàn*) of the patrilineage. Such histories recall the ancestral founder of the household, refer to the town or region from which the ancestor came with his followers, indicating (often cryptically) reasons for their departure, the vicissitudes of their journey, and the welcome they received upon arriving in the present location due to the particular skills or heroic deeds of the ancestor. An *ìtàn* may also refer to subsequent changes in the life of the patrilineage as a result of the ravages of war, periods of refuge in neighboring towns, and the powers of the *òrìṣà* who sustained them. Above all else, the *ìtàn* remembers those men and women who brought fame to the family. Such histories, therefore, often function as charters for the position and role of patrilineages in a town.

It is the wives and daughters of the house or patrilineage who sing *oríkì*, although there are women who are "professionals" in that they know the *oríkì* of many houses and persons and have developed the art form to the point where they are in demand throughout a community. *Oríkì orílè* (lineage praise songs) are chanted on the occasion of family gatherings, such as the annual festival for the ancestors or the taking of chieftaincy titles. As Karin Barber has demonstrated in her splendid analysis of praise singing in Okuku, *oríkì orílè* extol the *ìwà*, the character or characteristics (virtues?) of a lineage, including embarrassing reference to persons or situations less than praiseworthy (Barber 1991). The poetry takes full advantage of the tonal complexities and richness of the Yoruba language, entailing imaginative wordplay and varied rhythmic patterns by the singer. It is celebration, not history, that is the concern of the singer; and in the process such historical references as may appear are often reduced to cryptic phrases and metaphoric allusions that only members of the household understand. Individuals also have their *oríkì*, and here too it is the celebration of the *ìwà* (the essential nature or character) of the person that is the subject of praise.

In her essay in Part One, Roslyn Walker refers to *oríkì* as a source for our knowledge of the early twentieth-century master carver Ọlọwẹ of Isẹ (d. 1938). The praise song, created by members of his family and chanted during his lifetime, as well as in his memory at the annual festival for Ogun in Isẹ, heralds the ease with which Ọlọwẹ carved: "One who carves the hard wood of the *ìrókò* tree as though it were as soft as a calabash." So prolific was he as a carver and in such demand that he was praised in his own time as "One who achieves fame with the proceeds of his carving." The *oríkì* expresses other personal qualities when it refers to Ọlọwẹ as having been an "outstanding leader in war/One with a mighty sword" on whom the title Ẹlẹmọṣọ (Emissary of the Ọba) had been bestowed. He is flattered as being "Handsome among his friends/Outstanding among his peers." So awesome was his skill as a carver that he is referred to as "A great man, who, like a mighty river, flows beneath rocks/Forming tributaries/Killing the fish as it flows." What is unusual about the *oríkì* for Ọlọwẹ is that it ends by identifying the many places where Ọlọwẹ's carvings could once be found: the palaces at Ikarẹ, Ọwọ, Akurẹ, and Isẹ and the towns of Igede, Ogbagi, and even London, England.

In the *oríkì* for Lagbayi of Ojowon cited by Wande Abimbola, we are told that Lagbayi carved "during the reign of Abiodun," who was the Alaafin of Old Oyo from 1775 to 1805. It is said that his carvings were not shapeless but "looked robust and beautiful," for he had the skill to change "a wooden object into a human being." He "inscribed beautiful and delicate *kéké* facial marks" and "*àbàjà* marks on a wooden object," giving them a "naturalistic" quality. Lagbayi was held in such awe as a carver that not only did short people stand on their toes and tall persons stoop down to catch a glimpse of him at work, but when he entered the forest, "The *apá* trees collided with one another in trepidation./The *ìrókò* trees collided with the palm trees in great fear," for they "wondered where next Lagbayi would place his load of carving instruments."

Roslyn Walker is certainly correct—"Anonymous Has a Name." Great carvers are remembered among the Yoruba. Oba Solomon Babayemi's reference to the *oríkì* and name of Idowu Olodo, a carver for the Olufi's palace in Gbongan at the turn of the century, adds support to Walker's observation. One must ask, however, what kinds of sources *oríkì* provide the art historian? An analysis of the *oríkì* of several carvers from the Ekiti and Igbomina areas may suggest an answer.

Although Areogun was well known throughout the villages and towns in the northern Ekiti area of Opin, it was the late Father Kevin Carroll who brought his major sculptural achievements to the attention of art historians (fig. 8.1). The following *oríkì* is for Dada Areogun (1880–1954) of Osi-Ilorin:

	Dàda Arówó Ògún bu ná	Dada, who has Ogun's money to spend.
	A bi kókó aso bi ìdèrúkù omo tuntun	The end of his cloth is knotted like an infant's umbilical cord.
	Omo ajídè Lúgbèyìn	One who awakens to a comfortable life in Igbeyin.
	Omo olú abepo	Son of those who possess palm oil.
5	Omo òmónà somo lójú wèrèwèrè	The expert, whose sculptures dazzle the beholder.
	Omo a sù sì sílé Ìjérò	He made his reputation in Ijero.
	Ó da gbangba lójú olúbi	He confronts the wicked bravely.
	Òsonà gbomo esin	He carved and was given a horse.
	Dàda amojo	Dada, who knows how to dance.
10	Apugi bí eni pugbá	He carves hard wood as though he were carving a soft calabash.
	O bómo tuntun bi eni bówú	He fed his younger children as though he were feeding an older person.
	Àrì sijú ikú kèjú gbègbè su hàn	The fear of death does not make having a goiter pleasant.
	Àrì sijú ikú kètú gbègbè kúrò	The fear of death makes the removal of the goiter frightening.
	Bí a pé gbègbè á kúrò olúwa rè á góbe	If one wants to remove it, he must cut himself and risk death.
15	Ìrèmògún, abulele sowó	Iremogun [Ogun], who turns wood into money.

	Ìrèmògún ti gbódù n'Irè	Iremogun consulted divination at Ire.
	Ìrèmògún, ará yón yéké	Iremogun, native of the town where people are well fed.
	Ayonyéké, oyún ò yokùnrin, óye Olufadi	Oye Olufadi [a title]. Obesity does not befit a man.
	Óye àre àgbà bá won mú tà n'Irè	The senior chieftaincy title was sold to them at Ire.
20	Omo ejíbojó, ará Ìlágbède	Son of those who came early [whose ancestors were early settlers]. Natives of Ilagbede [home of blacksmiths].
	Ìrèmògún ti gbódù n'Irè	Iremogun consulted Odu at Ire.
	Ìjà lògún jà ó rè 'Rèsà	It was a quarrel that took Ogun to Iresa.
	Kíní se lé Ògún lágbède	What has happened to the Ogun house of the blacksmiths?
	Ìrèmògún, ará yónyéké	Iremogun, native of the town where people are well fed.
25	Àjíle kò yokùnrin	It is not good for a man to wake up in the morning and remain at home,
	Ó ye Olúfadi	But it is appropriate for Olufadi to do it [for he is a carver].
	Omo eji tó n lolá, ará Ìlágbède	Son of those who prosper from little.
	Omo awúkó gbinrin bí ewúfon	Son of those who cough like elephants [speak with authority].
	Ìrèmògún, ará yónyéké	Iremogun, native of the town where people are well fed.
30	Omo eji tó n lolá	One whose mother lived to see his greatness [as a carver].
	Omo aníyilóyè	One who knows how to carve appropriately for kings,
	Omo okun morí adé ké	
	Omo átèpá owá jìyà òfin	Who carved for the Owa and gained favor. Son of those who are wiley.
	Omo abòkè Òyègbé kí han má bo tèké	Son of those who worship Oyegbe [a local hill deity], and do not worship falsely.
35	Abinú ponrongandan bi Ifá fore.	As in a favorable divination, he has nothing to hide.[1]

As with most personal *oríkì*, the praise song for Dada Areogun refers to the qualities of the man and how he was perceived by his contemporaries. Numerous references are made to his lineage in phrases such as "One who awakens to a comfortable life in Igbeyin/Son of those who possess palm oil," "Son of those who came early," "Son of those who prosper from little/Son of those who cough like elephants," even though their authority is not that of a crown. The focus, however, is on the qualities of the man who is a great carver. The opening line refers to Dada as "Areogun" (One who has Ogun's money to spend). Repeated reference is made to Ogun, the *òrìsà* of iron, the deity of warriors, blacksmiths, carvers, and all others who work with metal instruments, and calls

attention to the danger of using Ogun's knives. Dada Areogun, however, "dazzles people with his carving" skills. He is perceived as empowered by Ogun's *àṣẹ* (authority) and is honored with the deity's *oríkì* (lines 15–24). The phrase celebrating the ease with which Ọlọwẹ carved is also found in the *oríkì* of Dada: "He carves wood as though he were carving a calabash." There is only one line that contains an interesting historical reference: "He made his reputation in Ijero." Otherwise, the chant lauds his ability to feed his large family, his generosity to others, and his social grace ("Dada, who knows how to dance").

The *oríkì* for Bamidele (or Bandele), son of Dada, as it was given to me, is briefer and more focused on his work as a carver (fig. 8.2):

	Àjé Ìsòlá	Isola, who does the extraordinary [a "wizard" among carvers],
	Oní Sàngó àkéké	Whose axe is like the thunderbolt of Ṣango [the deity who manifests his power in thunder and lightning],
	Tó n fagi yapàrà nínú oko	Who chops wood violently at the farm,
	Oworowo apógi nífun dà sí gbó	Stripping away the bark, leaving piles of wood chips in the forest, as he lays bare the inner wood.
5	Bí ò bá gbẹ nínú, a gégi lu móko	If the heart of the tree is not yet dry, he leaves it lying in the bush.
	'B ′dóko bá bínú, a tún gé mi si	Even if the owner of the farm becomes angry, he cuts down more trees.
	Agbà àwìn òlèlè sigi lórùn	In the morning he purchases bean cakes on credit to be paid for later with his carvings.
	Baba Olátúndé	Father of Olatunde [One who brings prosperity].[2]

In its longer version, Bamidele's *oríkì* would have included passages from his father's *oríkì*, especially those referring to his lineage. As it is, it is essentially a celebration of his physical power, for Bamidele was equally adept in using the adze with either hand as he stripped the bark and roughed out the basic form of a sculpture.

Among the carvers of Ila-Ọrangun, the crowned town of the Igbomina Yoruba, few are remembered as well as Taiwo of Ore's compound (ca. 1855–1935). In the *ìtàn* recited by Taiwo's youngest son, Bello Onadokun (b. 1898) (fig. 8.3), Taiwo's father, Ajayi Arowo Ẹgbẹ, moved from Ọtun to Ila-Ọrangun about the time when Ọrangun Amesomoyo resettled Ila in 1885, following the retreat of the Ibadan armies after they had laid waste the Igbomina area.[3] The Ọba asked Ajayi to carve a *gbẹdu* drum for him that would entone the sound "ada . . . ada . . . ada" so that he could call his son, Chief Ada, to come home from the wars. The Ọrangun and the people of Ila were so impressed with Ajayi's skills that they gave him many commissions and urged him to bring his family from Ọtun to Ila.

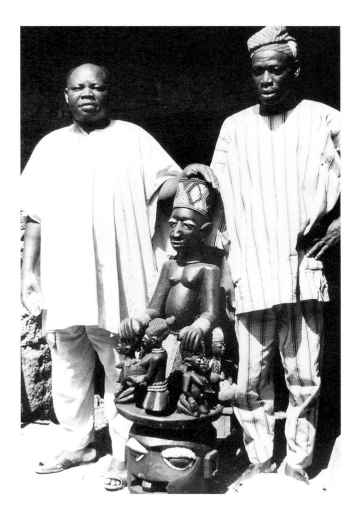 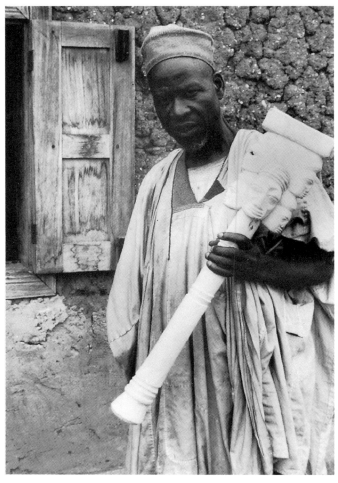

Among Ajayi's many apprentices, Taiwo was the most accomplished, and upon his father's death he became the *baálè* (elder head) of the carvers associated with Ore's and Ọbajisun's compounds. According to Bello, Taiwo carved several of the palace veranda posts during the restoration program of Ọrangun Oyinlọla Arojojoye (1924–36). He also carved the Ẹlẹmpẹ sculpture for the palace while Fakẹyẹ was his apprentice. The sculpture is now in the National Museum in Lagos.[4]

Taiwo's *oríkì* heralds his skill as a carver:

Ọmọ agbó mọtí òjé	Son of an ancient cult [Egungun Arowosoju].
Ọmọ agbó tán feyín si ké	Child of those who become younger as they grow older.
Ofupa pagida o deniyan	He transformed wood into human beings.
Erú òjé ti gbénà pegbèje	The slave of Oje carved and earned 1,400 cowries.[5]

5	Ìwòfà òjé ti gbénà pegbèfà	His servants carved and earned 1,200 cowries.
	Ọmọ bíbí òjé ti gbénà pẹgbèẹ́dógún	His sons carved and earned 30,000 cowries.
	Ba gbénà bí è pé	If our carving is not profitable,
	Ẹ gbókó etí roko	You carry your hoe and go to the farm.
	Ẹ sàgbè ẹ sì nájà	You farm and you trade.
10	Ẹ kórì oyè léwó	You carry chieftaincy materials in your hand [i.e., carvings for chiefs],
	Ẹ mú saworò kú òde	And they bring you respect in the town.
	Ọmọ atè má soògùn.	You who prosper [with your hands] without using powerful medicines.
	Baba ọkọ mi w'Ọyọ dùn ní rèlú ilé	My father-in-law says that living in Ọyọ [i.e., in town] is sweet.
	Igi gbígbẹ ló sọ ó d'ará oko	But it was carving that makes him a dweller in the forest.
15	Ará omúhùnmélé ọmọ ọlóta ló lawo	You are the people who alone know the secrets of the [Egungun] cult.
	Ìyèrú ọmọ akàn-lójè	Offspring of the ever present cult.
	Ọkọ mi ọmọ a gbénú èku rèku	My husband who enjoys performing wonders beneath the mask.
	A gbenú aṣọ da sẹsẹ ré	Who enjoys dancing and playing in beautiful clothes [of the egúngún].
	Baba ọkọ mi t'Ẹfòn wá soògùn l'Erin	My father-in-law went from Ẹfọn to Erin to learn about powerful medicines.
20	Èjé lẹ há gbà l'Erin 'lé	It was a debt you came to collect at Erin Ile.
	Igi gbígbẹ lo sọ yín dará oko	It was carving that made you a person of the forest.
	Ọmọ a-gbó mótí òjé	Son of an ancient cult.
	Ọmọ a-gbó-tán feyín sike	Those who become younger as they grow older.
	Eru Òjé ti gbénà pegbèje	Oje's slave carved and earned 1,400 cowries.
25	Ìwòfà Òjé ti gbénà pegbèfà	His servants carved and earned 1,200 cowries.
	Ọmọ bibi Òjé ti gbénà pegbèẹ́dógún	His sons carved and earned 30,000 cowries.
	Ba gbénà bí è pé	If our carving brought no profit,
	Ẹ gbókó etí roko	You carry your hoe and go to the farm.
	Ẹ sàgbè ẹ sì nájà	You farm and you trade.
30	Ekórì oyè léwó	You carry chieftaincy materials in your hand,
	Ẹ mú saworò kú òde	And they bring you respect in the town.
	Baba Ọnàrínkẹ	Our father Ọnarinkẹ [who earns respect with his carvings].
	Baba Ọnàyèbi	Our father Ọnayẹbi [one whom carving befits].
	Baba méjì lódùn; baba Ẹdúnjọbí	Father of twins. Ẹdunjọbi. Twins are numerous in the family.
35	Ọmọ aláhéré méjì lódò oko	Son of those with two huts at the farm.

Òkan seédé òkan è seé dé	One can be entered, the other cannot [since it contains a shrine to Ogun].
Ọmọ Àkábíyí	Child of Akabiyi.
Ọmọ Yóyinóyè	Child of Yọyinoye.
Ọmọ ògùdù ahó b'ìlù 'Jèṣà	One who roars like a great river, like the great drums of Ijẹṣa.
40 Baba ọkọ mi	My father-in-law.
Ó gbẹ́gi lójú ó gbẹ́gi lẹ́nu	He carved wood so that it had eyes and a mouth.
Ó gbẹ́gi ní gèngè àyà	He carved it so that it had a broad and powerful chest.
Ó lákẹtè lórí okó	He carved the penis with a cap [i.e., circumcised].
Baba ọkọ mi Àjàlá	Ajala, my father-in-law.
45 Ó gbẹ́gi olójú o gbẹ́gi o lẹ́nu	His carving properly depicts the eyes and the mouth.
Ó gbẹ́gi ó ní gèngè àyà	His carving has a broad and muscular chest.
Baba ọkọ mi Àjàlá	Ajala, my father-in-law.
Ó gbẹ́gi o lákẹtè pénpé lórí okó	His carving depicted the penis perfectly with its cap.
Ará àrélù ọmọ olóta lo lawo	Famous hunters who know the secret of the cult,
50 Ẹpa wọn kò gbọdò takàn	Whose shot must not miss its target.
Ọmọ èpà kan epa kàn	Offspring of those who kill various animals.
To ta ogófà ni Ìrèlú Ilé	They shot 120 at Irẹlu Ile.
Ọmọ baba dáadáa	Child of a good father.
Asíhún eni asiwèrè ènìyàn	Crazy and strange people
55 Wọ́n se bí ẹpà yẹpà ni	Thought that he hit his targets by chance.
Wọ́n ò mò pé ẹpà ọdẹ epà bàbà	They did not know that he was the sharpshooter
Ló ta ogófà ni Ìrèlú ilé	Who shot and killed 120 at Irelu Ile.
Ọmọ olóta gbámú esérin	The sharpshooter with the fast bullets
Èpa han è gbọdò tà kàn	Whose shot must not miss the target.
60 Baba ọkọ mi ó gbẹ́gi	My father-in-law carved.
Ó lákẹtè óní pénpé lórí okó	He carved the penis with a cap.
Ìhan e sọmọ Olójé òkósó	They are not of the lineage of the cowardly Ọlọjẹ [owners of *egúngún*].
Ọmọ Olójé òlóló ni hán	They are the descendants of the valiant Ọlọjẹ.
Ó gbẹ́gi ó lójú ó gbẹ́gi ó lẹ́nu	He carved perfectly, depicting the eyes and the mouth.
65 O gbẹ́gi ni gèngè àyà komòkomò	He carved, bringing out the chest clearly.
Baba ọkọ mi, Àjàlá, ti gbẹ́gi	Ajala, my father-in-law carved,
O lákẹtè pénpé lórí okó	Depicting perfectly the penis with its cap.
Ọmọ Oòrè l'Ọtùn	Offspring of the royal family at Ọtun.
Njó enìkan puró to wọmọ Olójé lòhun	One day someone lied, pretending to be from the lineage of Ọlọjẹ [owners of *egúngún*]
70 Hán ní kó gbẹ́gi há	They asked him to carve.
Kígi lójú, kígi lẹ́nu kìrìgì	The carving, they said, must depict the eyes and the mouth clearly,

	Kígi ní gèngè àyà komò komò	As well as a powerful chest.
	Kígi láketè pénpé lórí okó	The penis should have a cap on the end of it.
	O gbégi tán, igi ò lójú	He carved the wood without eyes.
75	Èèní gèngè àyà komò komò	The wood had no chest.
	Èèní gbáketè pénpé lórí okó	He failed to carve a small cap at the end of the penis.
	Nhán wí wo èé somo olójé òlòlò	They said: "You are not a real son of Oje."
	Nhán á ransé si baba ti wa ko wá túngi re gbé	Then they sent for our father to come and do it again.
	Ki gbégi kó lójú, kó lénu, kó layà gèngè, kó láketè pénpé lórí okó	A carving with eyes, mouth, chest, and penis cap.
80	Ó ha gbégi tán, igi pé	He carved the wood, and it was perfect.
	Igi lójú, igi lénu, óni gèngè àyà	The wood had eyes, a mouth, and a powerful chest.
	Ó ha láketè lórí okó	It also had a capped penis.
	O gbégi tán igi pé, igi pé lójú	This carving was perfect, perfect in the eyes,
	Igi pé lénu, igi pé ni gèngè àyà	Perfect in the mouth, perfect in the broad chest.
85	Ó tún wá gbégi láketè pénpé lórí okó	To crown it, he depicted perfectly the penis with its cap.
	Baba há tàse	The father [king] then spoke with authority:
	Ó ní òsá bòsa ore bóre	"Let the appropriate sacrifice be made for òrìsà and Ore [Taiwo's family compound].
	Ó ní àtìran díran ré igi ni ki nwon ma gbé	Future generations shall be known for their carving skills,
	Be bá ti ngbégi tán amá dáa fún yín kánrinkánrin	And they shall continue to prosper for generations."
90	Baba ha tè gbàlè tán	Our father established the Egungun festival [for the house of Ore].
	Owo òle ètí ransé mó	The hand of the lazy one can no longer work.
	Baba wa sè sònà	Our father continues the profession of carving.
	Ónísu lajà bí àgbè	Yet he farms and he has an abundance of yams in his barn.
	Baba Onàrínké	Onarinke, the father who is admired for his carving.
95	Baba Onàyèbi	Onayebi, the father whom carving befits.[6]

The following passage is a portion of the *oríkì orílè* for Ore's patrilineage which was chanted as part of the personal *oríkì* for Taiwo. It illustrates the way in which *oríkì* for persons and *oríkì orílè* are at times inextricably related.

Àrówó ègbé yàn ná	He who has plenty of money from his carving to spend.
Arówó igi wín ni	By working with wood you have much money to lend.
Onílé owó òtún èta wèrè tewà	One whose [carving] skills [right hand] make him a house owner, and who sells sacred and beautiful things.

Òtawèrè dá kẹ́kẹ́ baba Èjídùn	The revered and gentle father of twins.
5 Baba mejì ló wù mi	The beloved father of twins.
Baba Ẹdúnjọbí, baba Bojúwọlá	Ẹdunjọbi [father of twins]; Bojuwọla [who beheld riches with his eyes].
Baba Ọnàyèbi	Ọnayẹbi, the father from the lineage that gains respect through carving.
Kì í rálejò sá baba Bojúwọlá	Bojuwọla, the father who is always hospitable.
Òtété a mọ́ lẹsè bi èga	The handsome one who is as neat as an *ega* [weaver bird].[7]
10 Baba dáada	A good father.

The *oríkì* pays eloquent testimony to Taiwo's achievements in a variety of spheres. He is celebrated as an excellent *egúngún* dancer in the cult of the ancestors. It is remembered that he traveled widely to gain knowledge about powerful medicines (*oògùn*) used by those who dance the *egúngún*. His prowess as a hunter is recalled. He is the beloved father of twins. Above all, Taiwo is the son of a lineage known for its carvers, and it is his skill and artistry that brings him fame. He is "The one with the house on the right who sells sacred and beautiful things." He carved for kings and chiefs. Hence, he is "The father who is admired for his carving." In a delightfully humorous way he is praised for his understanding of what is appropriate with reference to the subject matter of a carving. But Bello also recalled that "Taiwo's carvings were always a surprise. Each time he carved he did something a little different."[8] As in many *oríkì*, the praise song ends on a didactic note, celebrating the virtue of hard work and the importance of farming, and disparaging laziness. Taiwo is thus presented as a model for others to emulate. For he is one who became wealthy through his carving, yet he farmed and had "an abundance of yams in his barn" as if he had farmed full time.[9]

The elder Fakẹyẹ (ca. 1870–1946) was apprenticed to Taiwo and was one of the most prolific of the third generation of carvers of Inurin's compound in Ila-Ọrangun.[10] Fakẹyẹ's grandfather, Bogunjooko, a master carver, came from Omido. Hence the *oríkì* for Fakẹyẹ contains part of the *oríkì orílè* of Inurin's compound in Ila. The first nineteen lines refer to the Ikole and Apa origins of the patrilineage. In lines 20 to 35 reference is made to the lineage's fame for its *egúngún* dancers and itinerant carvers (*àrè òjé*), who traveled to various towns and villages to fulfill commissions, such as at the palace of the Ọba of Ire. The last four lines of the *oríkì* refer specifically to Fakẹyẹ:

Àmì s'Ikòlé	One who is related to Ikọle.
Ọmọ ajepa jólele	Who dances to *epa* and to *ólele* music.
Òlèlè lorò ẹléfòn	The Efọn people are famed for *òlèlè* [bean cakes].
Báà régùn a gbọdò sebọ n'ílé wa	Without masquerades, we cannot make sacrifices in our house.
5 Báà rákàlàmògbò aò sorò	If the vulture is not available, we cannot perform the Oro festival.

Njó wón gbé ohun orò lè n'Íkòlé

Igún wolé dé, igún kó won lébo je

Àpà ènìní tajíhìn ejò

Gbálègbálè Àpà, kí won má gbaràwé

10 Nitori pé eni lerè rìn l'Apà

Òla loká nkómo je

.

Omo agbénlá oká s'ebo

Àpà ènìní tajíyìn ejò

Gbálègbálè Àpà kí han e mó gbaràwé

15 Torí pé òní lerè nrìn l'Apà

Òla loká nkómo je

Àpà ènìní tajíyìn ejò

.

Omo òrólojù mejì bomi wo léná

Iwó jiná Olojò o fò áré

20 Àrè Òjè ará Ojowon

Kó jé nra ará gbó kàn 'nkéké

Olójè ni mo gbégi ránsé sí

Nílé oba Ìrè mo pagidà mo sogi dènìyàn

Àrè Òjé, bi mo gbénà bí ò tà

25 Bí mo gbénà bí ò pé

Ma roko ma fi mosé se

Ma sòwò, ma sì nájà l'Ojè

Gbigbé ni wón 'ngbé, àíru Òjè-Ile

Osé agbé mórù

30 Oòni agbé rekete fóba

Àrù pagidà sogi dènìyàn

Omo òrólojù mejì bomi wo léná

Iwó jiná Olojò o fò áré

Omo Ológbójo

35 Omo elétò Egúngún

Àkóbí Ògún

The day they prepared materials for rituals in Ikole,

The vulture arrived and consumed all their sacrifices.

It is foolish (àpà) to disregard a snake.[11]

Sweepers in Apa, do not sweep away the leaves,

Because today a python may slither through them,

While tomorrow a cobra may appear with its young.

.

The son of one who uses large vipers for sacrifice.

It is foolish to disregard a snake.

Sweepers in Apa, do not sweep away the leaves.

Today a python may slither through Apa,

While tomorrow the cobra will appear with its young.

It is foolish to disregard a snake.

.

The son of a person who saw two spirits and placed ritual water on a fire.

By the time the water boiled, the spirits had flown away.

Are Oje [family of itinerant egúngún performers] from Ojowon [a lineage of famous carvers].

When he carves, the wood is as white as a person's teeth.

I made a fine carving for the Olojowon.

In the palace of the king of Ire I transformed wood into a human being.

If Are Oje does not prosper from his creations,

If carving is not profitable,

Then I [Are Oje] shall add farming to my work.

I shall trade and go to the market at Oje.

But we are carvers, not carriers of ordinary loads in Oje.

Carvers who do not carry loads

Are the powerful persons who create beautifully carved figures for kings.

He transformed wood into a human being.

The son of a person who saw two spirits and placed ritual water on a fire.

By the time the water boiled the wicked spirits had flown away.

Child of Ologbojo [a lineage of carvers].

Child of Egungun.

Akobi Ogun (The first born of Ogun).[12]

Ari l'ọkùnrin ò jọ ni l'ójú	At first glance he appears to be an ordinary person.
Asúnmọ tán ó d'apọn	When we see him clearly, we know that he is extraordinary.
Ọ̀gbìn ará Ògbojo	One from a lineage of Ogbojo [carvers].[13]

The *oríkì* places Fakẹyẹ in a lineage of carvers who "create[d] beautifully carved figures for kings" and "transformed wood [lit. "the materials of the earth"] into a human beïng." Like his itinerant predecessors, his sculptures have been found on shrines in Omu Aran and other neighboring Igbomina towns and villages. As late as 1972 his carvings for Ṣango devotees graced the altars of many compounds in Ila-Ọrangun (fig. 8.4). What is remarkable in Fakẹyẹ's *oríkì* is that, although he was not a chief, he was greeted with the title "Ọọni" (line 30), the title of the Ọba of Ile-Ifẹ. In the eyes of his contemporaries his skill as a carver (*ifarabalẹ̀*, control of hand and mind) and his artistry (*ojú-inú*, insight, and *ojú-ọnà*, eye for design) commanded the respect and awe due a king. Indeed, his powers linked him in the minds of his peers with the gods. Such was his dexterity in the use of the adze and knife, the metal instruments forged with the powers of *òrìṣà* Ogun, that he is addressed as Akọbi Ogun ("The first born of Ogun").

It is clear that *oríkì* for carvers reveal the recognition bestowed upon an artist by his contemporaries and how he is remembered by his descendants. While set phrases, such as, "One who carves wood as though it were a calabash" and "He transformed wood into a human being," are often employed, the *oríkì* are highly personal, referring to the carver in the context of his particular lineage and workshop, albeit often in an oblique and highly stylized language dependent upon local knowledge for its understanding. More important, as Karin Barber observes, personal *oríkì* allude to "the subject's achievements, sayings or qualities." They go to "the heart of a subject's identity by evoking whatever is distinctive in it" (Barber 1991:13). And herein is their importance for the student of Yoruba art history. Apart from whatever bits of information about where or for whom a carver worked, the personal *oríkì* of carvers provide abundant evidence of the regard with which carvers were (and are) held in Yoruba communities. They were, in a sense, "big men" with their followers—apprentices, assistants, and patrons—and commanded the respect of other persons in the community, including those who wore crowns. Their *oríkì* testify to the fact that they were not ordinary persons in the community. Indeed, as Rowland Abiọdun and Funṣo Afọlayan have observed, the *oríkì* not only proclaims that the subject of praise is extraordinary but also plays a significant role in the transformation of perception into reality.[14] Taiwo is remembered as one who knew the secret of Egungun and possessed powerful medicines. Ọlọwẹ's carvings were thought to be so beautiful that persons said that they were carved by spirits who were always at Ọlọwẹ's service in the night. The *oríkì* for Bamidele begins by describing him as a "wizard" (*àjẹ́ ọkùnrin*), and his axe is likened to the thunderbolts of *òrìṣà* Ṣango. Hence the sensitive observation in Fakẹyẹ's *oríkì*:

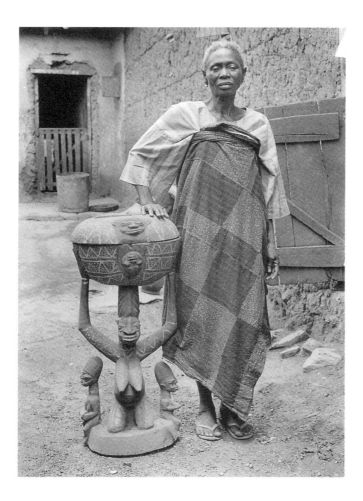

Fig. 8.4.
Sango Ponle, a
devotee of *òrìṣà*
Sango, with an
arugbá Ṣàngó
carved by Fakeye.
Ila-Orangun, 1977.
Photo: John Pemberton III.

The first born of Ogun.
At first glance he appears to be an ordinary person.
When we see him clearly, we know that he is extraordinary.

Aesthetics and the Interplay of the Arts in Yoruba Culture

We must now turn to a second question raised by the essays in Part Two. Yoruba art historical studies have, until recently, focused upon the visual or plastic arts as the primary area of inquiry. This is not surprising, since the ancient Ife sculptors created in bronze and terracotta some of the

world's artistic treasures, and over the centuries the Yoruba have been among the most prolific carvers in ivory and wood in sub-Saharan Africa. Following the model of Western art historical studies, the primacy of the object has, until recently, dominated and shaped the inquiry, and formal analysis of a visual art work has been accepted as its principal task. Connoisseurship is as essential in the study of Yoruba sculpture as in the study of Italian Renaissance art. One may explore regional styles, analyze the distinctive characteristics of carvers' workshops in a particular town, or seek to identify the hands of individual artists. To venture beyond such inquiries, however, was, until recently, thought to be engaged in anthropology and the study of material culture, not in art historical studies.[15]

Heretofore, a commitment to the "primacy of the object" meant seeing and understanding a sculptural form in the context of collecting art, a distinctly Western notion and practice. Yoruba sculptural forms, however, while amenable to formal analysis, resist the limitations imposed by the inquiry as pursued in Western art historical studies. The term *ojù-ọnà* (eye for design) clearly indicates Yoruba attentiveness to composition, to developing a connoisseur's eye for the formal properties (*ọnà*) of an art work.[16] The term also suggests that sculptural form reveals an artist's sense of appropriateness (*yíyẹ*) with respect to the use of what he/she creates. Such an understanding entails the knowledge that an art work exists within a larger context of use and meaning than a collection of art works.

To sculpt is to sculpt for a patron, place, and use: a shrine sculpture for the altar of a devotee of *òrìṣà* Ṣango, a headdress for an Ẹpa or Egungun masquerade, an *opón Ifá* for the rituals of a *babaláwo,* or a palace door to celebrate the authority of one who wears a beaded crown. To dance is to perform the distinctive steps and body movements appropriate in festivals for the ancestors, "the mothers," and *òrìṣà* Agẹmọ or in accordance with one's status within the community. To sing or chant is to do so in a manner required by the occasion: hunter's *ijálá* chanting for Ogun, *Sàngó-Pípè* for *òrìṣà* Ṣango, *iwì* for the ancestors, *rárà iyàwó* by a young bride, *oríkì orílè* for a lineage, and *ẹṣẹ Ifá* in rituals of divination. There are instruments and rhythms to be played only for the Ọba, for a procession of mourners, or for the dancing of *òrìṣà* worshipers.

To fail to create that which is appropriate is to invite severe criticism. I once showed David Fakẹyẹ, the eldest son of Fakẹyẹ and Chief of Inurin's compound in Ila-Ọrangun and a fine carver in his own right, a carving that appeared to be an *ibejì* figure except that protrusions from either side of the head suggested that it was a Ṣango dancewand that had lost its handle. There was no evidence that a handle had been removed, and I had documented several similar carvings by the same carver, who, I believe, was a carver in Ila around the turn of the century. Following a careful examination, Chief Inurin said: "It is the work of a good carver, but he did not know how to carve an *ibejì.*" While watching the dancing of a spectacular masquerade during the 1982 Agẹmọ Festival in a forest clearing near Imosan Ijẹbu, an elder turned to me and said: "The crowd may

be delighted by the dancing, but the òrìṣà will not be pleased. One must first perform the steps for Agemọ correctly and then entertain the audience."

For the Yoruba, aesthetic judgments entail both formal and contextual analyses. The English term *art work* is helpful in this respect, for it has dual connotations. It usually refers to a work of art, an object of art. However, it may also be thought of as artistry, the creation of art, as praxis, as well as object. The essays by Karin Barber, Akin Euba, and Margaret Drewal make it quite clear that the Yoruba are more apt to think of art as an act of creative imagination executed with skill and an understanding of the subject, than of art as object, and to evaluate art, whether expressed in verbal, visual, or kinetic modes, in specific contexts and in the interplay of the arts.

As Karin Barber observes, while the virtuosity of Ṣangowẹmi's *oríkì* chanting is applauded as high entertainment, it is the chanting by Faderera that is said to have "depth" (*ìjìnlè*). Faderera, too, is skilled in imaginative wordplay and delights in exploring and pressing the poetic possibilities of a tonal language. But she does not lose sight of her subject or control of her verbal artistry. Her task as a singer of *oríkì orílè* is not simply to entertain but to evoke from her listeners an awareness of themselves, a depth of understanding.

The same may be said of the sculptural artistry of Bamgboye of Odo Ọwa. Bamgboye's *oríkì* refers to him as "One who created large carvings/And gave his carvings names." (Ọmọ osọnà se rìbìtì/ Gbégi mú sọni.) In his great Ẹpa headdress, known as "Ọrangun," Bamgboye displays his virtuosity as a carver, as one whose work reveals a discipline of mind and hand (*ìfarabalè*) (figs. 8.5, 8.6).

"Ọrangun" consists of numerous figures, each distinctive and visually interesting, surrounding a larger equestrian figure. Thus the Ẹpa headdress may be thought of as a visual *oríkì*, a celebration of the warrior chief in the establishment of Ekiti towns. As the last masquerade to appear in the Ẹpa festival in Erinmọpe, "Ọrangun" is greeted with the drumming and chanting of praise songs which proclaim the power (*àṣẹ*) of the Ọba (ruler) as a source and expression of the life of a Yoruba community.[17] Verbal and visual *oríkì* coalesce in a festival celebrating cultural achievement. In Bamgboye's monumental work the distinctive roles of individuals within a loosely structured hierarchical framework are visually celebrated. His artistry combines virtuosity and deep knowledge.

Thus the *oríkì* for Bamgboye concludes with a fitting tribute to his genius as a carver:

Erin lọ tuú lójú alájá	The elephant has fled in the face of the hunter.
Àjànàkú kú lugbo ò le dide	The mighty one has fallen in the forest and can no longer rise.
Eerin wó; eerin lọ	The elephant has fallen; the elephant is gone.
Eerin wó; eerin lọ	The elephant has fallen; the elephant is gone.
5 Àjànàkú subú kè le dide	Ajanaku the mighty one has fallen and can no longer rise.

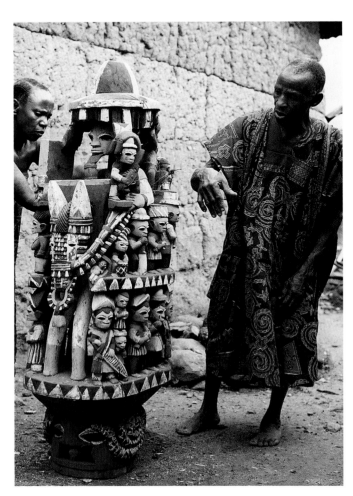

Àjànàkú subú ke le gòkè	Ajanaku has fallen and cannot climb the mountain.
Baba se be o mò lo	Our father has indeed departed.
Pèlé mo Olóra arìnledù	Well done, son of Olora, who walks majestically.[18]

Artistry and virtuosity, as Akin Euba suggests, is what is expected when the lead drummer challenges (*kì*) the dancer of an ancestral masquerade (*egúngún*) by drumming the tonal patterns of its *oríkì* which empower the dancer to be, and the lineage members to perceive, the ancestral presence. It is in the interplay of drumming and dancing, when the *egúngún* moves with stately grace and then, responding to the drums, whirls, the layers of cloth lifting, filling the surrounding space, that followers of an *egúngún* shout its *oríkì*, empowering the *egúngún* and themselves.

Olabiyi Yai refers to oral and visual *oríkì* as "vocative discourse" which is both "evocative" and "provocative." Drummer and dancer continuously challenge and empower each other to a fuller

Fig. 8.5.
Ẹpa headdress
called "Ọrangun,"
carved by
Bamgboye of Odo
Owa. Erinmope,
1971. Photo: John
Pemberton III.

Fig. 8.6.
Bamgboye at his
home in Odo
Owa, 1971. Photo:
John Pemberton
III.

expression and embodiment of the ancestral presence. In turn, the members of the household respond with chants of praise, occasionally adding new salutations to their repertoire, capturing in a cryptic phrase something more to be remembered about the lineage. Virtuosity and deep knowledge are the hallmarks of a powerfully affective total performance.

In sculptured forms, dance movements, drum rhythms, or chants there must be a sensitivity to what is appropriate and an insight (*ojú-inú*) into the subject of an artistic work. Art is always part of a particular cultural tradition (*àṣà*) and is created in the context of an artistic heritage within the larger cultural enterprise. As Ọlabiyi Yai astutely notes, *àṣà* not only refers to a tradition of received ideas and materials but also to "innovation." The Yoruba concept of "tradition" does not imply a fixed, unchanging heritage but entails creative imagination, exploration of a subject and/or medium, and innovation. In this respect, it is analogous to what Margaret Drewal observes about the ritual process in Ifa divination. Rituals rely upon formal procedures and received meanings, but they also entail "searching," exploring the deeper meanings of the verses of Ifa, examining the metaphors in relation to the concerns, needs, and aspirations of a suppliant. It is not simply a matter of a priest's knowing what actions to perform and when. Mindless repetition of the practices and words of the ancient *babaláwo* is not what it means to "follow in the ways of the fathers." Rather, it is to think anew about the human condition in the context of rites and verses bequeathed to later generations by the ancient *babaláwo*, as well as in festivals for ancestors who are "dwellers-in-heaven" (*ará òrun*) yet present in the world of the living. For the Yoruba, artistry is the exploration and imaginative recreation of received ideas and forms.

Notes

1. Chanted by Bamidele Areogun with the assistance of elders of the Dada Areogun household, 25 March 1992, Osi-Ilorin. I am grateful to Funṣo S. Afọlayan for transcribing the tape recording and assistance in translating the text.

2. Recited by an elder of Dada Areogun's house with the assistance of Lamidi Fakẹyẹ, 25 March 1992, Osi-Ilorin. I am grateful to Funṣo S. Afọlayan for transcribing the tape recording and assistance in translating the text.

3. Bello Onadokun, personal communication, 30 March 1992.

4. Lamidi O. Fakẹyẹ has claimed that the Ẹlẹmpẹ figure was carved by Fakẹyẹ, his father (Pemberton 1987:122). When the sculpture was taken to the National Museum in Lagos in order to preserve it from further deterioration, Ogunwuyi, Taiwo's son and a highly skilled carver, was commissioned by the *ọba* to carve another Ẹlẹmpẹ sculpture for the palace veranda. It may be that Bello is correct in attributing the first carving to Taiwo. It may also be true that Fakẹyẹ, who was apprenticed to Taiwo at the time, did much of the carving and thus felt justified in claiming to be the sculptor. Stylistic analysis is difficult, since Fakẹyẹ was strongly influenced by Taiwo. Nevertheless, when one examines works attributed to each artist, the earlier Ẹlẹmpẹ figure suggests the hand of Taiwo.

5. Cowries were the form of currency among the precolonial Yoruba.

6. The first thirty-nine lines of the *oríki* were chanted by Alhaja Rabiatu Bello, wife of Bello and

daughter-in-law of Taiwo. Lines 40 through 95 were chanted by a junior wife whose name I failed to record. Both women chanted the *oríkì orílè* and were present throughout the recording sessions at Ore's compound on 30 March 1992 in Ila-Ọrangun. I am grateful to Funṣo S. Afọlayan for transcribing the tape recording and assistance in translating the text.

7. Bello explained that when Taiwo carved, he always placed his feet on a pile of wood chips so that, like the weaver bird, his feet never touched the ground and got dirty.

8. Personal communication, 22 April 1981.

9. I am indebted to Funṣo S. Afọlayan for his insightful observations about the nature and structure of *oríkì*. In the course of working together on the translation of *oríkì* for carvers, he called my attention to the didactic character of praise poems.

10. For an extended discussion of the work of Fakẹyẹ in the context of the history of carvers' workshops in Ila-Ọrangun, see Pemberton 1987:117–35.

11. According to Funṣo S. Afọlayan, the state of Apa was in a region well known for its variety and abundance of snakes, which were used in the ritual life of Apa.

12. "Akọbi Ogun" is a praise name which could be used as a form of personal address.

13. Recited by Lamidi O. Fakẹyẹ at Inurin's compound on 25 March 1992 in Ila-Ọrangun. I am grateful to Funṣo S. Afọlayan for transcribing the tape recording and assistance in translating the text.

14. In conversations following the reading of earlier drafts of this essay, Abiọdun and Afọlayan called my attention to the ways in which the language of *oríkì* contributes to the creation of the person to whom it is addressed. The word *oríkì* is formed of two terms: *orí* (in this instance, *orí inú*, the inner head) and *kì* (challenge). Thus an *oríkì* "challenges the head," calls forth one's identity.

15. For a critical examination of the history and recent developments in African art historical studies see *African Art Studies: The State of the Discipline*, Papers Presented at a Symposium by the National Museum of African Art, Smithsonian Institution (16 September 1987), Washington, D.C.: 1990.

16. For an extended discussion of Yoruba aesthetic terminology as it applies to the visual arts, see Abiọdun, Drewal, and Pemberton 1991.

17. See Thompson 1974:191–98.

18. Recited by James Bamgboye, 25 March 1992, at Bamgboye's house in Odo Ọwa. I am grateful to Funṣo S. Afọlayan for the transcription of the tape recording and assistance in translating the text.

9. Lagbayi: The Itinerant Wood Carver of Ọjọwọn

Wande Abimbọla

Yoruba art historians are now beginning to focus on the works of individual artists and to analyze the style and contribution of each artist in what can easily be described as one of the richest artistic cultures the world has ever seen. Several Yoruba art exhibitions which have toured Europe and America during the last ten years have rekindled the interest of art historians, anthropologists, collectors, and the general public in Yoruba art and especially the master artists who produced the beautiful works of art that have put the Yoruba people on the world map.

Thus far, a good number of art historians working on this subject have concentrated on the wood carvers of northeastern Yorubaland, especially Ekiti and Igbomina master carvers such as Arẹogun, Bamgboye, Ọlọwẹ, Obembe, and Lamidi O. Fakẹyẹ, the contemporary wood carver. This is due largely to accidents of history, since many ethnographers and historians of the early part of this century did their work in northeast Yorubaland. They include investigators like Father Kevin Carroll, William Fagg, and others who personally encountered these artists or recorded their contributions (see Carroll 1967; W. B. Fagg 1969:42–57; Fagg and Pemberton 1982:35–49). In fairness, it should also be noted that William Fagg also documented the work of individual carvers and carvers' compounds in southwestern Yorubaland, and William Bascom wrote at length on the work of Duga of Meko (Bascom 1969:98–119). Subsequent writers on Yoruba art have since written about the same artists, as if they were the only ones worthy of remembrance or celebration.

Apart from the identification of carving styles, few scholars have studied the work of individual wood carvers of the northwestern savanna lands, even though some are well known by the Yoruba, since they have been celebrated in the oral traditions of the area. One such artist is the legendary Are Lagbayi, the carver (*ara*) from Ọjọwọn. Lagbayi was also known as the itinerant citizen of Ọjọwọn. The purpose of this short essay is to present some of the *oríkì* (praise poetry) of this great artist as remembered by the members of his own lineage, variously known as the Ọlọjọwọn, Ọlọjẹẹ, Abogunde, or Lagbayi lineage. This same lineage is also known as Agbo, which is a shortened version of Agbo-mọ-tii Ọjẹ (descendant of Ọjẹ who lived to a ripe old age without losing his beauty). My mother belongs to this lineage, and the excerpt quoted below, rendered in the Ṣango chanting mode (*Ṣàngó-pípè*), is from my mother who is now ninety-one years old.

Are, Lagbayi, Ara Ọjọwọn	Lagbayi, the Wandering Citizen of Ọjọwọn
Mo ní ẹ̀yin ò rí onílálukú o.	Note, everyone!
Bí wọn ó sàna ìyàwó láyé Abíọ́dún.	Whenever men paid dowries on their wives during the reign of Abiọdun,
Wọn a músu,	They took yams,
Wọn a sì mádìe,	They took chicken
5 Wọn a mú relé ayaa ti wọn.	To the homes of their wives.
Àwọn onìkàlùkù,	Behold, everybody!
Bí wọn ó sàna ìyàwó.	Whenever a man paid the dowry on his wife,
Wọn a músu,	He took yams,
Wọn a sì mádìe,	He took chicken
10 Wọn a mú relé ayaa ti wọn.	To the home of his wife.
Ọmọ Eégún sékéte wére	It is a small but agile Egungun
N làwá a fí í sàna nílée wa.	Which we use as dowry in our house.
Ìyáà mi Òjè.	My mother is an Ọje.
Babaà mi Òjè,	My father is also an Ọje.
15 Òjè n ló wáá ni mí tìbi tìran.	My entire family and lineage belong to Ọje.
Ìrèké dìran àkùọ̀.	Sugarcane has become a family of marshland.
Àkùọ́ dìran ìrèké.	Marshland has become a family of sugarcane.
Eégún dorò nílé àwa.	Egungun has become a ritual object of our house.
Èyin lọmọ òkúta ́nlá borí kogó o.	"You-are-an-offspring-of-the-big-stone-with-hard-top,"
20 Ọmọọ gbò́ngbò ọ̀nà múlẹ̀ ta gìrìrì.	"You-are-an-offspring-of-a-tree-stump-a-bush-path-which-shakes-the-ground-persistently,"
Àwọn náà ló dífá fún ọlójà mérìndínlógún.	These are the names of the diviners who cast Ifa for the sixteen great noble men of old.
Ọlójẹ̀ẹ́ nìkan sọsọ ló rúbọ . . .	Ọlọjẹe was the only one who performed the prescribed sacrifice.
Ọmọ méta nìyáa wọ́n bí.	Their mother had three children.
Òsé lẹ̀gbọ́n.	Ose was the senior child.
25 Okoye làbúrò.	Okoye was next to him.
Ajíbógundé lọmọ ìkanyìn wọn lénje lénje,	Ajibogunde was the last of them all.
Òsé ́n gbénà níjù.	Ose used to carve wood in the deep forest,
Okoye ́n kéégún relé.	While Okoye carried the Egungun art objects [produced by his brothers in the forest] into the city.
Eégún dorò nílé àwa.	Egungun has become a ritual in our house.
30 Ìrèké dìran àkùọ̀.	Sugarcane has become a member of the family of marshland.
Àkùọ́ dìran ìrèké.	Marshland has become a member of the family of sugarcane.
Eégún dorò nílé àwa . . .	Egungun has become a ritual of our house . . .
Mo ní ẹ̀yin ò rí oníkálukú o.	Watch, everybody!
Bí wọn ó gbẹnà lósòkun.	When artists carved wood at Ọsọkun

35	Wọn a gbẹ́ ti wọn lébọ́rọ́ igi, lébọ́rọ́ igi.	They carved shapeless wooden objects.
	Àwọn onìkàlùkù,	See, all and sundry,
	Bí wọn ó gbẹnà lósòòkun, Òjéẹ'lé.	When people carved wood at Ọsọkun in the city of Ọje Ile, our ancestral home,
	Wọn a gbẹ́ ti wọn lébọ́rọ́ igi, lébọ́rọ́ igi.	They carved shapeless wooden objects.
	Bàbáà mí gbẹ́ tiè,	But whenever my father did his own carving,
40	Ó rí bòlòjò bolojo.	It looked robust and beautiful.
	Àrè pagi dà, sọgi dènìyàn.	The itinerant carver, who changed a wooden object into a human being.
	O sá kékéẹ gi wére wére.	You, my father, inscribed beautiful and delicate *kéké* facial marks on a wooden object.
	Bàbáà mi bàbàjàa'gi pòòtò pàatà lówòn.	You inscribed broad *abàjà* marks on a wooden object in the city of Ọwọn.
	Àrè, Làgbàyí, o gbẹ́nà gbáwòrán láyé Abíódún.	Lagbayi, the itinerant artist who carved wooden objects resembling real persons during the reign of Abiọdun.
45	Níjọ́ tí Àrè Làgbàyí ń toko ọnàá bò.	On the day Lagbayi, the itinerant artist, was returning from one of his carving expeditions,
	Apá ń sáá lapá.	The *apá* trees collided with one another in trepidation.
	Ìrókò wọn a dìgbò lòpè.	The *ìrókò* trees collided with the palm trees in great fear.
	Wón láwọn ò mọbii Làgbàyí ó sọgbá ọnà yí kà.	They wondered where next Lagbayi would place his load of carving implements.
	Ẹni ó kúrú, ń tiro ni wón ń tiro.	Short people in the crowd stood on their toes,
50	Ẹni ó gùn, wọn a bẹrè.	While very tall spectators stooped down [to catch a glimpse of him].
	Wón ń se, "Kújénrá, Àgbósòkun,	They all exclaimed, "Kujenra, whose other name is Agbọsokun,
	Léwo lò ń lò.	Where are you going?
	Ònà wo lò n rè.	On which road are you going to tread?
	Ǹ bá mọbi ò ń rè,	I wish I knew where you were going,
55	Ma bá o lọ."	I would have gone with you."
	Ikújénrá o, Àgbósòkun,	Ikujenra, whose other name is Agbọsokun.
	Ọmọ a gbégi wúrúkú mú se láyaba.	Offspring of those who carved small pieces of wood and turned them into queens.
	Àrè, Làgbàyí o, ará Òjọwòn.	Lagbayi, the itinerant citizen of Ọjọwọn.
	Ọmọ eléégún sékéte wére.	Ikujenra, whose other name is Agbọsokun.
60	Ikújénrá, Àgbósòkun,	Offspring of owners of small but agile Egungun.
	Àrè, Làgbàyí o, ará Òjọwòn.	Lagbayi, the traveling citizen of Ọjọwọn.
	Ikújénrá, Àgbósòkun,	Ikujenra, whose other name is Agbọsokun.
	Ọmọ agbe dúdú	Offspring of the blue turacoo bird
	Tí ń yéyin funfun.	Who produced white eggs.
65	Àrè, Làgbàyí o, ará Òjọwòn.	Lagbayi, the itinerant citizen of Ọjọwọn.

The subject of this *oríkì* is Lagbayi, *ará* Ọjọwọn. He was an itinerant wood carver, although there is no doubt that his real home was Ọjẹ Ile. Some art historians have discussed the works of the master carver Abogunde of Ẹdẹ.[1] Future research should discover whether Abogunde of Ẹdẹ was related to the legendary Lagbayi, son of Abogunde's compound in Old Ọyọ, who is the subject of this essay. Is it possible that Abogunde of Ẹdẹ was a descendant of the same Abogunde of Ọjẹ Ile who took the name of this ancestor?

According to the *oríkì*, it was the style of Lagbayi to inscribe short *kéké* marks and broad *àbàjà* marks on the faces of his artistic creations, and also to make his carvings as naturalistic as *àwòrán* (a picture [literal depiction]).[2] His carvings were tall and robust human figures. The Yoruba words used to describe them are *bọ̀lòjọ̀ bọlọjọ*. Even small carvings appeared queen-like, that is, had monumental qualities. Unfortunately, objects carved by Lagbayi have not been found or documented in any literature. There are not, however, many Yoruba wood carvings with *kéké* marks which have been preserved. Perhaps an examination of the few that are known might provide a clue to the work of the ancient carver. The *àbàjà* facial marks on the faces of carvings by the late nineteenth-century master Abogunde of Ẹdẹ are not as thick or broad (*pòòtò pààtà*) as those attributed in the *oríkì* to Lagbayi (see Drewal, Pemberton, and Abíọdun 1989:150, pl. 16). We are, therefore, still in search of the works of art produced by the legendary Abogunde Lagbayi, citizen of Ọjọwọn.

The *oríkì* also reveals that Lagbayi had two older brothers, Ose and Okoye. Ose was also a master carver who did all his carving work in the deepest part of the forest known as *yu*, while Okoye carried home the carvings of his two brothers and, presumably, sold them or handed them over to patrons who used them to adorn their *egúngún*. Oral tradition does not record much more than this about Okoye and Ose.

Why were the carvings of Lagbayi and his brother Ose done in the deep forest? One of the motivations for carving in the forest was to be close enough to the best trees used for carving, such as *apá* (a West African mahogany known as *Afzelia Africana Caesalpinaceae*), *irókó* (a West African teak known as *Chlorophoro Excelsa*), and other famous hardwoods of the Yoruba forest, including *iréna*, *ṣigo*, and *èmí* (the Shea Buttertree, *Butyrospermum Parkii*). But the most important reason for carving in the forest was to allow the carver to be away from his family and community and thereby to be alone in order to gain the much-needed inspiration, tranquility, and quiet composure of mind and body necessary to carry out his creative task. In Yoruba belief, the forest is the abode of spirits and supernatural beings as opposed to the city, which concerns itself with everyday economic and social issues. It is for this reason that sacred and important assignments are carried out in the forest. For example, Ifa priests are ordained or initiated in the forest. In ancient times the most important ritual for an Ọba-elect was performed in the forest or bush (*eréko*). Hunters and warriors treated their wounded colleagues only in the bush.

One must also comment briefly on the reference in the *oríkì* to Ọjẹ Ile or Ọjọwọn which was

the setting for the production of art objects by Lagbayi and his brothers. Ọjẹ Ile was a flourishing major town in upper Ogun not far from the present town of Aha, before it was destroyed soon after the fall of the Old Ọyọ Empire in 1836. The father of the present writer, the late Aṣipade Abimbọla Iroko, used to hunt in the area where the ruins of Ọjẹ Ile and other ruins can still be found today. Stories told to me by my father inspired me to write an article entitled "The Ruins of Ọyọ Division" (Abimbọla 1964). This article soon came to the attention of Professor J. F. Ade Ajayi, who then obtained funds enabling us to collaborate in a research project to study the history of the area, where there are ruins of more than twenty Yoruba towns. The area was certainly one of the most densely populated in Yorubaland in the eighteenth century. Unfortunately, I could not leave my position at the University of Lagos, but the project's research assistant, Mr. S. O. Babayẹmi, continued the research and produced his Ph.D. thesis several years later on the same subject.

I remember vividly that my late father guided Babayẹmi to Ọjẹ Ile and other ruins of the area. What was, at that time, a hunter's paradise has now been resettled mainly by farmers whose slash-and-burn clearing of the land destroyed many of the historic sites. The forests in which Lagbayi did his carving have probably disappeared, but the ruins of Ọjẹ Ile investigated by Babayẹmi should be visited for further interdisciplinary research involving scholars of oral history, archaeologists, and art historians. This research should be carried out in conjunction with knowledgeable elders of Aha Ọjẹ, the town that succeeded Ọjẹ Ile, and its Ọba, who still holds the title of Olojeẹ. Such interdisciplinary research will assist us in learning much more about Lagbayi, the legendary master carver of Ọ̀jọ́wọ̀n, and give us a glimpse of the social, economic, political, religious, and environmental forces that influenced the development of wood carving and artistic creativity in general prior to the fall of Ọyọ Ile in the 1830s.

Another important reason to visit Ọjẹ Ile once again is to study the connection of this famous town in Yoruba oral tradition with the history and mythology of Egungun. The story of Egungun has always been closely associated with the traditions of wood carving and other forms of artistic creativity in the Ọyọ area. According to Oludare Ọlajubu, the idea of Egungun was originated by the Ologbin, otherwise known as Èsà Ògbín ará Ògbojo (the great ancestor known as Ogbin, citizen of Ogbojo) (Ọlajubu 1972). According to oral history (ìtàn) in the area, the first costume of Egungun was woven by the Alaaran, whose place of abode is known today as Omu Aran, and it was Olojeẹ who produced the beautiful masks conspicuously displayed on the head of Egungun masquerades.

One of the most important patron groups of the carvings of Lagbayi and his brothers were the Egungun devotees of Ọjẹ Ile and its surrounding district. But perhaps the most important patron of all was the royal court of the Alaafin Ọyọ, especially Alaafin Abiọdun, who reigned toward the end of the eighteenth century. He was famous for his patronage of Egungun, as well as the wood carvings with which he lavishly decorated his palace. Another important lineage of wood carvers

who produced decorated posts for the royal court of Ọyọ is the Opomulero lineage, who are also well remembered in oral literature (Abimbọla 1978). Without the patronage of the royal courts and the commissions of individual devotees of the Yoruba *òrìṣà* community, such as the Egungun worshipers, it is doubtful if the rich tradition of wood carving would have survived and developed as a major artistic occupation among the Ọyọ Yoruba.

It is important to comment on the word *àrè*, which is used as a praise term for Lagbayi. This word is used to describe an itinerant person. In traditional Yoruba society, artists, such as singers, carvers, and dramatists, were regarded as *àrè* because they traveled from place to place to carry out their artistic work. Even today, most artists, such as dramatists who operate traveling theaters, singers, and entertainers, live the life of *àrè*. The same is true of modern Yoruba artists who now travel frequently in Africa, Europe, and America to stage exhibitions, attend conferences, stage live displays of their work, and meet would-be patrons to attain new commissions.

In this brief paper I have attempted to demonstrate the knowledge that we can gain from oral literature in our study of the Yoruba tradition of wood carving. We may never be able to find a single wooden object that can be recognized as an authentic carving of Lagbayi, but our knowledge of his work and the society in which he lived will certainly continue to enrich our understanding of Yoruba wood carving. This tradition goes back hundreds of years, but it probably reached the height of its development during the reign of Ọba Abiọdun, the great patron of the arts, and the time of the itinerant Lagbayi, one of the best-known wood carvers in Ọyọ Yoruba memory.

Notes

1. See Pemberton, "The Carvers of the Northeast," in Drewal, Pemberton, and Abiọdun 1989; H. U. Beier 1957; Fagg and Pemberton 1982.

2. The word *àwòrán*, which is now often translated as "photograph," is derived from the name of a very beautiful wife of *òrìṣà* Ọrunmila who turned out to be a lifeless person, not unlike a piece of wood.

10. The Role of *Oríkì Orílè* and *Ìtàn* in the Reconstruction of the Architectural History of the Palace of Gbongan

Oba Solomon Babayemi, the Olufi of Gbongan

I chose to write this paper for many reasons.[1] First, I am presently the Olufi, traditional ruler of Gbongan and inheritor of the palace. I have also been part of the process of building the *oríkì orílè* (the *oríkì* of origin) and *ìtàn* (oral history) upon which the architectural history of the palace at Gbongan is based.[2]

In 1937, as an apprenticed drummer, I had to participate in the early Friday morning drumming and praise singing sessions in the palace and chant the *oríkì* of the incumbent, Olufi Asabi, who reigned from 1925 to 1948, and all the past Olufis.[3] Present at these early Friday morning sessions were the *dùndún*[4] drummers and the *sèkèrè*[5] drummers. There were also the Alaros,[6] the priestesses of Sango and Oya; the main *ìjálá* chanters in Gbongan, then led by Aketi Elegbo Soogun;[7] the Iya Egbe (Popoola's mother),[8] who had a voice like cymbals, a very pure, resonating voice, who was the priestess of the inner spiritual head (*orí-inú*) of individuals. The Iya Egbe was usually the star of each drumming session with her *rárà* renditions. The priests and priestesses of *òrìsà* Akire, the Olufi's own *òrìsà*, who must be of royal descent, were also present at these early morning sessions.

The *oríkì* collected during these sessions provided more than enough historical data on the architectural history of the palace. It should be stressed that since all the verbal artists in Gbongan usually participated in this early morning session, the *oríkì* of the Olufi and of the palaces referred to should be understood as a corpus of oral literature known to many and not the preserve of a single artist. The structure of the *oríkì* is rather uniform, the content well established and adhered to by all the artists. As such, the *oríkì* could not be easily added to or diminished.

The *oríkì* chanted by the artists are also repeated by the priests, priestesses, and cult members in the various compounds and shrines in the palace during the weekly ritual performances and throughout the cycle of annual festivals. That is, the *oríkì* are rendered publicly on ritual occasions and are therefore regarded as sacred. Although the *oríkì* are common knowledge to all artists, they cannot be rendered profanely. For an *oríkì* is a creed to be preserved in honor of the Olufi.

While the Olufi's palace has features shared with other Yoruba palaces, making the palace at Gbongan fairly representative of Yoruba palaces in general, it is noteworthy that it contains some essentials one would find in the palace at Oyo. This point must be understood in the context of Gbongan's history.

Gbọngan's History and Its Contemporary Significance[9]

Gbọngan is the headquarters of the Ayedaade local government in Ọṣun State, Nigeria. The town's history dates to the first Olufi who was a son of Abiọdun Adegoriolu, the famous eighteenth-century Alaafin (King) of Old Ọyọ. This first Olufi contested the throne at Old Ọyọ with other princes, failed, and therefore had to leave Old Ọyọ. He took from the palace the white beaded crown [emblematic of the Ọyọ origin of the Olufi] and some other paraphernalia belonging to the Alaafin, [such as the royal umbrella and a royal robe and beaded slippers]. Some Egungun families, such as Esarun and Agbooye also followed the Olufi from Old Ọyọ, bringing with them the cloth mantles of the masquerades.

The Olufi took a route leading to Igbori where he stayed for a while, involving himself in the cultic rites of Egungun. He also adopted the Igbori's oríkì as his own. Then the Olufi moved with his entourage to found Gbọngan Ile (Old Gbọngan). [Thus the Olufi brought to Old Gbọngan symbols of kingship and the cult of Egungun from Old Ọyọ. In Igbori he added to his authority by adopting other Egungun cult practices and local oríkì orílè.]

Gbọngan-Ile was deserted by its inhabitants in 1823 due to the marauding activities of the Fulani from Ilọrin. The present Gbọngan was built at its site because of deep forestation which made it difficult, if not impossible, for the Fulani marauders to attack. The settlement pattern of the present site reflects its defensive nature, with names like Oke Ẹgan (a thickly forested area), Idi Apo (where Apo trees abound), Oke Apata (rocky terrain), and Ọwọ Ọpẹ (palm-tree plantation). There is also a network of streams such as Oyunlọla, Onireke, Alamọ, and Ọleyọ, which provided easy access to water for the new inhabitants.

The Role of Oríkì and Ìtàn

Oríkì and ìtàn are interwoven. The primary objective of chanting oríkì is to shower praises on the owner of the oríkì, to show mastery and the beauty of the language and also to entertain the audience. The objective of the chanter is not to narrate history, although he/she often recounts the past story of the owner's ancestors and their achievements. There are specialists in oríkì rendition, just as there are specialists in drumming, in singing ìjálá (hunters' praise poems), and iwì or èsà (types of Egungun poetry), in ritual praise poetry known as Ṣàngó-pípè and Ọya-pípè sung by priestesses of òrìṣà Ṣango and òrìṣà Ọya, and in Ràrà sísun sung by specially trained women praise singers. Hence the chanting of oríkì is the preserve of trained specialists.

Ìtàn can be derived from inquiries at ritual performances for Egungun, òrìṣà Akire, Ifa, Ṣango, and other deities, and also through participatory observations during reenactment ceremonies, as in the installation of a new ọba (ruler) and various other festivals.

The royal wives (ayaba), cultic priests and priestesses, and other professional chanters chant the

Olufi's *oríkì* tracing his journey from Old Ọyọ to Gbọngan-Ile, incorporating the Igbori and Egungun *oríkì* which was informed by his experiences at Igbori. Part of the Olufi's *oríkì* is as follows (see Babayẹmi 1980):

	Ọmọ 'kúlódò awùbi	The son of the man who died in the stream and became a pride to his family.[10]
	Ọmọ 'kúlódò awùsì Èyò	The son of the man who died in the stream and became a source of delight in Ọyọ metropolis.
	Ọmọ 'kú kan ń bẹ lódò tó ti Ìgbórí wá	The son of the death which occurred in the stream at Igbori.
	Ta ní sọ pé ará Ìgbórí ò lódò, omi ikú ni wón n pon-ón mu?	Who says that there is no stream in Igbori that the inhabitants drink death water?
5	Ta ń l'Asà?	Who has the Asa stream?
	Ta ń l'Ekoro?	Who has the Ekoro stream?
	Ta ń ni Dòbòdé omi Ìpákùn?	Who owns the Dobode stream at Ipakun?
	Ta ń lAfúnlélé tí ń fayaba lásọ?	Who has the white watered stream which holds up palace women's clothes as they walk in it?[11]
	Ta ló sọ pé Onígbòórí ò lágbà, pé gbogbo wọn ní ń jé baba?	Who says that there are no elders in Igbori, that all men are called fathers?[12]
10	Ọmọ a-jé-baba-má-jèẹ-arúgbó	They are called fathers, yet they are not aged.
	Ìgbórí lojà Sòngbè nílé	Igbori is the market, Songbe is home.[13]
	Bàbáà mi ọmọ aròkú-rojà-má-tà	My father, the son of the corpse that could not be sold at the market.
	Òkú tí a gbé rojà tí ò tà la dásọ fún tà ń pè lÉgúngún	The corpse that was taken to market and that was clothed and called *egúngún*.[14]

This is the portion of the *Oríkì Ìgbórí* which shows that when the first Onigbori (Ọba of Igbori) died in the stream, an Egungun mantle was made for the corpse. This is the Igbori tradition of the origin of Egungun. There are numerous other traditions regarding the origin of Egungun (Babayẹmi 1980).

The influence of the Egungun at Igbori on the Olufi is reflected in the architectural structure of the first palace at Gbọngan Ile, which was built around the Ọja Ọba (King's Market). This is in line with what obtains in Old Ọyọ where the palace was built in front of the Akẹsan market. [Hence the model for the location of the palace was taken from Old Ọyọ.] The rectangular architectural structure of Ọyọ was also retained, although the Gbọngan-Ile palace contained many compounds, shrines, and groves for *òrìṣà* and the Egungun cult not found in the Old Ọyọ palace structure. The shrines and groves of *òrìṣà* Akire and Egungun incorporated in this palace showed

the ingenuity of the Olufi in adapting his palace structure to suit local needs. The remains of these structures have been located at the original Gbọngan-Ile site.

With the destruction of Gbọngan-Ile by the Fulani marauders in 1823, the Olufi and the people of Gbọngan-Ile moved first to Ile-Ifẹ and from there came to rebuild the present Gbọngan in 1825. The first palace in the present Gbọngan built by Olufi Fagbọla was sited in front of the Ọja Ọba, while the Igbo Igbalẹ (Egungun grove) and the Igbo Orisa (Orisa Akire grove) also adjoined the palace. [Hence new òrìsà, which had not been present at the Old Ọyọ stage, have been added to the palace layout.]

Among other features that influenced the structure of the palace in the present Gbọngan were the influx of the Ile-Ifẹ people who followed the Olufi to the present Gbọngan and introduced the Edi festival. [Note that another festival has been added to the ritual calendar and architectural space of the palace.] The Owu people also settled with the Olufi following the fall of Owu. They came with their Egungun, known as Eébèlé. The oríkì and ritual performances of the people of Ile-Ifẹ and Owu enlarged the scope of ritual performance and oríkì-rendition in the palace at Gbọngan.

The palaces of succeeding Olufis were built in line with the tradition that sustained Fagbọla's palace. The abode of the Olufi was conspicuous and was surrounded by the compounds of his functionaries and wives. Apart from his chambers, there is usually a large assembly hall where the Olufi and his traditional chiefs sit in audience either to acknowledge the obeisance of the towns-people or to receive dancing groups during civil and religious ceremonies. For these occasions, the seats are arranged facing the main palace gate. The hall is also used for the meetings of the Olufi in council and for hearing disputed cases. The side of the palace facing the main market has several kòbì (gables [or projections, booths]), which are used as stalls by men and women traders. The stalls are also used as entertainment spaces during festivals for Egungun, Ogun, Ọya, and Edi. The stalls also act as the last point for all local celebrations and civic performances before proceeding to the palace to pay homage to the Olufi. In all of these celebrations and performances, oríkì songs and dances play very significant roles in the proceedings.

The oríkì of the artists who contributed to the building of the palaces are also chanted by dùndún and sèkèrè drummers, the Arọkins and the Alaros. For instance, the carvers who carved the doors, posts, and other palace utensils are remembered in their oríkì. An example is the oríkì of Idowu Olodo, some of whose work can be found at the Centre of West African Studies at the University of Birmingham.

Ìdòwú agbégirebete fóba	Idowu, one who creates beautiful carvings for the Ọba.
Bó tí ń gbẹ odó	He was not only an expert in carving mortars [bases for Ṣango ritual containers].

Ní ń gbé àpótí	He also excelled in [carving decorative] containers,	
Ní ń gbé òpó	In sculpting [monumental] veranda posts	
5	Ní ń gbé ààs̩è fún Olúayé	And in [bas reliefs on] wooden doors for important persons in the community.[15]

Hence the work of the artists who carved the doors and veranda posts of Asabi's palace still stands to the credit of these carvers today.

The *oríkì* and *ìtàn* associated with the architectural history of the palaces in Gbongan guided the Progressive Chiefs[16] who masterminded the building of a modern palace for the incumbent Olufi, Oba (Dr.) S. O. Babayemi. The Oja Oba and *kòbì* are now being built in order to serve purposes similar to those they served in the old palaces.[17] The Igbo Igbale and Igbo Orisa are still retained at Isale Oja near Ajagbogbo and Asabi's palaces. Compounds, shrines, a museum, and a mausoleum are built within the premises of the palace in consonance with the tradition of palaces in Gbongan.

The *oríkì* and *ìtàn* that sustained the architectural history of the Gbongan palace influenced the writer of this paper in other directions. The *oríkì* of Igbori, Ogbin, Adikun, Ikoyi, Igboho, and other deserted ruins and towns in the Old Oyo reserves motivated the writer to locate and research the history of these deserted sites in the Upper-Ogun and the Old Oyo game reserves.[18]

Notes

1. Due to illness Oba Solomon Babayemi was unable to attend the symposium on "The Yoruba Artist" and requested Dr. Karin Barber to present his paper. Dr. Barber discussed the paper with His Highness, raising with him a number of questions for the purpose of clarifying the text. With his permission, she interrupted the reading of the paper in order to share with the audience the author's comments and her understanding of his concerns and intentions. Dr. Barber's comments have been added to the text in brackets and in extended footnotes. She introduced the paper with the following observation:

"I believe that His Highness, the Olufi of Gbongan, is known to many of you as Dr. Solomon Babayemi. He was formerly a Senior Research Fellow of the Institute of African Studies at the University of Ibadan before ascending the throne in Gbongan two years ago. Anyone who has met him, even briefly, will have been captivated and impressed by his immense warmth and charm, as well as by his really deep and wide grassroots knowledge of his own culture. He traveled widely in the Oyo area of Yorubaland, talking with ordinary people as well as those of rank, as he collected the oral poetry of origins (*oríkì orílè*) and oral histories (*ìtàn*) of towns and villages. In addition to his scholarly achievements, he is notable for the generosity with which he shared his knowledge with others.

"I know that Kábíyèsí was deeply disappointed not to be able to be here to see so many of his old friends and share his knowledge in this august gathering. He was very ill this summer and had hoped against hope that he would be well enough to travel in January. The doctors would not allow him to make the trip, for he is still quite weak. So I have been given the serious responsibility of trying to relay to you some of what he wants me to say by way of introduction as well as commentary."

2. *K. Barber:* When the author refers to "the reconstruction of the architectural history of the palace at Gbọngan," he is not concerned with the architectural layout of the palace or palaces, for there are three palaces at Gbọngan. Hence there are no ground plans in this paper, no measurements. There are none of those useful multicolor charts that you receive when you visit old buildings in Europe telling you which section was added in which historical epoch. That is not the kind of "reconstruction" the author is about. What he is doing seems to me to be more complex.

First of all, Kábíyèsí is interested in the palace as the material manifestation of royalty, of the *oba* and office, and hence the palace as a symbol of the town's total identity. The palace is the focus of Gbọngan—Gbọngan history and Gbọngan identity—because it is in the palace that all the separate individual histories of the people, the lineage groups, as well as those who have served as Olufi, converge. The palace is the focal point of the historical identity of the town. Second, as the author also observes, the palace is the focus of the performance of the arts, in particular the verbal and kinetic arts, through which the past is recreated. Indeed, the palace is not only the venue, but the occasion, the reason, for many of these performances through which the identity of Gbọngan is affirmed.

3. *K. Barber:* The Olufi was brought up in a drumming lineage in Gbọngan. He was trained as a *dùndún* drummer in his childhood. Hence he understands, "feels," the tradition of singing praises and playing the drums in the palace from both sides—as a drummer and as a king—and that is a very interesting public perspective he has on this. All the drummers in the palace in Gbọngan, when I visited there recently, kept playing "*A à rí i rí, a à rí i rí, ọmọ àyàn tó jOlúfì, a à rí i rí.*" (We have never seen it before. We have never seen it before. A son of a drumming lineage has never been the Olufi in this town before.) They were very, very happy to have one of their own people now on the throne. That provides a unique perspective, and that is the first thing he talks about in his paper.

4. *Dùndún:* hourglass-shaped tension drum, usually called a "talking drum."

5. *Sèkèrè:* percussion instrument made from a gourd covered with a net of cowries. It is shaken, beaten with one hand, and thrown from one hand to the other to create a rhythmic rattle.

6. Alaros: players of the *aro*, usually translated "cymbals," but actually c-shaped metal bells which are struck against each other as percussion instruments.

7. Aketi Elegbo Soogun is a nickname meaning "One who cuts the ear of a person with sores, in order to make medicine," indicating a powerful traditional healer.

8. Popoọla was a prominent citizen of Gbọngan, now dead. He has influential children in the town.

9. *K. Barber:* It is important to bear in mind that the author sees the palace, not essentially as walls, the actual physical structure, but the palace with all its contents, which he refers to as "paraphernalia." He is referring to objects in the palace and at adjoining sites—the sacred sites, the shrines, which are significant features of the landscape surrounding the palace. He sees different epochs enshrined in, recalled by, various aspects of the physical surroundings. Thus the identity of present-day Gbọngan is built up out of the layers of past events. Starting from Ọyọ, the royal family, which originally came from Old Ọyọ, traveled to a town called Igbori which is a famous Egungun center. From Igbori they took another layer of identity. Then there was the period of the nineteenth-century wars and the great dispersal of lineages. The followers of the Olufi moved from the open plains of Igbori, where they were vulnerable to attack, south to the forest area. They founded the first Gbọngan and then had to move from there to found the second and present Gbọngan. Hence you have an accumulation of memories from different sites, different resting places and memories of different objects and practices brought from each of these previous places. And there are mementoes from all these

phases in their history in the present-day palace. I think this is what the author means by the "reconstruction of the architectural history" of the palace of Gbọngan.

10. *K. Barber:* This passage refers to the legend of origin of the Egungun cult.

11. *K. Barber:* In this portion of the *oríkì,* reference is made to the topography of the Igbori area. The *oríkì* commemorate the Igbori sojourn by its natural features, such as different streams, depicting their "royal" significance. They are not simply topographical references, but have become cultural symbols.

12. *K. Barber:* The phrase refers to the fact that since they are all Egungun people associated with the ancestors, they must all be called "fathers."

13. *K. Barber:* When asked the meaning of this passage, Kábíyèsí said that it referred to the market in Igbori. He did not know, however, the meaning of the reference to Songbe. Hence *oríkì* may be said to contain latent information which may be open to a variety of interpretations in different contexts.

14. *K. Barber:* This is another reference to the origin of Egungun.

15. *K. Barber:* Thus great carvers were not anonymous persons whose names and reputations were lost to history. Those who made important contributions to the communal heritage were remembered thorough their *oríkì.*

16. A group of Gbọngan sons and daughters given chieftancy titles because of their past contributions to the development of the town. They serve in advisory roles to the Olufi on contemporary issues and town development.

17. *K. Barber:* The palace in Gbọngan is currently under reconstruction. It is a large concrete building which is designed to recall the old structure with its *kòbì* that faced the market. At the moment, the Olufi reigns from his own house. In the plans for the new palace it is clear that His Highness is sensitive to the present as another time of transition. He is a modern author, highly educated, and he has traveled extensively. He is now a traditional *ọba* remodeling a modern-looking palace to make it more like what he knows from his historical research. He is modernizing by rediscovering traditions.

18. *K. Barber:* It was this type of material that motivated Dr. Babayẹmi in his role as a historian, not necessarily as an *ọba,* to research histories of other palaces, as well as those at Gbọngan, to achieve a broader picture. It was the knowledge of the *oríkì* and *ìtàn* of the palace architecture, among other things, that inspired the writer of this paper to accept, to be the Olufi, the traditional ruler of Gbọngan. Because of his own *oríkì* as Olufi and his knowledge of the *ìtàn* of the palace, he is now the custodian and the central focus of those very traditions.

11. Polyvocality and the Individual Talent: Three Women *Oríkì* Singers in Okuku

Karin Barber

Oríkì—the condensed, elaborated, highly charged verbal salutes of the Yoruba, often described as "praise poetry"—are polyvocal in the highest degree.[1] They are always vocative: that is, they are always utterance addressed by one person to another person, or to a spiritual being, animal, or other entity. But many voices, as well as the actual performer's, may be heard in the chant as it progresses.

Oríkì performances have been described as "disjointed discourse" (Wolff 1962) because the items out of which they are constituted are not only heterogeneous but to a significant degree autonomous. There often seem to be no necessary or permanent connections between them. A performer draws on a vast corpus of verbal formulations—some relatively fixed, some malleable; some brief, some extensive and internally patterned—and strings them together as she goes along. Each of these items may have a separate origin—each may originally have been composed by a different person, at a different time, in response to a different perception or situation. Each may also encode its meaning in a different way, so that the chant switches between literal, metaphorical, emblematic, and riddle-like formulations from one moment to the next. And the pronouns in each—the "I," "you," "we," and "they" of the utterance—may shift position and depth. Each speaks in a different voice. Because they are autonomous, the performer has great freedom of choice in her selection and ordering of items. The "I" of the utterance is only occasionally coincident with the "I" of the performer: other voices alternate in speaking through her. It could be said that the *oríkì* speak through the performer, and that at the same time the performer speaks through the *oríkì*. The question of the relationship between tradition and the individual talent is here raised in an insistent, paradigmatic form.

Although all *oríkì* chants are composed out of the same kind of materials and share the same properties of disjunctiveness and internal heterogeneity, nevertheless one of the most striking things about the totality of *oríkì* performance in a given community such as Okuku[2] is the sheer variety of styles. Chants range from the relatively fixed and homogeneous, with long internally patterned sections, to the extremely fluid, diverse, and fragmented. These differences can be related not only to the social context of the performance but also to the experience and skill of the performer. The point I want to make in this brief contribution is that, contrary to the assumptions of many scholars of "oral literature," fragmentation is not to be seen as the accidental or regret-

table byproduct of the mode of oral composition and transmission. In the view of the practitioners and listeners, a certain degree of fluidity and fragmentation is positively desirable. Skilled performers demonstrate their mastery of the genre by exploiting the possibilities of disjunction and polyvocality given to them in the corpus of material they have learned. They heighten the gaps between textual items with supplementary breaks, ellipses, interjections, and truncations. The more mature and accomplished a performer is, the more able she is to play with the risk of fragmentation without letting it overwhelm her.

Rárà iyàwó (in standard Yoruba *ẹkún ìyàwó*) is the first type of *oríkì* chant a girl will learn. Until recently, most brides in Okuku got married in the traditional way rather than in church (fig. 11.1). On the day before the girl moves into her husband's house, she makes a ceremonial tour around the town, starting with her own compound, saying farewell to her kin and announcing her impending change of state. *Rárà iyàwó* are the valedictory *oríkì* chants she performs as she goes round.

Almost all girls learn these chants, beginning from an early age. On the day of her outing, the bride is escorted by a party of younger girls from her compound. As the bride chants her laments and farewells, the girls provide a sympathetic chorus chanting in unison. Their role can be quite substantial; sometimes the performance develops into a dialogue where the chorus has almost as much to say as the bride. In language, structure, style, and manner of delivery they are indistinguishable from the solo part. The girls are therefore familiarized with the performance of bridal laments long before their own wedding days. They learn the *oríkì orílẹ̀* (*oríkì* of origin), which make up a large part of the bride's chant, by listening to other brides performing and by repeating the verses among themselves in play. Two or three months before the date of their wedding, young women go into intensive training with an older woman in the compound, to learn more extensive passages and to get used to performing without breaking down. This chant, then, is accessible to all young girls, regardless of their particular talents or interests. Performances tend to be standardized. The following excerpt is from a performance by Ibiyọ, a daughter of Ilé Olọkọ. She was sixteen when I recorded it, and not yet married. She was one of a group of young girls who played together in the neighborhood where I lived, and her way of performing was not significantly different from that of most other girls who volunteered to chant for my tape recorder at one time or another.

The style is almost stately in its clear, methodical progression. The entire quotation is only part of one "unit," revolving around a single theme, and her whole performance will consist of a number of such extensive passages interspersed with shorter, but equally clearly patterned, passages commenting on her future as a wife, her gratitude to her parents, and so on:

Lójọ́ òní mo fẹ́ kìlú àwa	Today I want to salute our town
Àgbà ló jẹ́ 'mọ ará Ọ̀yọ́	He is a senior man, offspring of Ọyọ

Ọmọ ará Ọ̀yọ́ mo fẹ́ kìlú àwa o.	Offspring of Ọyọ people, I want to salute our town.
Níbo ló jọlé?	Where might our home be?
5 Níbo ló sì wáá jọlé babaà mi?	And where might the home of my father be?
Ọ̀yọ́ ló jọlé	Ọyọ is our home
Ọ̀yọ́ ló mọ̀ wáá jọlé babaà mi.	Ọyọ is the home of my father.
Àparò mélòó péré	How many bushfowl
N náà ló ń bẹ ní Ọ̀yọ́ àwa?	Are there in our Ọyọ?
10 Àparò mẹ́ta péré	There are only three bushfowl
N náà ní ń bẹ ní Ọ̀yọ́ àwa.	In our Ọyọ.
Òkan ń ṣe ká ba ká ba	One said "Let's sit, let's sit,"
Òkan ń ṣe ká fò ká fò	One said "Let's fly, let's fly,"
Òkan ń ṣe ká fò piri ká relé Àlé-Ọ̀yun.	One said, "Let's whirr off and go to Ale-Ọyun."
15 Nígbà tó di lẹ́ẹ̀kìíní	The first time round
Mo dáko súrú	I made a little farm
Súúrú sùùrù súúrú sí Àǹlé-Ọ̀yun	A little tiny farm at Ale-Ọyun
Èṣú ṣe bí eré	Locusts came as if in jest
Èṣú mú mi lóko jẹ.	Locusts ate my farm up.
20 Nígbà tó dilẹ́ẹ̀kèjì èwè	The second time around
Mo tún dáko súrú	I made another little farm
Súúrú sùùrù súúrú sÀǹlé-Ọ̀yun	A little tiny farm at Ale-Ọyun
Èṣú ṣe bí eré	Locusts came as if in jest
Èṣú mú mí lóko jẹ.	Locusts ate my farm up.
25 Mo kẹjọ́ọ̀ mi ó dilé Àlé-Ọ̀yun.	I took my case to the palace of Ale-Ọyun.
Àlé-Ọ̀yun ti ní tèmi èbi ni.	Ale-Ọyun said I was in the wrong.
Mo ní torí kí ni?	I said, "Why?"
Ó ní ìgbà tí eṣú ò lóko tí ò lódò ńkọ́,	He said, "When the locusts have no farm and no river,
Emi lọọ ní késú ó móọ jẹ?	What do you expect the locusts to eat?"

Each sequence of this type is repeated almost word for word the same way each time. Each sequence is always completed before the bride moves on to another. And each owes its inner coherence to a high degree of patterning, based on structural parallelism and repetition. The performer moves through these sequences steadily and methodically, omitting nothing. The forward movement is initially slowed down by a pattern of question and answer, involving almost exact repetition: "Where might our home be?/And where might the home of my father be?/Ọyọ is our home/Ọyọ is the home of my father." The *oríkì* pertaining to Ọyọ are then introduced through an elaborate figure of the three bushfowl, again presented through a repetitive question-and-answer sequence: "How many bushfowl/Are there in our Ọyọ?/There are only three bush-fowl/In our Ọyọ." Each bushfowl in turn performs an action that leads toward the key name, Ale-Ọyun, where the story of the locusts is set. This story, the heart of this particular *oríkì*, is again

set out step by step: "The first time round . . . The second time around . . . ," with full repetition at each stage. Even though the bride is often nervous and tearful, and utters the lines at high speed, the measured, leisurely, and methodical unfolding of each theme still makes itself felt. Lines are of even length, well marked with breath pauses, and almost always end-stopped. In most performances of *rárà ìyàwó*, there is hardly any deviation from the theme, interpolation of other matters, or even interjection of vocatives apart from standardized forms like "My mother," "My father," "My brother," or "My companions." There is heavy use of a few standard formulas, most notably "May good luck attend me today," always used to close a section; but also "Today I want to salute our town," a stock opening, and "If that is not the way/If that is not the house," a way of announcing either closure of a section of *oríkì orílè* or the intention to embark on another one. *Rárà ìyàwó*, then, are more predictable than other modes of *oríkì* chanting: easy to remember and easy to follow. The style is transparent; though the inner meaning of the *oríkì orílè* is not at all self-evident, they are set out with an appearance of conscious lucidity.

Rárà ìyàwó are very attractive. They are also the closest to the traditional Western idea of poetic achievement, with their coherence and their promise of closure. This makes them easy to learn by heart—and the young girls who performed them did seem often to be reciting "set texts" from memory, rather than recomposing within a given performance mode. Some girls were more knowledgeable and more skilled than others, however, and during the wedding season in February every year, when dozens of brides would be celebrating their outing on the same day, people would comment on the differences. "That one only knows 'May good luck attend me today,' " said one woman scornfully of a bride who repeated the same handful of verses over and over again to each group of listeners. Others would attract a crowd as they held forth, elaborately and at length, their repertoire of material seemingly inexhaustible.

Although her wedding day is the only occasion when a girl, however talented, may publicly perform *rárà ìyàwó*, her early mastery of *oríkì* chanting is not necessarily lost. The materials used in *rárà ìyàwó* may be recycled in other performances in her married life. All women have frequent opportunities to master and perform *oríkì* chants connected with funerals, festivals, and domestic ceremonies of all kinds. Some women become recognized experts within their compounds; they will be called on to take the lead at every family ceremony and approached by younger women to impart their skills to them.

One such "woman of the household" (*obìnrin ilé*) was Faderera (fig. 11.2). Though a married woman, she had become more attached to the *ilé* of her father and brother than that of her husband after her second husband from the lineage died. Both her father and brother were prominent Ifa priests (her brother still is). The household was one where ceremonial *oríkì* chants were constantly required: at celebrations connected with the *òrìṣà* (deities), for the invocation of ancestors, and at ceremonies of the royal lineage, with which the family was closely associated.

Fig. 11.2.
Faderera, Okuku,
Nigeria, 1976.
Photo: P. F. de
Mosaes Farias.

Fig. 11.3.
Ṣangowẹmi,
Okuku, Nigeria,
1976. Photo: P. F.
de Mosaes Farias.

Faderera ascribed her exceptional talent to her parents. Her father was the great *babaláwo* Awo-yẹmi, Ọba Oyinlọla's personal diviner and senior title holder in the cult of Ifa. Her mother was a devotee of Ọya. Faderera said that when her father celebrated his Egungun feast, he would begin to call on his own, dead father, and his father's father, with all kinds of appellations. "We would gaze at his mouth as he spoke, we would gaze and pick up the words ourselves." Her mother also used to chant *oríkì*—her own and her father's—during the festivals or "whenever her parents came into her mind."

During the propitiation of the family's ancestors at the Egungun festival, Faderera led the whole body of "women of the household" in chanting the *oríkì* of the founder of the family. Though stately and formal to the ear, as each line was repeated by the chorus, her performance was not a set piece like the bride's but an emergent utterance, retaining the possibility of going in a different

direction at every juncture. After the ceremony was over, Faderera came back alone to the *ojú òórì*, the grave shrine inside the house, and addressed the ancestor in a chant that expressed an inner, private grief most movingly:

	Baba ọ ò ríkọ́ bó ti móhùn mi pèyaya?	Father, don't you hear the cough that has shattered my voice?
	Ìpèayédá o!	Ipẹayeda!
	Akínsòwọ́n Morónkèjì baba mi	Akinsọwọn Moronkeji my father
	Kelẹmbẹ ló ti móhùn mi rẹ̀ dòdò	Phlegm has made my voice gruff and low
5	Kelẹmbẹ tí ò bá ráyè jẹ́ n gbọ́ tìẹ o	Phlegm that doesn't let me attend to you properly
	Màá fojú ẹ yíiku	I'll spit it out and roll it in the dust
	Baba mi sọ mí níyè	My father, restore my memory
	Baba mi fi mì lọ́kànbalẹ̀ nílé ayé o	My father, give me peace of mind in this world
	Mòmọ̀ jẹ́ n rójú kí n ráyè gbọ́ tìẹ	Give me the means and opportunity to attend to your call
10	Èdùndùn òràn kan ń mọ̀ ń dùn mí Mobómiléjọ	One thing is causing me great pain, Mobomilejọ
	Baba mi bá n gbọ́hun tí ń dùn mí lọ́kàn mi	My father, help me deal with what is causing such pain to my heart
	Ògànyín ńlé ọmọ ológofà obìnrin	Ọganyin, hail, child of one with a hundred and twenty wives
	Mobómiléjó ọmọ olórí Abẹ.	Mobomilejọ child of the leader of the Abẹ people.

This utterance is much more intensely vocative than the passage of *rárà ìyàwó* quoted above. Faderera is calling on Ipẹayeda, summoning him to listen to her appeal, and empowering and gratifying him with a multiplicity of alternative names (Ipẹayeda, Akinsọwọn, Moronkeji, Mobomilejọ) and *oríkì* (Ọganyin, child of one with a hundred and twenty wives/child of the leader of the Abẹ people). It is emotionally all of a piece, a single impassioned appeal, but it is created from a skilled and sophisticated interweaving of utterances referring back and forth between herself and the ancestor in a text (that is, a web: something woven) that binds them together.

The only professional performer in Okuku, Ṣangowẹmi—a woman of immense experience, skill, and knowledge—produced chants more fluid and variegated still (fig. 11.3). Like Faderera, she came from an exceptional background. Her mother was a fully qualified practicing *babaláwo*, the only female one Okuku remembers, and a notable Ṣango priestess. She traveled for long periods performing divination for clients and adding to her knowledge of Ifa, and Ṣangowẹmi traveled with her, acquiring the art of performing *Ṣàngó-pípè*, the *oríkì* chant of Ṣango, the god of thunder and lightning. Ṣangowẹmi was selected to represent the town in competitions organized by the colonial authorities in the Ọṣun Division. Then "in the time of politics—1952—we began to perform the *oríkì* of all the politicians: Akintọla, Awolọwọ, all the Action Group leaders. I went

to many towns, and many of them were known to me because I had accompanied my mother there on her travels." Thus Ṣangowẹmi became a fully fledged professional artist who traveled from town to town to make her living.

The following excerpt from a performance by Ṣangowẹmi alludes to the same *oríkì orílẹ̀* as the *rárà ìyàwó* I first quoted above, but with very different effect:

Akótipópó o kú ọdún o	Akotipopo, greetings for the festival
Ọdún ọdún ni ọdún ayọ̀ ni yóò ṣe	This year's festival will be a festival of joy
Akótipópó ọmọ Ògúntóñlówò	Akotipopo, son of Oguntonlowo
N ò roko Ògúntóñlówò n ò yẹnà	I don't hoe the farm, Oguntonlowo,
	I don't clear the path
5 Ògòn̄gọgongo làrán oko Ṣaóyè	"Jutting velvet," husband of Ṣaoye
Ajílóñgbégbé ló wáá tó okoọ Jéjé ṣe,	Ajilongbegbe is worthy to be the husband of Jeje,
Àyìndé wáá sojú olóbò bó sòkòtò	Ayinde went and took his trousers off in front of a
	female
Gbà tí olóbò ò gbà mọ́ bàbá gbé	When the female refused him, the father just stuck his
kàgbáa rẹ bọtan, ọmọ ẹkẹ́ re ní	legs back in his breeches again! — son of "A good
Mojà	forked stick at Moja"
Ìwàñnú ọmọ Òrándùn	Iwannu, child of Orandun
10 Pèẹ́ ni wọn óò re jègbe la múkú wá	Suddenly, they'll go and eat yam pottage
ñ mú erin, olórí ọdẹ ajólù Eyọ̀	"Bring death and I'll bring an elephant,"
	Head of the Hunters, one who dances to the sound of
	the Eyọ drum
Àje-fèhìntì ni mo jògbodò níwálẹ̀ ògà	I ate *ògbodò* yam till I couldn't stand up at Iwalẹ Ọga
Tó o bá lè súnmú lásùnúnjù	If you wrinkle your nose too much
idà elesuku eja ni wọn ñ fi lani lénu	they'll slit your mouth with a blade made
	of fish-fins
N óò yáa bésú relé Ale-Ọyun,	I shall go with the locust to the home of Ale-Ọyun,
"mọ bebe aṣọ" Ìwàñnú ọmọ	child of voluminous cloth,
Òrándùn	Iwannu child of Orandun
Ìwàñnú ni ìyá Òpó jẹ́, ó dìgbà	Iwannu is the mother of the Opo people
èèkííní mo	the first time round I made a farm at Ale-Ọyun
dáko lÁlèé-Ọyun ńlé olórí-ọdẹ	at the house of the head of the hunters
15 Esú wáá jẹ mi lóko	The locusts came and ate my farm
Mo wáá kéjó òhún rỌ̀yó, Olóyòọ́ ti wí,	So I took my case to Ọyọ, the lord of Ọyọ said
ó léjóọ̀ mi, èbi ni	I was in the wrong
Èmi Àbèní ń pè ọ́, olórí ọdẹ, ajólù	It is I, Abẹni, calling you, head of the hunters, one
Eyọ̀	who dances to the sound of the Eyọ drum
Ó wáá dìgbà kèjì èwẹ, mo kó ejóọ̀	Then the second time around, I took my case to Ọyọ
mi rỌ̀yó, mo ní esú ń jẹ n lóko	I said the locusts are eating my farm up.

20	Ó ní ńgbà tí eṣú ò lóko tí ò lódò	He said, "When the locusts have no farm and no river,"
	Ó lémi n ẹ ní késú ó móọ jẹ, ó ní	He said, "What do you expect the locusts to eat?"
	omi ń bẹ lÁńlé-Òyun, ó ní ẹ fọsọ	He said, "There's water at Ale-Oyun."
		He said, "Use it to wash clothes."
	Ògèdè tí ń bẹ lÁńlé-Òyun, ó	"The bananas that are at Ale-Oyun,"
	lómọdé ò gbọdò sa á jẹ . . .	he said, "the children must not cut and eat them . . ."

Her delivery was very rapid, with sudden infrequent pauses of uneven length and a continual tumbling forward movement, so that whenever an utterance seemed to have reached its grammatical end she would tack on something else. Her breath-units were far longer than in *rárà ìyàwó:* indeed it seemed to be part of her virtuoso technique to prolong them to the utmost.

Like the performers of *rárà ìyàwó,* Ṣangowẹmi incorporates a variety of materials into her chant. But here it is not nearly as easy to see where one type of material ends and another begins. The chant does not fall into clearly marked segments, each treating a particular theme, as in *rárà ìyàwó.* Instead it seems like an eclectic mixture of fragments hurled on top of each other. It opens with greetings and good wishes appropriate to the occasion, the feast being held by Ogungbile the Head of the Hunters. Throughout the performance Ṣangowẹmi calls upon Ogungbile with a variety of names and appellations, insisting on his attention: "Akotipopo, child of Oguntonlowo," "Ajilongbegbe," "Ayinde," "Iwannu[3] child of Ọrandun," "head of the hunters"; some of these belong to Ogungbile in person, others to his father Oguntonlowo, or to more remote ancestors. All enhance his presence at the feast, and all are bestowed on him by Ṣangowẹmi with this intent.

The *oríkì* that she addresses to him before she reaches the theme of the locusts are fragmentary in the extreme, and often almost impenetrably obscure. "Jutting velvet, husband of Ṣaoye" comes from the personal *oríkì* of the nineteenth-century *ọba* Adeọba and was included because Jẹjẹ, the mother of Ogungbile and the wife of Oguntonlowo, was a direct descendant of Adeọba. "Ayinde took off his trousers in front of a female . . ." is a personal *oríkì* belonging to Oguntonlowo, who was renowned for his exploits as a hunter and as a womanizer. This passage is a fragment of a longer and more explicit *oríkì,* which, according to Ṣangowẹmi, was composed by Oguntonlowo's fellow hunters to tease him. An elder of a neighboring compound, Baba Johnson, explained that during the nineteenth-century wars Oguntonlowo was carried as far as the Ijẹsa town of Imẹsi, where he began laying siege to the local girls. Sometimes he was successful and sometimes not. If not, he would just tie up his trousers and move on to the next:

Ògúntóñlówò n ò roko	Oguntonlowo, I don't hoe the farm
Ògúntóñlówò n ò yènà	Oguntonlowo, I don't clear the path
Ó dóJèsà ó bá wọn dó "Yìn-mí-nù"	He fucked the Ijẹsa, he fucked "Leave-me-alone" [in Ijẹsa dialect]

Ògúntóñlówò babaà mi ó dó ẹrú Ọwá	Oguntonlowo, my father, he fucked the subjects of the
kunkun bí ẹni ń lagi	Owa [Ọba of Ilẹṣa] like someone splitting logs
5 Àyìndé wá ṣojú olóbò bọ́ ṣòkòtò	Ayinde took off his trousers in front of a female
Gbà olóbò ò gbà mọ́, baba gbé kàgbáa	When the female refused him, the father just stuck his
rẹ bọtan!	legs back in his breeches again!

Other phrases are fragments of *oríkì orílẹ̀* whose meaning and provenance I was unable to establish.

Ṣangowẹmi's exposition of the well-known locust story is similarly elliptical and broken up. No sooner has she announced the theme ("I will go with the locusts to Ale-Oyun") than she interpolates "Child of voluminous cloth, Iwannu child of Ọrandun," even adding "Iwannu is the mother of the Opo people" before getting back to the story. The interjections continue: after the first phrase she adds "in the house of the head of the hunters," after the second "It is I Abẹni calling you, head of the hunters, one who dances to the sound of the Ẹyọ drum." The story itself, instead of being methodically unfolded step by step as in the *rárà ìyàwó*, proceeds apparently erratically in fits and starts. The narrator goes to Ọyọ to complain about the locusts straight away (not after the second occasion as in the *rárà ìyàwó*) and is found guilty; but the reason for this is not given until the second visit, when the Lord of Ọyọ tells him/her "What do you expect the locusts to eat?" This is the climax of the story, but Ṣangowẹmi proceeds instantly and without any indication of closure to another theme (the water, bananas, and children) which she links on with the greatest of ease. On paper her performance looks fragmented, but in performance, the dominant impression is of a sinuous and confident—some would say overconfident—fluidity, demonstrated by an almost reckless disposal of themes.

Ṣangowẹmi, who used to derive most of her income from performance, was an entertainer. She used to thrive on large mixed crowds, and her great experience enabled her to adapt her style to almost any situation. Her performances were always more breathlessly varied, eclectic, and fluid than those of ordinary *obìnrin ilé*. They also contained a large dash of "show-womanship" and self-display. The *obìnrin ilé* established their own role in the interchange effected by the utterance of *oríkì*, and commented on its significance in the act of performing. But Ṣangowẹmi went further; she always presented herself as performer, at the same time that she addressed her subject. She more often included her own *oríkì*; boasted of the artistic feats she had accomplished or was going to accomplish; and drew attention not only to her own skill but to the gratification that this produced in the hearer. Unlike the *obìnrin ilé*, whose performance was bound up with their own compound and domestic life, Ṣangowẹmi was to be seen at every social gathering, among crowds of rowdy men, at big meetings at the palace, and at all the public events in neighboring towns.

However, people in Okuku did not necessarily consider Ṣangowẹmi to be the best performer of *oríkì*. Faderera's brother, the *babaláwo* Adeleke Awoyẹmi, once told me "There's too much Ṣangowẹmi in your recordings. She is fluent but she is superficial. She doesn't know as much about

any compound as the people of the compound itself." Faderera was given as an example of an *obìnrin ilé* whose *oríkì* performance had more "depth." If the range of styles is looked at as a continuum, from the most fixed, patterned, and homogeneous, to the most fluid, disjunctive, and heterogeneous, it seemed that people in Okuku tended to go for the golden mean. If it were too fixed and homogeneous, it became boringly predictable. If it were too fluid, fragmented, and eclectic, it became superficial, incapable of encapsulating deep knowledge. The preferred style was somewhere between the two: where the performer's individual skill and creativity had scope for display, but where the inherited knowledge condensed in the lapidary utterances of *oríkì* was preserved, allowing multiple voices from the past to continue to speak in the present.

Notes

1. This paper is based on passages from Barber 1991:chap. 4.

2. Okuku: a town in what is now the Ọ̀sun State of Nigeria and the administrative capital of Odo-Otin District. I lived there for three years (1974–77) while doing fieldwork for my doctoral thesis, and have visited frequently ever since.

3. Iwannu is contracted from *oniwa ninu* (owner of behavior/character), that is, someone who is blessed with a good disposition. I am grateful to Professor Wande Abimbọla for pointing out the meaning of this name to me. See also Babalọla 1966:47.

12. Drumming for the Egungun: The Poet-Musician in Yoruba Masquerade Theater

Akin Euba

The Egungun (lit. "masquerade") cult is an important institution among the Yoruba, and the appearance of masquerade dancers in the streets of a Yoruba town never fails to attract a crowd of onlookers. Egungun is associated with the celebration of the power and presence of the ancestors in the life of the living. It is symbolic of the Yoruba belief that the living world is "actively in touch with the spirit world [and] that the departed spirits of ancestors still take active interest in the affairs of their descendants" (Lucas 1943:185). Although Yoruba people in general believe themselves to be in contact with deceased family relations, it is the members of the Egungun cult "who are particularly concerned with the worship of ancestors" (H. U. Beier 1959:26). An *egúngún* masquerade is a personification of an ancestral spirit and is viewed by a Yoruba person as "a symbol of certain religious and philosophical ideas that he [or she] holds" (ibid.). Egungun societies are found in most Yoruba communities, but, according to Lucas (1943:187), Egungun worship is most popular among the Ọyọ Yoruba.

The Theatrical Aspects of Yoruba Traditional Music

Yoruba traditional music—vocal and instrumental—is synonymous with music-theater. It is seldom realized as a distinctive art form, for it is performed and heard in the context of other artistic and ritual performances which entail poetry, dance, mime, costume, and sculpted forms. Hence Yoruba music must be approached in terms of a wider cultural framework. Whatever artistic merits the music arts may have as individual arts, their purpose goes beyond artistic contemplation, and their ultimate function lies in their integration with religion and other aspects of Yoruba life-style. Indeed, I use the term "music arts" to indicate the extent to which music and other arts are interrelated. In Yoruba traditional culture, then, the term "music" has a broad connotation and does not have the kind of specificity that we find in some other cultures.

The theatrical basis of Yoruba music is manifest in the art of drumming. To begin with, Yoruba drumming is a fine example of the unity that exists between music and poetry. In the performance of drumming, particularly in the Ọyọ tradition, the patterns played by the lead drum (*iyáàlú*) are a blend of music and poetry, for the patterns are analogous to a text spoken by the human voice. A text is almost as inevitable in *iyáàlú* drumming as it is in that artistic form categorized as song

in European cultures. Western writers therefore often refer to the *iyáàlú* drum as a "talking" drum. In some performance contexts, however, the *iyáàlú* tension drum imitates singing rather than a speaking voice.

The use of the drum as a speech surrogate also, to my mind, augments the theatrical qualities implicit in Yoruba music. The *iyáàlú* drummer is a dramatist in the sense that he employs his drum to say things that he could as well say with his human voice. One of the best examples of Yoruba traditional music-theater is the performance of Egungun, in which there is an effective integration of drum music and song with the kinetic and visual arts.

Egungun Music in General

Egungun music is most often played on *dùndún* or *bàtá* drums, but is neither limited to these drums nor even to drumming. For example, the music performed for Jamujamu, one of the most powerful and important Egungun masked dancers in Èdè, is played on a small globular flute. Jamujamu appears in the middle of the night. It is not supposed to be seen. For most people the masquerade's presence and personality are expressed mainly through his flute player. *Dùndún* and *bàtá* drums are used predominantly for masquerades among the Ọyọ Yoruba and are also found outside the Ọyọ Yoruba area. In the non-Ọyọ communities, some masquerades employ local instruments in preference to *dùndún* or *bàtá*.

Apart from instrumental types, Egungun music also has vocal types. Part of the crowd that follows a major *egúngún* usually includes women from the *egúngún*'s family compound, who chant *iwì* poetry in praise of the masquerade.

The music of ancestral masquerades is performed by persons other than the masquerades themselves. In the case of the entertainment masquerades, variously referred to as *egúngún alárìnjò*, *egúngún onídán*, and *òjè*, the masquerades do their own chanting but still rely on drummers for their dance performance. In this tradition, the *egúngún*'s unaccompanied chants in free rhythm are interspersed with songs in strict rhythm, accompanied by drumming and dancing. When the dancer wishes to interrupt the chanting and have a drum-and-dance interlude in which everyone can join, the masquerade initiates a strict-rhythm song which is chorused by the female members of his troupe, who are usually from the family compound (figs. 12.1, 12.2).

Drumming for the Egungun

Although the instrumental music of Egungun celebrations is not restricted to drumming, there is no doubt that drumming is the most characteristic music of Egungun. The *dùndún* and *bàtá* ensembles are the most commonly used. The *dùndún* ensemble consists of tension drums of various sizes together with a small kettle drum with tuning paste called *gúdúgúdú*. The lead

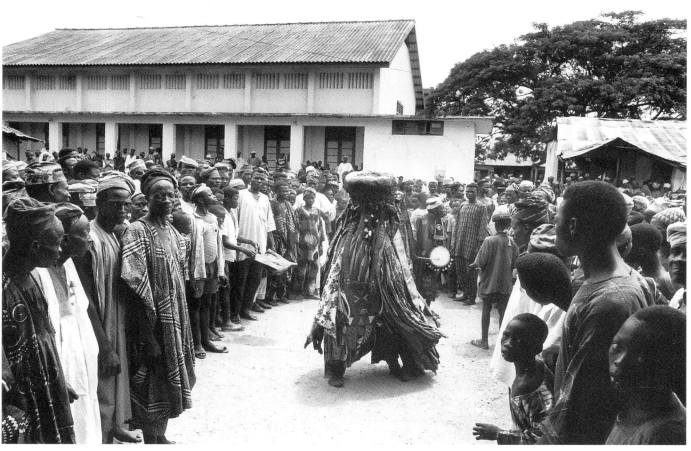

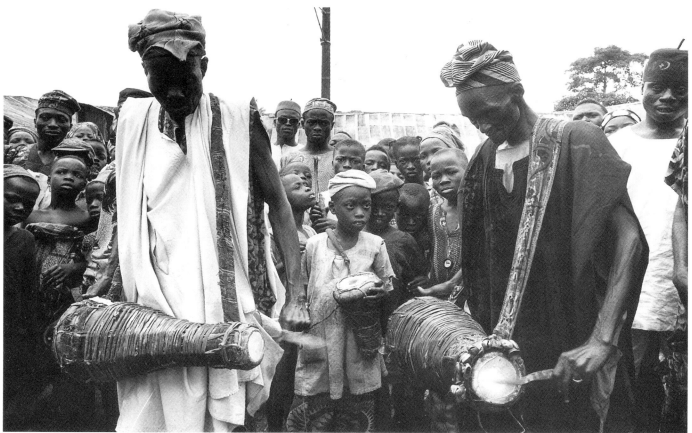

tension drum, *ìyáàlù*, is used for "talking," while the other tension drums are tuned to fixed pitches and play secondary patterns. A *dùndún* ensemble may be enlarged by having several tension drums playing in the speech mode.

The *bàtá* ensemble consists of conically shaped, double-headed, fixed-pitch membrane drums, the largest of which is also called *ìyáàlù* and performs in the speech mode. The instrument that is next in size to the *ìyáàlù*, known as *omele abo*, sometimes assists the *ìyáàlù* in articulating the speech mode, while at other times it joins the two smallest drums in playing supportive or complementary repetitive patterns.

The entertainment masquerades almost exclusively employ *bàtá* drums, at least in the Ọyọ-Yoruba area. *Bàtá* drums are also the favored instruments of the priests of Ṣango and Ọya. Furthermore, the performance of *idán*, which I translate as "miracles" or "magic," is another element common to the entertainment masquerades and the priests of Ṣango and Ọya. It is perhaps worth investigating whether the *egúngún onídán* and the Ṣango and Ọya priests prefer *bàtá* because the sounds of this ensemble are believed to have magical powers or be conducive to magic making.

The ancestral masquerades seem to prefer the *dùndún* tension drums. Indeed, one informant told me that ancestral masquerades would hire *bàtá* drummers only when there are no *dùndún* drummers available. This preference of the ancestral masquerades for *dùndún* drums does not necessarily invalidate the point made above with regard to a possible connection between *bàtá* drumming and magic. Although ancestral masquerades are fully equipped to demonstrate magical powers whenever the occasions arise, and a *dùndún* artist is thought to be competent in assisting these powers, the performance of *idán* is not in the everyday repertoire of the ancestral masquerades.

The typical Yoruba master drummer is trained to perform in all contexts in which drumming is required and does not specialize in a given type of music to the exclusion of others. We cannot, therefore, speak of a specialist masquerade drummer. Yoruba drummers do, however, specialize in performance for families. Important families in a town retain drummers who specialize in the *oríkì* (praise poetry) of those families. Whether or not such drummers are free to play for other clients depends on the rank of a given client-family. The Alaafin of Ọyọ, for example, retains a personal *dùndún* ensemble whose members come from a drumming family that has traditionally supplied drummers for past Alaafin. These drummers are engaged exclusively by the Alaafin and cannot be hired by other clients.

The most important *egúngún* also retain personal drummers who come from drumming families that have for past generations supplied musicians for the Egungun families. Drummers retained by Egungun families are free, however, to play for other clients. The principle that lies behind the practice of retaining personal drummers is implicit in the saying *onílù ẹni abọwọ́gbédè bí ofe*, "it is one's drummer whose hand can render the most fluent praise about one" (Euba 1990:74).

In the course of my research I have identified three basic forms of masquerade drumming: *oríkì* (praise) drumming, processional drumming, and dance drumming. In *oríkì* drumming, the emphasis is on poetry, and the music is not danceable. Pure *oríkì* drumming in the Yoruba context is music for listening and is perhaps an example of near-absolute music in Yoruba culture. A knowledgeable Yoruba would listen attentively to *oríkì* in the same way that a European listens to a string quartet. Even when a master drummer is not purely in the *oríkì* mode, fragments of *oríkì* are common occurrence in Egungun drumming.

An example of pure *oríkì* drumming is the *isèlù* (sounding the drums), which I heard and observed in Ẹdẹ during the 1972 masquerade festival. It was performed by Jimo Ayantunde and his ensemble, who were the musicians retained by *egúngún* Gbajẹẹrọ. On the first day of the festival, the ensemble went to Gbajẹẹrọ's compound in the morning and stood in front of the *ilé isòyìn*, a special room where the mask is kept, sounding the *oríkì* for *egúngún* Gbajẹẹrọ. The performance lasted about thirty minutes. A number of people from the Gbajẹẹrọ household were present to listen to the music. They stood quietly, nodding their approval as the attributes and power of masquerade, ancestor, and household were rhythmically entoned. There was no singing or dancing.

Pure *oríkì* drumming is synonymous with *pípè òrìṣà*, invocational chants for Yoruba divinities in which praise poetry is highlighted. Hence the drummer is meant to concentrate on a text and develop fully the text in all its nuances of meaning. In processional drumming, however, the purpose is to provide background music while an *egúngún* is moving from place to place; the text is, therefore, repetitive. The music is somewhat danceable, encouraging the dancer and the crowd following the *egúngún* to move in rhythm to the music.

Dance drumming, like processional drumming, makes little use of texts. The main feature of dance drumming is *ijálù*, which consists of rhythmic signals played by the *iyáàlù* drummer and to which an *egúngún* is supposed to react with appropriate movements of the body. In dance drumming an *egúngún* has the opportunity of displaying his competence, or virtuosity, as a dancer and as one who discloses the presence and power of the ancestor. Indeed, in the course of dance drumming, both the *egúngún* and his lead drummer are fully tested because each tries to outdo the other. There is a great deal of excitement among the crowd of onlookers, for they are attentive to the drummer's challenging the dancer to ever more intricate moves and theatrical displays of the cloth costume. The reputation of an *egúngún* very much depends on the dancer's ability to respond and in turn challenge the drums.

The Function of the Egungun Drummer

The role of the master drummer in the *egúngún*'s performance is of primary importance to the success of the ritual/theater. Music is, as I have noted, an integral part of the spectacle. Since the

ìyáàlú drum is used as a speech surrogate, it means that the drummer's expertise is not only in music but in poetry. The responsibility of the *ìyáàlú* drummer as musical director of the Egungun performance is combined with the need to employ his drum in speech communication with the *egúngún* and with the public at large.

The function of the Egungun drummer is to provide inspiration, encouragement, and assistance to the *egúngún* by playing the *egúngún*'s *oríkì*. For nothing inspires an *egúngún* more than hearing the *oríkì* of his lineage ancestry being played on the talking drum (Euba 1990:85). It is through the drumming that the *egúngún* "becomes" the ancestral presence. The drummer also constantly uses his drum to guide, perhaps command, the footsteps of the masquerade, whose vision is restricted. And it is the drummer who warns him of possible danger, for example, physical obstructions or hostile situations.

Every *egúngún* has his own individual personality, be it aggressive, comical, fearsome, or whatever. It is the drummer who helps him realize that personality. Although considered the *egúngún*'s helper, the drummer is not above taunting and provoking the *egúngún*. On occasions when an *egúngún* meets an opponent, the *ìyáàlú* drummer's musical patterns can either help to avert a confrontation or actually provoke one. The drummer's discretion on such occasions is crucial. Assuming that, after provocation, a fight does develop between two opposing *egúngún*, there follows a display of magical powers by them to show who is superior. Each of the *egúngún* must then rely on his drummer to inspire him to a great performance. The *ìyáàlú* drummer also sometimes reprimands the *egúngún* for neglecting his duties or for a bad performance. None of the activities of the drummer which I have been describing is realized by word of mouth; all are articulated on the talking drum and built into the musical structure.

In the course of processing around the town, an *egúngún* pauses now and again to dance, and such dance sections are among the most entertaining aspects of the Egungun ritual/theater. Here again, the masquerade must rely on his drummers to supply appropriate music. During the dance interludes, the *ìyáàlú* drummer moves away from the other drummers and directly faces the dancer. He and the *egúngún* together create the choreography. The number of variations that a drummer plays during such a dance performance depends on how skilled a dancer the *egúngún* is. Drummer and dancer try to outdo each other so that each might win greater applause from the audience.

In the theatrical performances of the *alárìnjò* masquerades, where the emphasis is on entertainment, the drummer is required to supply music that is relevant to the various features of the theater. These include *idán* (magic), drama, acrobatics, chanting, and dance. It is common in the *alárìnjò* theater to have a dramatic scene in which various characters in the society, such as the policeman, the nursing mother, the European, the farmer, are mimed and/or danced with appropriate costumes and makeup. In this dramatic portrayal, the drummer must play music that fits the character being described. In one dramatization of Europeans that I saw, the drummer used a

Yoruba song that was popular in the days when the conga dance was fashionable in Nigerian night clubs. "Adebisi conga, co-co-conga . . ." I suppose that this was the nearest to Europe the drummer could get while still maintaining a Yoruba idiom!

Sample Texts of Egungun Drumming

I would now like to illustrate some of the various functions of the *iyáàlú* drummer by giving sample texts of his drumming with brief comments on their relationship to the context of performance. On the third and most important day of the 1972 Egungun festival in Ẹdẹ, as we accompanied *egúngún* Gbajẹẹrọ from his home to the marketplace, where all the *egúngún* would assemble and pay homage to His Highness, Timi of Ẹdẹ, the leader of the Gbajẹẹrọ's drum ensemble, Jimọ Ayantunde, frequently used the following *oríkì*:

Ọkùnrin gìdìgìrọrọ	O man of fearful personality
Ọkùnrin gìdìgìrọrọ	O man of fearful personality
Ó dà bí olórisàoko	He looks like a devotee of *òrìṣà* Oko [god of the farm].
Ó dà bí olórisàoko	He looks like a devotee of *òrìṣà* Oko.

In the past, Gbajẹẹrọ was responsible for the execution of persons regarded as witches. He is, therefore, a powerful and dreaded *egúngún*, as the praise text implies.

The following two *oríkì* for Gbajẹẹrọ also describe his awesomeness.

Aláyà ṣoògùn	His chest accommodates a profusion of medicinal charms
Bí ọmọ Áígberí	Like the son of Aigberi,
Ilá ´nso lóko,	He plants medicine as one
òògùn ´nfà lòlò	plants okra.

The implication of this text is that, as the okra plant sprouts in abundance on the farm, so medicines weigh heavily on Gbajẹẹrọ's person.

Ara kú ní ńta 'lúwa rè	He is obviously anxious to die.
Àgbà tó réjò tí ò sà	The adult person who sees a snake and does not avoid it
Ara kú ni ńta 'lúwa rè	Is obviously anxious to die.

Yoruba drummers often praise their clients by castigating their enemies, and this is what Ayantunde seemed to be doing in this phrase.

Àbá nikán dá	[The Idea of eating up a stone is merely] wishful thinking on the part of the termite.
Ikán ò le mókuta	The termite can never devour a stone.

There is a praise text that pertains to the importance of Jamujamu, the Ẹdẹ night masquerade, but which is now used by Yoruba drummers to characterize important persons in general. I have heard it used for the former Timi of Ẹdẹ, His Highness Ọba Adetoyeṣe Laoye, and also by an Ibadan drummer for an Ibadan dignitary.

Jámújámú pọ̀ l'Éégún, ó pọ̀	Among masquerades, Jamujamu enjoys a position of great might.

When used for persons other than Jamujamu, the *oríkì* is changed to: "Just as Jamujamu enjoys a position of great might among masquerades, so do you enjoy a position of greatness among your fellow persons."

The following text from the drum music of *egúngún* Ọbadimeji, played by Laisi Ayanṣọla of Oṣogbo, is an indirect form of praise.

Bóo bá dé sọ̀ obì	When you get to the kola nut stalls at the market,
O wẹnii re kí	Make sure that you address your greeting to one that really merits it.

The kola nut stalls at the market are occupied by women, and the idea behind this text is: "Since you, Ọbadimeji, are a distinguished masquerade, you must not go around flirting with a woman unworthy of your status."

The crowd that follows an aggressive masquerade often includes young men wielding slender canes which they apply freely, not only to outsiders who get too close to the masquerade but also to one another. The following text from Ayanṣọla's music for *egúngún* Ọbadimeji indicates the use of canes by *egúngún* followers.

Ò-na-mo-ńlagbà	He who beats one with the *ilagbà cane*
Na-mọ-´nto	And also beats one with the *ito* cane.

I also found in Ayanṣọla's drumming for Ọbadimeji an example of the following provocative text.

Ńbo ṣòkòptò 'jà	He is putting on his trousers
Bọ ṣòkòtò jà.	ready to fight

During the 1972 festival in Ẹdẹ, there was a point at which *egúngún* Gbajẹẹrọ met the Balogun, one of the most senior chiefs in Ẹdẹ, but failed to acknowledge him. Ayantunde, his drummer, reprimanded him as follows:

Ọmọ Káríọlá	You, son of Kariola!
Ǹkán dìgbò lù ó ni?	Has something attacked you?
Yió bàá fùrò yáà rẹ	May your mother's vagina be cursed.

Some *egúngún* enjoy themselves so much that they do not know when it is time to end their outing and return home. In such instances, the following text, from Ayansọla's music for *egúngún* Ọbadimeji, is a useful reminder:

Ẹ fònà gbàlè hán	Show him the way back home.
Ẹ fònà gbàlè hán	Show him the way back home.
B'egúngún ṣere, bó ṣebi	Whether or not a masquerade has performed satisfactorily
Ẹ fònà gbàlè hàn	[The time comes when we must] show him the way back home.

Summary and Conclusion

The Egungun tradition is partly ritual and partly theater. In this paper I have concentrated on the theatrical aspect. The elements of theater presented in Egungun include music, dance, drama, poetry, mime, and costume, with music not only being a key element but one that links all the other elements to one another. From this point of view, the Egungun drummer is crucial to the realization of the theatrical performances.

In the Yoruba tradition, a good drummer is one who is not only able to handle the drumming stick with dexterity, but also has a rich command of language and poetry. The success of the *egúngún*'s public celebrative performance depends to a great extent on the drummer's use of language and poetry. Apart from the *egúngún* who is the central performer, no other person dominates the theater like the drummer. Much of the poetry of Egungun drumming consists of *oríkì* and, from this point of view, the drummer is an image-maker for the Egungun. The Egungun performance is very popular, and the participation of the audience is a major feature of the theater. Through the sounds of his drum, the poet-musician helps to publicize an *egúngún*'s outing and to ensure a good audience participation.

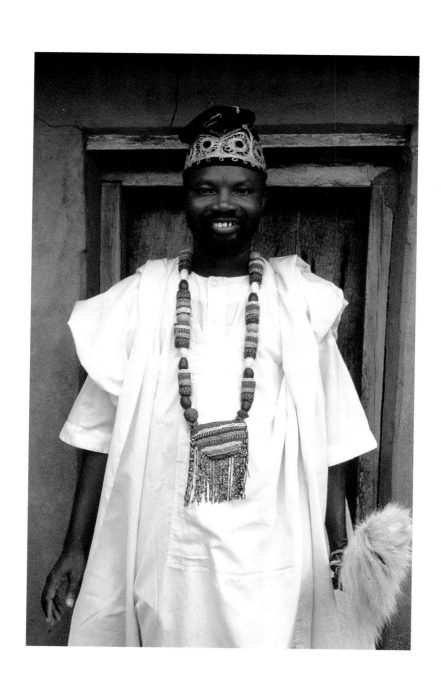

13. Embodied Practice/Embodied History: Mastery of Metaphor in the Performances of Diviner Kolawole Ọṣitọla

Margaret Thompson Drewal

"The way we think", what we experience, and what we do every day is very much a matter of metaphor.
(GEORGE LAKOFF AND MARK JOHNSON 1980:3)

If linguist Lakoff and philosopher Johnson are correct, then: "Our ordinary conceptual system, in terms of which we both think and act, is fundamentally metaphorical in nature. The concepts that govern our thought are not just matters of the intellect. They also govern our everyday functioning, down to the most mundane details. Our concepts structure what we perceive, how we get around in the world, and how we relate to other people. Our conceptual system thus plays a central role in defining our everyday realities" (Lakoff and Johnson 1980:3).

When applied cross-culturally, what this argument effectively does is to demystify performances such as ritual. It thus enables us to perceive ritual practitioners as self-reflexive masters of metaphor that people in turn live by. Ritual is composed of both linguistic and nonlinguistic cultural productions—oral histories and poetry, music, dance, and other ritual acts that are at once metaphoric and sensory in nature.[1] These various modes of representation play off and against each other to produce a complex system extending beyond the ritual performance itself into everyday life. Such a system, in Dean and Juliet MacCannell's (1982:158) words, is "capable of an indefinite increase in knowledge" through the interpretive processes of the participants. Ritual operates in this way as a mode for the transformation of the participants' consciousness as well as the acquisition and transmission of knowledge about the social world.[2]

Yoruba performers regard themselves as "people of action." The idea inheres in a Yoruba theory of action termed àṣẹ. And although I cannot claim to understand it fully—it is one of those concepts like "will" that philosophers write entire books about—it is at a very fundamental level understood by Yoruba performers as "the power to bring things into existence," or "the power to make things happen." In this paper, I examine the oral history and ritual of one performance practitioner, Ifa diviner Kolawole Ọṣitọla (fig. 13.1), and his use of metaphor as a hermeneutic tool. It should become apparent in the course of my argument that Ọṣitọla and other Yoruba ritual specialists are quite conscious that they are engaged in acts of interpretation and representation.

Ọṣitọla is a scholar of oral tradition, a ritual practitioner and healer, a master performer of

orature and drumming, and an intellectual. Trained in the two hundred and fifty-six sets of divination texts (*Odù Ifá*), each with uncountable verses (*ẹsẹ*), Ọṣitọla has a keen memory. In 1986 he remembered details of our discussions from 1982, sometimes reminding me that I was being redundant. When I responded that I was merely cross-checking, he retorted, "No, you are double-crossing." He always looked forward to "wonderful" questions, that is, ones that made him wonder. They were not always easy for me to produce; Ọṣitọla thinks analytically and by his own account used to pester his father and grandfather, quizzing them incessantly on the whys and wherefores of various ritual acts.

Nicknamed Abidifa (A-bi-di-Ifa, "One who teaches the ABC's of Ifa"), Ọṣitọla can go on at great length naming the segments that make up the rituals he performs, describing the action associated with them, and explicating their meanings. In interviews, after exhausting all my questions, he would usually end by telling me what I had failed to ask. This eventually developed into an almost structural feature of our interviews. My most "wonderful" questions by his standards were the ones for which there were no ready answers, the ones that required thought and sometimes left him momentarily blank. I have tried to give an idea of our relationship and way of working because it is important to understand that in everyday life, as in ritual, people operate *on* their situations, whatever they may be, and are always taking stock of those others who happen into them.

We discovered that the best method of working was simply for him to narrate what he does—step by step—and for me to ask questions for clarification. The Ijẹbu Yoruba term for a discrete ritual segment is *aitò*, which is related to the noun *ètò*, an order or program, the root word for *létòlétò*, implying "in an orderly fashion one after the other." The serial form of performance is evoked in the very terms Yoruba uses to characterize it (Drewal and Drewal 1987). My translation of Yoruba divination ritual into an English text relied heavily on Ọṣitọla's expressed understandings of his own hermeneutic practices along with my participation in the rituals he conducted.

Divination and the Hermeneutic Project

We must be prepared to grant that the comic strip cannot be treated as qualitatively inferior to a Shakespeare play or any other classic text. From a semiological perspective, the difference is not qualitative but only quantitative, a difference of degree of complexity in the meaning-production process (complexity, I assume it will be granted, marks a qualitative difference between two objects only for those for whom complexity itself is a value). The difference in degree of complexity has to do with the extent to which the classic text reveals, indeed actively draws attention to, its own processes of meaning production and makes of these processes its own subject matter, its own "content." (White 1987:211)

Both ritual and oral history are "classic" in that they have had lasting historical and rhetorical significance. Both of these modes of the production of knowledge are performative, that is, in-

strumentalized by the performer through embodied techniques and practices. Even so, ritual and oral history have assumed different ontological statuses within different disciplinary traditions. Insofar as ritual has largely been treated by anthropologists and others as a structure of signs and symbols, it has assumed the status of an artifact of the ethnographic present that stands as an objectification of some historical past (see, e.g., Comaroff 1985:8, 197). Through distanced observation, scholars proceeded to analyze the timeless structure and meaning of particular rituals. In marked contrast to those who study ritual, historians have treated oral history as unstable and thus question its validity as a document of the past, arguing that its very status as an authoritative representation makes it susceptible to continual negotiation and reworking to serve the political interests of the narrators (Peel 1984). For this reason, oral histories have been treated as inherently unstable and therefore problematic for historical analysis.

As I hope to demonstrate below, both oral history and ritual are not only embodied practices whose pasts are always already manifest in their performance, as in P. Bourdieu's concept of *habitus* (1977). But, equally important, they are never exact reproductions of that past inasmuch as embodied practices are at the same time resources for negotiation and transformation in the process of the doing (M. T. Drewal 1992). In addition, oral history is often part and parcel of ritual performance. But even when performed apart from ritual, oral history often implies the historical importance of ritual. Implicit in the historical account itself is a hermeneutic consciousness. In other words, the act of interpretation is not only a primary concern in divination ritual, but it is also a practice that is reflected in the reporting of history. In the broadest sense, then, performance itself, whether cast as oral history or as ritual, is by its very nature interpretive. But so are the disciplines of anthropology and history! Ọṣitọla's family history not only grounds him in the past but helps him make sense of himself today, just as his ritual performances are at once interpretive strategies for negotiating the present as well as tried and true practices that have withstood the test of history. In my retelling of Ọṣitọla's family history, I have calculated approximate dates of births and migrations in relation to other documented historical events in order to appeal to the scholar's sense of historical reality. Precise dates were of little concern for Ọṣitọla and his own sense of history; rather, he reckoned history in terms of generations and seniority.

The History of Divination in Ọṣitọla's Family

Some seven generations ago (around the second half of the eighteenth century), Ọṣitọla's forefather, a diviner named Osijo, migrated to Ijẹbuland from Ile-Ife, bringing with him his diviner's iron staff (*òpá osun*), and settled at a place called Idomoro, a small hamlet near present-day Imodi. Osijo was instrumental in establishing an Osugbo council—the judicial branch of traditional Yoruba government—and built an Osugbo lodge (*ilédi*) at Agan.[3] In Osugbo, Osijo held the office of Olotu Agbaoke, an Iwarẹfa chieftaincy title that identifies him as one of the "kingmakers."[4]

After Ọṣijo's death, probably around the turn of the nineteenth century, his son, Ọṣinaalo, was given the title of Apena, the caretaker of the brass figures known as *edan* (H. J. Drewal 1989). Whereas Ọṣijo is remembered primarily for his dedication to Ifa, Ọṣinaalo is remembered for his "Apenaship" in Ọṣugbo.

At Idomoro early in the nineteenth century, Ọṣinaalo's wife, Orukonuku (an *àbíkú* name), gave birth to Ọṣibuluren, who established and became head, Araba, of a noted group of *babaláwo*. Ọṣibuluren's wife, Ẹfunbamówó, in turn gave birth to Ọṣinaike, probably around 1835. During the first half of the nineteenth century, Ijẹbu was rife with warfare; war captives were sold into slavery.[5] People previously scattered throughout the area in small hamlets now gathered in one location for protection. They called their new home Imodi, a fortified town (*odi* = wall). At this time, Ọṣibuluren and his son Ọṣinaike shifted their settlement to one of the two Imodi quarters, known as Aledo, where Ọṣibuluren practiced divination until his death and where his descendants remain until today. At Aledo quarter, Ọṣibuluren became close friends with the carver, Ọnabanjo, whose family, over the years, carved most of the family's ritual objects.

Ọṣinaike, Ọṣibuluren's eldest son, practiced Ifa divination only part time and was better known for his work in the Ọṣugbo Agan, where he held the title of Olurin.[6] Nevertheless, Ọṣinaike inherited all his father's Ifa ritual paraphernalia, much of it having been damaged over the years by the collapsed mud walls of their house. Even so, Ọṣinaike's younger brother, Ogunaderin, became the most notable diviner during his generation. He was also a special child known as Ilori, one born before his mother's menses had returned after she had given birth to another child.

During Ọṣinaike's time, around the 1860s, there was another war.[7] The Awujalẹ requested the aid of Ọṣugbo Agan. Its members prepared their ritual objects—the brass Onile figures, the brass rattle (*ipawo apènà, ipawo onílé*)—and "some of the power within the *ilédì*," and used them to assist the Awujalẹ. They were successful but quarreled over the gifts that the Awujalẹ gave them for their help. This disagreement led to their disbandment.

Ọṣinaike and his wife, Densulu, gave birth to Ọṣinẹyẹ around 1876.[8] When Ọṣinaike consulted Ifa during the Imori ("Knowing-the-Head") ritual on behalf of his son, Ifa revealed that Ọṣinẹyẹ's spirit (*èmí*) had come from the mountain (*òkè*) and that he should have a shrine prepared for the mountain deity, Oke Agbona, which should always be in his view.[9] Later, during his Itẹfa ("Establishing-Ifa") ritual, Ifa instructed Ọṣinẹyẹ to become a diviner.[10]

Ọṣinẹyẹ was diverted from his destiny, however, for this was the heyday of cocoa plantations in Nigeria, and, having inherited a substantial amount of land from his father, Ọṣinẹyẹ focused his attention on raising cocoa and kola nuts. He is also remembered as the earliest tailor in Imodi. Because of his success in these endeavors, he neglected Ifa.

It was also during this time that Islam took a strong hold in Imodi. Because Ọṣinẹyẹ was well known and prosperous in the community, he attracted the attention of the Muslims, who persuaded him to convert to Islam and renamed him Bello.[11] Ọṣinẹyẹ fathered his first daughter around 1900.[12] But he was unlucky. On the day that his daughter was scheduled to become a

Muslim, she died, and he was unable to have any more children for about fifteen years. To make matters worse, his cocoa and kola nut plantations burned, and he went into debt. Concerned about his welfare, Ọṣineye's mother, Densulu, an Oriṣanla priestess, convinced her son to consult Ifa, for, during the ten to fifteen years when he was a practicing Muslim, he prospered only for a short time, and then suddenly and tragically plummeted to a position much worse than where he began.

Ọṣineye was advised to give up farming and tailoring and to devote himself full-time to Ifa. Fortunately he had stored all his shrines in a new house. Even though he had converted to Islam, he continued to divine occasionally. He was also fortunate to be able to learn more about Ifa from his uncle, Ogunaderin, and from other *babaláwo* practicing at Imosan, only a kilometer away.

Ọṣineye became a celebrated *babaláwo*, and people came from Ijẹbu Ode, Agọ Iwọye, Imosan, Ọsosa, and Odogbolu to consult him. He had one of the few *igbá* Odu in the area, that is, a closed gourd that constitutes the shrine of the goddess Odu who, together with her husband, Ọrunmila, originated Ifa divination. Because of the age and power of the *igbá* Odu and his *òpá osun*, diviners often preferred to use these sacred items in their own Itẹfa ceremonies. Ọṣineye was so renowned that he was able to organize diviners from many Ijẹbu towns into a cooperative. And when Ogunaderin and Anikenuku died, Ọṣineye was made the Araba of that area and was also the diviner for the Head Chief of Imodi.

Around 1914, as soon as Ọṣineye resumed as a *babaláwo* in his late thirties, his wife Odujọkẹ gave birth to twins, who died prematurely. Subsequently, she gave birth to Ọṣitọla's father, Ọṣifuwa, an Idowu, that is, a child born after twins, who is associated with the divine mediator, Ẹṣu. By that time Imodi had grown into a sizable town, with four experienced *babaláwo*—Adagiri, Ogunaderin, Ọṣineye, and Anikenuku, who was the Araba of Imodi. Ọṣineye prospered, and at an old age he took another wife, Talabi, and had one more child.

At the Ikọse W'aye ("Stepping-One's-Foot-into-the-World") ritual for Ọṣineye's son, Ọṣifuwa, Ifa said that Ọṣifuwa's soul (*èmí*) came to the world from an ancestor who was a *babaláwo* and that his father should not prevent him from becoming a diviner.[13] And when they performed his Imori ritual, it was discovered that Ọṣifuwa was a reincarnation of Ọṣibuluren and that he should dedicate himself to Ifa. Because Ọṣineye had suffered the consequences of neglecting Ifa, he took special care to groom his child to become a *babaláwo*. At the age of six, Ọṣifuwa performed his Itẹfa ritual during which it was revealed that he should be the husband of a certain child right from his youth.

It was at the same time, around 1921, that Ọṣineye was called upon to perform the Ikọse W'aye at the birth of the granddaughter of the Head of Imodi, Odulaalu. Ifa advised the family that this granddaughter, Bukọnla, should marry a *babaláwo*. And a few months later, when they performed the Imori ritual for her, Ifa instructed that she should be betrothed to Ọṣifuwa. Ọṣifuwa's parents and the Head of Imodi kept Ifa's instructions in mind until their children were old enough to marry.

Ọṣifuwa went to primary school for about three years before he began to practice Ifa and

learned how to write and read Yoruba. He practiced Ifa from an early age and had a quick mind and a good memory. He became very knowledgeable during his lifetime; however, by that time, traditional religion was in decline, and Islam was on the rise. Muslims accused traditional practitioners of Yoruba religion of being "idol worshipers"; the Koran informed them that ritual sacrifice was not godly. People were no longer interested in Ifa, even if they were on the verge of death. Osifuwa therefore had few clients.

Even though Osifuwa was less successful than his father had been, he nevertheless heeded Ifa's advice. And he also served as the attendant (*ojubona*) for a society of women, who performed "miracles" and called themselves Iya Alawo (Mothers who Possess-Esoteric-Knowledge). To expand his knowledge of Ifa, Osifuwa traveled as far as Ile-Ife, Osi Ekiti, and Ofa to find capable *babaláwo* who could teach him more divination verses.[14] In fact, he was traveling during the months before his wife was to give birth to their first child.

One night Osifuwa's father, Osineye, dreamed that, as he was performing an annual Ifa festival, one of his comrades brought him a male child and said that this boy would bring prosperity back to the house. He advised him to encourage the boy to become a *babaláwo*. Osineye then consulted an experienced diviner from Ago Iwoye about his dream, and the *babaláwo* told him that his daughter-in-law, Bukonla, would give birth to a diviner, that he should instruct him in Ifa practice, and that they should perform an Isefa ("Making-Ifa") ritual for him before his birth—traditionally performed at age five or six.[15] The pregnant mother knelt down, and the diviners prayed for her womb. Instead of putting kola nuts on the child's head to pray, as is the common practice, the diviners placed them on the mother's belly.

Meanwhile, Osifuwa was in Ofa where he dreamt that he saw his grandfather, Osinaike, who told him to return home immediately, that his child was coming, and that he should name him Kolawole. On his return, he heard of the Isefa ritual. Osifuwa vowed to name the son Kolawole, while Osineye, not wanting to forget the traditional Osi name, gave him Ositola. In evidence of the impact of Islam, he also received a Muslim name, which he does not acknowledge and will not divulge.

Kolawole was born 31 August 1945. By then his grandparents were growing old, but he was very close to them; he slept and ate with them. His grandfather taught him much about Ifa, and he accompanied his father and grandfather whenever they performed Ifa rituals. He was able to memorize special incantations quickly, which he could hear only during Ifa rituals, and by age ten he was given the leading role in performing Itefa ceremonies for clients. From his grandmother, Odujoke, who was a priestess of Obatala, he learned how to prepare and install shrines for the deities. Around 1952 Ositola began to dream that enemies pursued him and that he would escape them by flying above their heads. When he reported these dreams, his father interpreted them to mean that nobody would be able to conquer him.

After the death of his grandfather, Osineye, in 1956, the *babaláwo* associated with Osineye

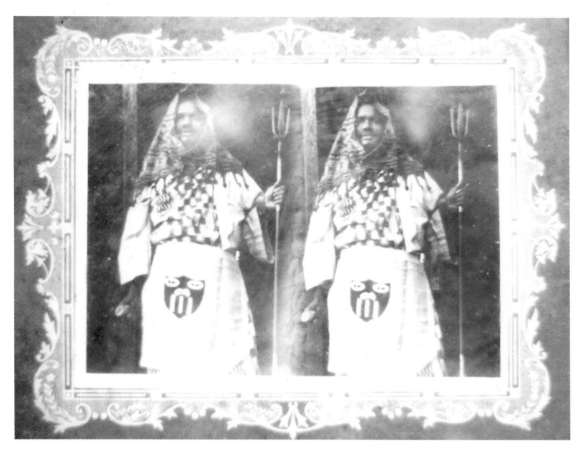

Fig. 13.2.
Ọṣifuwa, father of
Kolawole Ọṣitọla.
Photo: M. T.
Drewal.

went their own separate ways, and each town selected its own Araba. There was no longer any cooperation among them, and people with little training and no experience began to call themselves *babaláwo*. For this reason, Ọṣifuwa and Ọṣitọla lost interest in working with them. Ọṣifuwa died in 1969 in his late forties/early fifties (fig. 13.2).

Ọṣitọla continues his father's work, but times are not easy. With the strong influence of Islam and Christianity and with industrialization, people do not consult Ifa as often as they did in the past. Today men go through Itẹfa ceremonies only after their lives have been shattered, or "scattered like a broken gourd." In spite of this, however, and in spite of his young age, Ọṣitọla has organized a small group of diviners and students (*ọmọ awo*), who are committed to traditional religion.

Ọṣitọla's family history as he narrated it is replete with interpretations of ancestors' lives, interpretations derived from divination rituals performed particularly in conjunction with the birth of a child. Ọṣitọla referred to several different types of divination ritual, including Ikọṣẹ W'aye (Stepping into the World), Imori (Knowing the Head), Itẹfa (Establishing Ifa), and Isẹfa (Making Ifa). As I demonstrate below, the parables that these divinations elicit are metaphoric in nature and

serve as individuals' guidelines in life through processes of interpretation and application. Although Ọṣitọla did not narrate the parables per se, the signs that invoked them are inscribed on the shrines dedicated to each of his ancestors (fig. 13.3). As embodied knowledge, history is performative in the act of speaking. Likewise, divination ritual is embodied knowledge put into practice through performance. To the extent that ritual knowledge has been passed down from person to person, generation to generation, its practice is living history. But since ritual performance is always at the same time interpretive, the practitioner continually reworks that past to make it relevant to the concerns of the present. Embodied practice is embodied history, a history that was always already hermeneutic in the making.

Ọṣitọla's Practice and the Hermeneutics of Divination Ritual

As boys grow to an age of understanding—around seven years old—Ọṣitọla performs rituals known as Itẹfa to construct their identities, and in so doing attempts to transform their consciousness. To accomplish this, with his entire group of diviners, he leads young boys through a ritual dialectic on autonomy and dependence, bestowing on them personal paradigms for living, in this way initiating their independent pursuits of self-identity. What Ọṣitọla and other diviners hope to accomplish is to provide them with an ever-expanding corpus of texts that serve as models for self-examination and self-interpretation. Since individuals ideally accumulate texts that comprise *their* personal corpus of models over their lifetimes, and at various points weigh those texts in relation to others that may turn up in subsequent divinations, they embark on a lifelong program of searching, reflection, and interpretation. This program serves, according to Ọṣitọla, as their guidance in life.

To establish the initiate's self, Ọṣitọla conceptualizes and performs Itẹfa as a journey with travel from one place to another and a return, new experiences, joys and hardships along the route, and material for further contemplation and reflection.[16]

Ọṣitọla's Metaphoric Projections[17]

One of Ọṣitọla's explicit intentions in performing Itẹfa rituals is to prepare the initiate's personal set of divination palm nuts, which will be used initially to divine his personal texts and subsequently throughout his life whenever he consults a diviner. As the group of diviners "worked on" the initiate during Itẹfa rituals, they simultaneously worked on his palm nuts to "build them up," imbuing them with the power to overcome life's difficulties. This personal set of divination palm nuts represents the male initiate's rebirth, his personal destiny and, by extension, Ọrunmila, the deity of divination.

On the nights before the journeys began, the diviners focused the attention of the sojourners on

Fig. 13.3.
Ifa shrine room
with Odu Ifa,
Imodi, Ijẹbu, Nige-
ria, 1982. Photo:
M. T. Drewal.

the work at hand in a formal preparatory ritual (*idiifá*). They accomplished this by invoking the sojourners' inner heads. The diviners displayed all of the sacrificial items and other materials brought by the initiate and his family at the diviners' request to be used during the following fourteen days. Each diviner held up each item one by one for all to see and then touched it to the forehead of the sojourner for whom he would later divine.

The journeys began at dark the following day with a warm-up in front of Ọṣitọla's house, when his group of diviners chanted texts and explicated the original journey of Ọrunmila and what it had accomplished. As the story went, when Ọrunmila failed to educate his three children properly, they carried him to the bush and threw him away, something that the sojourning party would also do, but with one major difference in light of the original mishap. The sons would now receive an education on their trip to the bush and therefore would not discard their father (Ọṣitọla 82.38II; see also Ọṣitọla 1988:34). Since the incantations were cast in archaic language described as "deep words" (*òrò ijìnlè*), the uninitiated could not understand them. But, Ọṣitọla (1988:35) explained, as the verse is explicated, "all the participants are listening and have ample time so that they might reflect for themselves." After a couple of hours the journey began.

The sojourning groups were made up of the ritual specialists—the diviners and their students (omo awo)—the initiate, his mother, and/or wife—depending on his age—and other family members and friends. Their numbers vary greatly according to the number of initiates and their family members: anywhere from thirty to fifty people in the Itefa I attended. Although the groups' physical destination was only Oṣitọla's backyard not more than fifty yards away, the diviners imbued the trip with a feeling of distance. They took a circuitous route, stopping at significant places along the way to chant incantations alluding to the spiritual and physical hardships of life in order to "clear their path." The group carried all their supplies on top of their heads—one of the hardships of the journey.

In Oṣitọla's backyard is a grove made of tin sheeting, an enclosure for the deity Odu (igbódù = igbó Odù, "Odu's bush"), a sacred, exclusive space that the diviners constructed themselves. Before the initiates could enter the grove, there was a prolonged sequence of actions outside in full view of everyone. They included a divination on the road to determine if the palm nuts were strong enough to survive the rituals (ìdáfá ònà); a two-hour-long, or more, dance segment of stepping on the buried palm nuts (orokiti), part of their build-up; and an elaborate sequence of incantations at "the gate"(enu ònà) in order to "take permission" to enter (ikaago). The initiates were as if entering the ancient city of Ile-Ifẹ—according to oral tradition the sacred origin of all humankind, the only ancestral city with which Yoruba collectively identify. This was followed by a ritual washing of the palm nuts by women (iwèfà); another dance to celebrate the participants' successful arrival at another stage in the ritual process (iyi ifá); an elaborated entry into the sacred grove, when the initiate and the mother or wife proceed down the path on their knees carrying an iron staff on top of their heads (imosun)—a further hardship; a sequence of jumping through fire (finona), an affirmation of the initiate's resiliency; and finally, a sacrifice to Death at a site prepared for the iron staff (ibosun). At last, the initiates entered the sacred grove (imawogbodu), and they did so blindfolded.

Only the diviners, their initiated students, and the initiates themselves were allowed to enter the sacred space. This began their period of physical separation from their family and friends, who remained in close proximity outside and kept a vigil in the "women's market" (ojà obìnrin), that portion of the backyard where women can wander freely in contrast to the restricted space of the grove.[18]

On the inside of the grove, initiates experienced many "wonders" that were kept secret from the uninitiated. Part of the importance of making a portion of the journey secret was to preserve the intensity and impact of experiencing it for the first time.[19] During this period of separation, males were given rebirth. In the wee hours of the morning as the sun rose, the initiate and his family learned through divination the set of texts that "brought him to the world," that defined his personality and potential in life. Once a person begins to learn his personal texts, he will understand how to conduct his life to maximize his chance for success. The diviners' identification and interpretations of each initiate's personal texts foregrounded the individual and provided each

Fig. 13.4.
Ọṣitọla's sons,
Imodi, Ijebu, Nige-
ria, 1986. Photo:
M. T. Drewal.

guidelines for living. Those who do not perform Itẹfa risk "behaving against their luck, against their way of living."

By the evening of the second day, the initiates emerged from the grove with heads shaved and painted white, wearing white cloth and the red tail feather of the African gray parrot on their foreheads (fig. 13.4). The white cloth is the color of the birth caul, and thus the color worn by all human beings when coming into the world anew. In painting the initiate's head with "star chalk" (*efun ìràwọ̀*), the diviners made a visual analogy between the newly defined personality of the individual and a shining star.[20]

The group journeyed home again as elaborately as it went. Once back in the house, the initiates were confined to specially prepared mats (*itẹn*), where they slept and ate for the next twelve days. There, too, all the subsequent divinations were performed.[21] On the third day (*ìta Ifá*), the diviners checked their progress through divination. Like the third day of a funeral, the greater part of the day was taken for feasting, dancing, and playing. Between the third and seventh days, the initiates formally saluted the deities first thing every morning, rested, and ate. On the sixth day (*ìjẹfá*), they again made sacrifices, feasted, and danced. The fourteenth day (*ìjẹnlá*)[22] the novices were reincorporated into their ordinary daily routine. They became "new" (*títun*), discarding their ritual

dress and putting on everyday clothes and hats. Then they enacted weeding, and for not working hard enough were whipped with single, quick, sharp lashes across their legs or backs at irregular, unexpected intervals; they were forced to climb a tree; and finally they pretended to sell cloth in the market—all, Ọṣitọla explained, were lessons in perseverance (*iróju*) for success in the real world.

The openness of the ritual form enabled Ọṣitọla to tailor it to the initiate's immediate needs. Reportedly, Itẹfa ritual segments are themselves based on experiences from the lives of the deity of divination (Ọrunmila) and other ancient diviners, as documented in the corpus of oral verses or texts. The verses, often chanted during rituals, relay these experiences that then serve as precedents for the series of actions comprising Itẹfa. Both the male and his mother or wife, as the case may be, perform many of these acts simultaneously. When recreated, these acts bring the presumed past to bear on the present situation. As models for present practice, they are regarded as tried and true formulas for negotiating the desired results for the initiate through what Stanley J. Tambiah (1985:72, 77) has referred to as the transformative power of analogical thought and action. Composed of both linguistic and nonlinguistic cultural productions—oral histories and poetry, music, dance, and other ritual acts at once metaphoric and sensory in nature—these

Fig. 13.5. Women dancing with ritually treated palm nuts, which have been submerged in a herbal bath inside a gourd. Imodi, Ijẹbu, Nigeria, 1986. Photo: M. T. Drewal.

various modes of representation play off and against each other transversally to produce a complex system capable of an indefinite expansion of meanings through the interpretations of the participants.

At one level, Itẹfa is about the relationships of men to women. Diviners, who are male, take over women's prerogative by giving males a rebirth. According to one of the myths that served as a precedent, it was the wife of the deity of divination who taught her husband how to perform Itẹfa. She divulged her secret power to him, telling him that if he gave her proper respect she would use that power to help him. Through his wife Odu, Ọrunmila got his "sixteen children," that is, the sixteen major divination signs known as Odu Ifa. Odu is represented in ritual by a closed gourd usually concealed inside a larger container, which a woman carries during rituals (Ọṣitọla 1988:35). Odu's secret is the knowledge of birth.

On 3 November 1986, not long before four young boys performing Itẹfa entered the sacred grove, women danced with their ritually treated palm nuts, which had been submerged in a herbal bath inside a gourd (fig. 13.5). The form and style of the dance were not as significant in this context as the act itself. The dancer often performs a simple, repetitive stepping pattern requiring no particular skill. This dance, Ọṣitọla claimed, "brings happiness into the heart of the palm nuts."

As the women danced, the diviners invoked women's spiritual support by singing a series of incantations. The first asserted that "it was a woman who gave birth to a king before he could become sacred," that is, the deputy of the gods. The second added, from a woman's womb come all the important people in the world. The third called attention to the pact between mother and child by reminding the mother of her days breast-feeding, or nurturing, her child. The fourth song cursed any evil intentions on the part of women. It alleged that the diviners had offered them all the required sacrifices; therefore, if any of them cause trouble, let them go the way of the sacrifice (that is, let them die). And the final song reminded women of the pact between the deity of divination and his wife, who is the source of female power, in order to insure that their sacrifices would be accepted and the ritual would be successful. To demonstrate men's respect, one of the diviners prostrated himself at the feet of each of the dancing women.

The diviners invoked the spiritual support of women by acknowledging their power and appealing to their motherly roles and especially the close physical and emotional bond between mother and child. The palm nuts are to the gourd that the dancing woman carries what the unborn child is to his mother's womb, and indeed it is this relationship that the diviners appeal to during the women's dance. Afterward, each initiate danced with his own palm nuts in a ritual segment called "the owner of the deity has come," that is, the owner of the palm nuts. The inner head of the individual was elevated to the status of a personal deity; the palm nuts are its shrine. According to Ọṣitọla, the dancing woman represented both the mother and the Ifa devotee's potential wives. The transfer of the palm nuts from the mother/wife to the male initiate is at once analogous to the diviners taking charge of the processes of rebirth and an assertion of the autonomy of the initiate.

As a sign that the dancing had finished successfully, Ọṣitọla sprinkled the heads of the others—the diviners, the women, and the initiates—with the herbal water that contained the palm nuts. He thus drew a physical relationship between the participants and the palm nuts through a process of incorporation. Then he "split Ifa" (*ìlàfá*), a performance segment also called "hippopotamus swimming, or splitting, the river" (*erinminlado* [*erinmi n a odo*]). He put his hand in the water to make ripples as he prayed, giving thanks for the safe return of the initiate from his journey through the water just as, according to an oral text that served as the precedent for this segment, Ọrunmila, the deity of divination, returned successfully from his journey to visit the goddess of the sea, Olokun.[23] Conceptually, the palm nuts and the initiate were united.

The metaphors piled up and played off each other to create a new synthesis: the palm nuts were to the herb bath what the initiate was to his mother's womb what the hippopotamus is to the river (or a:b::c:d::e:f). This latter image referred broadly to water as the source of all life, wealth, and prosperity. The earth's water mass is personified in Ijẹbu Yoruba cosmology as Olokun, the deity of the sea, who by extension owns all waters. Hippopotamus in Yoruba is "the elephant of the water" (*erinmi* [*erin omi*]), an image that monumentalizes a rather minuscule action. These verbal and kinetic manipulations in effect attached the physical origins of the newborn child to the spiritual origins of all life, wealth, and prosperity and then brought them into relationship with the initiate's rebirth. It is not by chance that, among the Yoruba, rivers and streams tend to be associated with female deities.

This mini-journey through water was nested within the larger context of the ritual journey and was represented by the dance and later on by the motion of the diviner's hand in the water. As Ọṣitọla conveyed it, he "puts his hands in the water as if something is going through the water as a hippopotamus goes through the river without a hitch." There was a further contiguity in the ease with which the passage was, and would be, achieved—"without a hitch" in Ọṣitọla's words—the ease of the hand through water, the ease of the hippopotamus through the river, the ease of the new baby's idealized passage through his mother's water, as well as the ease with which the palm nuts soak in the herbal bath in relation to the ease of the woman's dance. This idea is conveyed explicitly in the name of the final ritual segment of the *iyì ifá* known as *tutù niní*, which characterizes water as a "cool" medium for "cooling down." It is "very cool, like the bottom of the ocean." With this, Ọṣitọla took the palm nuts inside the enclosed sacred space where Odu's shrine had been erected to "work" on them further.

The ritual transformations occurred through sets of metonymic displacements performed by Ọṣitọla, each set based on a container/contained structure.[24] This structure was sustained throughout the ritual and carried over into the initiate's daily life. Thus, when an initiate is young, his mother provides his first container to hold his palm nuts. Like Odu's shrine, this container should be a gourd. During the preliminary portion of the ritual, which initiates the preparation of the divination palm nuts, the mother replaces the gourd with a clay pot. Then, for the next stage of

the ritual, she replaces the clay pot with a wooden or porcelain one. Finally, when the child grows up and marries, his wife should replace the third container with one specified through divination. Whenever these series of rituals are performed for an adult male, his wife provides all the various containers for the different ritual stages.

As these containers are discarded, according to Ọṣìtọla, they are buried inside Odu's sacred grove, just as the afterbirth is buried in the bush, or in the backyard, after the birth of a child. The changes in containers that hold the palm nuts reflect their maturity, that they have been "built-up" through successive rituals. At the same time, they reflect the devotee's maturity and his changing relationships with the women closest to him—first with his mother, as a dependent infant, and later his wife. There is a progression in the sequence of containers from gourd, to clay, to carved wood or porcelain. The various types of palm nut containers that line the back and side walls of a family's shrine room, as well as those set out on display during annual festivals, reflect the different stages of the maturity of male family members. While the palm nuts represent the devotee himself, and by extension his male deity Ọrunmila, the containers represent his mother and ultimately his wives, as well as the wives of his deity.

The initiates did not understand the sophistication of the analogical thought that the series of words and acts embody. At first, they did not even fully understand the implications of their personal texts. There was no common intellectual or emotional meaning for all the participants. They experienced only unfathomable difficulties and "wonders." But, as Ọṣìtọla noted, the journey does not end there. Itẹfa is to be re-experienced for further contemplation.

Once the child has been initiated into Ifa practice, he is from that time on permitted to join the group of diviners inside the restricted grove during the transitional period of others' initiations. From a different perspective, he then re-experiences what he has already gone through. Ọṣìtọla himself—as much as he understands and explains about the ritual process—continues to analyze and interpret what he does, asserting that any diviner who claims knowledge of everything is spurious because, if there is anything that a wise person knows for certain, it is that there is always more to learn and understand.

Ọṣìtọla's Hermeneutics

The Yoruba notion of interpretation in divination practice (ẹyọ Ifá), its personalization, and the way it ultimately shapes further performances in everyday life can to some extent be evoked in an account of Ifa verses for Ọṣìtọla's eldest son. Ọṣìtọla stated:

Our concern is taking care of the child. You see we don't finish Itẹfa in a single instance. We do it just to know how to establish [the individual]. It is the initial information on somebody. And that enables us to know how we shall prepare the individual further based on our interpretation according to the changing world. . . .

One of the things in reciting a verse that occurs during an Itẹfa for somebody is that finding a meaning to it is a continuous exercise. For instance, I still need to discuss it [the verse] with some senior diviners other than my colleagues. And I am sure they will still have to educate me more on some of the facts that I don't know. Nobody can claim single knowledge of all the sets of verses. We still need to discuss it further with other people. But to know the direction, it is this that can be explained.

Even I want to tell you, Yẹmi himself [one of the initiates] will still continue to find meanings to his life, to his verses. In the first instance, it is only a direction. I still find meanings to my own verses. We don't relent. It is our guidance. We have to be looking at it thoroughly.

Tomorrow somebody might come from Cuba and tell me a meaning of the Olosun meji [his own personal set of verses] and advise me on it. If it is sacrificial, I still have to do it. If it is not sacrificial, I have to abide by the advice—by the words of wisdom. It is continuous; it is to know a direction.

But other diviners will continue to give meaning to your particular set of verses all along, all along, as it develops. It may be the next century before I get more meaningful interpretations to my own verses. (Ọ̀sịtọla 86.142)

The dialogue between one's divination texts and one's personal experience is lifelong. There is no concept of "a meaning," or "the meaning," of a personal set of texts. Thus when I suggested to Ọ̀sịtọla that he might be "partial"—that is, biased—if he interpreted his own children's texts, he replied, "no." Quite the contrary, "not to interpret them would be partial" (that is, incomplete). Indeed, the more meaning a person reads into his personal texts, the better he knows himself. Ọ̀sịtọla thus interpreted his children's verses, although he was not permitted to cast the palm nuts to elicit them.

Ọyẹku meji was the Odu divined for Ọ̀sịtọla's eldest son, age eight at the time.[25] Its direction indicated overall achievement. Ọ̀sịtọla narrated a parable about a child named Sunrise (Ojo), who came to the world protected:

He lived a full, complete life, and he was bright and prosperous and loved. He had everything in life.

Words of wisdom were spoken to Sunrise in his early life [i.e., when he was rising]. They said he would complete his journey, that his journey would be bright; everybody would like his brightness. And he would also be powerful. But if he wanted to ensure this success, his parents must make a sacrifice on his behalf. They should sacrifice a bunch of brooms, a bundle of white cloth (àlà), and a sheep.

Sunrise gathered the items and was told, as you are rising, as your life becomes bright, there will be some enemies who will be jealous, who will try to dim your brightness (Ò tá máa fẹ́ pá na ọla Ojo). They will use their power of dangerous inner eyes (ojú burúkú inú) to stare at you. But if you can satisfy the divine mediator, Eṣu, then he will assist you to prevent those dangerous eyes from dimming your brightness.

Sunrise's parents, named Eṣuwata, made the sacrifice on his behalf.[26] They prepared Sunrise for his journey right from his rise. When he arrived at his destination, everything went well. People understood his light. Everybody admired him (Ojo yii san an), for they did better as a result.

But, as he moved higher in the sky, as Ifa predicted, some people attempted to dim his light by staring at him with their dangerous eyes. Immediately Eṣu, the divine mediator, who was by Sunrise's side, inquired from wise men, "things are now topsy turvy. What happened? What is the matter with these

troublesome people?" The wise elders responded, "it is Sunrise they want to trouble." But Sunrise had been well prepared. He had been well established. He had performed the necessary sacrifices. Eṣu asked, "where is the evidence of the sacrifices?" The wise men showed him the bunch of brooms prepared with medicines, instructing him to put the brooms on Sunrise's forehead so that no one can see his inner head well.

Because Eṣu blessed the brooms, when anyone stared at Sunrise, they saw only the brooms, which scratched and hurt their eyes (*Ó fi'gbále gbá a lóju*). It is the broom straws scattered in the sunrise that injure people's eyes and prevent them from looking into it; it is the broom straws that prevent people from dimming Sunrise's brightness. The broom blinds the evil inner eyes of onlookers.[27] Extraordinary eyes cannot penetrate a prepared person. If they dare disturb the child, they will be blinded.

The last two lines take the form of a curse.

Ọṣitọla only hinted at how he understood this parable:

You see, the interpretation of Ifa just provides us a model to follow, not just exactly what should be done. You can perform in the changing world manner. You don't have to do exactly what Ifa did historically. Our own knowledge, our own power, our own *àṣẹ* [power of accomplishment] may not be as powerful as the one they used for the broom in the past. And, again, it may be more powerful than that. And it may not be in [the manner of] that broomish preparation. We have to look at what to do. How can we do it? For instance, we are not in a world where we can give [name of child] a broom to be carrying all the time. Then we have to do it in the changing world fashion.

What shall be given to him as protection? It may not necessarily be material things like a necklace, or wristwatch, or any such thing. It may be some sort of food he can eat. It may be some sort of soap he can take a bath in, and nobody will know that he has been prepared.

We can also make use of incantations. It depends on the changing world and our research. You have got the examples. You know what has been done. You can relate it. (Ọṣitọla 86.138)

In addition to understanding how the parable related to his son's life, Ọṣitọla also had to figure out how the suggested remedies to the problems sketched out in the oral texts applied to "the changing world." The part of the interpretation that had to do with the immediate action to be taken was confidential for the reason that, if potential detractors were to gain access to the secret, they could counteract its potency and render the action ineffective.

In the road of "overall success," Ọyẹku meji posited a bright child both intellectually and physically, who would be embarking on a journey in a jealous, vengeful world.[28] In 1986 Ọṣitọla's eldest son was an extremely intelligent, quiet but intense child, with very beautiful refined features and large bright eyes with thick lashes (fig. 13.4). It is not difficult to understand the meaning of the story of Sunrise in relation to the boy or the jealousy his very existence would be expected to incite. The parable constructs the son's brilliance in multiple senses. At the same time, Ọyẹku meji is considered a harsh sign because it speaks generally about the threats of death and destruction. It is the same sign that appeared during the Imori ritual for the girl "born to die," when darkness went inside darkness. To understand Ọyẹku meji as general overall success in the midst of threats

of death is to prepare the Itẹfa initiate to operate cautiously and to be sensitive to the implications of making others jealous.

The journey to the sacred grove of Odu presented the initiates with new experiences, with lessons about the hardships and joys in life, and with a wealth of material for further reflection. The experimental part of Itẹfa ritual, its creativity, was not confined to its structure, its process, or any liminal phase of performance. Rather its creativity lay in the artistry of Ọsitọla to improvise, to play the tropes; to interpret and to manipulate the action skillfully and persuasively. The Itẹfa ritual worked through Ọsitọla's ability to pile up and layer metaphors. The transversality of these metaphors across oral, material/visual, and kinetic modes of representation generates an open, expansive, experiential, and intercommunicational system for participants to interpret, to reflect upon, and to make meanings that carry over into their performance of everyday life.

Notes

1. Research for this paper was sponsored by the National Endowment for the Humanities in 1982 (#RO-20072-81-2184) and 1986 (#RO-21030-85), for which I was a co-recipient with Henry John Drewal and John Pemberton III. Without the generous cooperation of Kolawọle Ọsitọla and his group of Omo Awo, this paper would not have been possible. The Itẹfa ritual discussed in this paper was analyzed in more detail in M. T. Drewal 1992. It has been condensed here for the purpose of elaborating certain theoretical and methodological issues with regard to performance praxis.

2. Scholars have long recognized the transformational capacity of ritual (see Meyerhoff 1990). They have placed emphasis on the transformation of consciousness and changes in social status. In so doing, they have tended to attribute agency to the ritual structure itself, as in Victor Turner's tripartite model of ritual process (1977). From this point of view, the ritual is successful only if the participants fulfill or complete all the stages of the ritual structure (see Fernandez 1986:43). It has long been the assumption of scholars that the agency of ritual inheres in its structure as a system of signs and symbols. This has led further to a view of ritual as more or less static. Sally Falk Moore (1975:219), for example, has written that rituals represent "fixed social reality" and "stability and continuity acted out and re-enacted." She continued, "by dint of repetition they deny the passage of time, the nature of change, and the implicit extent of potential indeterminacy in social relations" (Moore 1975:221).

3. At the time, there was only one other Ọṣugbo in the vicinity at Imosan, called Ọṣugbo Ikan. For further details on Ọṣugbo (also known as Ogboni), see Morton-Williams 1960, Williams 1964, Agiri 1972, Atanda 1973, and H. J. Drewal 1989.

4. The Iwarẹfa comprise the six highest ranking chiefs in Ọṣugbo (Lloyd 1962:41–42). According to Bovell-Jones (1943:74), the Iwarẹfa sit on the shrines of the ancestors in the *ilédi* and their titles derive from the names of the original founders of Ọṣugbo in that town.

5. This tradition probably refers to the Owu and the Owiwi wars. The former took place in the first quarter of the 1800s (see Ajayi and Smith 1964:17; Mabogunje and Omer-Cooper 1971:53–54). Then, according to Biobaku (1957:18–19), between 1825 and 1832, Shodẹkẹ, the Ẹgba leader, pursued marauders deep into Ijẹbu territory. In 1832, during the Owiwi war, fought primarily between the Ijẹbu and Ẹgba (Biobaku 1957:19–20), he supposedly captured seven Ijẹbu generals and buried their heads in front of his

compound in Iporo. Sometime during the early 1800s, Awujalẹ Fusengbuwa, the king of Ijẹbu-Ode, awarded land in Imodi to one Balogun, the first Otunba Suna, for his service in the Owu wars. The date of his burial in Imodi is calculated to be 1835, based on archaeological evidence (Calvocoressi 1978).

6. Olurin is the Oṣugbo title of the Baalẹ (Head Chief) or the Ọba (King) of a town. For example, the Awujalẹ, king of Ijẹbu-Ode, held the title of Olurin in Oṣugbo; however, since kings traditionally did not appear in public, he had a representative attend meetings, who was also called Olurin (Bovell-Jones 1943:74).

7. It is likely that this event refers to the Ijaye war. According to Ajayi and Smith (1964:92–93), the Ijẹbus aligned themselves with the Egba and in 1861 raided Ibadan farms and captured Apomu.

8. Oṣinaike was already middle-aged by the time he fathered a child; he had lost his youthful appearance, and his muscles had become flabby. The family places his son, Oṣineye, in the same age grade as the mother of Chief Timothy Adeola Odutọla, which suggests he was born around 1876–78. Chief Odutọla himself was born in 1902 (Longe 1981:7).

9. The Imori ceremony is performed for a child usually three to nine months after birth in order to establish from where the èmí, or the soul, of the child has come. Knowing the origin of the soul that animates the child's body is the first stage in "knowing the child's head" (imo orí), that is, knowing his or her character and destiny. For a discussion of èmí and orí, see Bascom 1960.

10. Itefa is a ceremony traditionally performed when a male child reaches six or seven years old. It is during this ceremony that the child's family learns which Odu Ifa brought him into the world, what life holds for him, the nature of his inner head (orí inún), his deities (òrìṣà), and his prohibitions (èwò) (M. T. Drewal 1992).

11. According to Gbadamosi (1978:32, 45, 96), Islam did not take hold in Ijẹbuland until after the British conquest of Ijẹbu-Ode in 1892, although some Ijẹbu-Ode notables appeared on horseback in Muslim festivals before 1879. Ironically, Gbadamosi (1978:92–93, 115) attributes Islam's success, in part, to Ifa divination:

> When some parents sought out a diviner, to predict the future life of the children, they were informed by some of these Ifa diviners that such a child was predestined to be a Muslim. The parents were then taught by the diviner the proper steps to take to ensure the well-being of the predestined Muslim. On being so informed, the Yoruba parents, true to Yoruba custom, hardly queried Ifa predictions, and followed such divinations strictly. They prepared in the house a small enclosure of the size of the "girigiri", held parties for the child once every week, especially on Fridays, and cut for the child a number of white dresses. This was continued until the child came of age. As soon as any mallam appeared, the parents called on him to "surrender the child to him". The child was then given a Muslim name and, as a protégé of a Muslim, was brought up in the true Muslim way. There were many examples of these "predestined Muslims" in Ijebu area. . . . The particular Odù divining Islam as being the religion for the child is Otura Méji.

Likewise, in Ijẹbuland, Muslim diviners also send clients to Ifa diviners for help whenever they deem it necessary.

12. Oṣineye's first daughter was of the same age group as Chief Odutọla, who was born in 1902. See Longe 1981:7.

13. The Ikoṣe W'aye is a ceremony performed for a child just after birth, but before the Imori ceremony, so that the parents may have some indication of the child's identity.

14. The name of one of his babaláwo friends in Ọfa is still remembered; his name was Abifarinmapose, and he was slightly older than Oṣifuwa's father, Oṣineye.

15. The Isefa ceremony follows Imori and precedes Itefa. It is performed to "build-up" the sacred palm nuts (*ikin*) used in divining, in order to give them the strength to go through Itefa.

16. I have attended three Itefa—one in 1982 and two in 1986. These three performances led by Ositola generated approximately thirty-nine hours of discussions with him in 1982 and twenty-three hours in 1986. Our 1982 discussions naturally influenced the way I viewed and understood the 1986 performances. More important, in these three performances I was able to see similarities and differences. I have cited only those taped discussions I have quoted.

17. It is impossible within the limits of this essay to unpack Itefa semiotically or even to convey all of what goes on. I have tried to present just enough to give some indication of its richness and complexity without at the same time oversimplifying it.

18. Markets in Yorubaland are ordinarily controlled by women.

19. Ositola (1988:36) suggests other explanations.

20. According to an Ifa text, Orunmila himself was instructed to paint his head with star chalk for protection when going to meet with "our mothers," the spiritually powerful women in the world. The relationship between one's personality, a shining star, and protection from the mothers was not a topic Ositola was willing to discuss, although I speculate it is one dimension of the discourse on autonomy and dependence, which is implicit in Itefa performance.

21. Confinement to the *iten*, and a ritual segment known as *ileten*, are also performed during the installation rites of kings and other chiefs.

22. *Ìjenlá* means literally "big seven"; or, in other words, it is seven times two.

23. As one diviner explained, Christian preachers pray to go to paradise when they die; diviners pray to go to Olokun.

24. See Sapir (1977:22) for a discussion of the container/contained structure of metonyms. The action put into effect, in Fernandez' words (1986:42), "metaphoric predications upon the pronouns participating in the ritual."

25. The following parable is an edited version of that told by Ositola (taped discussions 86.138 and 86.142, Ijebu-Ode, 30 November 1986). It is a retelling of the one told inside the restricted grove.

26. Esuwata implies devotees of Esu.

27. That is, just as the sun blinds those who look directly into it and just as the eyelashes protect the eyes.

28. A second narrative from Oyeku meji presented a similar kind of conflict, warning a mother that her son had been born in a dangerous place, full of so much evil that they had to prepare them both so that Death did not take them away. As a decoy, the diviners hung a live chick on the front door of Ositola's house which after some time Death took.

PART THREE
TRANSACTIONS, TRANSITIONS, TRANSFORMATIONS

14. Introduction: Yoruba Art and Life as Journeys

Henry John Drewal

Ayé l'àjò . . . ("LIFE IS A JOURNEY")

The image of life as a journey is deeply embedded in Yoruba thinking. It is a central metaphor for instructive accounts in Ifa divinatory verses (Abimbọla 1976) and rituals that encapsule and critically re-present events and processes of daily existence, of life's experiences (M. T. Drewal 1992). It is also implied in the *"oríkì* that is a discourse on *oríkì: àkììkitán* (the one whose praises are endless") (Ọlabiyi Yai, this volume). Journeying connotes constant newness, unceasing explorations, countless discoveries, revelations, and insights.

The same may be said for art, a complex concept that includes such ideas as skillful manipulation of media in the decoration, design, or embellishment of form (*ọnà*), innovation/creativity (*àrà*), visual playfulness or improvisation (*eré*), completeness (*pípé*), appropriateness (*yíyẹ*), insight (*ojú-inú*), design consciousness (*ojú-ọnà*), aliveness (*ìdáhùn*), and durability (*tító*), among other attributes (H. J. Drewal 1980; Abiọdun 1983; Abiọdun, Drewal, and Pemberton 1991). Yoruba art might thus be defined summarily as "evocative form."

Art as evocative form is generative and transformative for both artists and audiences. This idea is embedded in a Yoruba metaphor about a verbal art form, the proverb (*òwe*): "A proverb is the horse of speech" (*òwe l'ẹṣin òrò*), that is, its artfulness lifts and carries forward discourse, transforming communication into evocation that opens up and intensifies thinking. The use of *ẹṣin* (horse) in this metaphoric construct is intriguing for several reasons. For one, it suggests simultaneously not only moving/evocative verbal imagery but actual movement through time and space—journeying. Second, it connotes a history (*ìtàn*), in particular the introduction of the horse through connections with African peoples to the north and Europeans to the south, the expansion of the Ọyọ-Yoruba state via its cavalry and of mounted warriors and warfare generally. Third, it conveys a social ordering in which people with power and authority, such as rulers or military leaders, are elevated, highlighted, and displayed, as is thoughtful speech or *òrò*. Fourth, it recalls another metaphor from Yoruba religious practice where those possessed by the gods are called *ẹṣin òrìṣà*, "mounts of the gods." Here humanity renders service to divinity in bringing cosmic realms, the other world and this world, together. The polyphony of the metaphor enhances its effectiveness.

Now if one were to understand the saying *òwe l'ẹsin ọ̀rọ̀* as "evocative words generate discourse" and then play with it and turn its referents to other senses and other arts, specifically visual arts, then we might invent such analogous sayings as: *ọnà l'ẹsin ìran*, "evocative images create moving sights," or *ọnà l'ẹsin ojú*, "evocative forms move the eye" or the "mind's eye" (*ojú-inú*). Whether verbal, visual, or performed, art is about transcendence.

The conceptual association of transcendence and art seems related to a widespread compositional mode in various Yoruba arts—verbal, visual, performed—namely, "seriate" or "segmented." Explained by Yoruba as *l'étò*, *l'étò* or *l'ẹsẹ ẹsẹ* ("section by section" or "step by step"), seriate/segmented form has no unified wholeness. Rather, its autonomous parts create a sense of fluidity, flexibility, indeterminacy, and infinity. This form of seriate composition, which highlights the distinctness of parts, characterizes aspects of Yoruba social life as well as the form of various arts (Drewal and Drewal 1987; Barber 1991). Seriate composition works to allow different voices to be heard, different senses to come into play, different images to come into focus or to fade. It acknowledges the unique contributions of various entities in the arts and in society and permits them to come forth and contribute—a mode that accords with the ideas of individuality and autonomy associated with a person's destiny (*orí*), a sign of difference, as Yai notes in this volume.

Seriate composition's autonomous units permit unlimited extension and also interconnection, as in a dialogic ethos, polyglottism, and transculturalism, since "Yoruba have always conceived of their history as diaspora" (Yai, this volume). It is not only segmentation and distinctiveness of parts but also the fluidity and flow among them, the risks and dangers of innovative versus conventional transitions—the "playing with possibilities" in performances of *oríkì*, as Karin Barber demonstrates, or the living of life "at the seams."

Such seriate composition mirrors a world of structurally equal and autonomous elements that express Yoruba concepts of being and existence, especially that of generative, performative power (*àṣẹ*) possessed by all things and spoken words (Drewal and Drewal 1983:5–7). In a sense, *àṣẹ* is the power to accomplish things. In the arts, it is the power of evocation, the power to open up thought (H. J. Drewal 1992). Or, as in the elegant words of Ọlabiyi Yai, art's very mode of existence rests in "constant departure."

Concepts of segmented, seriate composition, of indeterminacy and constant departures confirm that conventional notions of "tradition" and "traditional" hinder rather than free our thinking about art and its history. The recent debates about this at the conference at Ile-Ifẹ with John Picton's keynote address (Okediji 1992) have considered such matters in some detail. Raymond Williams (1985:318–20) clarifies the concept of "tradition" as what we *choose* to remember and use from the past. In other words, it is something that is creatively, actively, intentionally selected and constructed, not thoughtlessly preserved and repeated. Yai's essay makes this point clearly in an analysis of the Yoruba term for "custom, tradition" (*àṣà*) which embodies notions of both continuity and innovation, for, as he explains, the verb *ṣà* means to "select, choose, discriminate,

or discern." It seems clear that we need to recognize the processual and transformative processes at work in Yoruba *transitions*, traditions being creatively constructed.

Viewed from this perspective, issues of agency can emerge. When Yoruba say "the world is a marketplace" (*ayé l'ojà*), they intentionally choose a metaphor that wonderfully captures the dynamics surrounding transactions, the pushes and pulls, the actions and reactions, the negotiations involved in living life, which is for Yoruba the utilization of/ serious play with *àṣẹ*, the power to act and accomplish. Yoruba are no strangers to the notion of agency.

Before turning to points in specific essays, I want to comment on another aspect of the arts that needs examination: the role of the senses (seeing, hearing, speaking, touching, and tasting), as well as our experience of movement in creating and responding to the affective qualities of art. John Picton, in his essay in this volume, notes the limiting effects of "logocentric" approaches to the arts which have tended to limit understandings of art on its own terms. As I have argued elsewhere (H. J. Drewal 1990:35), language-based approaches, such as semiotics, are just that—language-based, not vision-based. Art communicates and evokes by means of its own unique codes, and these need our attention.

Recently, such a vision-based approach has been outlined by the Yoruba artist and art critic Moyọsore Okediji (1992:119–23). He imaginatively terms this approach *semioptics*—an approach that recognizes the limitations of the linguistic basis of semiotics and seeks to uncover the ways in which the sense of *sight* shapes our perceptions and understandings of the world. Distinguishing between the broader term of semiology as the study of signs and the narrower, linguistically-based field of semiotics, he writes: "Drawing from the treasures of critical resources replete in semiology, semioptics is a dynamic composite approach to critical inquiry, specifically designed to address the challenge of visual arts" (Okediji 1992:120).

I see semioptics as an important part of a much larger investigation of the bodily, multisensorial basis of understanding. I would contend that while language is one of the ways we re-present the world, prior to the use of language we begin by perceiving, reasoning, theorizing, and understanding through *all* our senses (sight, sound, touch, smell, taste, and motion) and that these continually participate, though we may often be unconscious of them, in the ways we literally "make sense" of the world. Seeing (hearing, tasting) is thinking; seeing is theorizing. In the beginning, there was *no* word.

In stressing the importance of the senses in the constitution of understanding, I am adapting the arguments of Mark Johnson who, in *The Body in the Mind* (1987:xiii, xv, xvi), wrote that " 'Understanding,' . . . is here regarded as populated with just those kinds of imaginative structures that emerge from our experience as bodily organisms functioning in interaction with an environment." A full exposition and illustration of the sensorial/bodily basis of understandings about objects is not possible here. However, having stated this theoretical position, I want briefly to suggest how certain senses contribute to "understandings" of art in a Yoruba environment.

Take, for example, the importance of hearing. Might this not be an extremely important sensorial mode of understanding in Yoruba society, given the fact that the notion of "educability" is conveyed in the term *ilutí*, in the ability to hear (Abiọdun 1983, 1990)? This certainly makes sense in a culture shaped in large part by orality. Sounds, surely a very important mode of appreciation, are often ignored or devalued in discussions of so-called "visual" art forms. Witness Ifa divination trays (*ọpọ́n Ifá*) and tappers (*irọ́ké Ifá*). While we marvel at the complex imagery on the tray's border or the tapper's surface, we forget that the hollow area carved into the underside of the tray creates a sound chamber. The tray is a wooden drum. When the pointed end of the tapper strikes its surface, the sound reverberates in order to "communicate between this world and the next," as one diviner explained to me. Sacred *sounds*, not just images, create transcendence. Another example comes from what one might consider a "visual" art, body tattoo scarifications (*kóló*) (Drewal 1988). While the sense of sight certainly is used to perceive and appreciate them initially, it is the sense of touch (whether actual or imagined) that provokes a deeper sensual pleasure and appreciation. As one Yoruba man confided to me, "when we see a young woman with *kóló* and try to touch the *kóló* with our hands, the weather changes to another thing (we become sexually aroused)!" A third example involves the sense of smell. At Abẹokuta in 1978, a warrior Egungun's powerful aura, its *àṣẹ*, resided not only in the power packets sewn into and attached to its costume, not only the powerful chorus words of praise that energized it (see Karin Barber, this volume), not only the kinetic energy of the accompanying dancers and rushing, boisterous crowd, but also the pervasive, overpowering *stench* that emanated from its blood-soaked tunic! Can we ever find words to capture such moving multisensorial experience?

One of the recurring themes in many of the essays in this volume concerns a world of competing forces (historical, political, social, religious, economic), *how* the dynamics of hegemony and resistance have shaped sociocultural, personal, artistic, and scholarly practices over time and space. Such matters center on the concept of agency.

Jutta Ströter-Bender's essay proposes an "intercultural dialogue" that critiques what she perceives as neo-colonialist attitudes toward "exotic" contemporary African art generally, and the work of Rufus Ogundele in particular. She traces his career as a member of the "Oṣogbo School" of artists, discussing the influences of Georgina Beier on specific style elements in Ogundele's work and the possible sources of these in Georgina's own work. By implication, the play of "influences" is theoretically endless, since no style of working by any artist ever comes out of nothing but is rather "repetition with critical difference" (M. T. Drewal 1992:3). Ogundele and his works are the site of encounters, the encounter of cultures, of histories, of social, economic, political, aesthetic issues/debates through which he had to find his way. In a field of often asymmetrical power relations, Ogundele was no doubt "influenced" by his mentors and patrons, yet he also influenced the situation and *made* something of it too, transforming his ideas into images meant for new audiences.

Rufus' story is clearly one of departure, as Yai would say, but it also contains an interesting

return as well. Ströter-Bender reports how Rufus consulted an Ifa diviner (one possessing "ancient wisdom") during a period of difficulty in his life and learned that his *orí* (his individuality, destiny) was tied to his grandfather and, through him, to Ogun, god of iron. Thus, during a moment of crisis, a crossroads in his life's journey, Rufus sought out and *chose/selected* his path in which his *àsà ìbílè*, family custom/tradition became a guide and allowed his Ogun-ness expression through his art—the violent bold forms, heavy black lines that fragment the composition, and "hot" colors—analyzed by Ströter-Bender as she seeks to understand the artist's motivations in opposition to external, neo-colonial perceptions and expectations.

In forging his technique in alliance with Ogun the deity of technology, Rufus fashioned a career in a high-tech world of commodities, some mass-produced, and others, in a world art market, handmade. Rufus saw his path, knew the game, and played it well.

John Mason pushes the issues of agency and resistance even further in his account of the Yoruba or Lucumi of Cuba where "Africans thoughtfully and actively resisted the cultural oppression of the whites." He rejects the notion of "syncretism," proposing instead "transfiguration" as more appropriate and relating it to the Yoruba idea of *paradà*—to mask or transform in order to conceal power, especially in hostile environments.

Mason then traces the history of Lucumi art in relation to saints' statues and dolls, created by the French, Danish, American, and Spanish for the Cuban market and their recontextualization in altars and commemorative figures of deceased family members and friends, some life-sized. He continues this history with Cubans in New York, describing the role of the owners of Botanica (religious goods stores), who fostered the propagation of cheap, standardized sacred art forms (an "assembly-line approach") because both producers and retailers were generally ignorant of the religion and separated from consumers. Botanica owners who controlled the market did not support the creative, innovative artists who wanted to "expand the boundaries of *òrìsà* art while reaffirming the traditional foundations," a battle to enlarge and enrich the corpus.

Then, in April 1970, a renaissance in Yoruba *òrìsà* art occurred with the establishment of Oyotunji village in South Carolina. Its founder, Olobatala Oseijeman Adefunmi, and other artists made a conscious effort to eliminate Catholic/slave vestiges in New World Yoruba art, a movement that has influenced many *òrìsà* artists since then.

Mason exposes white attempts to appropriate, control, and interpret African art while denigrating the makers of this art, as well as marginalizing African Americans by acting "as though we are not to be considered authentic Africans." While detailing the effects of asymmetrical power relations in the history of this art history, he outlines the countermove to create New World Yoruba religious art that is responsive and responsible to a growing community of devotees, not art dealers, critics, or outsider historians. Mason sees the artists of such work as teachers and mentors—politically aware agents in a "transcultural war against racism and neo-colonialism." These art activists include both professional artists working in a variety of media who support

themselves by charging one price for outsiders in the art establishment and another for those within the community in order to "level the playing field," and talented amateurs within òrìṣà houses who create altars, initiation thrones, anniversary displays, beadwork, costumes, implements, and so forth for themselves and for their òrìṣà sisters and brothers, mothers and fathers. Mason goes on to describe the sense of pride and competition among òrìṣà houses, of self- and communal critique, that is beginning to contribute to a dramatic refinement and elaboration of works.

Treating the works of two university-trained artists, Moyọsore Okediji and Ibitayọ Ojọmọ, Michael Harris suggests that they can be an important "site for the interrogation of many Western anthropological and art historical notions" of quality, authenticity, and modernism in twentieth-century African art, especially since the intellectual and philosophical concerns embedded in their work may be more accessible. He distinguishes their work from that of such artists as Lamidi Fakeye who works in "historically traditional modes," combining various elements in new configurations, and the Mbari movement and its progeny, the Ori Olokun workshop, which has been inspired by themes from vernacular orature and the writings of Amos Tutuọla.

The central concept he explores is the "transformative aesthetic process" in Yoruba society. Taking a Yoruba saying he was given by Moyọsore Okediji, *owọ́ ẹni la ńfi ńtún ọrọ̀ ẹni ṣe*, Harris translates it as "A person uses his hands to repair [create] himself." Let's interrogate this saying further. The verb *Tún . . . ṣe* means "to make and remake, repair, improve, or correct." It recognizes something already preexisting that is molded/shaped in new ways. In art, it is form that is envisioned and re-visioned. It also suggests a process in which the "art work" *creates* the maker as much as the artist fashions form. Returning to the saying, we might render its sense as "It is with one's hands that one creates [makes and remakes] oneself [and the world]."

Such ideas raise issues of hegemony and agency which Michael Harris develops in a critique of Western discourse about so-called "centers" and "margins," the language of the "mainstream" and "backwaters." He rightly questions positionality in such discussions and then analyzes the intentionality of Moyọsore Okediji's work which draws on indigenous traditions of pigment production in order to avoid dependence on imported media and the use of an earth medium due to its symbolic connections with the Ogboni/Oṣugbo Society, ancestral spirits and owners of the land.

Ibitayọ Ojọmọ's work epitomizes "metaphorical political statements," visual declarations in Nigeria's repressive climate of authoritarian rule. Harris relates Ojọmọ's architectonic style to his earlier training as an architect but concentrates on the artist's use of proverbs which he illustrates, calling the works "visual metaphors." They open up and carry forward critical thinking as do proverbs, "the horses of speech." In this way, Ibitayọ Ojọmọ is forging a new nexus for Yoruba verbal and visual arts. As Michael Harris points out, the dynamism of both artists stems from their capacities to look within and without, to look to the past and the future, commenting critically on all as their hands create works, selves, and societies in "constant departures."

Robert Farris Thompson's essay gives us a tour de force, one that carries us along with the "three warriors"—Eṣu, Ogun, and Oṣoosi—on their journeys from Africa to the Americas, from sacred groves to the Big Apple's Palladium, not only in the imagery of altars but in the shaking voices of Ogun's priests and poets, in the pulsing sounds of Desi Arnaz, Tito Puente, Chano Pozo, and Dizzy, and in the kinetic exuberance of Carmen Miranda. Along the way, Thompson points to the interconnections, the constant weaving, renewing, and incorporating of ideas and images from wherever they might prove useful: Bariba (and perhaps Mande and Gur) pillars of power and remembrance, phalli along the road between Alada and Abomey in Aja/Fon country, Kardecist spiritualism, Iberian Catholicism, Kongo assemblages and Amerindian ensembles, and forest photomurals and brambles. Yet through all these "sea-changes" (a moving evocation of the Middle Passage), as he calls them, things do not fall apart, rather the matrix holds in the reworking of conceptual continuities. He shows how Yoruba, while respecting the presence of ancient ideas and actions, are also expected to *wa si wara*—continually search, to be inquisitive—in order to experience moments of insight and create evocative forms during their lives.

What we are witnessing, as elsewhere, is the open, dynamic nature of Yoruba artistic practice, of personal interpretation and responsibility in the shaping of new departures, new identities, for as Yai's essay reminds us by reference to a Yoruba saying: "Outside the walls of your birthplace, you have the right to choose the name that is attractive to you."

15. Beyond Aesthetics: Visual Activism in Ile-Ifẹ

Michael D. Harris

There appear to be several types of artists working in Ile-Ifẹ in the 1990s, and the group having the most difficulty establishing a role and space in Western definitions of modern Yoruba culture may be the university-trained artists utilizing a modernist expression.[1] Artists working in what are historically traditional modes, such as the carver Lamidi Fakẹyẹ, who continues the Igbomina carving tradition of his family and that of his Ekiti master, Bamidele (son of Areogun of Osi-Ilọrin), have adapted to a changing clientele by improvising upon iconographic forms such as *ẹpa* masks and freestanding carvings of the type once found on shrines for the *òrìṣà* (deities). They use similar techniques and woods as those used in the past. Freed, however, from the constraints of religious patronage, they combine various elements in new configurations, as Fakẹyẹ has in a figure of a Ṣàngo worshiper (fig. 15.1).

Workshop artists such as Adeniji Adeyemi, from the Ori Olokun workshop in Ifẹ, in the late 1960s and early 1970s were freed from stylistic and iconographic constraints due largely to the influence of the Mbari workshops of Ulli Beier in Ibadan and Oṣogbo of which Ori Olokun is an offshoot. Adeyemi, working in a style reminiscent of Twins Seven Seven (fig. 15.2), like many of the workshop artists, draws upon vernacular culture, folkways, and the writing of Amos Tutuọla for his inspiration. His work is narrative, usually figurative, expressing or reflecting various cultural events and practices without comment. Thus a cultural space has been created and roles defined for the work of artists like Fakẹyẹ and Adeyemi.

Fakẹyẹ's experience as an apprentice to Bamidele and his association with Father Kevin Carroll's workshop in Ọyẹ Ekiti (Carroll 1967) provide the sign of "authenticity" for his credentials as a "traditional" artist, and his works, like those of the workshop artists, have the appeal of "difference" through the use of traditional forms associated with traditional Yoruba art works or figural images that remain outside modernist Western iconographic concepts.

Artists with university educations, drawing upon, as Africans always have, ideas, images, and techniques from encounters with other cultures, appear to have stepped outside of their received cultural space. Undoubtedly it is this situation that caused William Fagg in 1969 to observe: "although many are true artists, they are not truly African artists, although of African race, because they have been trained in art schools in the Western romantic tradition and conform unmistakably to the international style, whereas their patrons are almost exclusively not African" (1969:45).

Fig. 15.1.
Oṣé Ṣàngo, Lamidi Fakẹyẹ, 1991. Wood; height, 73.7 cm. Collection M. D. Harris. Photo: M. D. Harris.

Fig. 15.2.
Self-Portrait as a Dancer, Adeniji Adeyemi, 1991. Ink on canvas. Collection M. D. Harris. Photo: M. D. Harris.

Fortunately this hegemonic view is increasingly being challenged. Susan Vogel recently stated that the "widespread assumption that to be modern is to be Western insidiously denies the authenticity of contemporary African cultural expression by regarding them *a priori* as imitations of the West" (1991:30). As we shall see, the persistence of African artists working in a modernist mode is a form of artistic imagination that is in fact grounded in African aesthetic sensibilities. For the Yoruba artist the role of Ile-Ife as the spiritual center and point of origin of Yoruba culture adds moral imperatives to the work of contemporary artists in Ile-Ife. Two Ife artists, Moyosore Okediji and Ibitayo Ojomo, will be the focus of this paper. As they create art for exhibition in a culture without that tradition and attempt to transform their particular visions of Yoruba culture into relatively new formats, their art provides interesting insights into the transformative aesthetic process in Yoruba society.

Ọwọ eni lá fi ntun ọ̀rọ̀ eni ṣe.
A person uses his hands to repair [create] himself.

Ile-Ife is the place where Ifa (Ọrunmila) came down to fashion the earth, and Orisanla (Ọbatala) to mold humans. This is the primal crossroads, the place where spirit and matter first intersect, and where the intentions and imperatives of Olodumare (God)[2] are first manifested in material reality. The symbolic significance of this mythic genesis was played out politically by the designation of the Ọọni of Ile-Ife as the validating force for the crowning of many Ọbas in Yorubaland.[3]

A great many Yoruba theological constructs emerge from the primeval period with the coming down of the *òrìṣà* and Oduduwa. Ọbatala and Ori collaborated in the fashioning of humans and instilling in them their particular life, destiny, and character. Ẹlẹdaa is one's creator, "the matter that brought you into being." *Orí* is the guarantor of one's destiny (the "inner" head), and *àyànmọ́* is the destiny. A *babaláwo* of the Ifa divination system is consulted about one's *orí* as formed by Ẹlẹdaa. All three concepts are interrelated (some see them as the same), and the individual *orí* humans possess converges into one at the apex for the ultimate Ẹlẹdaa. The concept of "character" (*ìwà*) is part of this matrix of ideas.

Rowland Abiodun informs us that "political and socioeconomic stability and progress, artistic creativity, and criticism are all sustained through the invocation and utilization of the canons of *ìwàpẹ̀lẹ̀*" (1990:74). Therefore, *ìwàpẹ̀lẹ̀* (gentle character) has moral as well as artistic significance. Indeed, Abiodun uses it as a defining concept in Yoruba aesthetics. *Ìwàpẹ̀lẹ̀* connotes by implication modeling human behavior and character after that of Olodumare who embodies the paradigmatic *ìwàpẹ̀lẹ̀*. Thus Abiodun observes that the ultimate goal is to be *ọmọlúwàbí* ("the child born by Olu-iwa—the head, chief source, and originator of *ìwà*") (1990:73).

Moyọsore Okediji

Moyọsore Okediji, a professor of art at Ọbafẹmi Awolọwọ University in Ifẹ and founder of the Ọna group, attempts to meet the moral challenge of Ifẹ's traditions in his work. Okediji is very aware of Western artists and artistic movements, and he is acutely sensitive to and informed by Yoruba modes of cultural expression. His great grandmother was a priestess in the Ẹṣu cult in Ọyọ, and his grandmother was an Ẹṣu shrine painter in Ọyọ. His father, Oladẹjọ Okediji, is considered to be the first "realist" novelist in the Yoruba language. Okediji says that he could draw before he could write and that he drew inspiration from Van Gogh, Dali, and the Sudanese artist Ibrahim El Salahi.

In a conversation that I had with Okediji in 1991 he observed: "I am trying to do exactly what the traditional carver is trying to do. Expressing his society."[4] He believes the secularization of society has shifted the role of the artist in one sense, likening it to the work of a psychiatrist in "reorganizing the psyche of the people, humanizing people" and "pricking the conscience of the powerful." In another sense he feels that the artist has some of the obligations of a priest, "because if you consider any religion, the vehicle has always been art, whether poetry, or very good prose, or music, or visual art." In Yoruba culture, this would also include the drama of ritual performance.

Okediji was a founding member of the Ọna group in 1989, an organization of visual artists based in Ile-Ifẹ. It is a visual and philosophical movement, "an ongoing dialogue between the members and society at large." The fact that their work is essentially not commercial and that they organized themselves for purely artistic purposes, separates them from the workshop of traditional artists. Okediji defends university-educated artists and repeatedly states that works from the Oṣogbo artists are "masterpieces without masters."

Ọnà is a word used for art, but according to Okediji: "Any transformation of the material into advanced levels is the ọnà. It is making ọnà out of that material. So, in a way, we are not talking merely of a transformation of artistic materials, that is, merely a symbol of a transformation of the society itself, of Man, into a more advanced, a more human, into a more useful, a more creative person."

In some ways the university-educated artists reflect the experience of traditional carvers in the rigor and technical aspects of their training. Lawrence Ayọdele, a traditional carver with a shop on Ibadan Road in Ile-Ifẹ, studied with his master, Lawrence Alaaye, for four years and remained as his assistant prior to Alaaye's death in a motorcycle accident. Alaaye's father, Faṣiku, is represented in Father Carroll's book as a significant Ọpin carver. Fakẹyẹ studied with Bamidele for four years, and Bamidele's father, Areogun, studied with and assisted his master, Bamgboṣe, for sixteen years.[5]

Okediji and the members of his group have received university educations and have collaborated

in articulating visually a particular philosophical response to the changes experienced in postcolonial Nigeria. His work in ceramic tiles entitled *Esentaye* (fig. 15.3) represents a cultural bilingualism in form and function, but its color and content are rooted in the indigenous tradition. What he calls the traditional Yoruba palette consists of three polychromatic ranges called *fúnfún*, *púpà*, and *dùdù*, which roughly correspond to whites and light tones (*fúnfún*), yellows and red tones (*púpà*), and blacks, blues, and dark tones (*dùdù*). These colors correspond with those on the shrine murals done by women in Ifẹ. With the help of his grandmother, as well as his own research among Ifẹ shrine painters at the Oluorogbo shrine (fig. 15.4), Okediji has mastered the use of natural pigments found in the area or sold in the local market and mixed them with commercial, more permanent, binders to provide his medium. He views this as a political statement of identity, a conscious aversion to a dependency on imported supplies and materials from former colonial sources. The use of colors and materials from the earth ties him to his traditions, in a sense reanimating and transforming them into contemporary formats.

Okediji's reference to shrine paintings also represents a cultural artistic tradition that has not been "collected" by invading cultures, and my research to date has uncovered scant documentation of them. The earliest mention I have found is in an article by Ulli Beier in 1960, who indicates their decline.[6] Pierre Verger photographed a shrine painting with "statues of Oriṣanla (or Ọbatala) and his wife Yeye Mọ wo" in 1949 in the *ilésin* of their temple in Ifẹ,[7] which he published in *Dieux d'Afrique* in 1954. However, a similar type of wall painting in Abẹokuta is labeled a "cave painting" in photographs taken by District Officer Charles Partridge on 23 September 1910.[8] Several oblique references also exist in travel accounts of the period.[9] The paintings were done with organic, impermanent binders which required periodic renewal. The Oluorogbo shrine is renewed annually in Ifẹ as a ritual renewal of the town.

Esentaye has to do with going to see the *babaláwo* who divines one's head or "personal destiny" (*orí*). The spiral eye represents an inner eye able to see into the past as well as the future. Okediji formed the tiles from local clay, fired them, attached them to a board, and used a "grout" mixed from clay and an industrial glue binder similar to the material used to paint the work. This work marked the beginning of a new series in which he improvised upon the use of earthen materials and the resulting palette. See, for example, his paintings entitled *Meeting of the Ogboni Elders* and *Ẹlẹdàá (The Creator)* (fig.15.5), both completed in early 1991. Òrìṣà Ẹlẹdaa participates in the creation of humankind and the endowment of each person's *orí*. Divine intentions related to one's *orí* often are revealed through Ifa because Ifa (Ọrunmila) was one of the *òrìṣà* present at Creation and knows the destiny of every individual.

The Ifa system and the worship of the *òrìṣà* are not obviously prominent in Yoruba culture today, both challenged by the growth of Islam and Christianity. The system of traditional worship, however, provides the model for the worship of these world religions and functions as a sign of cultural authenticity or reference in the work of contemporary Yoruba artists.

Fig. 15.3.
Esentaye,
Moyosore Okediji, 1991. Natural pigments on ceramic tile. Photo: M. D. Harris.

Fig. 15.4.
Oluorogbo **shrine, Ile-Ife, Nigeria, 1991. Photo: M. D. Harris.**

Fig. 15.5.
Eledàá, Moyosore
Okediji, 1991. Nat-
ural pigments on
wood. Photo:
M. D. Harris.

Fig. 15.6.
*Daughters of the
Sun*, Moyosore
Okediji, 1991. Ink
on paper. Collec-
tion M. D. Harris.
Photo: M. D.
Harris.

Okediji's imagery has become more abstract in the series including *Esentaye* and has incorpo-
rated some of the linearity and use of pattern he experimented with in a series of drawings done
during the same period, exemplified by the small ink drawing *Daughters of the Sun* (fig. 15.6) and
an untitled work (fig. 15.7). He blends personal symbolism and creativity with cultural markers,
such as *ila* (facial marks), in these works.

It would be a mistake to assess Okediji in postmodern terms, as some have done. Luis Cam-
nitzer's assessment of Cuban art, however, might provide a better model. Camnitzer says that

Fib. 15.7.
Oge, Moyosore
Okediji, 1991.
Natural pigments
on wood. Photo:
M. D. Harris.

artistic "primary information is presumed to exist mostly in the museums and galleries of the 'cultural capitals' of the world," which is where, if we add the notion of a closed time frame, "primary" or "authentic" art by Africans is to be found.[10] Cultures on the periphery (read "margins") are to gain a more complete knowledge through travel to these centers as a prelude for the production of work "which shows its readiness to enter the cultural mainstream." Yet, as Fagg's statement shows, this readiness is at the expense of authenticity. What actually happens is that the societies on the periphery do not resign themselves to such constructs and definitions, and various cultural and visual elements are "merged through appropriation." Camnitzer continues: "Subservient and fragmentary mimesis blends with a syncretic use of resources and with recontextualization. The result is an aesthetic which long pre-dates postmodernism, but which often matches it in visual terms" (1990:19).

This process undoubtedly is similar also to the Cross River amalgam of Ejagham and Efik cultures that led to *nsibidi* writing for commercial communication. As Camnitzer observes, the "appropriation is not focused on an abstracted research around the topics of historicism and recycling, as it is in the West; instead it is connected with the long tradition of attempts to syncretize unstoppable imported influences with the surrounding reality" (1990:19).

In an example of this syncretization, Okediji creates work that is modern but, in certain ways, resonates with the mystery and power of the Ogboni society because so much of its meaning pivots upon the use of earth media. Not only is this society an earth cult, but aspects of its history and authority stem from its membership being indigenous *onílé*, founders of the community, though absorbed into the realm of ruling émigrés. The implication is that final authority over the land belongs to the original inhabitors. When blood is spilled upon the ground in dispute, the Ogboni often intervene to cool the circumstances and ritually cleanse the stain upon the sacred earth.

Ogboni is a society of "the eldest and wisest male and female elders in a community" who are emblemized by the *ẹdán*, twin brass images of a male and female joined with a chain (Drewal in Drewal, Pemberton, and Abíọdun 19889:136). R. F. Thompson says that these "strange objects fuse contradictory concepts to suggest a third, the presence of the earth" (1976:611). The earth is where a host of spirits, including those of the ancestors, reside. It is the realm that "unites all humankind and witnesses everything done by humans" (Drewal in Drewal, Pemberton, and Abíọdun 1989:136). It is at this point that an interesting analogy can be made between the *ẹdán* Ogboni and Okediji's work. Okediji attempts to fuse modern ideas of art functioning in a psychological sense, art exhibited for viewing and contemplation, and the Yoruba concept of *onà*, the design or transformative quality of something used in the life process, building human momentum toward the development of *iwàpẹ̀lẹ̀* in becoming *ọmọlúwàbi*. Not only is the third concept— earth—suggested, but it is present physically, metonymically, metaphorically, and allegorically, if we look at his work as a body rather than discrete entities. The Ogboni oath is materialized: *Ògbóni méjì, o di ẹta* (Two members, it becomes three).

Ibitayọ Ọjọmọ

Ibitayọ Ọjọmọ presses his visual activism in a very different way than Okediji. He constructs metaphorical political statements through the illustration of proverbs and the use of allusion, which is necessary because of the authoritarian political situation in Nigeria. His limited palette is the offspring of expediency because only three color families of oil paint were readily available to him in Nigeria: red, blue, and green. Cobalt medium for glazes was unavailable, so he adjusted accordingly.

Ọjọmọ presents an interesting case because he is an architect and taught architecture at Ọbafẹmi Awolọwọ University in Ile-Ifẹ. He studied at Yaba College of Technology in Lagos, the Philadelphia College of Art, and Drexel College and went to Cooper Union in New York for six months in 1977. His grandfather was the Ọba of Ijẹbu Ọwọ (Aruliwọ Ọjọmọ), and his grandmother and mother were weavers. Ọjọmọ's father became Aruliwọ Ọjọmọ the 2nd until his passing in 1986. Ọjọmọ has the right to become Aruliwọ Ọjọmọ the 3rd, but does not desire to do so.[11] Ọjọmọ came to the United States in 1970, returned to Nigeria in 1982 and to Philadelphia in 1992. He embodies the idea of cultural bilingualism, having spent twelve years in the United States and having married an African-American woman, yet possessing a heritage that emanates from deep within Yoruba culture.

One of his more recent works, *Agbà Tó Jẹ Àjẹ Ìwèhìn* (fig. 15.8), shows his unique style, limited palette, and use of stylized, somewhat naturalistic compositions to make statements. A more complete version of the proverb that is this work's title is *Agbà ti o jẹ ajẹtan onjẹ ni yio ru igbá rẹ de ile* (An elder who eats all his food will carry his load home by himself) (Delano 1983:4).

When an elder and a boy eat together, the elder will leave some food on his plate for the boy, who will wash the plate and help him carry his things. A man carrying things on his head is unheard of, so this image suggests a man who has neglected the young and ignored his responsibility. The structure in the distance is the Ọọni's palace in Ifẹ. Hence authority is metaphorically represented in a sly commentary on the methodical destruction of youth by an irresponsible authority. It is an admonition to be responsible to those dependent upon one with authority. The foreground figure has folded his arms and turned his back to the elder, implying unpleasant, disrespectful relations for the future. Barren trees provide additional unpleasant implications. The *ila* on the boy's face are the *àbàjà* type. They not only give a clan signature but, combined with the embroidered detail on the two garments closest to the viewer, help locate the work more emphatically in West Africa for those unfamiliar with other cultural and physical details.

Ọjọmọ says that architecture provides the genesis of forms in his work, and the sense of shifting planes confirms this; his images almost seem faceted. Some have seen Cubist reverberations in his work, and one can see similar solutions used by Cézanne in parts of the work. But Ọjọmọ claims never to have studied Picasso, Brancusi, or Cézanne. It seems reasonable to speculate that Ọjọmọ's proximity to visual traditions that regularly have abstracted imagery and are permeated with

sculptural and dimensional forms would make such solutions even more syllogistic than they became for early European modernists, even if their work had influenced him. Certainly he was not attempting to overcome a representational artistic heritage.

There is a private reflection of the collective mind in Ọjọmọ's work. He has refused to sell his work and began exhibiting actively only after Dr. Nkiru Nzegu came to Ile-Ifẹ in 1990. Nzegu had stayed in the home of Rowland Abiodun who introduced him to the artistry of Ọjọmọ. This led to an exhibition at the U.S. Information Agency offices in Lagos and participation in an exhibition organized by Okediji at the National Museum in Lagos. The reception of his work has been outstanding because he has materialized in a unique way the elements of the social psyche through the catalytic utility of proverbs known to most people, combined with details from the culture. He says his works are "Yoruba metaphors" that he tries to make visual.[12]

Perhaps the most overtly political work by Ọjọmọ is *Ẹyin Agbàgba Tó Jẹ Ẹsẹbi* (You Elders That Ate a Piece of Kola) (fig. 15.9). There are conspirators gathered and taking an oath of silence and collective commitment. Each takes a piece of bitter kola nut as a sign that each is in it together and that to betray another is to betray oneself. The conspirators form an amorphous mass where individual particularities disintegrate. The spherical shape of the cabal iterates the form of the kola, and it resonates upward and outward in repeated circular forms. The point of this suggests two related themes: corrupt leadership inspires cabals, yet, for conspirators, "no matter what you do, it will come out." One is tempted to interpret the circular forms in this painting as implying the circularity of deed and action as embodied in the saying: "What goes around, comes around."

Ẹyin Agbàgba Tó Jẹ Ẹsẹbi is part of a series which, according to Ọjọmọ, was inspired by the elders who neglected the development of the youth to impress the world with the wealth of Nigeria during FESTAC in 1977: "instead of investing all that money on youth development, they started to portray that they have 'arrived,' and they wasted all that money." Ọjọmọ investigates other aspects of the sociopolitical situation in works like *Ọmọ Lere Aiye* (Children are the Wealth of Life) (fig. 15.10). He asserts that a great nation is "judged by the type of children they have. The type of youth that they have that will take over." The conflict between old values and modern intentions begins to materialize in these canvases through the subtle commentary about what constitutes wealth and implications about the social responsibility to develop *ọmọlúàbí* who will bring *iwàpèlè* into responsible leadership in the future.

As in other works in this series, various details in *Ọmọ Lere Aiye* contextualize the painting in a Yoruba cultural milieu. The *gèlè* on the woman's head is that of a rural woman, and the buildings are typical rural structures with the notched roof reflecting the effect of Brazilian influence brought by returning slaves in the nineteenth century. The woman's *ila* is one called *kéké olowu* from around Old Ọyọ.

Another aspect of Ọjọmọ's FESTAC critique is implied in *Ajoju*, a work based on the proverb "Overdancing reveals the Egungun masquerader." This is an admonition against excess, with the direct metaphor of an Egungun masquerader spinning in the dance to the point that the various

Fig. 15.8.
Agbà Tó Je Àje Ìwèhin, Ibitayọ Ojọmọ, 1991. Oil on canvas. Collection of the artist. Photo: M. D. Harris.

Fig. 15.9.
Ẹyin Agbàgba Tó Je Ẹsebi, Ibitayọ Ojọmọ, 1990. Oil on canvas. Collection of the artist.

Fig. 15.10.
Ọmọ Lere Aiye,
Ibitayọ Ojọmọ,
1991. Oil on can-
vas. Collection of
the artist.

strips of fabric comprising the costume lift to "reveal" the dancer. Excess exposes, and Yoruba people generally counsel moderation.

These four works combine in a pointed, multilayered critique of Nigerian authority negligent in its responsibility and commitment to the coming generations. True to the Yoruba penchant for indirect or allusive criticism, these paintings "hit a straight lick with a crooked stick" and critique with the subtle appropriateness of a pointed proverb. This is how they are conceived and titled.

Not all of Ojọmọ's works involve political commentary. *Asòrò Kélé Bojú Wò Gbé* (Whispering and Looking in the Bushes) is a social critique depicting two women giving and receiving gossip. The suggestion is that they are looking in the bushes to see if anyone is around who might overhear and reveal their secret. But it is the receiver of the secret who will reveal it. The limited palette, as in Ojọmọ's other works, leads to a subtle, subdued light. Similar to the famous Ifẹ bronze heads, the work (as most of his paintings) presents an archetypal naturalism with synchronic sugges-tions—a timelessness appropriate to the adages and proverbs he dramatizes.

Ojọmọ's recent works comment quietly upon many aspects of life and human relationships in and around Ile-Ifẹ. The scope and scale of the paintings are consistent with the system of proverbs and adages he draws upon for subject matter. It is a system reflecting millennia spent observing human behavior and refining the code of social relations. Thus among the Yoruba a proverb anticipates and awaits nearly every conceivable circumstance. Concepts of character, responsibility, common sense, and morality are indelible in this system, and Ojọmọ uses them to develop visual metaphors, puns, and admonitions that give venerable vernacular understandings a contemporary spin, thereby renewing the old.

Conclusion

The work of Moyọsore Okediji and Ibitayọ Ojọmọ can be a site for an interrogation of many Western anthropological and art historical notions about the quality, "authenticity," and nature of modern art in West Africa.[13] At the very least, their work and its intentionality gives these two artists a voice in any dialogue about contemporary Yoruba art. As Ulf Hannerz has written, much anthropology is "sharply defined as a study of the Other, an Other as different as possible from a modern, urban, post-industrial, capitalist self." Too often the role of the Other has carried with it the expectation of a silence, something that a dialogue subverts. Hannerz observes that notions of Difference conflict with the idea that "Nigeria is a reality, of a certain kind. Countries like it are the results of the expansion of the present world system into non-Western, non-northern areas, and they have developed cumulatively through interactions within the world system, in its political and economic as well as its cultural dimensions" (1987:547–48).

In a very real sense, the works of Okediji and Ojọmọ become a sort of *oríta mẹ́ta*, a three-way crossroads presenting the confluence of so-called "traditional" Yoruba cultural expression, modern Western cultural influences, and the spicy concoction that is contemporary West African urban culture. The significance of university-educated artists grappling with the transformations of their societies is that they are re-creating themselves, extending their collective being into an appropriate self for contemporary times. They call into question the invented Africa of colonial times that informed Fagg's disclaimer and Ulli Beier's contention in 1960 that "most artistic activities in Yoruba country stopped some thirty years ago." But the philosophical foundations of their expression have a cultural intentionality that is very different from the idiosyncratic individuality of some vernacular artists often presented as cultural exemplars to the West. In some ways, the separation of intellectual and philosophical intention from expression succumbs to persistent essentialist ideas about Africans, ideas challenged consciously by the university-educated artists.[14]

The complexity of Yoruba aesthetics as outlined in the writings of Rowland Abiọdun stand as a testimony to the intellectual aspects of Yoruba art and culture, and serve to support Okediji's caution relative to limits of the workshop process in the generation of contemporary art in Africa. Okediji's work challenges postcolonial hegemonic cultural relations with the so-called First World

by drawing attention to the discrediting of African art not authenticated by non-African scholars. (In the postcolonial world, colonial subordination is maintained by epistemological imposition.) Very little serious scholarship has been published about modern African artists, and until recently most of what has appeared focused on artists from workshops led by Kevin Carroll, Ulli Beier, or Frank McEwen.[15] As Linda Nochlin points out in her essay about Orientalism, there are certain absences that become so significant that "they begin to function as presences, in fact, as signs of a certain kind of conceptual deprivation" (1983:122).

Okediji produces work driven by a political/philosophical motive, contemplating its surrounding conditions with formal language appropriate for the moment, not unlike the cultural response of Dada or the intentionality of the Constructivists. He consciously examines societal traditions from much less distance, utilizing much less fantasy and imagination, but with more legitimacy than eighteenth-century French Neo-Classicists. In the process of renovating his culture, Okediji threatens the boundaries assigned to modern African art and artists. The Oṣogbo and Ori Olokun artists have produced powerful and interesting work, but should not supersede the Ọna artists or those in the Aka group in Enugu. With his commentary about the commercial disadvantage for African artists, if they are dependent upon non-African materials and categorization, Okediji draws our eyes to the power relations in the collection and packaging of cultural products that in every way privilege Western scholars, museums, galleries, publications, art supply companies, and artists.

Ojọmọ, with his more conventional, pictorial approach, provides insight into intracultural relations and all those elements about modern Yoruba society that remain essentially Yoruba but are cloaked in new forms. Marilyn Houlberg touches on this with her documentation of the replacement of *ibéjì* figures with plastic dolls or photographs among the Yoruba (1973:20–27).[16] Ojọmọ deals with the morality of social relations and uses allusion to comment on political conditions within the society, "pricking the conscience of the powerful." His palette silently refers to the same global economics that Okediji confronts directly, but his transformation of this limitation into a stylistic asset speaks to the dynamism that this "peripheral" culture utilizes to prevent the possibility of any mistaken analysis that Ile-Ifẹ attempts to become anything but itself.

Together these two artists represent a kind of double vision, looking within and without and commenting upon both venues. Their work faintly echoes aspects of the *ẹdán* Ogboni and the classical Ifẹ bronzes. It directly draws upon the shrine paintings of women's guilds and the influences of modern European art. As artists, they are rooted in the vernacular for legitimacy, but continue to present the intellectual vigor that animates the complex cosmological system at the root of Yoruba culture. Consistent with their location in Ile-Ifẹ, they use their hands to create their collective selves, reiterating the work of Oriṣanla in the creation of humans at that very place.

Notes

1. The field research for this paper was made possible by a generous grant from the Yale Center for International and Area Studies, whose support is greatly appreciated.

2. Olodumare is often called Olorun, particularly as a counterpart to the biblical Yaweh. Ọlọrun (The Owner of Heaven) is an attribute of Olodumare, not an equivalent (see Abimbọla 1975a).

3. See "Native Crowns," *Journal of the African Society* 2(7) (April 1903), which describes the right of the Ọọni to confer crowns on nearby rulers and the penalty for wearing a crown without entitlement.

4. Taped conversation, Ile-Ifẹ, Nigeria, August 1991. Subsequent quotations and information, unless noted, are from my fieldwork in Nigeria in 1991.

5. Personal conversations with Lawrence Ayọdele, Lamidi Fakẹye, and George Bamidele, Nigeria, 1991; see Picton 1990a; Carroll 1967.

6. "Since most artistic activities in Yoruba country stopped some thirty years ago, the majority of paintings have disappeared" (Beier 1960b:36). Beier does illustrate shrine photographs taken in 1952 in his new volume (1991:14).

7. Pierre Verger, personal communication, 29 January 1992.

8. Charles Partridge Photo Collection, N VII, p. 3, xxv2, Museum of Mankind, British Museum, London.

9. According to A. B. Ellis, "Temples are ordinarily circular huts built of clay, with conical roofs thatched with grass; the interior is usually painted with the colour sacred to the god" (1894:98).

10. The statement by Beier, given in note 6 above, regarding the cessation of "most artistic activities" in Yorubaland circa 1930 is an apt example (Beier 1960b:36).

11. Letter to the author, 28 July 1992.

12. Personal conversation, May 1992. Further citations from Ojomọ are from this same conversation.

13. A very lively discussion about authenticity and African art was generated by Sidney Kasfir's article, "African Art and Authenticity: A Text with a Shadow," in *African Arts* (Kasfir 1992). The two subsequent issues contained solicited responses to Kasfir's text from a variety of art historians, anthropologists, museum curators, and a collector. It is ironic that the only African included in the discussion, V. Y. Mudimbe, is a professor of romance languages and comparative literature. The discussion itself, so configured, might be seen as a replay of the colonial hegemony with its inherent silencing of the colonial subject that almost all the participants in the discussion decry.

14. For discussions about some of the persistent essentialist ideas about Africans, see Hammond and Jablow 1977; Mudimbe 1988; Torgovnick 1990.

15. Affiliation with the Oṣogbo workshop and the "tradition" it has generated has come to act as a signifier of validity. I observed that many works by Oṣogbo artists displayed in London at the Horniman Museum (May 1992) and the gallery at Africa House had signatures followed by the word Oṣogbo. Susan Vogel's *Africa Explores* (1991) has generated much discussion which has brought more attention to modern African expression.

16. Just as we in the West appropriate African art, decontextualize it, and define it in our own epistemological system, Africans appropriate elements from the industrial West and recast them as tropes appropriate for their cultural milieu. The plastic doll *ibéji* may seem inauthentic, but Suzanne Blier, in a response to Sidney Kasfir's article on authenticity, states that "there is no such thing as an art work that is truly 'authentic'—if we mean by that free from admixture or influence from the outside" (Blier 1992:29).

Fig. 16.1.
Untitled, Rufus
Ogundele. Oil on
canvas, Bayreuth,
1983. Photo:
U. Beier.

16. The Transformation of Ogun Power: The Art of Rufus Ogundele

Jutta Ströter-Bender

y intention is to engage in an intercultural dialogue through a discussion of contemporary African art. In particular, I wish to address what appear to me to be colonialist attitudes or concepts that are still present in the perceptions of art critics in continental Europe.

I met Rufus Ogundele, a highly regarded Nigerian artist, in 1983 at Iwalẹwa-Haus at the University of Bayreuth, where he was an artist in residence. I interviewed him in preparation for an article that I was writing about him for a German art journal. I had seen some of his paintings in the exhibition of the Ulli Beier Collection in Mainz in 1980, which later became part of the permanent collection of Iwalẹwa-Haus.[1] I have to confess that in 1983, when I saw Rufus Ogundele's new paintings, I was shocked. They seemed to me violent, brutal in the treatment of material, color, and composition. And I was surprised that the general public did not share my view of the paintings. They saw them as colorful expressions of an exotic Africa—an attitude expressed not only toward Ogundele's paintings but also those of other modern African artists exhibited by Iwalẹwa-Haus.

In the catalogue for an exhibition of contemporary African art entitled *Africa Now*, in Groningen, Holland (January 1982), from the collection of M. Pigozzi, there is the following statement:

I need special HELP. . . . I need urgent treatment now. I started collecting contemporary African art. This shouldn't be a real problem. I should just add it to my collection of Weegee photographs, or plastic dinosaurs, of U.F.O. oil paintings, of tin and wood trains from the Forties. . . . I am really going crazy. This is my ultimate obsession. I am totally excited and totally dedicated. I think I am very hooked. . . . I hope *Africa Now* will bring you as much pleasure and fun as it brings me. Beware! Collecting African Contemporary art is addictive and very time-consuming but slightly less expensive than collecting Van Gogh or Cy Tombly. . . . For the last two years, André [Magnin] has been running all around this vast continent, bringing home more and more treasures. . . . The most important lesson we have learned from putting together this collection is that artists, if they have power, imagination, energy and vision, don't have to go to art school or visit the Louvre or the Whitney. If they have the internal fire of creation, it will come out of their work (Ministry of Welfare 1991:13 f).

This statement reflects a pervasive attitude and approach by Europeans to contemporary African art. It is, I believe, a neo-colonial attitude that is expressed in its language about "bringing home

treasures" and collecting "cheap and powerful art" from "uneducated" and, therefore, "original" artists.

Rufus Ogundele is a successful representative of the new Nigerian art that flourished following the country's independence in 1960. The development of his specific pictorial language, the choice of his motifs, and his growing artistic and commercial appreciation in Nigeria itself speak of the deep changes that have taken place within Nigerian society during the past decades. His art is strongly connected with the beginning and development of the so-called "Oṣogbo Art," which looks back now to thirty years of history—an event celebrated in February 1992 in Lagos with an exhibition under the auspices of the Goethe-Institute. There are numerous well-known Nigerian artists associated with Oṣogbo Art, including Twins Seven Seven, Jacob Afọlabi, Jimoh Buraimoh, Rufus Ogundele, and Muraina Oyelami. (However, no women were part of the Oṣogbo group.) Their style is well known for its pictorial language and narrative themes inspired by the religion and traditions of Yoruba culture.

Born in 1947 in Oṣogbo, Rufus Ogundele became a drummer when he was sixteen years old. He worked with the famous theater company owned by his uncle, Duro Ladipọ. His father wanted him to become a lawyer, but he decided to leave school and take up the life of an actor and musician, joining the theater group at the Mbari Club in Oṣogbo. Only later did he get in touch with art workshops run by the young English artist Georgina Betts, who would subsequently become Georgina Beier, and the West Indian artist Denis Williams at the Mbari Club. In these courses the organizers, together with young African men and women, tried to develop new artistic forms of expression by setting up new cultural initiatives in fighting against the continuous destruction of the cultural wealth of the Yoruba people during the hundred-year period of colonialization. Some young men were chosen for special art training by Georgina Beier. (Why she did not choose young women for this privilege is a question that has never been asked in the literature.)

With the unexpected success of the workshop, its main promoters, Ulli and Georgina Beier, were inspired to project a new image of modern African artists as non-academics working spontaneously and newly within their cultural heritage. Dele Jẹgẹdẹ, who is on the faculty of the Center of Cultural Studies at the University of Lagos, analyzes the image of the "new" African artist, drawn in the publications of Ulli Beier in the late sixties, to which Rufus Ogundele belonged:

In the opinion of Beier, his students were home grown—rustics who, rather than become . . . sick through "enough education," had remained sealed within their cultural precincts. They were the antithesis of the Nigerian academic artist whom Beier describes as being concerned "chiefly with establishing a new identity, with gathering the broken pieces of a tradition and building them—often self-consciously—into a new kind of collage in which the African renaissance is proclaimed" (Jẹgẹdẹ 1984:20 f).

The workshop of Georgina Beier was a turning point in the life of Rufus Ogundele, who wrote: "I first began to paint in 1963, in Denis Williams' workshop. He could excite us—though we did not know what we were doing and why. . . . [T]hen Georgina came and invited me and Afolabi to

work in her house. She gave us lino sheets. And the cutting imposed a new discipline on us. . . . [F]or a whole year, we worked like that" (1991:46).

In the wake of an exhibition at the Goethe-Institute in Lagos in 1965, the international (especially the North American) art market began to develop some interest in the "Oṣogbo artists," with the help and management of Ulli and Georgina Beier. In the United States their reception took place in the context of the "Black Power Movement." The Oṣobgo School came to an end in 1966 just as Nigeria's civil war, often referred to as the Biafran war, was approaching. A number of the young artists had achieved some economic stability, for they were able to sustain themselves with their paintings and graphic arts. With the demise of the Oṣogbo group, however, the search for new forms and contents, the exploration of the possibility of fusing tradition and modernity came to a sudden stop. Nevertheless, the artistic repertoire of the Oṣogbo group was retained for many years to come. In 1968 Rufus Ogundele went to Ifẹ where he became assistant to Dr. Solomon Wangboje in the Ori Olokun Centre. In 1974 he became co-founder of the Ogun Timehin Studios in Ifẹ, and in 1983 he was an artist in residence in Bayreuth at the Iwalẹwa-Haus. Since the early seventies he has sought to train other artists in his studios.

With the end of the Biafran war there was economic improvement in Nigeria due to its increasing oil revenues. A new interest in the contemporary work of their own country began to grow within the national bourgeoisie. They preferred paintings, graphic arts, and sculpture executed in a naturalistic style and which praised well-known personalities in the fields of politics and religion. Oṣogbo art, which had been held in little esteem, began to receive increasing attention in Nigeria. Collections of the work of Oṣogbo artists were developed by public cultural institutions and wealthy intellectuals.

Rufus Ogundele became increasingly appreciated as a "modern" Nigerian artist. He was commissioned to execute large mosaics and mural paintings in official buildings and cultural institutions, such as the large wall paintings in the Iganmu National Theater in Lagos. The decoration of walls, a traditional art that had been reserved exclusively for women, was now exercised in public by men. This was a new development that took place in many countries after independence.

I now want to point to some special elements in the work of Rufus Ogundele and the influence of Georgina Beier on his style, especially the use of intensive colors and the encircling of the painted areas by thick black lines that thread the composition as a kind of supportive structure.

The Oṣogbo Workshop and Contemporary Western Art of the Fifties

From the beginning, the art of the young Ogundele corresponded to the artistic conceptions and visions of Georgina Beier. He made the following observation in an interview with his sponsor, Ulli Beier:

Then in 1964 Georgina ran her own workshop at Mbari—and I remember: the first painting I did, Georgina became really interested in my sense of color. Georgina would come and look at my work

and—this was amazing—she would immediately know which area of the painting I was unhappy with. I would say to her 'Ma, I am stuck. I am not happy with this.' And she would immediately identify the problem area. She could see things exactly the way I saw things (Ogundele 1991:46).

This strong identification with his teacher was the basis of a long period of collaboration. Even today, Ogundele values the advice of his former teacher. Again, in the interview with Ulli Beier, Ogundele said: "Even last year, when I was in Bayreuth—I did great paintings, because I had somebody to talk with. . . . [N]obody is so much on the same wavelength with me as Georgina is. That is a great inspiration: to feel that somebody really understands what you are doing" (1991:46).

Encouraged by Georgina Beier, Rufus Ogundele developed his artistic interests using large pieces of hardboard canvas. He explored the juxtaposition of bold colors separated by hard black lines. This style, introduced to him by Georgina Beier, was probably inspired by the paintings and formal elements of German Expressionism in the work of painters such as Nolde, Kirchner, and Heckel. The style had been admired in Europe during the fifties and early sixties. Abstract art was a synonym for avant-garde, for being unconventional, while elements of naturalism were thought to belong to the old-fashioned language of the academy. The fifties and sixties in Europe were also the years of materialism. Existentialism broke with traditional religious thought and practices, and, in the eyes of many, Western culture suffered a significant loss of spirituality.

Georgina Beier's training as an artist must have been significantly shaped by these conceptions. No wonder, then, that she introduced this zeitgeist into her workshops. Dele Jẹgẹdẹ (1984) has called attention to the influence of these Western philosophic elements on Oṣogbo artistry. And Rufus Ogundele has observed that "Europeans also buy my paintings, but sometimes I get annoyed with their kinds of compliments; some of them call me 'the Picasso from Nigeria.' I never saw Picasso's work when I started with Georgina and I was told that it was he who was influenced by African Art. Then what sense is there in saying that I, an African, produce work which resembles the man who has copied African Art? That's nonsense" (1991:48).

The Transformation of Traditional Sacred Forms

Ogundele believes that the illuminating power of his colors is only in part the result of his relationship to his teacher. He points to his strong relationship to Ogun, the Yoruba god of iron, as the source of his inspiration, his passion for the intensity of color.

In an interview with Ulli Beier he asserted that, from the beginning, "I liked really hot colors! Maybe this is Ogun in me!" (Ogundele 1991:46). While this spiritual relationship to Ogun was more or less unconscious in the early Oṣogbo years, in 1971 Ogundele discovered a direct relationship to the god of iron. He told Beier:

[A]bout fifteen years ago when I had problems in my life, the [Ifa] oracle told me that I must worship Ogun. This was when I was living in Ife. I had a *babalawo* friend, a very nice man called Chief Otun. He

said to me: "You are your father's father and if you don't want to have any bad luck in your life you must worship Ogun, because you are a real Ogundele and everything good and strong in your life comes from Ogun." He introduced me to some Ogun priests in Ipetu Modu. Every year I go there to make Ebo (sacrifice). . . . I believe that Ogun is helping me with everything in life—even with my art (1991:43).

The power of Ogun seems to be present in the power of color in Rufus Ogundele's paintings, but it is no longer under the control of a traditional sacred canon of forms with its clear and archetypal lines of sculpture. The knowledge of the power of sacred forms is an expression of the reality of the spiritual world. In Ogundele's work the sacred forms are broken and deformed, expressing a new and individual style, although in some elements reminiscent of the old traditions. In nearly all his paintings, the persons depicted, their bodies and gestures, are enclosed by (or suffer the enclosure of) hard, black lines (fig. 16.1). The lines appear to infringe arbitrarily, sometimes even brutally, on the movement of color and its radiance toward the onlooker. The garish coloring exists in harsh juxtaposition to other cold and warm color contrasts. The color areas, thick and impenetrably coated, are radically separated from each other by hard black contours, which, however, provide the paintings with a rhythmic and dynamic character. Violence dominates, not by the selection of contents but by formal compositional qualities. The power of Ogun seems no longer to be in harmony with its surroundings. It becomes the expression of a new and much more violent society in which iron is synonymous with the dominating world of technique, scaffolding, limits, and frontiers, where each portion of the canvas is separated from other portions, broken up, fragmented. Sensing this, a Nigerian critic wrote: "abstract bursts of color. Violent images inspired by Ogun" (Oyelola 1976:113). A recent critic of the Oṣogbo group, D. J. Cosentino, asks:

Does Oṣogbo represent the iconographic revival of a fading religious tradition, or its exhumation into uplifting kitsch? There can probably be no unitary categorization for relations as complex as those of Oṣogbo. To those outside the culture, this style may continue to have the impact of revelation. Within the context of contemporary Nigeria, however, Oṣogbo art may seem as ostentatious, and ultimately as alienating. . . . [R]epresentations more "religious" than those produced by the religion itself are "kitsch" (1991:248).

Large Eyes

Another important element in the paintings of Rufus Ogundele is his depiction of human eyes. Reference to large and shining eyes in a trance-like condition are signs of spiritual power in the mythology and religious experience of many cultures. The symbolism of bulging eyes represents a higher consciousness manifest in the face of enlightened persons, priests, and saints. It appears in traditional Yoruba sculpture as well as in the sacred forms created by Susanne Wenger, another patron of the Oṣogbo group of artists. The fact that Ogundele takes up the symbolism of the eye is to be understood, I believe, in terms of the canon of traditional forms.

Large eyes appear in the very first graphic art works by Ogundele in his illustrations for the 1964

Yoruba opera, *Oba Kòso*, by Duro Ladipo. His line cuts reflect the musicality of the young actor/drummer/artist of this famous theater company, his joy in acting, dancing, and singing. In figure 16.2, an example of his early work, the lines and rhythm of the surface areas around the eyes connect harmoniously. In his later works this interplay changes (fig. 16.3). The areas of power and tension of his eye forms in the mask-like, abstract faces are formally broken. The eyes have a staring and hard expression. They remind the viewer of empty caves or the headlights of a car. They do not shine as mirrors of heaven and earth.

With regard to the surface area of a painting as a symbol of the space that engulfs a person in a sociocultural universe, this living space appears in Ogundele's work to be unsystematically and arbitrarily divided up. Its thick lines have frozen the gestures and movements of people, arrested their freedom of action. The element of iron finds its materialization in the world of modern technology. Human life is dehumanized.

Exotic Reception in the West

It is above all the luminous color and his mythological motifs that make the work of Rufus Ogundele appear to the European spectator so "typically African." From this point of view the Western world appears as gray and sad, coldly rational and limiting, while in the cultural world of "the other," everything is full of mythological spirits, color, luminosity, and vivaciousness. What struck Georgina Beier was the liveliness of Yoruba patterns of perception. Recalling one of her first experiences in Nigeria, she wrote:

When we travelled to Iboland, where there are giant trees, I suddenly understood something, not in my head, but purely physical. It had nothing to do with the intellect. It was a new feeling of freshness, of energy. I felt complete, as if all essential phantasies and realities at once melted together. I felt somehow clean. Everything unimportant and superfluous was suddenly inside, and the outside was washed away. My London past I had lost forever. Life had uncountable opportunities. I was not any longer infringed by any conventions and by no prejudices, my future was once [again] open . . .

As a child I consoled myself in phantasies for its grey daily life with deserts and wilderness, witches, giants and gods . . . solar cults and sorcery . . .

And then it hits me like an electric shock, seeing that life is really so rich, so abundant, so mysterious. The cultural diversity exceeded the boldest phantasies. The numerous plays of life changed the world in a permanent spectacle (1980:118).

In her positive characterization of Oṣogbo art Georgina Beier often uses terms such as "luminous," "strong," "staring at the spectator," "soft wisdom," "strange ghosts and animals that rear up (prance)," "monster," "mysterious beings without spine," "colorful and fresh" (1981:passim; 1980:117–28).

Colors, rhythms, strange-looking and dancing spiritual creatures belong to the qualities one likes to attribute to modern African art, or even demands of a decidedly "neo-African" style. There

Fig. 16.2.
Oba Kòso, Rufus Ogundele. Linocut, 1964. Photo: U. Beier.

Fig. 16.3. Untitled, Rufus Ogundele. Oil on canvas, 1984. Photo: "I.L."

is no recognition of possible relations that exist between the meditative function of stylized forms and the limited choice of color within a traditional aesthetic.

The torn creatures and their fractured, broken surroundings in Ogundele's paintings speak of the fears of the painter, of his visual impressions of contemporary society. Western observers, however, misunderstand them as expressions of a wild, lively, sun-flooded and original Africa.

Note

1. The exhibition, "Neue Kunst in Afrika" at Mittelrheinisches Landesmuseum, was organized by the Institute of Ethnology and African Studies, Johannes Gutenberg University, Mainz. Later in the year the exhibition was presented at Bayreuth University.

Fig. 17.1.
Oju Eṣu. Shrine at
Atakumasa Court,
palace of the Owa,
Ileṣa. Photo: Phyl-
lis Galembo.

17. The Three Warriors: Atlantic Altars of Ẹṣu, Ogun, and Ọṣọọsi

Robert Farris Thompson

… as theories go, the Yoruba seem to have been able to throw more light than ethnologists on the spirit of institutions and rules which in their society, as in many others, are of an intellectual and deliberate character (LÉVI-STRAUSS 1966:133).

Overture: Ẹlẹgba in New Orleans and New York, ca. 1800–1958

Walter Benjamin argues that "the authenticity of a thing is the essence of all that is transmissible from its beginning" (Benjamin 1969:221). By "all that is transmissible" include spontaneity, initiative, and change. We then have a line of reasoning appropriate to the study of the altars of three most important Yoruba deities in the Atlantic context: Ẹṣu, Ogun, and Ọṣọọsi. Their realms—uncertainty, smithing and war, and the hunt—relate. Their altars brilliantly resolve change with continuity. Regardless of accent or context, the laterite pillar of Ẹṣu, the irons of Ogun, and the metal bow and arrow of Ọṣọọsi, when fed with sacrifice, activate their spirit for the service of mankind.

Theirs are essential altars. They offer spiritual surveillance within meditative focus. Among the Lucumi Yoruba of Cuba and the Yoruba-oriented initiates of Miami and New York, Ẹṣu, Ogun, and Ọṣọọsi (called in these areas Echu, Ogun, Ochosi), together with the *osùn* bird-staff (and sometimes other forces, too), guard the street door of the house of their followers.[1] Echu, Ogun, and Ochosi compose, in Afro-Cuban worship, "the three warriors" (*los tres guerreros*): "rugged, independent, *orisas* who walk together to protect the devotee from the dangers outside one's doorstep" (Murphy 1988:45). The spirit of this creole reconstellation guides our tracing of their icons back to the Yoruba of Nigeria and Benin. There we find these feisty spirits working together in similar ways.

It is a tale of a triple diaspora. First the Yoruba came in the Atlantic trade to Cuba, mostly in the first half of the nineteenth century, though there are earlier attestations. Then came to North America Cuban devotees of the *òrìṣà* (the Afro-Cuban *oricha*), plus Puerto Rican *santeros* from Afro-Cubanizing barrios of that island. Migration from the Caribbean was continuous, from the thirties through the seventies. All of which was reinforced by a third arrival, the Mariel boatlift of 1980.

One of the first of the migrants to make a cultural impact was Desi Arnaz. This Cuban-born actor became an icon of early American television, although he had already become famous in the thirties for a song, "Babalu Aye." Who knew at that time that he was, for better or worse, invoking the praise name (*oríkì*) of one of the more redoubtable of the deities of the Yoruba?[2]

At approximately the same time, Arnaz was joined by Carmen Miranda, the Brazilian star of Hollywood (Roberts 1985:83–84). Miranda mimed the image of the *adepàte*, often pictured in Gẹlẹdẹ imagery—the market woman with her wares balanced on a tray atop her head. She borrowed the style from Yoruba-Bahian life, from the world of the *bahianas*, black food sellers in the streets, beads of the *òrìṣà* about their necks, crisp turban (modified *gèlè*) on their heads, *àkàrà* bubbling in a kettle set before them.[3]

Yoruba presence in the United States goes back to deeper sources, pinpointed to early nineteenth-century New Orleans. Here, in the city where jazz inevitably was born, women and men served the spirits, especially Papa Lebat (see Cable 1957:173).[4] This was their phrasing for Haitian Papa Lẹgba, who in turn was the creole counterpart of Dahomean Lẹgba and Anago Ẹlẹgba. Representing a complicated fusion and history of transmission, Papa Lebat kept "the invisible keys of all the doors that admit suitors" (Herskovits 1958:246). In other words, Lebat was spiritual keeper of the gate. This is how we meet him in New York in 1958. This was the year when a mambo orchestra leader, Tito Puente, brought together Lucumi singers for the *òrìṣà* and recorded a Yoruba-Atlantic classic, "Top Percussion" (Puente 1958).

In the opening track Julito Collazo, himself a black Cuban devotee of Ṣango, brilliantly invoked Eṣu:

	Ẹlẹ́gbára	Ẹlẹgbara
	Ẹlẹ́gbára	Master of potentiality
		Master of potentiality
	Bara suayo	Bara celebrating, [full and fed]
	Mọmọ ge yan O	With the pounded yam of the mother.
5	Eríwo, eríwo	Hail, exalted one,
	Ago, mẹta-mẹta	Make way for multiples-of-three
	Eríwo, eríwo	Hail, exalted one,
	Ago, mẹta-mẹta	Make way for multiples-of-three
	Odimọ, elésẹ́ kan	One-legged Odimọ
10	Pàá-mùrá ẹlésè kan . . .	One-legged being, *àṣẹ* flowing in his words,
		unhindered by a fence of teeth,
	Baá mi ò kérè, yunrayunra	My father is not small at all
	Mọ mi ò kérè, yunrayunra	My mother is not small at all
	Oníbodè, dáa-dáa	Perfect gatekeeper
	Oníbodè, dáa-dáa	Perfect gatekeeper
15	Oníbodè, dáa-dáa . . .	Perfect gatekeeper.[5]

These praises carried Ẹṣu into latino/black Manhattan in several brilliant roles: guardian at the crossroads (*oníbodè dáa-dáa*), deceptively lame (*ẹlẹ́sẹ̀ kan*), deceptively tiny (*baá mi ò kérè*), the better to test our powers of compassion and perception. Holding *àṣẹ* in a thousand vials, Ẹṣu's power is such that, when he sings, his teeth momentarily vaporize (*pàá-mùrá*) to allow his words full passage. The attractive riddle of Ẹṣu becomes a challenge, a quest for meaning in Yoruba tradition.

That quest can lead to an unsuspected time and place, as in New York mambo and Afro-Cuban jazz of the forties and the sixties. Chano Pozo, the incomparable black Cuban conga-drummer, shouted out *oríkì* for Yemoja while recording for Dizzy Gillespie's jazz orchestra in New York on 22 December 1947.[6] Another work that Pozo composed for Gillespie, built around three words in Lucumi, caught the attention of a talented mambo vibraphonist in San Francisco. And so the latter, Cal Tjader, chanted out, while recording in New York on 20 November 1964, the same three words: "Wa chi wara" (classical Yoruba: wa ṣi wárá)—Be inquisitive![7]

Pillar, Threshold, Cowries: Essentials of the Ẹṣu Altar

Okùnrin kúkúrú, kùkùrù, kúkúrú tí ṁbá wọn kéhìn ọjà alẹ́ Okùnrin dè, dè, dè, bí ọrun èbá ọ̀nà (Verger 1957:130).	He's the tiny, tiny, tiny guy, returning with the last stragglers from the market of the night. He's close, close, as close as the shoulder of the road.

Some thirty-two years ago, an African-Brazilian priest of the Yoruba religion, Pai Balbino, founded an important *candomble nago* at Alto da Vila Priana, north of Salvador: Ile Axe Opo Aganju. At that very moment he began an altar to the Dahomean avatar of Ẹlẹgba, Lẹgba. He built this shrine in a sentry-like structure to the right of the entrance. He did this in the conviction of his ancestors, that Lẹgba ignored will cause a man to lose his way.

A cylinder of cement, seasoned with medicines and prepared indigo (*waji*), became the throne for Lẹgba. Pai Balbino shaped the deity in an amorphous mass of clay, bristling with the inserted horns of a ram, "the power of Lẹgba," evidence of a specific animal sacrifice.

A powerful wooden phallus, imported from Anago in Africa, sexed the sculpture with a telltale raking accent. Four-cowrie motifs, inserted in the clay around the phallus, formed *iyerosùn* Ifa patterns. These signs predict good fortune; they attract fine things. A beige quartinha jar filled with fresh water stood nearby, for pouring liquid, as sacrificial kola are placed upon the altar: "to cool as you ask." Moist, white sand from the nearby ocean, scattered on the floor, completed an aura of ritual purity and coolness.

Pai Balbino explained that the cylinder upon which the head of Lẹgba rested was intended to reflect the circular space of cone-on-cylinder *rondavel* shrines in Dahomey. For Dahomey inter-

rupts the rain forest between Lagos and Accra with savannah-like anomalies of cactus, wells, *rondavel*s, and other aspects normally associated with the arid north. A triple geography of architecture, worship, and divination thus dovetailed in the making of this shrine. Pai Balbino chose a Dahomean avatar of the trickster to honor that side of his heritage.[8] Nevertheless, certain elements indelibly traced back, straight through Dahomey, to the cities of the Yoruba: clay pillar, phallus, cowries.

Pointed mounds in clay for Lẹgba and Eṣu recall clay pillar altars erected among the Mande, and Mande-related Gur-speaking areas, to honor the spirit of departed men.[9] Whatever the historical significance lying behind this powerful resemblance, Yoruba themselves call the Eṣu pillar of laterite (*yangí*) the "father" of all Eṣu images, older than old.[10] This is because it commemorates a primordial struggle between two gods:

Eṣu became a pillar of laterite to avoid the poisons of Ọbaluaiye. This dates from a time when the two of them were locked in mortal combat. Ọbaluaiye severely marked Eṣu with smallpox, scarring his entire body. All of this happened because Eṣu mocked the lameness of Ọbaluaiye.

Ọbaluaiye, enraged, made a journey to the land of the Bariba. Ritual experts there steeped him in the medicines of earth-made-hot [i.e., in the arcana of throwing smallpox on a person]. Ọbaluaiye returned. He immediately tried out his skills on Eṣu's body. It worked. That is why Eṣu fled into the *yangí* [clay pillar]—to hide a disease-ruined body.[11]

Ọlabiyi Yai points out that the Yoruba picture their history as perennial departure.[12] This applies to Ọbaluaiye and the Bariba. Note how Ọbaluaiye retires to a northern land, there to perfect his sophisticated revenge.

Devotees in Yorubaland cool the Eṣu mound with sacrificial liquid, lest matters flare or darken with misfortune. This is true of the Eṣu Ọbasin altar in Ifẹ on the Ifẹware Road. Here a small piece of granite miniaturizes the concept of the *yangí*. It represents Eṣu as messenger to Ọbasin, a deity associated with terrifying disturbances in the sky (Fabunmi 1969).

In nearby Ilẹṣa, in the palace of the king, the keepers of an Eṣu shrine in a corner of the famous Atakumasa Court talked about the spirit's powers in August 1989. They said that this is the "court where differences are settled" (*igbéjọ́*), adding that of course Eṣu lies behind each quarrel. His presence in the pillar is direct, eternal, and ubiquitous, for "if Eṣu does not appear in this rising cone, how can we qualify his presence?"

A deceptive simplicity defines this altar (fig. 17.1). Eṣu's *yangí* rises like an "island" in the raked sand of the Ryoan-ji Zen garden in Kyoto. Walls and levels are given different colors, accentuating the cardinal points and elevating the object. Strings of blood, recently congealed, lead from the ground to the top of the pillar, intuiting a life within the stone.

The pillar is a phallus, quintessence of maleness. In the Pai Balbino shrine, as along the road leading from Alada to Agbomey in Dahomey, Lẹgba's protruding penises lend visual overstatement to instructive shock. Ifa explains this, too: "Eṣu is a lover on an heroic scale./ We praise him

in this manner: strongest-of-erections, hardest-of-all-hard-ons."[13] Absolute virility is a gift. Olodumare so rewarded him because, at a critical moment in the history of the world, Eṣu alone was wise enough to sacrifice to higher force (Thompson 1984:18).

A positive aspect to the riddle of Eṣu reveals why the crossroads becomes his classic point of sacrifice and why Eṣu threw stones at the rich on the day he was born:

When Eṣu arrived on earth he was already walking as a full-grown child. He carried stones in a calabash before the houses of the rich. He asked them: "bring whatever food you have, bring it to the crossroads, that those less fortunate can eat."

To prompt the stingy, Eṣu threw magically incandescent stones in their direction. This caused their houses all to burst in flames. . . . People started bringing food in generous quantities to the crossroads. Soon all were eating. Dogs ate. Pigs ate. Even chickens ate. Aje Shaluga, god of money, offered cowrie coins, the small white shells that look like *kòkòrò* insects. He brought his cowries to the crossroads. Everyone was staring at him, calling him, admiringly, "Money!"

Eṣu took some of these cowrie coins and made of them a garment. He put this cowrie-stranded cape around his shoulders. Immediately people praised him as Lord of Riches, King of Coin.[14]

The cowrie money-cape, draped on a thousand altar icons for Eṣu, bears a special name: rain-of-money, torrent-of-coin (*òbàrà owó eyọ*), punning strongly on *àgbàrà òjò* (the torrent that flows after a strong rain).[15] The strands of cowries rain down Eṣu's shoulders and cross his chest with purpose. Monies from trade or privilege, crisscrossing time or space, when circulated by generosity and sacrifice, can unleash untold showers of sudden and dynamic wealth. Moral argument and moral promise, as well as more famous qualities of provocation and surprise, therefore haunt the Eṣu crossroads altar.

The Spirit in the Razor's Edge: Ogun Altars in Nigeria and Brazil

Olójú ekùn Ogun, of the cold, unblinking leopard stare (Mason
 1992:101).

Ogun rules in the cutting edge of iron. Lord of smiths, warrior among warriors, bloodthirsty, fearless, his prowess and ferocity are legendary. Today he invades precision technology, too, inspiring—and protecting—persons who weld or solder, who handle oil rigs, drive taxis, or shoulder modern arms (see Barnes 1989).

The cutlass of Ogun ennobles space, opening roads and village clearings in the forest. His razor similarly civilizes the human face with patrilineal descent group markings. Terror and decorum, blood and boundaries, exquisitely commingle in his image. A pure male drama unfolds wherever he appears, a sword that cuts the problems of the weak in two, a cutlass born in brawn and fire, hammered to perfection in the midst of smoke and sparks.

This seasoned warrior only fears being vanquished. According to Ifa, his famous altar on the hill at Oke Mogun, in Ile-Ife, marks the moment when he finally was defeated: "Ogun turned to stone at this very place, when shame overcame his spirit. Once Ogun waged war against the divination spirit. But Orunmila defeated him. Shame came upon Ogun and he turned to stone."[16] This is one version of the stones at Oke Mogun. One of the keepers of the Ogun Laadin shrine, in the palace of the Ooni, told another: "Ogun came down. And immediately displayed his prowess by carving images right out of stone. We cannot do this. His strength exceeds our understanding."[17]

Ogun carved himself at Oke Mogun. The long lines of three carved stones go up in space, rising from the ground (fig. 17.2). Two of the liths read like blades. Augmenting rhythms enliven their arrangement: the small stone at left abuts a slightly taller stone. Then comes an incredible jump in scale to one huge standing force, the phallus of Ogun. The carving and erecting of these stones possibly dates to the first millennium A.D. (Drewal in Drewal, Pemberton, and Abiodun 1989:49).

It is said that their insistent verticality also renders spiritual uprightness (ìdúrógangan),[18] like the staffs of Osanyin, that flesh out the complement of certain other Ogun altars. The "blades" and the phallus embody danger and intimidation. But other altar objects reveal conviction that Ogun's spirit can be reached by sacrifice and honor.

By the lesser stones the keepers placed an orù, a small vessel for pouring cool water when invoking the name and aid of Ogun. Both "blades" bear weathered traces of red palm oil. Oil on stone pours soothing incantation (ìtútù l'ójú) upon a fiery point, conferring harmony, establishing protection. Rowland Abiodun reminds us that we dare not see Ogun's face too nakedly—we see only stones and membrum.[19]

Devotees sprinkled the smallest stone with salt (iyò), conferring honorific savor for a man of complicated tastes. For Ogun is not just an aggressive warrior. He is also a famous connoisseur of the ballads of the hunters (awon ijálá), "which [are] chanted on and on protractedly and [which are] also licked up or relished with gusto" (Babalola 1989:148).

Ogun loves the characteristic ijálá tremolo (ìwohùn) as if it were acoustic salt. He was in fact the first to "vibrate his throat" in this manner (i.e., invent tremolo) as a sign of joy when he overcame his enemies and when he killed or captured important beasts. He would sing, tremulously, to render his joy to Olodumare, to thank Him for his fortune.[20] "Shaking the voice" (ìwohùn), expressing intense emotion, is as much a part of Ogun as activating his raffia garment or twirling his sharpened swords. It is a sacred sound. It whips up sentiment, like seasoning Ogun altar stones with salt.

Ogun's primordial altar—"the elder shrine, oldest of old"—is Ogun Laadin in the palace of the Ooni in Ife. It, too, probably dates to the first millennium A.D. Here we meet Ogun's own hammer, a virtuoso piece of fused wrought iron, rising like a miniature volcano from the ground (fig. 17.3). We also discover Ogun's anvil and his body, developed in a visionary sea of fish and crocodile, all turned to stone. Oloriidoko, one of the present keepers of the Laadin shrine, explains:

Fig. 17.2.
Oni Ogun. Shrine
at Oke Mogun, Ile-
Ife. Photo: Phyllis
Galembo.

Fig. 17.3.
Ogun Laadin
shrine at the pal-
ace of the Ọọni of
Ifẹ, Ile-Ifẹ. Photo:
Phyllis Galembo.

Once the people of Ifẹ wanted to kill Ogun Laadin. He asked them to show him the palms of their hands. He asked them: "who is the artist connected with the cutting of these lines upon your palms?" They had no answer. So he asked them to sleep. While they slept, he went into the ground and all his emblems and his body turned to stone. He then asked them to regain consciousness. Immediately they tried to shoot at him, but to no avail. Traces of their bullets mark to this day the sides of certain stones here at Laadin.[21]

The keepers of the Laadin altar position, and sometimes shift, the stones to claim the space for Ogun. Whatever the arrangement of the stones, the tear-shaped metal hammer (*owú*) of Ogun relates to the looming rock of the anvil (*ọta àrọ*).[22] The latter (also sometimes given as Ogun's own body) was so drenched with sacrifice (roasted yams, red palm oil, salt, corn meal, and dog flesh) that it took on life in gritty lights and darks (fig. 17.3).

Fish and crocodile qualify this space as primordial. From the waters of the beginning, hammer and anvil emerge like islands in a sea of rocky laterite. Laadin, dating from the first millennium A.D., is older than Soami's famous fifteenth-century *kare sansui* ("dry landscape") at the Zen temple of Ryoan-ji in Kyoto. In both cases earth and stone combine in an aura of spiritual concentration. But the difference, the blood and roughness, gives us back Ogun.

The stones of Laadin also return protection by analogy with their victory over time. Small wonder the blacksmith/warrior is immune to blades and bullets.[23] This explains why he is the not-so-secret deity of present-day Nigerian Yoruba drivers of taxis and lorries. They pray to Ogun to protect them from violent ends, from tangles of blood, metal, and shattered glass.[24]

In antiquity, so it is believed, Ogun brought the iron arts to the Yoruba. Later, when his followers wished to honor him, they had only to combine some metal pieces and moisten them with oil to summon his presence: "[The altar] becomes Ogun once you have placed two pieces of iron together and poured oil on it. The shrine needs food to be active. Then you can offer prayers to it. As soon as it is put together it stays Ogun and will be Ogun forever after. By dismantling the iron one takes Ogun away" (Barnes 1980:37).[25]

Similar is the rationale of a gun-altar to Ogun among the Ketu Yoruba in the village of Kajọla, as documented in the summer of 1989. Here devotees set up Ogun, as an altar, in the guns of the leading hunters. When men are hunting and move the guns from the altar and carry them into the forest, it is believed that Ogun's spirit rides these weapons in the hunt. Moreover: "When Ogun is going on a hunt, we first bring his guns [and medicines] and invoke him at this point. After which [he gives us luck in hunting] and we kill a lot of game and the town will be cool [lit. "sweet"]. The face [of this altar] is a stone, an object which our ancestors covered with his food."[26]

An *ìyeyè* tree lends focus to the gathering of the guns, sheltering the shrine with associative values of nobility and collectedness of mind. The guns of Ogun were festooned with three charms. But when two devotees, Elijah Adelakun and Basini Laimu, asked to be photographed, Laimu removed the charms and placed them on his body (fig. 17.4). *Àbò*, a square amulet, hangs about the hunter's neck: "wear this and see things to shoot—it will work on the brain of animals, they'll

get confused and become an easy mark." The bag is *àpò*: "when spiritually 'tied' in the forest, an animal will stop dead in its tracks and become a target." The third charm, *pante*, is a medicated belt: "it is worn in the forest to make sure bullets miss your body."[27] This altar combines not only obligatory iron and sacrifice, but some of the medicines that Ogun long ago shared with Ketu followers of his forest path.

Today blacks and whites honor Ogun across the Americas, New York to Buenos Aires. More anciently, Ogun's vital powers of protection spread beyond the borders of the Yoruba, into Benin, to the southeast, and among the settlements of the Popo, Fon, and Ewe to the west.

I close with an Ogun altar in southernmost Brazil, set up by a woman (now deceased) who followed the modern Brazilian fusion-faith, Umbanda. Her daughter tends it now. Umbanda blends Kardecist spiritualism from France with Roman Catholic elements, plus the names and concepts of the *òrìṣà*, plus some of the principal animate medicines of God from Kongo, plus romanticized Native American images from the forests of the interior of Brazil.[28] The mix is rich. We are light years from the traditionalist *candombles* of Bahia, to say nothing of Yorubaland itself.

Fig. 17.4. Gun-altar to Ogun at the base of an *iyeyè* tree in the Ketu village of Kajola. Photo: Phyllis Galembo.

Ogun becomes Ogum, Ọ̣ọọsi transmutes to Oxossi. Nevertheless, for all the change swirling around the continuities, we still find Ogun, even in Umbanda, associated with Eṣu and Ọ̣ọọsi. In Umbanda Ogun presides over "phalanxes" of Exu possession-spirits and Caboclos (Native American spirits, creolized with many Kongo touches) who are sometimes also called Oxossi, or related to him, because they possess together bows and arrows as important emblems. If that were not complicated enough, Ogun in Umbanda syncretizes with São Jorge Guerreiro (St. George the Warrior) for reasons of shared swords and martial aggression. Ogun/São Jorge appears on altars riding a white steed, in direct translation from Roman Catholic chromolithographs.

We come now to an altar to Ogun made by the late Senhora Menezes in Rio Grande do Sul, Brazil, dated tentatively to the 1970s (fig. 17.5). This altar not only constellates ritual speech and act but marks a place where a bold genius took upon herself the supreme responsibility of an Ogun artist: how to handle the spirit of his martial presence, how to imagine herself into his aura of sweat, blood, and bullets. First, she turned the wall into a green flag and emblazoned it with a slashing bar of white. This accent comes down at a raking angle, like hammer to anvil, sword to assailant. Then, in relation to this aggressive stripe, she assembled three artfully staggered shelves, laden with Ogun's masculine metal.

The world of an urban dweller permeates this vision: she puts up shelves to index things that are loved and handled. A used riding crop, horseshoes, and even thigh-guards for a polo player give us back mounted São Jorge, whereas all the rest could appear in a room in Edo, Ketu, or Bahia and immediately be accepted as Ogun offerings: handsaws, handcuffs, a chisel, a pick without handle, a railroad spike, a concrete bolt, grooved for penetration into the hardest of walls, a factory-made machete, and a pulley with chain which seemingly hoists all this macho toil to heaven. Senhora Menezes thought herself into leather and metal, making a room incredibly male.

The Ode Nexus: Hunters against the Negative Mothers

Rezo de Ochosi	Prayer for Ochosi
Ochosi alli loda, alamala ode,	Ochosi gets up and creates,
	In fluent [Obatala] whiteness,
sire-sire.	With confidence.
Ode mata, ode, ode.	Hunter, don't shoot, hunter, hunter (Goicochea 1932:11).

The daring of the hunter spirits—Ọ̣ọọsi, Erinlẹ, Ibu Alama, Logunode—makes them logical colleagues of Ogun. They are fearless warriors against all witchcraft. In this regard they surpass the kings. Even mortal hunters can see and handle what a reigning monarch cannot view.

Thus, according to Rowland Abiọdun, when a king proves tyrannical and the elders decide he must "go to sleep" (i.e., commit suicide), they show him a calabash brimming with taboo: parrot's

eggs. Being forced to view the forbidden means: die.[29] The taboo recalls the prohibition against looking into the inside of the royal beaded crown, guarded with birds (Thompson 1970). The inside of the bird-crown has medicines that blind or kill if deliberately transgressed; the bird eggs, viewed, set in motion the ending of a life. But who brought these eggs to the elders that they might activate the sanctions of the earth? The unusual sight of a nest full of parrot eggs, mystically tended by "a mother" on the top of a tree, is something that only hunters, with their bravery and brawn, can reach and know.

An axis of doom extends to the tops of certain trees, notably ìrókò, where "our mothers" congregate in feathered form at midnight. This axis is intimated in the cluster of beaded birds atop the royal beaded crown with veil, worn as deliberate moral intimidation. The same axis extends downward, into the depths of the river. One of the most important altars of Erinlẹ at Ilobu is an impressive depth (ibú) in the river of this hunter/herbalist/riverine deity. This dark and swirling depth is called Ojuto. It is believed to be so deep that a two-story house (ilé pẹ̀tẹ́sì) would be swallowed up in its indigo-colored currents.[30]

From the bottom of Ibu Ojuto, so it is believed, escorts of pigeons fly up through the water and disappear into the air.[31] At the top of the ìrókò, and at the bottom of the ibú, birds cluster. Hunter/herbalists comprehend and harness these powers for the salvation of mankind. This blessing is sealed in their sharing with Ifa and Osanyin metal staffs surmounted by the bird of mind. This warns the mothers "how powerful [the herbalists] are about their herbs" (Thompson 1974).

Osoosi, the major hunting deity of the Yoruba, links up with the "mothers" in other ways. In a spectacular myth, Osoosi saves the world by firing a mystic arrow into the heart of a gigantic witchbird that had blanketed the sky with doom (Verger 1981). Osoosi's bow and arrow, rendered on his altars in honorific iron or brass, is consequently more than a sign of hunting. At deeper levels it signifies neutralization of the "our mothers" and stays their murderous potentiality.

At Ila-Orangun Osoosi's bow and arrow is sacred to Obatala for warding off evil (Pemberton 1977:10).[32] Obatala's link with Osoosi is also explicit at Ile-Ife. Here a prominent temple to Obatala is guarded by, first, an Esu altar at the entrance to the first courtyard, and then, in the middle of the second court, by an altar to Osoosi. The latter was given as "the hunter working for Obatala" (ode Òbàtálá).[33] Osoosi is Obatala's scout, his instrument of surveillance. Osoosi and Esu screen all persons entering and report to the third and final court where Obatala presides in a panoply of appropriate objects and ideographic writings within his shrine.[34] This is doubtless one of the ultimate roots of the three guerreros tradition of Lucumi New York.

The praise singing of the Lucumi of Cuba and New York reconnect Osoosi to the conceptual whiteness of Obatala. The music also links him to one of Obatala's Afro-Cuban avatars, the mountain, the word for which (òkè) puns on the cry of the hunter-deity's devotees (òkè):

Ọṣóòsì oloomi	Osoosi, my lord
Wàràwàrà	Quickly
Òkè, òkè	[Rise up like] a mountain, a mountain.
Ọṣóòsi a yí ló dà	Osoosi gets up in the morning and creates,
Àlàmálàdè	Whiteness that brings whiteness,
Èé, tilé-tilé	Yes, with confidence
	Hunter, don't shoot—
Ode má tá, òré, òré	I'm your friend, your friend
Yambéleke iwòrò, Ode ma tákùn l'ọ̀nà.	Yambeleke iwòrò, hunter, don't snare me in your rope-trap on the road.[35]

One of the primary images of Osoosi—setting traps and preparing snares—undergoes a sea-change in Afro-Cuban worship. First, as in the modern altars of Ogun, handcuffs and manacles appear, here less for the metal, more as extensions of ensnarement. Second, and most remarkably, an entire jail, as an ultimate contrivance for catching persons, can serve as a secret altar

in his name. Thus Afro-Cubans in New York once left sacrifice to Ọṣọosi, in the dead of night, on the steps of the Dyckman police station in Manhattan (David Brown 1989:369). These are American representations of an original altar tradition that in Abẹokuta in 1964 consisted of simply a metal bow and arrow in a ceramic dish or calabash, activated with sacrificial food and liquid.[36]

John Mason recently argues various tonal etymologies for the first two syllables of the name of the deity: ọṣó, a snare for large animals and ọ̀ṣọ, thorns used in a pitfall trap (Mason 1992:81). With Mason's etymologies in hand, we return to one of the famous African shrine traditions for Ọṣọosi, Ketu "bramble altars," and comprehend a hidden line of thought.

Consider a small altar documented in Imẹko in August 1989. Here a deliberate tangle of brambles (*igángán*) surrounds and covers an *iṣaasùn* pot and stones. Pot, stones, and bramble receive the sacrifice. Nearby a small vessel (*orù*) is used for pouring cool water to accompany invocations and prayer. There is an Ọsanyin staff, too, for "Ọsanyin and Ọṣọosi live here together." The bramble is Ọṣọosi, the thorny snare with which he captures animals and the thickets through which his tough athletic body moves with nonchalance.[37]

There are possible echoes of the bramble-shrine when Ogun or Ọṣọosi initiates in New York are brought before a presiding spirit. According to John Mason, "he or she is concealed in a moving blind of tree branches. Each of the priests in the procession holds a branch. With the [initiate] in the center concealed, there is the illusion of seeing a forest dance toward you" (Mason 1992:50, n. 29).

As to Brazil, the forest altars built of brambles apparently disappeared at the foundation of the *candombles* of Bahia. We find them, so it is alleged, neither in Casa Branca, nor Retiro, nor Gantois.[38] But something of the sylvan reference remains where Ọṣọosi altars in Salvador appear with animal skulls or antlers, the latter sometimes richly wrapped with ornamental ties of silk in shades of light blue or light green.

Altars to Ọṣọosi in the coming century will renew their coherence in the continuity of key principles of the forest world of the god of the hunt. Aildes of Jacarapagua, a major African-Brazilian priestess and architect of this century, points toward this future with a remarkable altar to Ọṣọosi. This she prepared during the late 1970s–early 1980s. She facets a hunter's world with contrasting vistas: a photomural of a deciduous forest on one wall, and a tropical sequence, gigantic banana leaves, on another. Warm browns and yellows, autumnal trees and foliage, contrast strongly with the mint-fresh greens of the wall of leaves. The herbs are tall. They stand as persons in a forest hierarchy, bowl of *àṣẹ* positioned at their feet. A hunter-herbalist devotion, combining something of the mind of Ọṣọosi and something of the mind of the lord of the plants of the forest, Ọsanyin, permeates the right-hand panel to this altar: submit to the leaves, God-given instruments of healing.

Notes

1. See, for example, Brown 1989:287.

2. William Bascom was the first to link this U.S./Cuban pop hit of the forties, composed by Marguerita Lecuona, to its ultimate Yoruba origins. See Bascom 1951:14. Miguelito Valdes' version of "Babalu Ayue" (Victor LPM–1641) was probably better, but John Storm Roberts explains why Arnaz was more famous and successful (1985:82).

3. Zeca Ligiero recaptures an image, embedded in a song, of the Nigerian *adepàte* in black Brazil in the observation that "on the tray [carried by the] bahiana there is vatapa [an African-Brazilian dish], caruru [a dish specially beloved by *ibéjì*] munganza [a dish for orisha Nana Bukuu]" (1983:96).

4. As Melville Herskovitz pointed out long ago (1958), this text has special resonance for students of African-American cultural history.

5. Guided by comparison with Felix Goicochea's excellent *libreta de santo* (1932) and John Mason's careful annotation and translation of Lucumi singing, I have worked with Dejo Afolayan in translating this New York *oríkì* for Esu. The merit of the translation belongs to Afolayan, particularly where he clarified knotty or challenging phrases like *pàá-mùrá* (lit. "toothless").

6. See "Dizzier and Dizzier" (RCA Victor LJM–1009:side 2, track 1). In a forthcoming publication on Yoruba-Atlantic altars, I annotate and translate Afro-Cuban *oríkì* for Yemanya on this album.

7. Cal Tjader, "Soul Sauce" (Verve LP V–8614:side 1, track 1). According to Dejo Afolayan, the literal meaning is "open the *wárá*," that is, an invitation "to see a new thing." *Wa sí wárá* nicely symbolizes reconquest of Yoruba world presence through close study of musical and verbal reverberations.

8. The discussion represents a composite of several interviews with Pai Balbino on the iconography of this altar in Alto da Vila Priana between 1982 and 1985.

9. See Prussin 1973:figs. 3.23a and b. Her examples, and they are dramatic ones, are Bobo and Birifu.

10. Joan Wescott observes that "the Yoruba of Oyo call this large laterite pillar the 'father of all other Elegba' " (1961:338). For Esu and his art among Igbomina, see Pemberton 1975.

11. The late Araba Eko, Isale-Eko, personal communication, 3 January 1983.

12. Yai discusses this point in a rich and fascinating contribution to this volume.

13. Araba Eko, Isale-Eko, personal communication, 3 January 1983.

14. Araba Eko, Isale-Eko, personal communication, 3 January 1983.

15. Ibid.

16. Ibid.

17. Emese Oloriidoko, palace of the Ooni, Ile-Ife, personal communication, 9 August 1989.

18. Rowland Abiodun, Ile-Ife, personal communication, 9 August 1989. Professor Abiodun accompanied me on certain of my field trips at this time. He strongly enriched my comprehension of iconographic problems.

19. Personal communication, 21 February 1993.

20. Araba Eko, Isale-Eko, personal communication, 1 January 1983.

21. Oloriidoko, palace of the Ooni, Ile-Ife, personal communication, 9 August 1989.

22. Other accounts include Elgee, 1907–8:338–43; Marti 1964:164–65; Drewal in Drewal, Pemberton, and Abiodun 1989.

23. Cf. Ibigbami 1978:44: "Because [Ogun] was the first to produce and use iron weapons and is believed immune to their adverse effects people called him 'the god of iron'."

24. Persons also offer thanksgiving to Ogun after escaping from a motor accident; see Akinyeye 1978:1127.

25. See also J. O. Ojo's observation that "any piece of iron, from a pin to an American limousine will do as a shrine [for Ogun]" (1976:62).

26. Elijah Adelakun and Basini Laumu Kajola, Ketu, personal communication, 19 August 1989. Adelakun appears to the right in Figure 17.4, Laiumu to the left. I thank Phyllis Galembo for accompanying me on this field trip and for her excellent photography.

27. Adelakun and Laimu, Kajola, Ketu, personal communication, 19 August 1989.

28. To restore detail and depth to my drastic abbreviation of the nature of Umbanda, consult Brown 1986; see also Birman 1983.

29. From a conversation with Rowland Abiodun, Ile-Ife, August 1989.

30. Baba Elerinle, Ojuto shrine, near Ilobu, personal communication, 15 August 1989. His Highness, Alhaji Oba A. O. Olaniyan II facilitated research in this area, and I thank him heartily. I am also grateful to Rowland Abiodun for translating and nuancing the responses of Baba Elerinle at the banks of Ibu Ojuto.

31. Baba Elerinle, Ojuto shrine near Ilobu, personal communication, 15 August 1989.

32. Pemberton subsequently learned in 1984 that the priest of Obatala in Aworo-ose's compound was also the priest of Oṣoosi and that the ritual artifacts of the bow and arrow were for Oṣoosi. According to the priest, the founders of the Aworo-ose house brought the worship of Obatala and Oṣoosi with them from Ile-Ife when they migrated to Ila-Orangun with Orangun Igbonnibi in the third quarter of the fifteenth century (personal comm., 28 February 1993).

33. Chief Obalala Onisoro Obatala, Ile-Ife, personal communication, 15 August 1989.

34. Ibid.

35. Again my translation stems from Dejo Afolayan, checked against John Mason's text and Goico-chea's unpublished *libreta*. Mason's translation and my own differ at certain points. This signals an invitation to further research.

36. As documented by the present writer near Olumo Rock in early January 1964.

37. Reading the brambles as snare and forest is my own interpretation but based on convergence with the lore of the Yoruba of the Americas. Baba Olorisa Oṣoosi himself said, at Imeko on 18 August 1989, that the brambles were Oṣoosi's dress (*aṣo*) which he wore to "make clear to the people the powers that he possesses."

38. Aildes, head of the *candomble* Xango Ca Te Espero Jacarapagua, personal communication, 1 January 1991. Aildes was from Bahia where she was steeped in the lore of the founding *candombles*. In fact, such was the depth and prestige of her erudition that she was one of the few persons off the island of Itaparica authorized to maintain a full worship of the masked ancestors (*awon egúngún*). She died in 1991, an incomparable loss to African-Brazilian studies. I dedicate this study to her memory.

Fig. 18.1. "Ṣango" doll, c. 1890. Artist unknown. Casa de Africa, Habana, Cuba, 1986. Photo: John Mason.

18. Yoruba-American Art: New Rivers to Explore

John Mason

The rivers Niger and Kongo flowed out of Africa and joined sea currents in carrying millions of captive fathers and mothers, sons and daughters across the Atlantic and depositing them on deathcamp shores all over the Americas. These Africans became one with the rich soil and provided the fertile cultural base for their seed to grow in and thrive. At all times Africans thoughtfully and actively resisted the cultural oppression of the whites. They resisted in the ways they prepared their food, the colors they selected to wear, the style of houses they built, the way they talked, the music they made, the songs they sang, the dances they danced, and the images of God they clung to and recreated. The misinformed use the word syncretism to describe this process when it would be more appropriate to use the term transfiguration. Africans did not compromise with the white man's images; they transformed them. The Yoruba use the words *ìparadà* or *paradà* (mask or act of masking) when talking about things and actions that transform and conceal power. Catholic statues and chromoliths were transformed into masks/costumes for the *òrìsà*. The statues became *ère*, dolls, playthings, childish spirit deputies of the *òrìsà*. In Cuba, the Lukumi not only had to transform the white man's icons but had to rethink and redesign their own centuries-old sacred images. Shrines for the *òrìsà*, *ojú òrìsà* (face of the *òrìsà*),[1] were rethought as portable masks that could dance about the house from room to room or from house to house as the dictates of New World secrecy and survival demanded. Art must be able to transform itself in a hostile environment, yet continue to teach, inspire, and revolutionize.

Norman Mailer, in his book *Ancient Evenings*, said it best when speaking of religious artists and their works: "You make traps to snare the Gods. When you make one of your little pieces of jewelry, or any of your little wonders, it is so beautiful that the Gods are delighted and come down from the sky to touch it."

For some years members of the *òrìsà* community thought that the lack of serious written material on the art produced by New World Yoruba/Lukumi somehow implied that this art did not measure up and was but a poor hand-me-down relative of collectable "classical" Yoruba art. Yet devotees knew that the *òrìsà* were still moved to come and touch their art.

Robert Thompson wrote: "Artistic development happens where an individual, after the mastery of the skills of his métier, surmounts this basic competence with continuous self-criticism and

change. In a world of conservative bent, these innovations are perforce discrete, so as not to disturb a necessary illusion of the continuity of ethical truths in their abstract purity."

This artistic development can be charted in all phases of Lukumi life in Cuba from the mid-1800s to the present. Up to 1900 there is ample evidence that traditional carvers of òrìṣà art were in great demand and produced art of high quality (fig. 18.1). These artists, at first, came directly from the large pool of Lukumi right out of Africa, both free and slave, that existed in Cuba at the turn of the century. Almost all were drum makers and carvers. Atanda, Eduardo Salakọ, Adofo, Pablo Roche, and Gregorio "Trinidad" Torregrosa are the best remembered of this group (Mason 1992:12–13).[2] The lack of artist guilds, the growing number of Creoles, Africans born in Cuba, who tended to look down on the customs of their parents and grandparents and sought the worldly goods and manners of the whites, coupled with the economic changes in the world at large, were to impact on the artistic world of the Lukumi.

Fine plaster and porcelain statues of the saints and the infant Jesus came from Spain to be sold in Cuba and found their way into the homes and Cabildos of Africans who had to keep up a good Christian front. African self-help societies were not allowed to parade on their special holidays unless they carried a statue or a painted banner of their patron Catholic saint at the head of their procession. In many Lukumi homes in Cuba today, the front or public sitting room is often dominated by a large altar adorned with statues of the saints or by a life-size statue of the patron saint of the house. The private back rooms are almost always given over to the shrines for the ancestors and òrìṣà. In 1850 the French introduced the manufacture of cloth dolls with papier-mâché heads, arms, and legs. By 1910 Danish and French dolls with porcelain faces, called Frozen Charlie, had arrived in Haiti and Cuba. At the turn of the century Cubans made only cloth or rag dolls. Since they did not have a fine-doll making industry, they imported from the United States and Spain undressed porcelain and papier-mâché dolls and parts.[3] Today, in the houses of the Creole descendants of the Lukumi, these porcelain and papier-mâché dolls can be seen sharing altar space with hand-carved wooden statues, plaster madonnas, and black rag dolls. In figure 18.2, illustrating a public shrine in the salon of the house of Eugenio Lamar Delgado, Eṣudina, the "Infant of Antioch" doll (Niño de Atoche/Eṣu) is of German or French origin (ca. 1875–90) and the "Ere Olubata" (Master of Sacred Drums) doll is of Spanish origin (ca. 1960). Delgado is the current head of the oldest house shrine or òrìṣà in Matanzas. In this position he is the custodian of the set of bàtá drums consecrated to Ayan belonging to the house. The "Ere Olubata" doll accompanies the drums whenever they leave the shrine to be played. When the drummers perform, it is hung on the wall behind the drummers in clear view of all. In some houses the rag dolls are created as life-sized commemoratives of dead friends and family members, as in the case of dolls created in 1948 by Eugenio Lamar Delgado in Matanzas (fig. 18.3). The doll with cane, glasses, and cross was made in memory of Tata Diego Ledesian, of Kongo descent, who died in 1948 at the reported age of 100 years. The second doll was made in memory of a Haitian friend of Delgado

Fig. 18.2.
Òrìṣà shrine in the
house of Eugenio
Lamar Delgado
in Matanzas, Cuba.
Photo: John
Mason.

Fig. 18.3.
Commemorative,
life-sized dolls by
Eugenio Lamar
Delgado, Matan-
zas, Cuba, 1948.
Photo: John
Mason.

who was of Kongo ancestry and came from Santiago, Cuba to live in Matanzas. He was famous for his knowledge of medicine. The carving of wooden statues has completely gone out of use.

Today in New York City, just as it happened in Cuba, the sons of artists rarely want to take up the profession of their fathers. The solitary craftsman, working without the support of a guild and usually not having anyone to whom to pass his or her great learning, cannot keep up with the demands of the community. This situation has given rise to the production of ritual art by poorly trained professionals, sometimes talented amateurs and money-hungry hacks. The "Botanical 5 & 10 Cent Store" came into being to fill the gap. The creation of the *òrìṣà* medicine, art, and ritual paraphernalia one-stop-shopping center in many cases separated the devotee from the producer of art and the social and ritual interplay this relationship demanded. Great numbers of devotees in urban centers knew little or nothing of herbal lore and so depended on the Botanica's limited stock to fill their needs. Ritual items and fresh herbs became merchandise, and the Botanica middlemen resisted any change that might threaten profits. This conservatism helped to usher in mediocrity in

the production of *òrìṣà* art. The assembly line approach had arrived. You could only order something from column A or column B, anything else would be a special and would cost you more, if the Botanica owner knew what you were talking about and the artist was capable of producing what was needed.

The notion of the Botanica as an African herbal and medicine market where ritual art could be purchased was moved further and further to the back, while the white, Catholic, new-age religious article/spiritual store was moved to the fore. Over time this trend helped to convince the uninformed devotee that the Botanica wares (rosaries, money oil, lucky-in-love spray, holy water, Catholic statues, candles, crystals, etc.) were the legitimate items, and innovative and novel items were to be viewed with skepticism. Ogundipẹ Fayomi, a well-known African-American artist who works in the New York City area, upon showing one of his miniature bronze *òrìṣà* pendants to a well-known white Cuban priest of Ṣango, who owned a Botanica, was severely criticized for depicting "Ṣango with breasts." You could talk about positive, empowering African images, but the owners and their clientele, pressured by racism, ignorance, habit, and the profit motive, by and large did not support its production. Creative and thoughtful artists interested in expanding the boundaries of *òrìṣà* art, while reaffirming the traditional foundations, saw themselves pushed out of this market.

In April 1970 the Yoruba village of Ọyọtunji was founded at Page's Point, South Carolina, by Olobatala Oseijeman Adefunmi and a group of African-American *olòrìṣà* and followers. This village was to move twice before being established in 1974 at its present location off Highway 17 near the town of Sheldon, South Carolina. Ọyọtunji served as the focal point in the United States for the renaissance of traditional Yoruba art from earlier times. There was a conscious, all-out effort to remove Catholic/slave vestiges from Yoruba worship and to reclaim the best parts of an ancient and valued past in order to build a free and enlightened future. Oseijeman and Babaloṣa Orisamọla Awolọwọ, both professionally trained artists, spearheaded this art revival and were responsible for creating the vast majority of art that was created in the early years at Ọyọtunji (fig. 18.4). They served as inspirational models for a host of young artists who visited, studied, or lived at Ọyọtunji. Thousands of African Americans, Puerto Rican Americans, Cuban Americans, and white Americans who followed *òrìṣà* were and are influenced by the art/cultural statement presented by Ọyọtunji.

Ọyọtunji presented an alternative real-life view of how *òrìṣà* art could be produced, used, and cherished. White patrons control the market in African art, but do not use it ritually to instruct and refresh their lives. For them African art is an investment. As Miles Davis said, "They love my art but don't love me." Whites have become art brokers who tend to talk over our heads about us and our art, while treating New World traditionalists, who produce art, as not to be taken seriously. They act as though we are not to be considered authentic Africans. They sell the Ifa board, but the

**Fig. 18.4.
Roof supporting
post carved by
Oseijeman Ade-
funmi, Ọyọtunji
Village, Sheldon,
South Carolina,
1988. Photo: John
Mason.**

sacred *ikin* and *itàn* are passed over. Òrìsà vessels are sold, but not spirit-imbued stones. Art dealers do not believe in or sell charms. They do not dance my dances or sing my songs.

While the full life-style alternative offered by Oseijeman and his group was taken up by a relatively small number of Yoruba devotees, the bold living art of Oyotunji, coupled with other fundamentalist movements in the Yoruba world, proved to be very effective in directly and indirectly stimulating the imaginations and affecting the direction of many diverse groups of artists who were creating New World Yoruba religious art. Although coming from varied back-grounds, all these artists share an intense love for the art of Africa in general and an intimate and, because they are all òrìsà devotees, a personal commitment to creating New World Yoruba art in particular. Their art is a synthesis, combining old world forms in ways that fill the re-quirements of new world demands. Congolese drum bodies host Yoruba sacred designs. For example, Yvette Burgess-Polcyn, a priestess of Obatala living in New York City, developed her interest in Yoruba culture while in the Peace Corps. She was stationed at Okitipupa in the Ondo area of Nigeria where she worked from 1961–64. She has been a potter since 1972, and her artistry combines Yoruba sacred shrine motifs so that *àwo ota* Erinle now hold *ota* Yemonja (fig. 18.5). And in the sculptures of Ogundipe Fayomi, Yoruba *ère ibèjí* are depicted with mus-cular Lobi/Fang/Baule bodies (fig. 18.6).

This "fusion art" captures and blends the beauty and vitality of different ethnic styles creating a unique reflection of the multi-ethnic character of our New World culture. These artists are not bound by the restraints of overtly conservative and parochial ethnic customs. Artists feel free to borrow and combine those strong features of each style in an attempt to assuage the eye and sensibilities of the electronically tuned-in, media-bombarded, and hipped New World devotees. They and their art, while seeming autonomous, are embedded in and guided by tradition and culture. They look to their community for validation, not to art dealers and outsider historians. This is certainly true of the work of Trevor Holtham ("Sol Sax"), a sculptor who graduated from Cooper Union College of Science and Art (fig. 18.7).

The most important group is to be found in New York City. It is made up of painters, brass casters, carvers, potters, beadworkers, and soap makers. Artists such as Ogundipe Fayomi, Manny Vega, Trevor Holtham, Stephanie Weaver, Jose Rodriguez, Yvette Polcyn, Renaud Simmons, and the late Charles Abramson carry on the traditions of the Asude (brass caster), Amokoko (potter), and Agbegi (wood carver). All are possible guild starters, politically aware and committed to fight the transcultural war against racism and neo-colonialism. They are purposefully African, actively rethinking what is. Like other artists, they are faced with the need to earn a living, and yet they are aware that they must be alert to the attempts by outsiders to become the brokers/experts who seek to become the validating agents for their art. These artists are creating art that serves their community. Such is the case of Jose Rodriguez, a graduate of the Parson's School of Design and Friends World College. Although trained as a graphic artist, he is an expert beadworker and wood

Fig. 18.5.
Yemọnja/Erinlẹ
ritual pot made of
white porcelain
with blue indigo
glaze by Yvette
Burgess-Polcyn,
Ọyọtunji Village,
Sheldon, South
Carolina, 1986.
Photo: John
Mason.

Fig. 18.6.
Èrè ibèjí **carved by**
Ogundipẹ Fayomi
for the shrine of
the late Charles
Abramson, 1980.

carver. Rodriguez created an *ado Èṣù* for Eṣudina's shrine in Matanzas, Cuba (fig. 18.8). The "medicine gourd of Eṣu" is covered with a netting of red and black beads and has three strands of cowries hanging from the neck of the carved mahogany head which serves as a stopper. The *ado Èṣù* was given as a gift to Eṣudina in celebration of his fiftieth year as a priest of Eṣu.

Western values and training, however, coupled with the cost of materials, often causes them to price their art out of the reach of the very community they come from and serve. In order to earn the dollars needed to live in an urban metropolis, two standards had to be created, "Yuppie Yoruba Art vs. Religious Community Art." Quality is tied to the ability to pay. Manuel Vega, a painter and master beadworker, who graduated from the School of Art and Design in New York and the Taller Boricua, is also a priest of Oṣoosi who makes beaded *òrìṣà* crowns and costumes for members of the *òrìṣà* communities in Bahia and New York. Manny once admitted to me that the same costumes would cost five thousand dollars or more if he were making them for outsiders (fig. 18.9). This allows different markets to be served, while enabling the *òrìṣà* community to be on an even playing field with richer outsiders. We all want to own beautiful things (fig. 18.10).

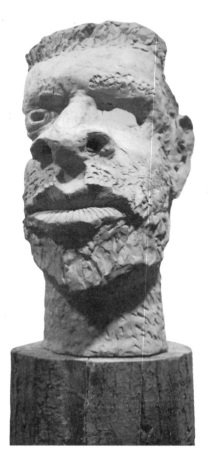

Fig. 18.7.
Bust of Oṣanyin by Trevor Holtham.
Terracotta; height, 61 cm, width, 30.5 cm. Photo: John Mason.

Fig. 18.8.
An *àdó Èṣù* by Jose Rodriguez on Eṣudina's shrine in Matanzas, Cuba. Photo: John Mason.

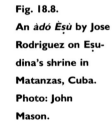

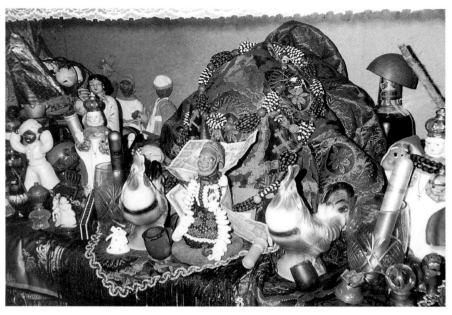

The problem that arises is the community's lack of education regarding the important role of these artists in their religious life. Members of the community do not yet support these artists in great enough numbers. Too often they fall back on mass-produced inferior products. There is beginning to be a change in understanding, but the process must be accelerated and widened in order to keep these artists from plying their craft for strangers. It should be noted that all of the aforementioned artists are aware of this situation and are striving to keep their prices within reach of the community. For the past fifteen years large amounts of affordable traditional medicines (*eja àrò̩*, *ikóíde̩*, fresh *obì àbàtà* and *orógbó*, *o̩se̩ dúdú*, etc.) have been imported from Yorubaland. Art from the workshops of artists such as O̩de̩wale and Lamidi Fake̩ye̩ has been brought by Yoruba traders into the *òrìs̩à* communities of the United States and Puerto Rico. While this contemporary Yoruba art has not yet found its way into the mainstream of white collectors, it is being readily snatched up by hungry Yoruba devotees in the United States. A few traditional Yoruba carvers have set up direct sale links with certain houses of *òrìs̩à* devotees.

Fig. 18.9.
Ofa O̩soosi (bow of O̩soosi) by Manuel Vega as part of his anniversary costume. Brass covered with beads and leather. Photo: John Mason.

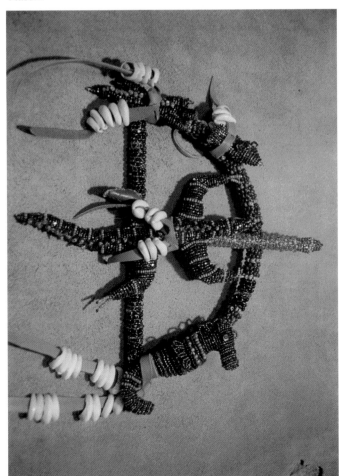

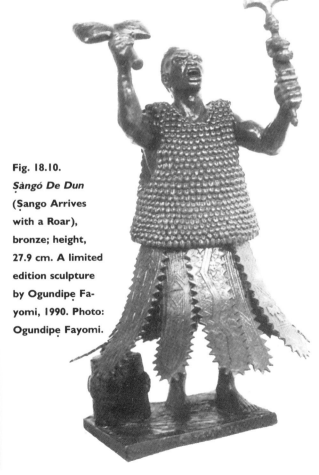

Fig. 18.10.
S̩àngó De Dun (S̩ango Arrives with a Roar), bronze; height, 27.9 cm. A limited edition sculpture by Ogundipe̩ Fa-yomi, 1990. Photo: Ogundipe̩ Fayomi.

Within each òrìṣà house in various American locales there are talented amateurs who create beautiful òrìṣà altars, initiation thrones, anniversary displays, various types of beadwork, dyed cloth, and tailored clothes. They try their hand at everything from calabash decoration to carving ère ibéjì and oṣé Ṣàngó. Some of these amateurs are so talented that they have permanent positions in their òrìṣà house for creating their specialty. They are actively encouraged to continue to refine their skills by the prod of competition with their counterparts in other òrìṣà houses and by elders and fellow devotees who, because of their travels to Yorubaland, Brazil, and Cuba, have a new sense of pride in being òrìṣà followers and want their shrines and homes to reflect this. Together, both the professional and the amateur artists in the òrìṣà communities are striving to recreate art that will continue the tradition of excellence supported by continuous self-criticism and change.

Notes

1. The word ojú can be translated to mean "eye, face, presence, imprint." The shrine can be, though, of a two-way mirrored mask where one can look into the "eyes" of the òrìṣà or egún and see their "soul" as well as be seen by these powers concealed. As a mask, it is a work of art in progress. All the priests that I know collect keepsakes that have special meaning in regard to their lives in relation to the òrìṣà and egún and add them to their masks/shrines. This adding on/improvisational process extends tradition and definition to include new fashion, materials, and images. It allows for the personalizing of the shrine.

2. All of the men mentioned in this group were bàtá drummers and drum carvers. Atanda was a babaláwo who was known as an Agbẹgi (carver of statues). Eduardo Salakọ and Pablo Roche were priests of Ọbatala.

3. The information in the preceding three sentences was provided in a personal interview by Mr. Irving Chais, the owner of the Doll Hospital, in New York City. Mr. Chais is considered an expert in the history of dolls, their manufacture and repair. He was kind enough to spend several hours looking at slides of dolls on Lukumi shrines in Cuba and commenting on their possible country of origin, year of manufacture, and availability in the Caribbean area.

Bibliography

Abimbọla, Wande

1964 "The Ruins of Ọyọ Division." *African Notes* 2(1):16–19.

1968 *Ijinle Ohun Enu Ifa*. Glasgow: Collins.

1975a *Sixteen Great Poems of Ifa*. Zaria: UNESCO.

1975b (Ed.) *Yoruba Oral Tradition*. Ile-Ifẹ: Department of African Languages and Literatures, University of Ifẹ.

1976 *Ifá: An Exposition of Ifá Literary Corpus*. Ibadan: Oxford University Press.

1978 "Two Lineages of Yoruba Wood Carvers: Evidence from Oral Literature on the Visual Arts of Africa." In *The Role of Afro-American Folklore in the Teaching of the Arts and Humanities*, edited by A. L. Seward, pp. 283–93. Bloomington: Indiana University Press.

1983 "The Contribution of Diaspora Blacks to the Development and Preservation of Traditional African Religions in the Americas." In *Cultures Africaines*, pp. 79–89. Documents de la Réunion d'experts sur "Les Apports culturels des Noirs de la Diaspora à l'Afrique." UNESCO.

Abiọdun, Rowland

1966 *The Content and Form of the Yoruba Ijala*. Oxford: Clarendon Press.

1974 Review of *African Art and Leadership*, edited by D. Fraser and H. Cole. *Odu* 10:135–39.

1975a "Ifa Art Objects: An Interpretation Based on Oral Traditions." In *Yoruba Oral Tradition*, edited by W. Abimbọla, pp. 421–69. Ile-Ifẹ: Department of African Languages and Literatures, University of Ifẹ.

1975b "Naturalism in 'Primitive' Art: A Survey of Attitudes." *Odu* 11:129–36.

1976 "A Reconsideration of the Function of Ako Second Burial Effigy in Owo." *Africa* 46:4–20.

1983 "Identity and the Artistic Process in the Yoruba Aesthetic Concept of Iwa." *Journal of Cultures and Ideas* 1:13–30.

1987 "Verbal and Visual Metaphors: Mythical Allusions in Yoruba Ritualistic Art of *Ori*." *Word and Image: A Journal of Verbal/Visual Enquiry* 3(3):252–70.

1990 "The Future of African Art Studies, an African Perspective." In *African Art Studies: The State of the Discipline*, pp. 63–89. Washington, D.C.: National Museum of African Art, Smithsonian Institution.

Abiọdun, R., H. J. Drewal, and J. Pemberton III

 1991 *Yoruba Art and Aesthetics*. Zurich: Museum Rietberg Zürich and The Center for African Art.

Abraham, R. C.

 1958 *Dictionary of Modern Yoruba*. London: University of London Press.

Adeeko, Adeleke

 1991 *Words' Horse, or the Proverb as a Paradigm of Literary Understanding*. Ph.D. diss., University of Florida, Gainesville.

Adepegba, Cornelius O.

 1989a "Nigerian Art: The Death of Traditions and the Birth of New Forms." *Kurio Africana, Journal of Art and Criticism* 1(1):2–14.

 1989b "Modern Nigerian Art: A Classification Based on Forms." *Kurio Africana, Journal of Art and Criticism* 1(2):117–37.

Agiri, B. A.

 1972 "The Ogboni among the Oyo-Yoruba." *Lagos Notes and Records* 3(2):50–59.

Ajayi, J. F. A., and R. Smith

 1964 *Yoruba Warfare in the Nineteenth Century*. Cambridge: Cambridge University Press.

Akinjogbin, Adeagbo

 1967 *Dahomey and Its Neighbours*. Cambridge: Cambridge University Press.

Akinnaso, Niyi

 1983 "Yoruba Traditional Names and the Transmission of Cultural Knowledge." *Names: Journal of the American Name Society* 31(3):139–58.

Akintoye, S. A.

 1969 "The North-Eastern Yoruba Districts and the Benin Kingdom." *Journal of the Historical Society of Nigeria* 4:539–53.

Akinyeye, Olu

 1978 "Ogun—God of Iron." *West Africa* 12 June.

Allison, Philip A.

 1944 "A Yoruba Carver." *Nigeria Magazine* 22:49–50.

 1952 "Travelling Commissioners of the Ekiti Country." *Nigerian Field* 17:100–115.

 1968 *African Stone Sculpture*. Praeger: New York and Washington, D.C.

Andree, R.

 1914 "Seltene Ethnographica des Stadtischen Gewebe-Museum zu Ulm." *Baessler Archiv* 4:29–38.

Anonymous

 1955 "Idanre." *Nigeria Magazine* 46:154–80.

Araeen, Rasheed

 1989 *The Other Story, Afro-Asian Artists in Post-War Britain*. London: Hayward Gallery and South Bank Centre.

Atanda, J. A.

 1973 "The Yoruba Ogboni Cult: Did It Exist in Old Oyo?" *Journal of the Historical Society of Nigeria* 6(4):365–72.

Awe, Bolanle

1974 "Praise Poems as Historical Data: The Example of the Yoruba Oriki." *Africa* 44:331–49.

Awolalu, J. Omosade

1979 *Yoruba Beliefs and Sacrificial Rites*. London: Longman.

Awonuga, Emmanuel O.

1981 *The Art of Rufus Ogundele*. Ile-Ifẹ: Fine Arts Department, University of Ifẹ, Nigeria.

Awoniyi, T. A.

1978 *Yoruba Language in Education*. Ibadan: Oxford University Press.

Ayorinde, Chief J. A.

1973 "Oriki." In *Sources of Yoruba History*, edited by S. O. Biobaku, pp. 63–76. Oxford: Clarendon Press.

Babalọla, Adeboye

1966 *The Content and Form of Yoruba Ijala*. Oxford: Oxford University Press.

1989 "A Portrait of Ogun Reflected in Ijala Chant." In *Africa's Ogun: Old World and New*, edited by S. T. Barnes, pp. 147–72. Bloomington: Indiana University Press.

Babayẹmi, S. O.

1980 *Egungun among the Oyo Yoruba*. Ibadan: Board Publications, Ltd.

Bandele, Gabriel

1979 *Opin in the History of Yoruba Sculpture*. M.A. thesis. Ambadu Bello University, Zaire.

Barber, Karin

1991 *I Could Speak until Tomorrow: Oríkì, Women and the Past in a Yoruba Town*. Washington, D.C.: Smithsonian Institution Press.

Barbour, Jane, and Doig Simmonds, eds.

1971 *Adire Cloth in Nigeria*. London: Longman.

Barnes, Sandra T.

1980 *Ogun: An Old God for a New Age*. Philadelphia: ISHI.

1989 (Ed.) *Africa's Ogun: Old World and New*. Bloomington: Indiana University Press.

Bascom, William

1951 "The Yoruba in Cuba." *Nigeria Magazine* 37:14–20.

1960 "Yoruba Concepts of the Soul." In *Men and Culture*, edited by A. F. C. Wallace. Philadelphia: University of Pennsylvania Press.

1969 *Ifa Divination. Communication between Gods and Men in West Africa*. Bloomington: University of Indiana Press.

1980 *Sixteen Cowries. Yoruba Divination from Africa to the New World*. Bloomington: Indiana University Press.

Bassani, Ezio

1983 "Il Vassoio dell'Oracolo di Efa di Ulm e le Statuette del Culto Abiku." *Africa* 38.

Bassani, E., and W. Fagg

1988 *Africa and the Renaissance—Art in Ivory*. New York: The Center for African Art.

Bassani, E., and M. McLeod

1985 "African Material in Early Collections." In *The Origin of Museums—The Cabinets of*

Curiosities in Sixteenth and Seventeenth-Century Europe, edited by O. Impey and A. MacGregor, pp. 245–50. Oxford: Clarendon Press.

Beier, Georgina

1980 "Oshogbo, Ein Interview mit Jenny Zimmer." In *Neue Kunst aus Afrika*, edited by U. Beier, pp. 117–28. Berlin: Bremmers.

1981 "Aussenseiter der Kunst in der Dritten Welt." In *Neue Kunst in Afrika*, edited by U. Beier, pp. 33–42. Bremen.

1992 "To Organize Is To Destroy." *Daily Times* 17 August.

Beier, H. Ulli

1957 *The Story of Sacred Wood Carvings from One Small Yoruba Town*. Lagos: Nigerian Printing and Publishing Company, Ltd.

1959 *A Year of Sacred Festivals in One Yoruba Town*. Lagos: Nigerian Printing and Publishing Company, Ltd.

1960a *Art in Nigeria 1960*. Cambridge: Cambridge University Press.

1960b "Yoruba Wall Paintings." *Odu* 8:36–39.

1975 *The Return of the Gods: The Sacred Art of Susanne Wenger*. Cambridge: Cambridge University Press.

1982 *Yoruba Beaded Crowns. Sacred Regalia of the Olokuku of Okuku*. London: Ethnographica.

1988 *Three Yoruba-Artists*. Bayreuth: Universität Bayreuth, African Studies Series.

1991 (Ed.) *Thirty Years of Oshogbo Art*. Bayreuth: Iwalewa-Haus.

1992 "Oshogbo Art When It Dawned." *Daily Times* 16/17 August.

Ben-Amos, Paula

1980 *The Art of Benin*. London: Thames and Hudson.

Bender, Wolfgang, and Claus Peter Dressler

1979 "Wenn wir das sehen, werden wir glücklich sein: Afrikanische oder Afro-Europäische Kunst." In *Berliner Festspiele Horizonte '79. Festival der Weltkulturen, Moderne Kunst aus Afrika, Katalog zur Ausstellung*.

1980 "Kunst und Kolonialismus in Nigeria." In *Neue Kunst aus Afrika*, edited by U. Beier, pp. 11–24. Berlin: Bremmers.

Benjamin, Walter

1969 *Illuminations: Essays and Reflections*. New York: Schocken Books.

Bernal, Martin

1987 *Black Athena*, Vol. I. London: Free Association Book.

Biobaku, S. O.

1957 *The Egba and Their Neighbours, 1842–1872*. Oxford: Oxford University Press.

1973 (Ed.) *Sources of Yoruba History*. Oxford: Clarendon Press.

Birman, Patricia

1983 *O que e Umbanda*. São Paulo: Editora Brasilense.

Blier, Suzanne Preston

1988 "Words about Words about Icons." *Art Journal* 47(2):75–87. Summer.

1990 "African Art at the Crossroads: An American Perspective." In *African Art Studies: The*

State of the Discipline, pp. 91–107. Washington, D.C.: National Museum of African Art, Smithsonian Institution.

1992 "Shadow Plays: Reading between the Lines in Postmodernist Criticism." *African Arts* 25(3):26, 29–30.

Blocker, Gene

1982 "The Role of Creativity in Traditional African Art." *Second Order, an African Journal of Philosophy* 11(1–2):3–18.

Bourdieu, P.

1977 *Outline of a Theory of Practice.* Cambridge: Cambridge University Press.

Bovell-Jones, T. B.

1943 Intelligence Report on Ijebu Ode Town & Villages, May 7 (IJE Prof. 2/122, Confidential File C 55/1). Ibadan: National Archives.

Bradbury, R. E.

1967 "The Kingdom of Benin." In *West African Kingdoms in the Nineteenth Century*, edited by D. Forde and P. M. Kaberry, pp. 1–35. London: Oxford University Press.

Brasio, Antonio

1956–68 *Monumenta Missionaria Africana: Africa Occidental* (1640). Reprinted Lisbon: Agencia General do Ultramar.

Brett, Guy

1991 "Being Drawn to an Image." *Oxford Art Journal* 14(1):3–9.

Brett-Smith, Sarah C.

1984 "Speech Made Visible: The Irregular as a System of Meaning." In *Empirical Studies of the Arts* 2(2):127–47.

Brown, David

1989 *Garden in the Machine: Afro-Cuban Sacred Art and Performance*, Vol II. Ph.D. diss., Yale University, New Haven.

Brown, Diana DeG.

1986 *Umbanda: Religion and Politics in Urban Brazil.* Ann Arbor: UMI Research Press.

Cable, George W.

1957 *The Grandissimes.* New York: Sagamore.

Calvocoressi, D.

1978 *Rescue Excavation of the First Otunba Suna at Imodi, Ijebu-Ode. May, 1977.* Ibadan: Biyi Printing Works.

Camnitzer, Luis

1990 "The Eclecticism of Survival: Today's Cuban Art." In *The Nearest Edge of the World, Art and Cuba Now*, pp. 18–23. Brookline: Polarities, Inc.

Carroll, Kevin

1961 "Three Generations of Yoruba Carvers." *Ibadan* 12:21–24.

1967 *Yoruba Religious Carving: Pagan and Christian Sculpture in Nigeria and Dahomey.* London: Geoffrey Chapman.

1973 "Art in Wood." In *Sources of Yoruba History*, edited by S. O. Biobaku, pp. 165–75. Oxford: Clarendon Press.

Chappel, T. J. H.

1972 "Critical Carvers: A Case Study." *Man* 7:296–307.

Cole, Herbert M.

1982 *Mbari: Art and Life among the Owerri Igbo.* Bloomington: Indiana University Press.

Comaroff, J.

1985 *Body of Power, Spirit of Resistance: The Culture and History of a South African People.* Chicago: University of Chicago Press.

Cosentino, Donald John

1991 "Afrokitsch." In *Africa Explores*, edited by S. Vogel, pp. 240–55. New York: The Center for African Art.

Crocker, J. C.

1977 "The Social Functions of Rhetorical Forms." In *The Social Use of Metaphor: Essays on the Anthropology of Rhetoric*, edited by J. D. Sapir, pp. 33–66. Philadelphia: University of Pennsylvania Press.

Crowther, S. A.

1849 *Yoruba Primer.* London: CMS.

1852 *Grammar and Vocabulary of the Yoruba Language.* London: Seeleys.

Dapper, Olfert

1989 "Description de l'Afrique." In *Objects interdits* (1686), pp. 76-81. Reprinted Amster-
[1686] dam: Volfgang, Waesberg, Boom & van Someren.

Dark, Philip

1975 "Benin Bronze Heads: Styles and Chronology." In *African Images: Essays in African Iconology*, edited by D. F. McCall and E. G. Bay, pp. 25–103. Boston University Papers on Africa 6. New York and London: Africana Publishing Co.

Delano, Isaac O., ed.

1983 *Owe L'Esin Oro Yoruba Proverbs—Their Meaning and Usage.* Ibadan: University Press Limited.

Derrida, Jacques

1976 *Of Grammatology.* Baltimore: Johns Hopkins University Press.

Deutsch-Nigerianische Gesellschaft

1989 E. V./Goethe-Institut Lagos (Hrsg.). Bonn and Lagos: Zeitgenössische Nigerianische Kunst.

Dobbelmann, Th. A. H. M.

1976 "Het Geheime Ogboni-Genootschap." In *Bronskultuur uit Zuid-West Nigeria.* Berg en Dal: Afrika Museum.

Drewal, Henry John

1980 *African Artistry: Technique and Aesthetics in Yoruba Sculpture.* Atlanta: The High Museum.

1983 "Art and Divination among the Yoruba: Design and Myth." *Africana Journal* 14(2–3):136–56.

1988 "Beauty and Being: Aesthetics and Ontology in Yoruba Body Art." In *Marks of Civilization*, edited by A. Rubin, pp. 83–96. Los Angeles: Museum of Cultural History.

1989 "Meaning in Oṣugbo Art among the Ijẹbu Yoruba." In *Man Does Not Go Naked:*

Textilien und Handwerk aus afrikanischen und anderen Ländern, edited by B. Engel-brecht and B. Gardi, pp. 151–74. Basel: Basler Beiträge zur Ethnologie.

1990 "African Art Studies Today." In *African Art Studies: The State of the Discipline*, pp. 29–62. Washington, D.C.: National Museum of African Art.

1992 "Image and Indeterminacy: Elephants and Ivory among the Yoruba." In *Elephant: The Animal and Its Ivory in African Culture*, edited by Doran H. Ross, pp. 187–207. Los Angeles: Fowler Museum of Cultural History.

Drewal, H. J., and J. Pemberton III, with R. Abiodun

1989 *Yoruba: Nine Centuries of African Art and Thought*. New York: The Center for African Art and Harry N. Abrams Inc.

Drewal, Margaret Thompson

1992 *Yoruba Ritual: Performers, Play, Agency*. Bloomington: Indiana University Press.

Drewal, M. T., and H. J. Drewal

1983 "An Ifa Diviner's Shrine in Ijebuland." *African Arts* 16(2):60–67, 99–100.

1987 "Composing Time and Space in Yoruba Art." *Word and Image: A Journal of Verbal/Visual Enquiry* 3(3):225–51.

Eades, J. S.

1980 *The Yoruba Today*. Cambridge: Cambridge University Press.

Elgee, C. H.

1908 "The Ife Stone Carvings." *Journal of the African Society* 7:338–45.

Ellis, A. B.

1894 *The Yoruba-Speaking People of the Slave Coast of West Africa*. London: Chapman and Hall.

Euba, Akin

1990 *Yoruba Drumming: The Dundun Tradition*. Lagos and Bayreuth: Elekoto Music Center and Bayreuth African Studies Series.

Evans-Pritchard, E. E.

1962 "Anthropology and History" (1961). Reprinted in *Social Anthropology and Other Essays*. New York: The Free Press.

Exoticophylacium

1659 *Exoticophylacium Weickmanianum oder Verzeichnis Unterschiedlicher Thier . . . und anderen Mutzen*.

Eyo, Ekpo

1977 *Two Thousand Years of Nigerian Art*. Lagos: Federal Department of Antiquities.

Eyo, Ekpo, and Frank Willett

1980 *Treasures of Ancient Nigeria*. New York: Alfred A. Knopf in association with the Detroit Institute of Arts.

Fabunmi, Chief M. A.

1969 *Ife Shrines*. Ife: University of Ife Press.

Fagg, Bernard

1977 *Nok Terracottas*. London: Ethnographica for the National Museum.

Fagg, William B.

1968 Foreword to *African Stone Sculpture*, by P. A. Allison. New York and Washington, D.C.: Frederick A. Praeger.

1969 "The African Artist." In *Tradition and Creativity in Tribal Art*, edited by D. Biebuyck, pp. 42–57. Berkeley: University of California Press.

1973 "In Search of Meaning in African Art." In *Primitive Art and Society*, edited by A. Forge, pp. 151–68. London: Oxford University Press.

1974 Descriptive catalogue entry in *Antiquities and Primitive Art*. London: Christie's 17 (11 December).

1981 "Figure with Bowl." In *For Spirits and Kings: African Art from the Tishman Collection*, edited by S. Vogel, pp. 104–6. New York: The Metropolitan Museum of Art.

1985 Descriptive catalogue entry in *Important Tribal Art*. London: Christie's (24 June).

1991 "One Hundred Notes on Nigerian Art from Christies's Catalogues 1974–1990: A Selected Anthology," edited by E. Bassani with a biography and bibliography by F. Willett. *Quaderni Poro* 7.

Fagg, William B., and John Pemberton III

1980 *Yoruba Beadwork*. New York: Rizzoli.

1982 *Yoruba Sculpture of West Africa*. New York: Alfred A. Knopf; London: Collins.

Fagg, William B., and Margaret Plass

1964 *African Sculpture—An Anthology*. London: Studio Vista.

Fernandez, James W.

1986 *Persuasions and Performances: The Play of Tropes in Culture*. Bloomington: Indiana University Press.

Fioupou, Christiane

1991 *La Route: Réalité et représentation dans l'oeuvre de Wole Soyinka*. Ph.D. diss. University Paul Valéry, Montpellier III, France.

Forde, Daryll

1951 *The Yoruba-Speaking Peoples of South-Western Nigeria*. London: International African Institute.

Fosu, Kojo

1986 *20th Century Art of Africa*, Vol. I. Zaria: Gaskiya Corporation.

Frobenius, Leo

1912 *Und Afrika Sprach*. Berlin-Charlottenburg: Deutsches Verlaghaus.

Gbadamosi, T. G. O.

1978 *The Growth of Islam among the Yoruba, 1841–1908*. Atlantic Highlands, N.J.: Humanities Press; London: Longman.

Giddens, A.

1979 *Central Problems in Social Theory*. London: Macmillan.

Glissant, Édouard

1990 *Poétique de la relation*. Paris: Gallimard.

Goicochea, Felix

1932 Libreta de santo. Unpublished *libreta*.

Gombrich, Ernst

1960 *Art and Illusion*. London: Phaidon.

1963 *The Story of Art*. London: Phaidon.

Hallen, Barry

1975 "A Philosopher's Approach to Traditional Cultures." *Theoria to Theory* 9:259–72.

Hammond, Dorothy, and Alta Jablow

1977 *The Myth of Africa.* New York: The Library of Social Science.

Hannerz, Ulf

1987 "The World in Creolisation." *Africa* 57(4):546–59.

Hansford, K., J. Bendor-Samuel, and R. Stanford

1976 *Studies in Nigerian Languages no. 5: An Index of Nigerian Languages.* Ghana: Summer Institute of Linguistics.

Herold, H.

1989 *African Art.* Prague: Artia.

Herskovits, Melville J.

1958 *The Myth of the Negro Past.* Boston: Beacon Press.

Houlberg, Marilyn

1973 "The Texture of Change: Yoruba Cultural Responses to New Media." *Cultural Survival Quarterly* 7(2):20–27.

Ibigbami, R. I.

1978 "Ogun Festival in Ire-Ekiti." *Nigeria Magazine* 126–27:44–59.

Jegede, Dele

1981 "Made in Nigeria, Artists: Problems and Anticipations." *Black Orpheus* 4(1):31–45.

1984 "Critical Perspectives in Contemporary Nigerian Art: The 'School' Syndrome." Unpublished paper delivered at the Centre for Cultural Studies, University of Lagos, 11–15 December.

Johnson, Mark

1987 *The Body in the Mind.* Chicago: University of Chicago Press.

Johnson, S.

1966 *The History of the Yorubas from the Earliest Times to the Beginning of the British*

[1921] *Protectorates* (1921). Reprint of 1st edition. Edited by O. Johnson. London: Routledge.

Kasfir, Sidney

1992 "African Art and Authority: A Text with a Shadow." *African Arts* 25(2):40–53, 96–97.

Kecskesi, Maria

1989 "Ikonographie eines Turreliefs der Yoruba." *Münchner Beiträge zur Völkerkunde* 2:233–48.

Kennedy, Jean

1992 *New Currents, Ancient Rivers: Contemporary African Artists in a Generation of Change.* Washington, D.C.: Smithsonian Institution Press.

Kerchache, Jacques

1986 *Sculptura Africana—Omaggio a André Malraux.* Rome: De Luca Editore/Arnoldo Mondadori Editore.

Krieger, Kurt

1965–69 *Westafrikanische Plastik,* 3 vols. Berlin: Museum für Völkerkunde.

Kubler, George

1962 *The Shape of Time.* New Haven: Yale University Press.

Labouret, Henri, and Paul Rivet

1929 *Le royaume d'Arda et son évangélisation au XVIIe siècle.* Paris: Institut d'Ethnologie.

Lakoff, George, and Mark Johnson

1980 *Metaphors We Live By.* Chicago: University of Chicago Press.

Laotan, A. B.

1960 "Brazilian Influence on Lagos." *Nigeria Magazine* 69:156–65.

Law, Robin

1977 *The Oyo Empire, c. 1600–c. 1836. A West African Imperialism in the Era of the Atlantic Slave Trade.* Oxford: Clarendon Press.

Lawal, Babatunde

1974 "Some Aspects of Yoruba Aesthetics." *The British Journal of Aesthetics* 14:239–49.

1977 "The Living Dead: Art and Immortality among the Yoruba of Nigeria." *Africa* 47:50–61.

1979 "The Search for Identity in Contemporary Nigerian Art." *Black Phoenix, Journal of Contemporary Art & Culture in the Third World* 1:23–26.

Lawrence, C. T.

1924 Unpublished collection of photographs entitled "Photographs of Nigeria, 1907–1912." London: Foreign and Commonwealth Office, Library and Records Department.

1985 "Report on the Nigerian Section, British Empire Exhibition." *West Africa* 1212–16.

Lévi-Strauss, Claude

1966 *The Savage Mind.* Chicago: University of Chicago Press.

Ligiero, Zeca

1983 "Candomble Is Religion-Life-Art." In *Divine Inspiration*, edited by Phyllis Galembo. Albuquerque: University of New Mexico Press.

Lloyd, P. C.

1962 *Yoruba Land Law.* London: Oxford University Press.

Lombard, Jacques

1967 "Contribution à l'histoire d'une ancienne société politique du Dahomey: La royaume d'Alada." *Bulletin de l'I.F.A.N.* 29, ser. B (1–2).

Longe, Foluṣo

1981 *A Rare Breed: The Story of Chief Timothy Adeola Odutola.* Lagos: Academy Press, Ltd.

Lucas, J. Olumide

1943 "The Cult of Adamu-Orisha." *The Nigerian Field* 11:184–96.

1948 *The Religion of the Yorubas.* Lagos: CMS Bookshop.

Mabogunje, A. L., and J. Omer-Cooper

1971 *Owu in Yoruba History.* Ibadan: Ibadan University Press.

MacCannell, Dean, and Juliet F. MacCannell

1982 *The Time of the Sign: A Semiotic Interpretation of Modern Culture.* Bloomington: Indiana University Press.

Mack, John

1982 "Material Culture and Ethnic Identity in Southeastern Sudan." In *Culture History in*

the Southern Sudan, edited by J. Mack and P. Robertshaw. Memoir 8, British Institute in East Africa.

Marti, Montserrat Palau

 1964 *Le roi-dieu au Benin*. Paris: Éditions Berger-Lavrault.

Mason, John

 1992 *Orin Orisa*. New York: Yoruba Theological Archministry.

Maupoil, Bernard

 1936 *La géomancie à l'ancienne côte des esclaves*. Paris: Mémoires de l'Institut d'Ethnologie 42.

Merlo, Christian

 1975 "Statuettes of the Abiku Cult." *African Arts* 8(4):30–35.

Meyerhoff, Barbara

 1990 "The Transformation of Consciousness in Ritual Performances: Some Thoughts and Questions." In *By Means of Performance: Intercultural Studies of Theatre and Ritual*, edited by R. Schechner and W. Appel, pp. 245–49. Cambridge: Cambridge University Press.

Meyerowitz, Eva

 1943 "Wood-Carving in the Yoruba Country Today." *Africa* 14:66–70.

Ministry of Welfare, Public Health, and Cultural Affairs

 1967 *Moderne Künste aus Oshogbo*. Nigeria and Munich.

 1991 *Africa Now*. Catalogue, Groninger Museum. Neue Münchner Galerie. The Netherlands.

Moore, Sally Falk

 1975 "Epilogue: Uncertainties in Situations, Indeterminacies in Culture." In *Symbol and Politics in Communal Ideology*, edited by S. F. Moore and B. G. Meyerhoff, pp. 210–39. Ithaca: Cornell University Press.

Morton-Williams, P.

 1960 "The Yoruba Ogboni Cult in Oyo." *Africa* 30:362–74.

 1964 "An Outline of the Cosmology and Cult Organization of the Oyo Yoruba." *Africa* 34:243–61.

Mount, Marshall Ward

 1973 *African Art*: The Years since 1920. Bloomington: Indiana University Press.

Mudimbe, V. Y.

 1988 *The Invention of Africa: Gnosis, Philosophy, and the Order of Knowledge*. Bloomington: Indiana University Press.

Murphy, Joseph M.

 1988 *Santería: An African Religion in America*. Boston: Beacon Press.

Nochlin, Linda

 1983 "The Imaginary Orient." *Art in America*. May.

Norris, C., and A. Benjamin

 1988 *What Is Deconstruction?* London: Academy Editions.

Obayẹmi, Ade

 1976 "The Yoruba and Edo-Speaking Peoples and Their Neighbours before 1600." In *His-*

tory of West Africa, edited by J. F. A. Ajayi and M. Crowder, vol. I, pp. 196–263. 2nd ed. London: Harlow, Longman.

Ogunbowale, P. O., ed.

1981 *The Essentials of the Yoruba Language*. London: Hodder and Stoughton.

Ogundele, Rufus

1991 "Rufus Is Rufus, an Interview with Ulli Beier." In *Thirty Years of Oshogbo Art*, edited by U. Beier, pp. 43–48. Bayreuth: Iwalẹwa-Haus.

Ojo, G. J. A.

1966a *Yoruba Culture: A Geographical Analysis*. London: University of London Press.

1966b *Yoruba Palaces*. London: University of London Press.

Ojo, Jerome O.

1976 "Yoruba Customs from Ondo." *Acta Ethnologica et Linguistica* 37.

Ojo, J. R. O.

1973 "Ogboni Drums." *African Arts* 6(3):50–52, 84.

1975 "A Bronze Stool Collected at Ijebu-Ode." *African Arts* 9(1):48–51, 92.

1978 "The Symbolism and Significance of Epa-Type Masquerade Headpieces." *Man* 12:455–70.

n.d. "A Note on Yoruba Aesthetics, Based on Evidence from Oral Literature." Unpublished manuscript.

Okediji, Moyọsore

1989 "Orisa Kire Painting School." *Kurio Africana, Journal of Art and Criticism* 1(1&2).

1992 *Principles of "Traditional" African Culture*. Ibadan: Bard Book.

n.d. "Sacred Painting in Ile-Ifẹ." Unpublished manuscript.

Olajubu, Oludare

1972 *Akojopo Iwi Egungun*. Ibadan: Longman.

Olbrechts, F.

1941 "Bijdrage tot de kennis van de chronologie der Afrikaansche plastiek." *Institut Royal Colonial Belge*, Section des Sciences Morales et Politiques, 10(2). Brussels.

Oloidi, O.

1989 "Hindrances to the Implantation on Modern Nigerian Art in the Colonial Period." *Kurio Africana, Journal of Art and Criticism* 1(1):15–24.

Ọnabolu, D.

1963 "Aina Onabolu." *Nigeria Magazine* 79:295–98.

Ọsitọla, Kolawọle

 Note: M. T. Drewal's interviews and discussions with Kolawọle Ọsitọla are listed according to their audio tape number. The first two digits of these numbers indicate the year they were taped.

1982 Personal communication, 3 July.

 82.17, taped discussion, 22 April 1982.

 82.38II, taped discussion, 25 May 1982.

1986 86.138, taped discussion, 30 November 1986.

 86.142, taped discussion, 30 November 1986.

1988 "On Ritual Performance: A Practitioner's View." *The Drama Review: A Journal of Performance Studies* 32(2), T118:31–41.

Ottenberg, Simon

1990 "Response by Simon Ottenberg." In *African Art Studies: The State of the Discipline*, pp. 125–36. Washington, D.C.: National Museum of African Art, Smithsonian Institution.

Oyelami, Muraina

1980 "Wie ich Kunstler würde." In *Neue Kunst aus Afrika*, edited by U. Beier, pp. 101–6. Berlin: Bremmers.

Oyelaran, Olasope

1982 "Was Yoruba a Creole?" *Journal of the Linguistic Association of Nigeria* 1:89–99.

Oyelola, Pat

1976 *Everyman's Guide to Nigerian Art*. Lagos.

Peel, J. D. Y.

1984 "Making History: The Past in the Ijesha Present." *Man* 19(1):111–32.

1989 *The Cultural Work of Yoruba Ethnogenesis*.

Pelrine, Diane M.

1988 *African Art from the Rita and John Grunnwald Collection*. Bloomington: Indiana University Art Museum.

Pemberton III, John

1975 "Eshu-Elegba: The Yoruba Trickster God." *African Arts* 9(1):20–26, 66–70.

1977 "A Cluster of Sacred Symbols: Orisha Worship among the Igbomina Yoruba of Ila-Orangun." *History of Religions* 17(1):1–28.

1987 "The Yoruba Carvers of Ila-Orangun." *Iowa Studies in African Art* 2:117–35.

Picton, John

1990a "Sculptors of Opin." *Orita Meta Proceedings, 1990 International Conference on Yoruba Art*, edited by Moyosore Okediji, pp. 80–91. Ife, Nigeria.

1990b "Transformations of the Artifacts: John Wayne, Plastic Bags and the Eye-That-Surpasses-All-Other-Eyes." In *Lotte or the Transformation of the Object*, edited by C. Deliss. Published as *Durch* 7/8. Kunstverein: Graz, Austria.

1991 "On Artifact and Identity at the Niger-Benue Confluence." *African Arts* 24(3):34–49, 93–94.

1992a "Technology, Tradition, and Lurex: Some Comments on Textile History and Design in West Africa." In *History, Design and Craft in West African Strip-Woven Cloth*, pp. 13–52. Washington, D.C.: National Museum of African Art, Smithsonian Institution.

1992b Review of "Yoruba: A Celebration of African Art." *African Arts* 25(1):82–85.

Picton, John, and J. Mack

1989 *African Textiles*. 2nd ed. London: British Museum Press.

Plato

1955 *The Republic*. London: Penguin.

Prussin, Labelle

1973 *The Architecture of Djenne: African Synthesis and Transformation*. Ph.D. diss. Yale University, New Haven.

Puente, Tito
1958 "Eleguana." *Top Percussion: Tito Puente* (RCA Victor LPM-1617): side 1, track 1.

Read, Herbert
1974 *A Concise History of Modern Painting* (1959). Reprinted London: Thames and Hudson.

Rejholec, Jutta
1983 "Zerissene Wesen: Zur Malerei des nigerianischen Malers Rufus Ogundele." In *Tendenzen* 144(24):70 ff.

Roberts, John Storm
1985 *The Impact of Latin American Music on the United States.* Tivoli, N.Y.: Original Music.

Roth, H. Ling
1968 *Great Benin: Its Customs, Art and Horror.* London: Routledge and Kegan Paul.

Russell, Bertrand
1946 *History of Western Philosophy.* London: Allen and Unwin.

Sandoval, Alonso de, S. J.
1956 *De Instauranda Aethiopium Salute. El mundo de la esclavitud negra en America* (1627). Reprinted Bogota: Empresa Nacional de Publicaciones.

Sapir, J. D.
1977 "The Anatomy of Metaphor." In *The Social Use of Metaphor: Essays on the Anthropology of Rhetoric*, edited by J. D. Sapir, pp. 3–32. Philadelphia: University of Pennsylvania Press.

Sieber, R., and R. A. Walker
1984 *African Art in the Cycle of Life.* Washington, D.C.: National Museum of African Art, Smithsonian Institution.

Smith, Robert
1988 *Kingdoms of the Yoruba.* 3rd ed. London: James Currey.

Ströter-Bender, Jutta
1991 *Zeitgenössische Kunst der "Dritten Welt."* Cologne.

Tambiah, Stanley J.
1985 *Culture, Thought, and Social Action.* Cambridge, Mass.: Harvard University Press.

Thompson, Robert Farris
1969 "Abatan: A Master Potter of the Egbado Yoruba." In *Tradition and Creativity in Tribal Art*, edited by D. Biebuyck, pp. 120–82. Los Angeles: University of California Press.
1970 "The Sign of the Divine King." *African Arts* 3(3):8–7, 74–80.
1971 *Black Gods and Kings: Yoruba Art at UCLA.* Reprinted Bloomington: Indiana University Press.
1974 *African Art in Motion.* Berkeley: University of California Press.
1984 *Flash of the Spirit.* New York: Vintage.

Torgovnick, Marianna
1990 *Gone Primitive: Savage Intellectuals, Modern Lives.* Chicago: University of Chicago Press.

Townsend, Richard Fraser

1979 *State and Cosmos in the Art of Tenochtitlan.* Washington, D.C.: Dumbarton Oaks. Studies in Pre-Columbian Art and Archaeology 20.

Turner, Victor

1977 *The Ritual Process: Structure and Anti-Structure.* Ithaca: Cornell Paperbacks Edition.

Udechukwu, Obiora

1981 *No Water.* An Exhibition Catalogue of Drawings, Watercolours and Prints. Nsukka: Odunke Publications.

1989 *Nsukka Landscape.* An Exhibition Catalogue. Lagos: Italian Cultural Institute.

Underwood, Leon

1949 *Bronzes of West Africa.* London: Tiranti.

Vansina, Jan

1984 *Art History in Africa: An Introduction to Method.* London and New York: Longman.

Vastokas, Joan M.

1987 "Native Art as Art History: Meaning and Time from Unwritten Sources." *Journal of Canadian Studies* 1(4):7–36.

Verger, Pierre

1954 *Dieux d'Afrique.* Paris: Paul Hartman.

1957 *Notes sur le culte des Orisa et Vodun à Bahia.* Dakar: Mémoires de IFAN 51.

1968 "La société Egbe-Orun des Abiku, les enfants qui naissent pour mourir maintes fois." *Bulletin de l'I.F.A.N.* 30(B):1448–87.

1981 *Oxosse, O Cacador.* Salvador: Editora Corrupio.

Vogel, Susan, ed.

1981 *For Spirits and Kings: African Art from the Tishman Collection.* New York: Metropolitan Museum of Art.

1991 *Africa Explores, 20th Century African Art.* New York: Center for African Art.

Wahlmann, Maude

1974 *Contemporary African Arts.* Chicago: Field Museum of Natural History.

Walker, Roslyn Adele

1991 "The Ikere Palace Veranda Posts by Olowe of Ise." *African Arts* 24:77–78, 104.

Walters, David

1967 "Jedermann in Oshogbo." *Tendenzen, Neue Kunst in Afrika,* 1. Sonderheft 1967 (8. Jahrg.): 92–104.

Webster's Collegiate Dictionary

1932 London: Bell and Sons.

Werner, O., and Frank Willett

1975 "The Composition of Brasses from Ife and Benin." *Archaeometry* 17(2):141–56.

Wescott, Joan

1962 "The Sculpture and Myths of Eshu-Elegba: Definition and Interpretation in Yoruba Iconography." *Africa* 33(4):336–53.

Wescott, R. W.

n.d. "Did the Yoruba Come from Ancient Egypt?" *Odu* 4:10–15.

White, Hayden

　　1987　　*The Content of the Form: Narrative Discourse and Historical Representation*. Balti-
　　　　　　more: Johns Hopkins University Press.

Willett, Frank

　　1959　　"Bronze and Terracotta Sculptures from Ita Yemoo, Ife." *The South African Archae-
　　　　　　ological Bulletin* 14(56):135–37.

　　1966　　"On the Funeral Effigies of Owo and Benin, and the Interpretation of the Life-size
　　　　　　Bronze Heads from Ife." *Man* 1:34–45.

　　1967　　*Ife in the History of West African Sculpture*. London: Thames and Hudson.

　　1971　　*African Art: An Introduction*. London: Thames and Hudson.

　　1973　　"The Benin Museum Collection." *African Arts* 6(4):17.

　　1986　　"A Missing Millennium? From Nok to Ife and Beyond." In *Arte in Africa*, edited by
　　　　　　Ezio Bassani, pp. 87–100. Modena: Edizioni Panini.

Willett, Frank, and John Picton

　　1967　　"On the Identification of Individual Carvers: A Study of Ancestor Shrine Carvings from
　　　　　　Owo, Nigeria." *Man* 2(1):62–70.

Williams, Dennis

　　1964　　"The Iconology of the Yoruba Edan Ogboni." *Africa* 34(2):139–65.

Williams, R.

　　1985　　*Key Words: A Vocabulary of Culture and Society*. Revised edition. New York: Oxford
　　　　　　University Press.

Witte, Hans

　　1982　　"Fishes of the Earth. Mudfish Symbolism in Yoruba Iconography." *Visible Religion,
　　　　　　Annual for Religious Iconography*. 1:154–74.

　　1984　　*Ifa and Esu. Iconography of Order and Disorder*. Soest, Holland: Kunsthandel Luttik.

　　1987　　"Images of a Yoruba Water-Spirit." In *Effigies Dei: Essays on the History of Religions*,
　　　　　　edited by D. van der Plas. Leiden: Brill.

　　1991　　"La quête du sens dans le symbolisme Yoruba: Le cas d'Erinle." *Numen, International
　　　　　　Review for the History of Religions* 38(1)59–79.

Wolff, Hans

　　1962　　"Rara: A Yoruba Chant." *Journal of African Languages* 1(1).

Woolff, Janet

　　1981　　*The Social Production of Art*. London: Macmillan.

Yai, Olabiyi

　　1992　　"From Vodun to Mawu: Monotheism and History in the Fon Cultural Area." Forth-
　　　　　　coming in *Religion et histoire afrique*. Colloque du Centre de Recherches Africaines,
　　　　　　Université de Paris III.

Glossary of Yoruba Terms

àbàjà type of facial mark

àbíkú "born-to-die" child

àbò amulet used by hunters

adépàte a market woman with her wares on a tray balanced on her head

àdìre indigo resist-dyed cloth with patterns

afèdèfèyò one who speaks all languages, including Yoruba

àgbà mature or elderly person

àgbà ìlú senior leaders in a town or community

àgbàrá òjò torrents of water from a heavy rainfall

agere Ifá container for storing palm nuts used in divination

àgúrù generic term for a headdress with figurative superstructure above a helmet mask; see *epa*

aitò ritual acknowledgment of a spiritual presence

àjé okùnrin wizard

ajere Ifá see *agere Ifá*

àkàrà fried bean cakes

àkììkìtán one whose praises are endless

akòko *Newboldia laevis*: leaf used in chieftaincy rituals

àlà white cloth

alárìnjó traveling entertainment masqueraders

àló riddle, puzzle, folktale

apá *Afzelia Africana*, type of tree

àpò shoulder bag

àpótí boxlike container made of wood for storage; stool

ará native or citizen

ará òrun "dwellers in heaven"; refers to ancestors

àrè itinerant person

àrẹ̀ ọ̀jẹ̀ itinerant masked performers

áro c-shaped metal bells struck against each other as percussion instruments

arugbá Ṣàngó ritual bearer of calabash; sculptural artifact for *òrìṣà* Ṣango

àṣà tradition; style; custom

àṣà-àtijọ́ ancient tradition or style

àṣà-àtọwọ́dọ́wọ́ tradition or style passed on from one generation to the next

àṣà-ìbílẹ̀ local tradition

àṣà-tuntun recent tradition or new style

àṣẹ authority; ritual power; life force; efficacious speech; medicine to empower speech or incantation

àwòrán picture; literal depiction of a person or thing

aworo priest

ayaba wife of paramount chief

àyànmọ́ one's destiny; fate

baálẹ̀ head of village or small town

baálé head of a household/compound

babaláwo "father of secrets"; Ifa divination priest

bàtá type of drum

bọ̀lòjò bọlojọ tall and robust

dídán shining smoothness

dúdú black

dùndún hourglass-shaped drum; often referred to as a "talking drum"

eébèlé type of *egúngún* brought by the Owu people to Gbọngan

egún, egúngún ancestral masquerade

egúngún onídán entertainment-type masquerade

èjìogbè a major *Odù* in Ifa texts

èkùrọ́ palm nut

ère ìbejì carving for deceased twin

erékó district surrounding a town

erinmínladò hippopotamus

erin omi elephant of the water

ètò order; arrangement

ẹbí family; relation

ẹdan ritual artifacts of the Oṣugbo/Ogboni society

ẹfun ìràwọ̀ "star chalk" with which Itẹfa initiate's head is painted

ẹgbẹ́ ikọn aspect of age-grade system in Ọpin Ekiti

ẹja àrò mudfish

ẹkún ìyàwó bride's *oríkì*-based lament

ẹlẹ́sẹ̀ kan one-legged being

èmí *Butyrospermum Parkii*; shea butter tree

ẹnu ọ̀nà gate; entrance; doorway

ẹpa *àgúrù*-type masquerade found in Igbomina/Ekiti area

ẹsẹ Ifá verse of Ifa

ẹsẹ̀ ọpọ́n position on a divination tray opposite the face of Eṣu

ẹwà beauty

ẹyin egg

ẹyọ Ifá interpretation of Ifa texts

fífun white

fínònà ritual act of jumping over a fire in Itẹfa

gbẹ́ to carve

gbèdu type of drum, usually reserved for kings or important persons

gẹ̀lẹ̀dẹ́ masked festival in southeastern Yorubaland

gígún straight

gúdúgúdú drum rhythm

hàn visible

ìbọ́ interlaced pattern

ìbosùn sacrifice performed at an *osùn* staff

ìdáhùn response

idán miracles; wondrous transformation; see *egúngún onídán*

ìdúrógangan upright; erect

ìfarabalẹ̀ calmness; control of hand and mind

ìgángán tangle of brambles

igbá gourd; calabash

ìgbẹ́jọ̀ court where disputes are settled

igbódù sacred grove for divination

igi tree; wood

ìjálá *oríkì*-based hunter's chant

ijálù rhythmic patterns played by *ìyáàlù* drummer in *egúngún* performance

ijìnlè depth

ìkáàgo receiving permission to enter

ikin Ifá sacred palm nuts used in Ifa divination; also *iken Ifá*

ikóidé red parrot feather

ìkòkò pot; earthenware container

ilé-ayé the physical world

ilédì lodge of Oṣugbo/Ogboni society

ilé imọnlè sacred enclosure

ilé ìsòyìn chamber for an ancestral masquerade

ilé-òrun realm of the spirits; heaven

ilé pètésì a two-story building

ilutí good hearing; teachable; comprehending

imawogbodù to enter a sacred grove (*igbodù*)

imosùn ritual conveyance of an Ifa staff

ìparadà transformation

iréna type of wood used in carving *ère ìbeji*

ìrójú perseverance

iróké Ifá Ifa divination tapper

ìrókò *Chlorophora Excelsa*; African teak

iṣaasùn soup pot

iṣẹ́ dídán completeness; finished

iselu "sounding the drums"; pure *oríkì* drumming

ìtá òrún spiritual realm; heaven

ìtàn history; narrative

iten specially prepared mat for Itẹfa rite

ìtutù l'ójú "cooling the face"; soothing effect

iwà character; essential nature of a person or thing; existence (in a broad sense)

iwàpèlé gentle character

iwì *oríkì*-based *egúngún* chant

iwọhùn tremolo sound in *ìjálá* chanting

ìyá ẹgbé leader of a woman's society

ìyáàlù "mother drum" or lead drum

ìyàtò difference, distinction

iyẹ̀ròsùn powdered wood dust of the *iròsùn* tree used in divination

ìyeyè *Anacardiaceae*; hog plum tree

iyi Ifá divination rite

iyọ̀ salt

kábíyèsí "Your Highness"; salutation to an *ọba*

kẹ́kẹ́ type of facial mark

kì verbal performance of *oríkì*

ki ibọn to load a gun

kọ̀bi small market stalls on the side of a building

kóló body tattoo

létòlétò in an orderly fashion; one after another; also *l'ẹ́sẹ ẹsẹ*

obì kola nut

obì àbàtà a type of kola nut with two to four cotyledons

obìnrin ilé woman of the household

odi wall

Odù the 256 groupings of Ifa texts; also *òrìsà* Ọrunmila's wife

òdùsọ́ see *olóri ikin*

ogun war

ojú eyes

ojúbona attendant

ojú-inú "inner eye"; insight

ojú-ọnà "eye for design"; design consciousness; originality

ojú òórì grave shrine

ojú ọpọ́n "face" or surface of a divination tray

ojú òrìsà "face" of the *òrìsà*; altar of the gods

òkè hill; mountain

olóri ikin leader of *ikin Ifá*

olórìsà devotee of an *òrìsà*

oníbodè dáa-dáa guardian at the crossroads

oògùn medicine; charms

orí-inú inner head of the spiritual self; prenatal destiny

oríkì appellations; attributions; epithets

oríkì orílè *oríkì* of place of origin

òrìsà deity

òrìsà funfun deity associated with whiteness

oríta méta "where three roads come together"; intersection

orokiti a dance in Itefa rite

orù pitcher or clay pot for storing water

òsánmásìnmì carved wooden ram's head placed on ancestral altars in Owo

osó wizard

Òsùgbó/Ògbóni cult of the elders

osùn camwood

òtìtà a wooden stool or box

òwe proverb

Oya-pípè *oríkì* for *òrìsà* Oya

oba ruler; monarch; sovereign

òbàrà owó eyo "shower of money"; "torrent of coins"

ode hunter

ogégé-a-gbáyé-gún perfection; primeval order; regulative principle of the universe

ojà oba ruler's market

ojà obìnrín women's market

Òjè title in family where *egúngún* is venerated

ológìnìngíni expensive and lavishly designed textile

omo child; offspring

omo awo "children of ancient, esoteric wisdom"; Ifa initiates

omolúabi, omolúwabi "child born of Olu-iwa"; gentleman; cultured person

onà bíbù roughing out the shape of a sculpture

onà lílé initial definition of the major volumes of a sculpture

ònà munu direct path

ònà òganran straight path

òpá osùn Ifa priest's iron staff

òpé léngé slender, tall, lean person

òpèlè divining chain

opón Ifá divination tray

òpón Ògún ritual sculpture of kneeling female figure with bowl on head; also known as *arugbá*

ọrùn orí neck

ọrùn ọwọ wrist

ọṣẹ dúdú black soap often used medicinally

òṣó snare for large animals

ọtá stone

ọtá àro rock anvil

pa break open; cut something in half; hatch

paa mura momentarily vaporize

pa ìtàn to tell a story or fable; to shed light on an experience

pante medicated belt providing protection

páràdà to be transformed, changed

pìtàn to tell a story

pọ́n to praise, flatter

pòòtò pààtà thick and broad

pupa red

rárà royal bard's *oríkì* chant

rárà ìyàwó bride's lament

rárà sísun bride's lament

Ṣàngó-pípè *oríkì* chant addressed to *òrìṣà* Ṣango

ṣèkèrè musical instrument; calabash covered with net of cowrie shells

ṣigo type of tree used for carving

tàn illuminate, enlighten; discern, disentangle

títọ́ enduring, lasting

títun new

unkan/siseli carving tool used in Ekiti, the handle and cutting edge consisting of one iron bar

waji prepared indigo dye

yá to carve

yá àwòrán to depict

yá ère to carve an image

yangí reddish brown laterite rock

yíyẹ appropriateness

Contributors

Wande Abimbọla Former Vice Chancellor of Ọbafẹmi Awolọwọ University. Author of several collections of Ifa oral poetry in Yoruba and English, including *Ifá: An Exposition of Ifá Literary Corpus*, 1976.

Rowland Abiọdun Professor of Fine Arts and Black Studies, Amherst College. Author of numerous essays on Yoruba art and aesthetics, including co-authoring with H. J. Drewal and J. Pemberton III *Yoruba: Nine Centuries of African Art and Thought*, 1989 and *Yoruba Art and Aesthetics*, 1991.

Ọba Solomon Babayẹmi Former Senior Research Fellow at the Institute of African Studies, University of Ibadan, Nigeria, and now the Olufi of Gbọngan. Author of numerous articles on the history of Old Ọyọ, and of *Egungun among the Oyo Yoruba*, 1980.

Karin Barber Lecturer at the Centre of West African Studies, University of Birmingham. Author of *I Could Speak until Tomorrow: Oríkì, Women, and the Past in a Yoruba Town*, 1991.

Ezio Bassani Author of numerous articles on West African art and co-author with William Fagg, *Africa and the Renaissance: Art in Ivory*, 1989.

Henry John Drewal Evjue-Bascom Professor of Art History, University of Wisconsin, Madison. Author of numerous essays, exhibition catalogues, and films; co-author with M. T. Drewal, *Gẹlẹdẹ: Art and Female Power among the Yoruba*, 1983 and co-author with J. Pemberton III and R. Abiọdun, *Yoruba: Nine Centuries of African Art and Thought*, 1989 and *Yoruba Art and Aesthetics*, 1991.

Margaret Thompson Drewal Associate Professor in the Department of Performance Studies, Northwestern University. Co-author with H. J. Drewal of *Gẹlẹdẹ: Art and Female Power among the Yoruba*, 1983 and author of *Yoruba Ritual: Performers, Play, Agency*, 1992.

Akin Euba Visiting Andrew Mellon Professor, Department of Music, University of Pittsburgh. Author of *Yoruba Drumming: The Dùndún Tradition*, 1990.

Michael D. Harris Assistant Professor, School of Art and Design, Georgia State University. Author of articles on African and African American art and co-author with W. MacGaffey of *Astonishment and Power*, 1993.

John Mason Initiated as a Yoruba priest of Ọbatala, co-founder and director of the Yoruba Theological Archministry, a non-profit research center, and author of several books, including *Orin Òrìsà: Songs for Selected Heads*, 1992.

John Pemberton III Crosby Professor of Religion, Amherst College. Co-author with William Fagg, *Yoruba Sculpture of West Africa*, 1982; co-author with H. J. Drewal and R. Abiọdun, *Yoruba: Nine Centuries of African Art and Thought*, 1989 and *Yoruba Art and Aesthetics*, 1991.

John Picton Professor of Anthropology, School of Oriental and African Studies, University of London. Author of numerous articles on Yoruba and Igbira art and co-author with J. Mack, *African Textiles: Looms, Weaving and Design*, 1979.

Jutta Ströter-Bender Member of the faculty of the University of Frankfurt, painter, and author of a study on contemporary art in the third world.

Robert Farris Thompson Master of Timothy Dwight College and Professor of the History of Art, Yale University. Author of numerous books, articles, and exhibition catalogues on African and African-American art, including *African Art in Motion*, 1974, *The Flash of the Spirit*, 1983, and *Face of the Gods: Art and Altars of Africa and the African Americans*, 1993.

Roslyn Adele Walker Associate Curator of African Art, National Museum of African Art, Smithsonian Institution, Washington, D.C. Organizer of several exhibitions on African art, author of numerous essays and co-author with R. Sieber, *African Art in the Cycle of Life*, 1987.

Frank Willett Formerly Keeper of Ethnology and General Archaeology in the Manchester University Museum and Archaeologist to the Federal Government of Nigeria and Curator of the Ifẹ Museum, as well as on the faculty of universities in Great Britain and the United States. Author of *Ife in the History of West African Sculpture*, 1967 and *African Art: An Introduction*, 1971.

Hans Witte Author of numerous essays and exhibition catalogues on Yoruba art, including *Ifa and Esu: Iconography of Order and Disorder*, 1984 and *Earth and the Ancestors: Ogboni Iconography*, 1988.

Ọlabiyi Babalọla Yai Professor of African Languages and Literature, University of Florida. Author of numerous essays on linguistics and West African languages, including "Issues in Oral Poetry: Criticism, Teaching and Translation," in *Discourse and Its Disguises: The Interpretation of African Oral Texts*, edited by K. Barber and P. F. Farias, 1989.